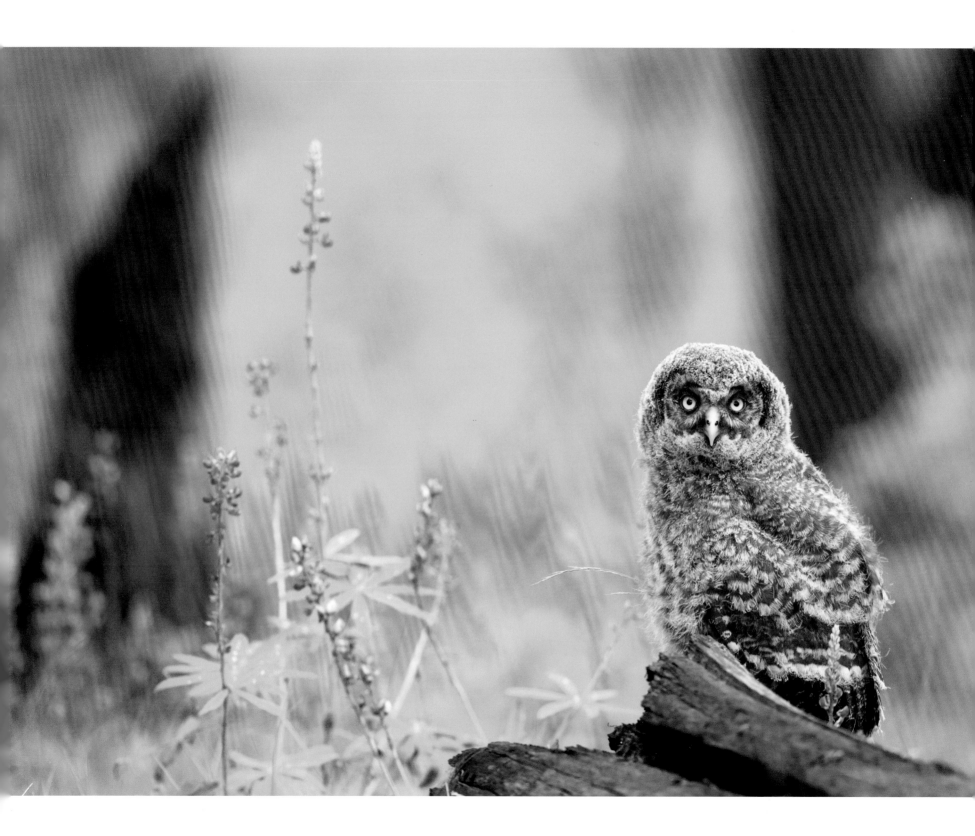

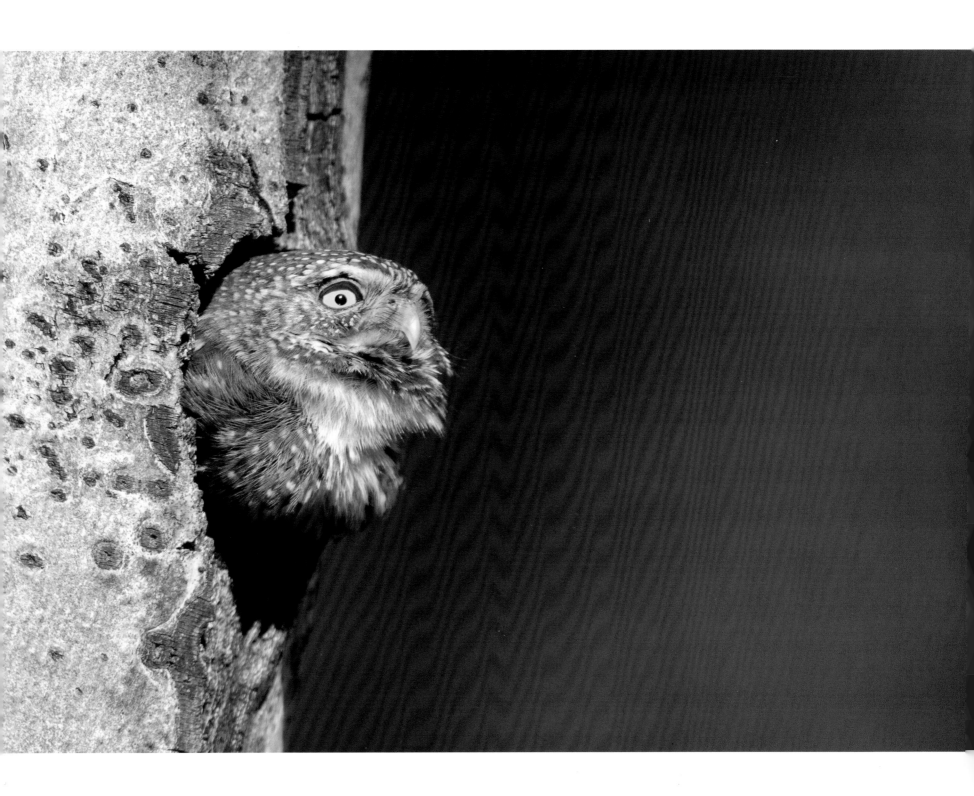

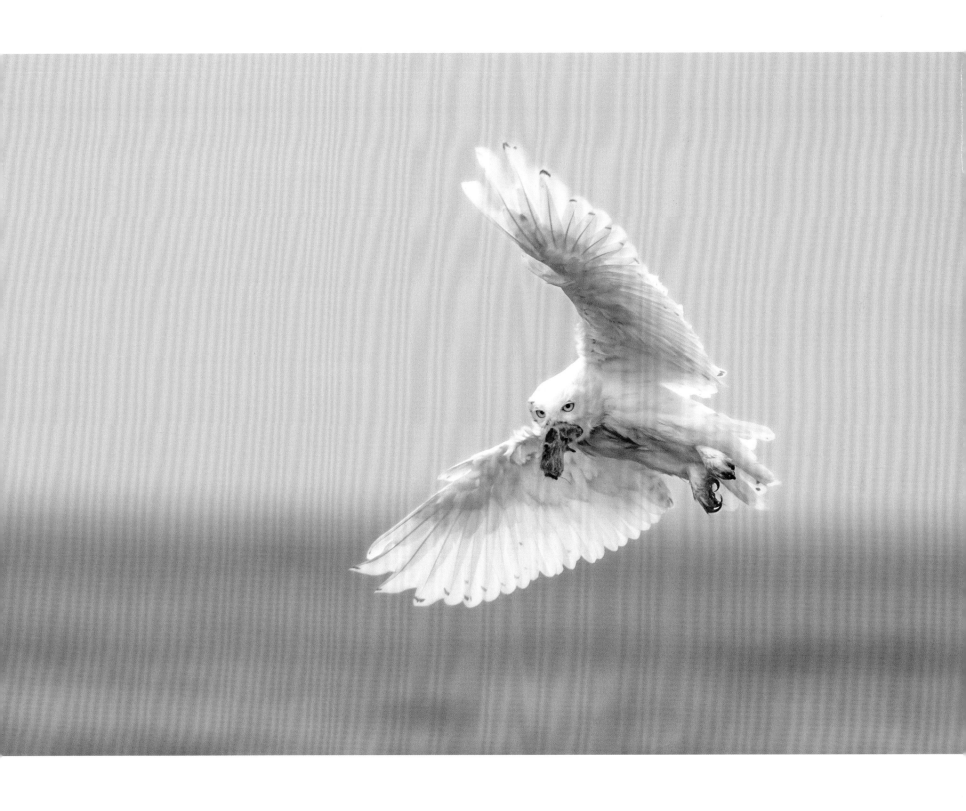

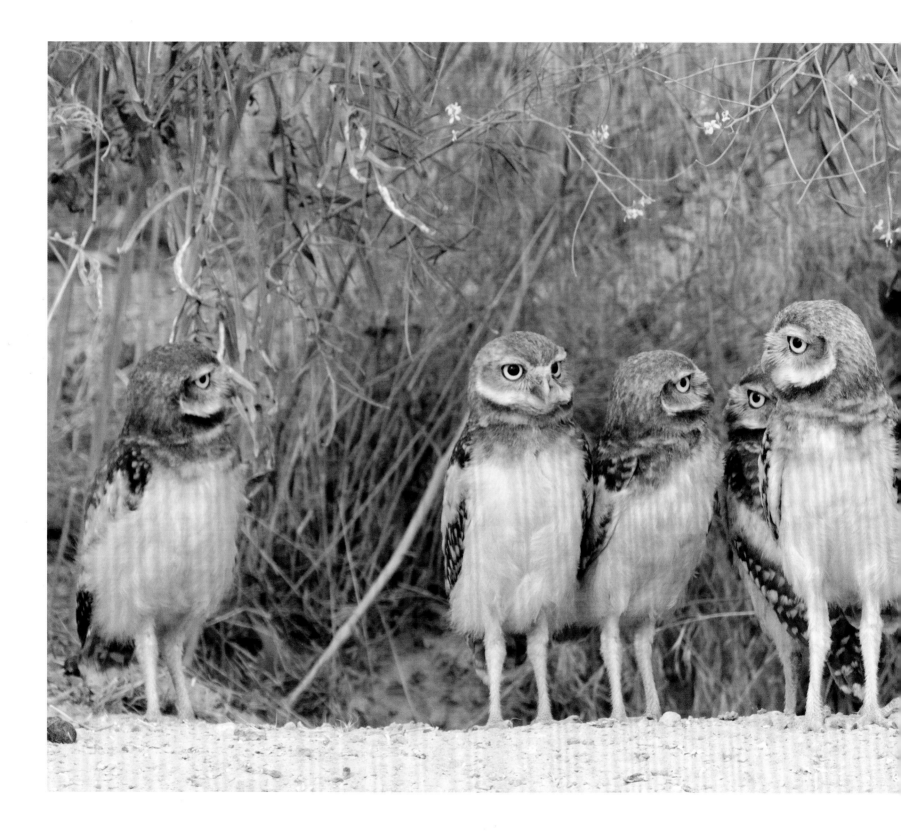

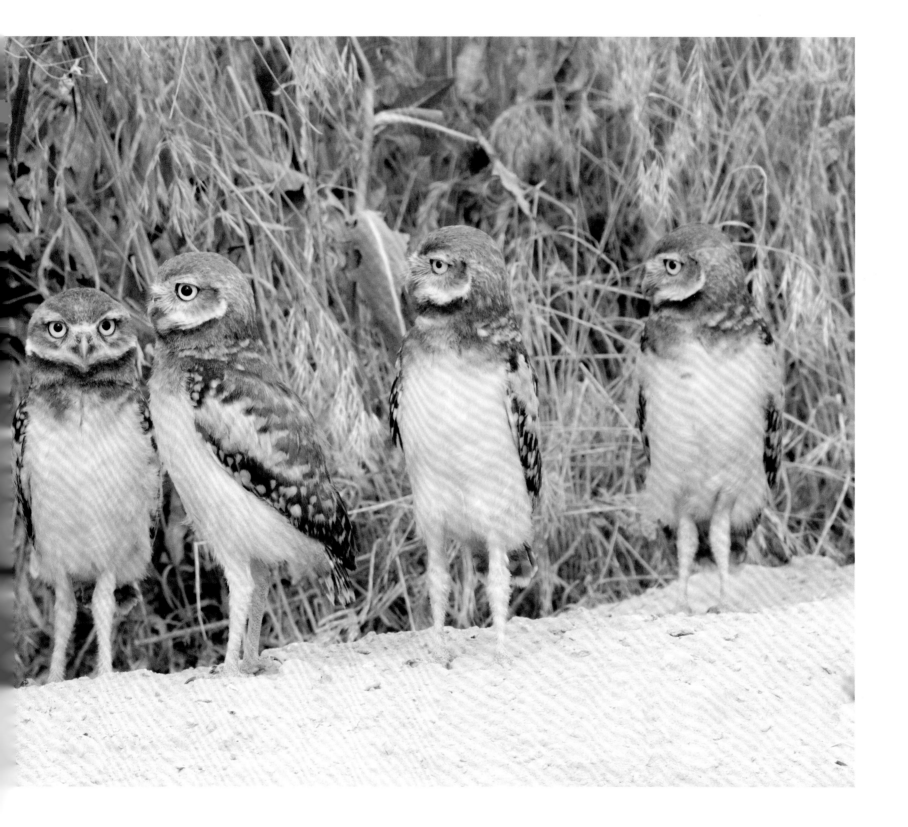

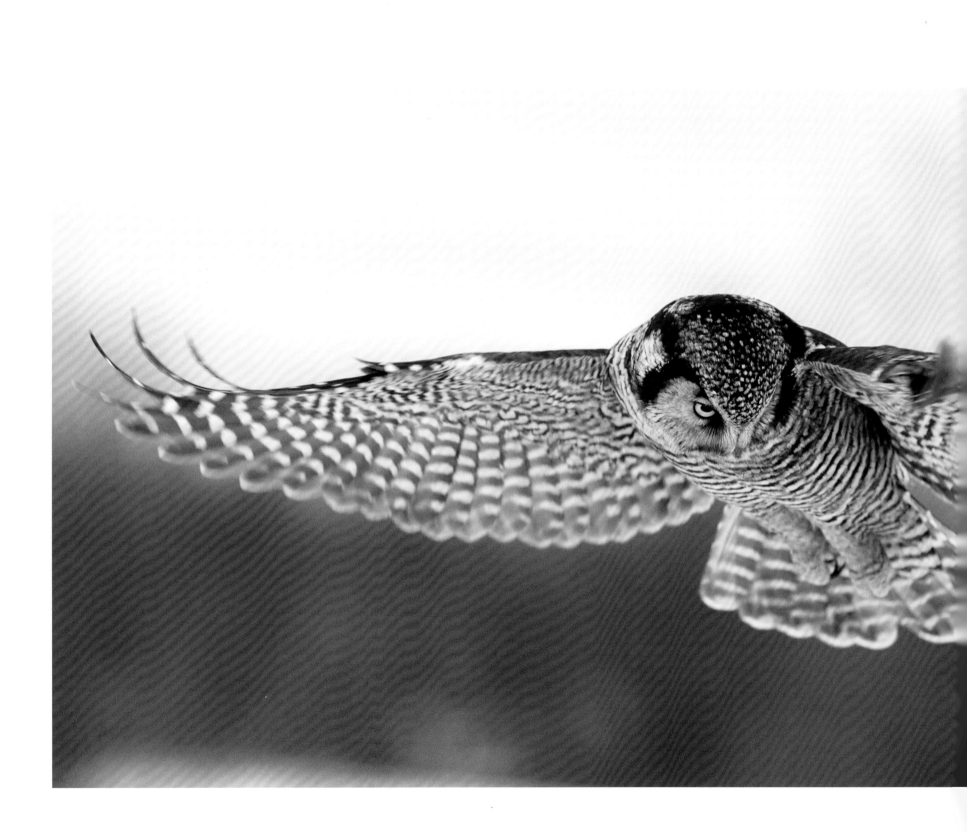

OWL

A YEAR IN THE LIVES OF NORTH AMERICAN OWLS

PAUL BANNICK

BRAIDED RIVER

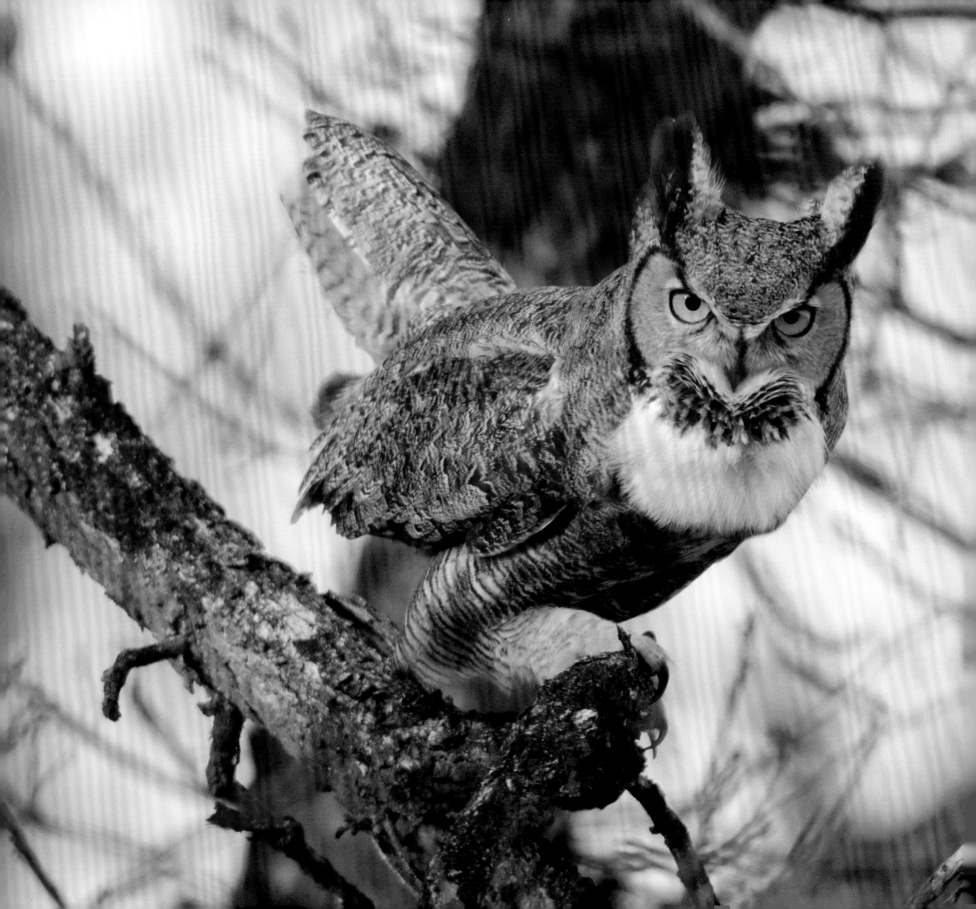

Contents

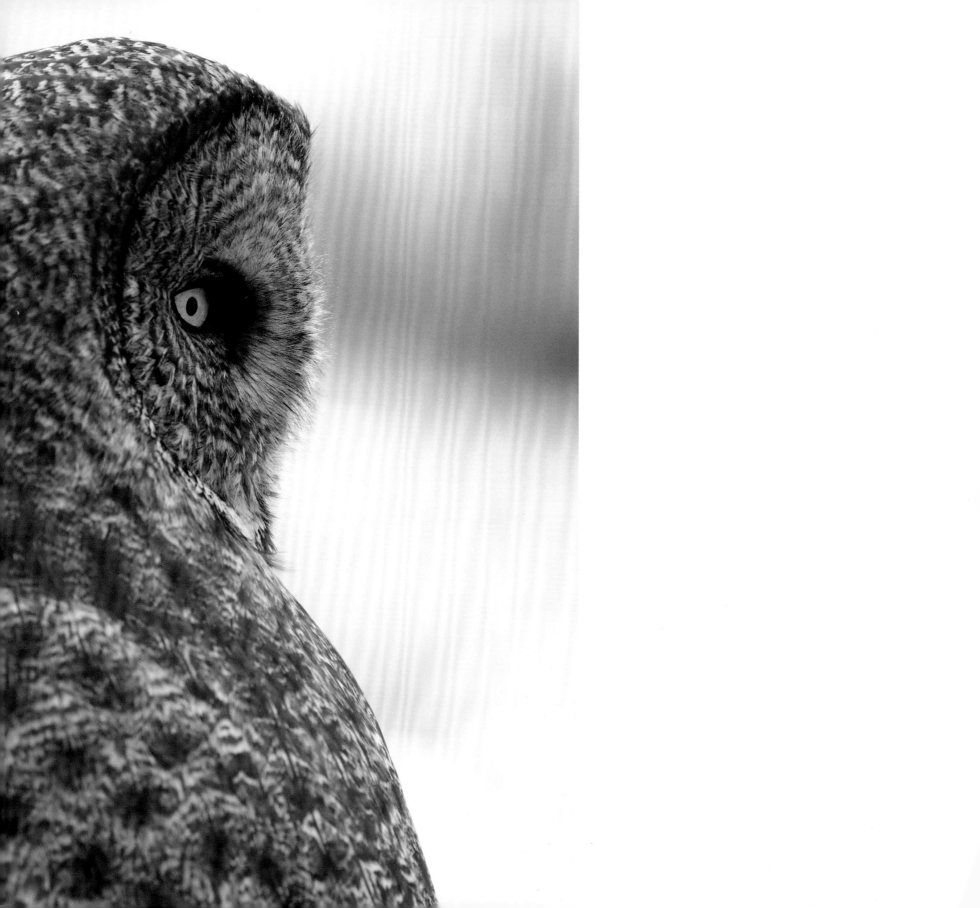

Introduction: The Owl's Message

They stir at the magic hour, that otherworldly time when golden light casts long shadows at twilight. As you near the forest or the field, you may hear their haunting calls.

You do not find owls—owls find you. Their camouflage conceals them until you catch a fleeting glimpse of broad, soft wings illuminated by the setting sun or, more likely, the moon. An owl may alarm you in the darkness as it flies inches from your face without a sound. Perhaps you marvel at the way it hovers over a patch of snow, then dives to capture a vole it cannot see. Or you may feel ill at ease at the way it thrives in the dark hours, making its ghost-like calls.

The face startles: its large, golden eyes are wide set in a disk-shaped face above its hooked bill. Perched on a low fir branch, the owl slowly turns its oversized head more than two hundred degrees to explore its surroundings, then stops, giving you an ambivalent stare.

But we do not share that ambivalence. Since the beginning of recorded time, people throughout the world have held owls in great, although not always positive, esteem. Owls have been associated with wisdom and protection as well as considered bad omens and messengers of death. They have been immortalized in art from the earliest cave paintings to the folklore of every place where people have encountered owls, including Greece, Rome, Egypt, India, Australia, Arabia, Africa, China, and Japan, and among Iñupiat, Inuit, Hopi, Inca, and other native peoples of the Americas. Part of the owl's mystique comes from its association with the dark and all that the unseen represents for us. Are owls, in some way, portentous signs? Do they have a powerful message to share?

Every encounter I have had with an owl has been memorable. As a boy, I constantly scoured the woods, fields, and ponds for wildlife, tantalized by the thought of what animals I might find. Owls were beyond my expectations, since I imagined them roaming far wilder, inaccessible places while I was asleep. When our paths finally crossed, it was momentous.

The Snowy Owl that perched atop a telephone pole near my boyhood home as I arrived home from school one foggy afternoon felt like a singular gift. Several years later, my younger brother and I came upon a lifeless Great Horned Owl, which entranced us with its huge, sharp talons and long ear tufts. I noticed flashes of owls illuminated by headlights at night. These unexpected encounters with these striking creatures made owls seem even more mysterious.

My experience as a naturalist grew, and I became compelled to learn about all nineteen North American owl species to be found in the United States and Canada. (Although Mexico is technically part of North America, this book focuses on only those species to be found in the United States and Canada.) I discovered that many were

While the Great Gray Owl's appearance is mysterious and compelling, its distinctive facial disk is strictly practical: It funnels sound to the owl's offset ears, allowing the owl to more precisely locate prey using hearing alone.

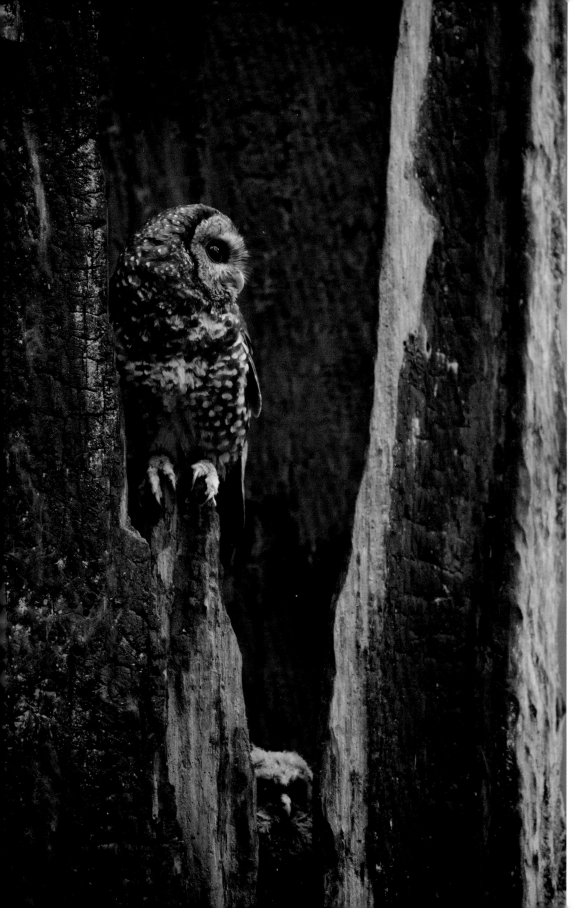

living in the very places I had been exploring over the years. When I listened to recordings of owls' vocalizations, I realized how often these calls had soothed and inspired me as part of the evening soundscape when I hiked, kayaked, or was falling asleep at my campsite. Owls had been closer to me throughout my life than I had known, and I became more fascinated with them.

I learned that owls live in every habitat of North America except the alpine tundra. They often rely on vulnerable elements of many of these habitats, such as ancient trees and snags, wetlands and meadows, and voles and lemmings, for their nests, shelter, and food. Owls are a good measure of the health of the ecosystems they inhabit and of the other animals that also rely on those habitats. This makes owls an indicator species for many of our most threatened habitats. That realization took hold of me.

As a photographer, I had long been driven to contribute to conservation. I paid particular attention to plant and animal groups with many members, because they challenged me to critically examine the habitats each species takes advantage of. The nineteen species of North American owls are difficult to find and photograph. But if I were successful, I might be rewarded with powerful images that could move viewers and motivate them to protect these intriguing birds.

Wildlife photography has taught me to slow down and pay greater attention—to learn about each plant and animal I encounter and what each needs to survive. I remember overhearing a man sitting next to me on an airplane as he pointed out the window to the conifers of the Cascades below and explained to his son, "All those environmentalists want to protect the trees for owls, but look at all those trees—we have more than enough." That comment saddened me, but served as a reminder that our lives now are so removed from the natural world, we risk accidentally eliminating what we fail to see.

Learning about individual owl species was like suddenly finding a much more detailed guide to natural places.

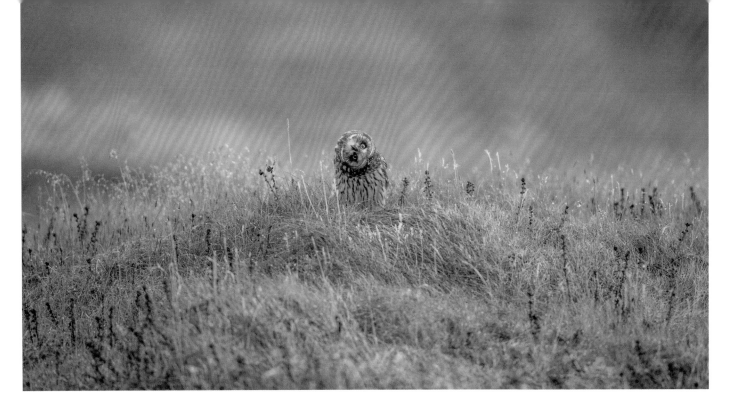

I discovered subtleties I had not fully appreciated before. Today, I return to habitats that once seemed appropriate for several species, and I recognize essential components that may be present or absent for each of those species. I understand that even if species share the same habitat, each has unique needs within that common landscape.

At a time when population growth and development are consuming more natural lands, owls help us see essential parts of the landscape we might otherwise sacrifice or fail to properly steward. As we recognize each owl species' particular habitats, we no longer see them as mystical creatures from another world bearing otherworldly messages. Rather, they are neighbors, reliant on our ability to preserve their habitats. They give voice to subtle variables we might otherwise ignore. The true message they bring us relates to our very real world.

Since owls live in nearly every habitat in North America, their stories are the stories of our natural landscapes.

In the following pages, I follow North American owls through their four annual life phases. I discuss how owls attract mates and select nests, how they find food for and raise their young, how the young leave the nest and gain their independence, and how owls survive the winter. And I discuss the species-specific habitat components that owls need to successfully survive each of these life phases.

In telling the story of the North American owls, I primarily focus my lens and my narrative on four: the Northern Pygmy-Owl, Great Gray Owl, Burrowing Owl, and Snowy Owl. These four species exhibit the majority of behaviors at each phase of an owl's life, inhabit most of the owls' geographic range, and represent much of the variation in owl size and color. And throughout the narrative, I also include photographs, anecdotes, and natural histories of the other fifteen species found in the United States and Canada. (See the field guide at the back of the book, which lists all the North American owl species and provides a photo and natural history facts for each.)

By studying the species-specific habitat needs of owls, I have come to better appreciate the complexity of our natural world. Owls have moved me to empathize with them, and their evocative calls have awakened me to their message—that their future, and the fate of myriad other animals that live alongside them, depends on our understanding their needs and protecting their habitat.

Being unable to move their eyes within their sockets, owls, like this young adult Short-eared Owl on the Arctic National Wildlife Refuge, often turn their head to assess the unfamiliar.

{ *opposite* } Most Northern Spotted Owl nests in Washington and Oregon are in trees that are at least 140 years old. These trees have had time not only to grow large, but also to experience trauma and rot out—and so provide the essentials for a good nest.

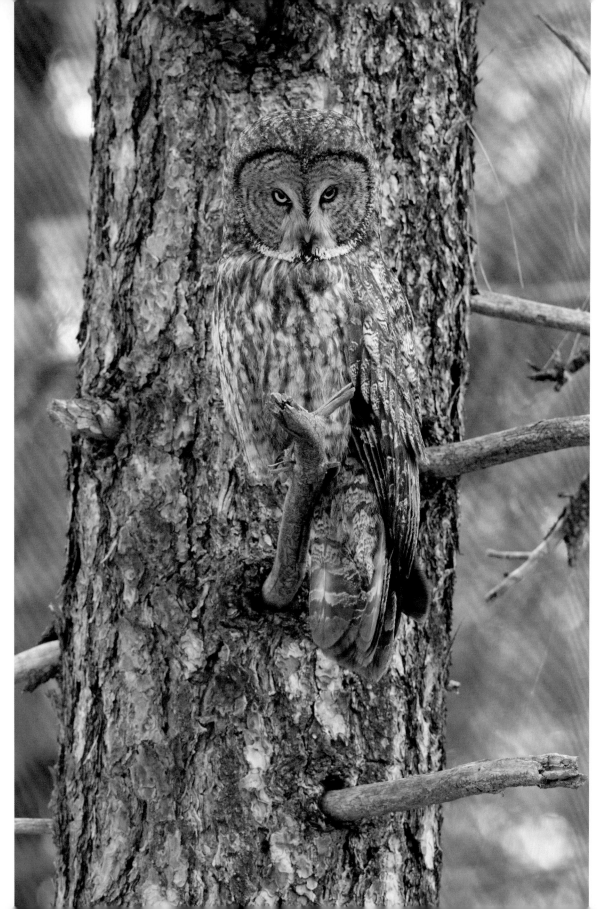

This Yosemite Great Gray Owl is a rare subspecies found in the Sierra Nevada. In order to blend into the tree even more effectively, Great Gray Owls fold their facial disks to break up the shape of their faces.

{ *opposite* } A female Northern Pygmy-Owl explodes from her nest after delivering prey to her young.

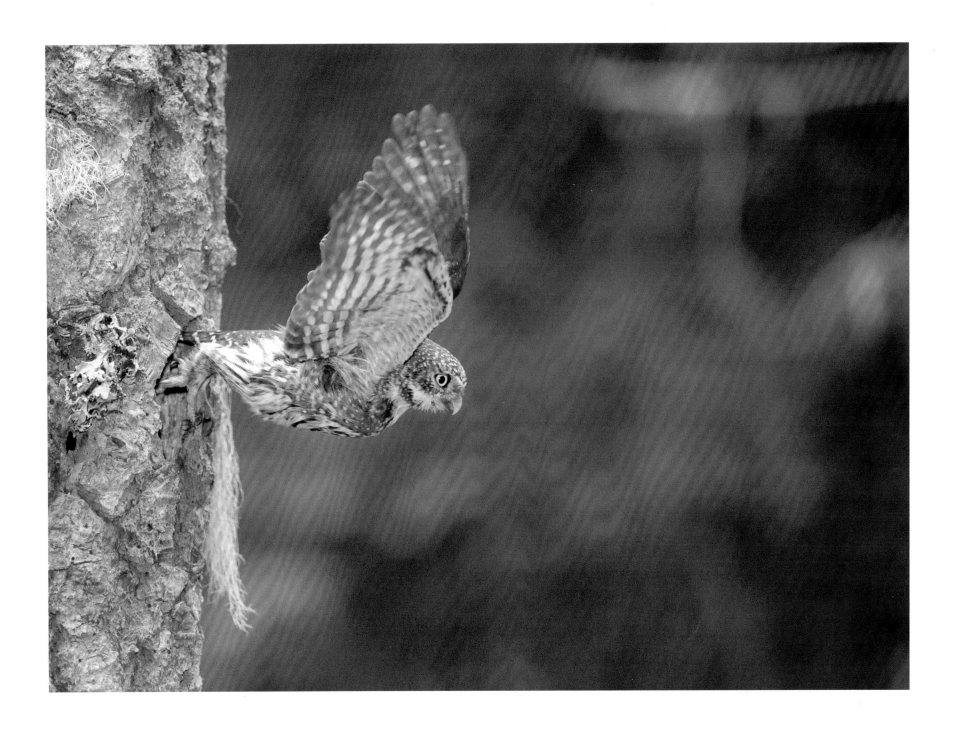

A Great Gray Owl flies low over a mountain meadow in the Canadian Rockies where it is hunting gophers and voles.

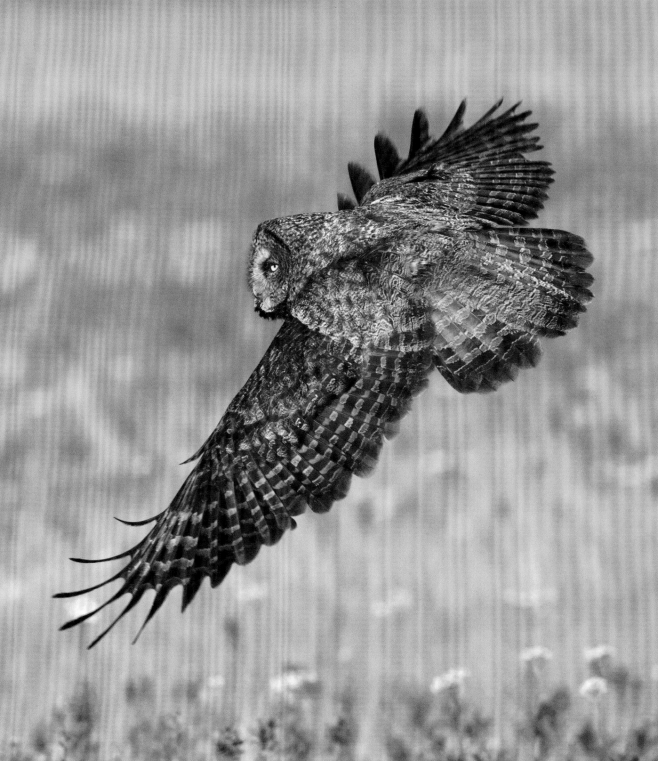

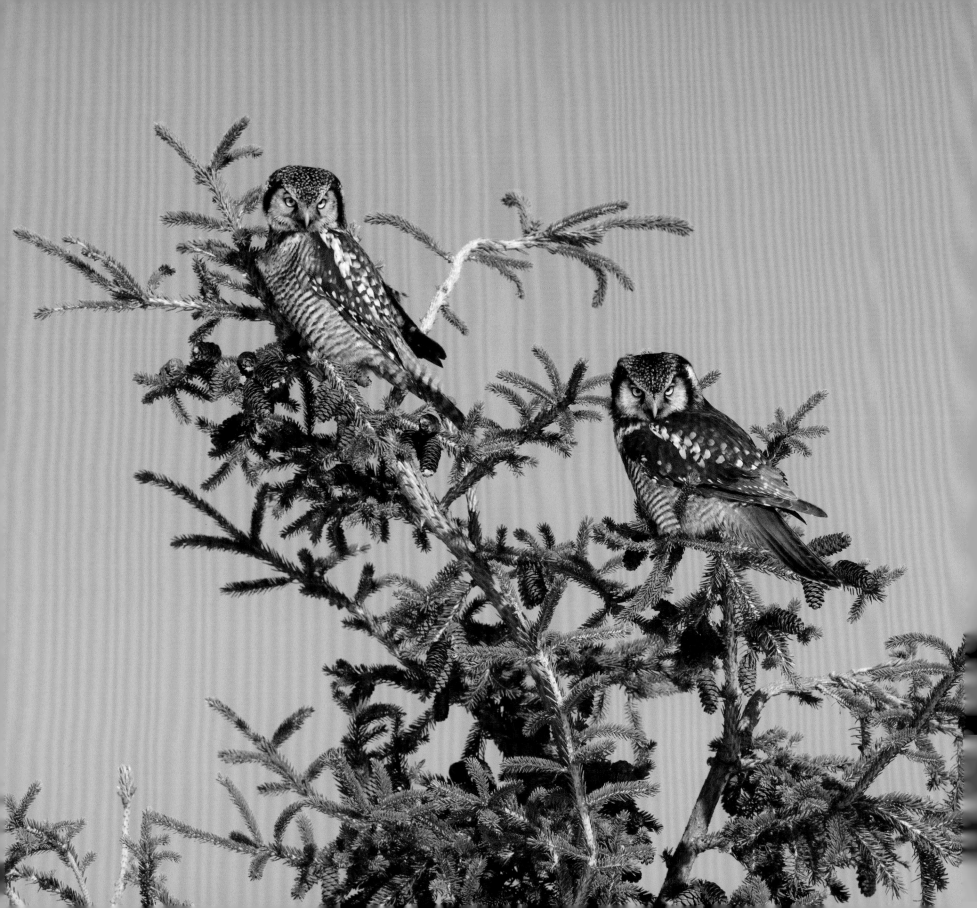

COURTSHIP AND NEST SELECTION

Spring comes early for owls. Their spring is not necessarily our calendar spring, but the beginning of an annual cycle of behaviors that varies by species and habitat. Throughout much of the United States and Canada at this time, nights are icy and the ground is still heavy with wet snow while flowers are far from blooming. The cycle begins when subtle changes in the amount of daylight trigger hormones that stimulate owls to move to breeding lands, establish or re-establish territories, find potential nest sites, secure mates, and breed. These behaviors vary by species, habitat, geography, and in response to weather and prey availability, but the goal is the same: to create the next generation.

Owls are for the most part solitary animals that come together to mate. Some owls simply move within their home ranges to spend more time with one another; others make predictable annual migrations from and to the same places; still others wander nomadically; and some show a mix of patterns. For the most part, the behavior is based on the species, but even owls of the same species vary in their movements and behaviors, depending on where they live. The farther an owl has to travel and the more irregular its movements, the less likely it is to retain the same mate year to year. But we know very little about the movements of owls, and what we do know is based on small numbers of birds in specific locations.

Normally solitary and nomadic, Northern Hawk Owls begin to perch close to each other, engage in mutual preening, and follow one another in flight as part of courtship in early March.

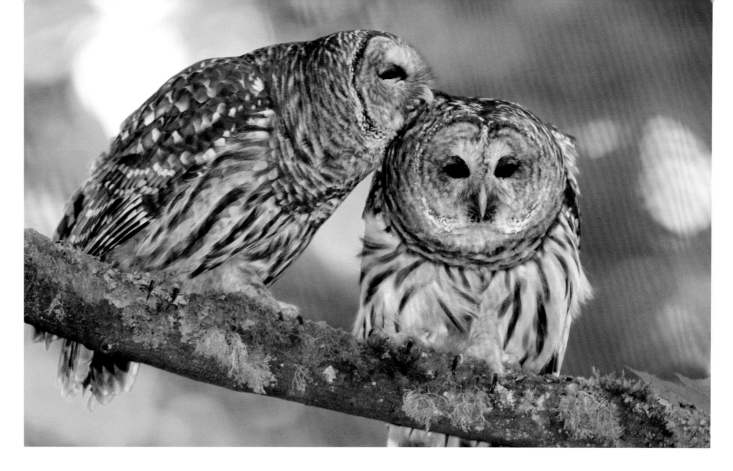

Two Barred Owls preen each other, a common part of owl courtship.

Owls that stay in more or less the same area year-round, such as Great Horned Owls, Western Screech-Owls, Eastern Screech-Owls, Whiskered Screech-Owls, Barn Owls, Barred Owls, Spotted Owls, Ferruginous Pygmy-Owls ("ferruginous" alludes to the rust color some have), and others, often simply reinitiate courtship with long-term mates.

Some owls, such as Elf Owls and Flammulated Owls, are strictly migratory and return to their breeding areas from distant winter grounds. Some Flammulated (from the Latin for "flame-colored") Owls in Colorado, for instance, fly more than 1,500 miles from locations in Mexico to reach breeding sites. And impressively, even after long migrations, they often choose the same mate for many consecutive years. Elf Owls, on the other hand, are fairly typical among owls in that males often return to the same territory every year but usually secure a new mate each time.

Short-eared Owls, Snowy Owls, and Northern Hawk Owls are among several species that wander unpredictably at times. They do not have attachments to perennial

nesting areas and will establish territories, court, and breed where food and nest options are abundant. For example, if the local prey cannot support them, the young of some Northern Hawk Owls will sometimes wander hundreds of miles to where food is more plentiful and will often stay in that area to breed.

I witnessed this behavior in north-central Alberta over a few weekends one late February and early March. When I arrived, two eventual Northern Hawk Owl mates were still a few miles apart, but that was quickly changing. Normally, Hawk Owls are relatively quiet during the winter and make swift, direct flights. I was surprised to see the trilling male flying in a circle and then down the road and deep into a bog with wings held out and head up. Fortunately, the ice held firm as I followed him on my snowshoes over the fifty-foot-wide band of snow marking the deepest part of the bog. As I nervously stepped over the ice, the silhouette of the Hawk Owl perched atop a forty-foot-high spruce snag kept me headed in the right

direction. Every hour or so, he flew to the top of the snag and forcefully issued his *ulululululul* trill call, often for ten seconds or more at a time. On the second day, a female flew in and they copulated, again accompanied by the loud trill. On the third day, the male captured prey and flew into a stand of burned trees with the female at his tail. I watched as they introduced each other to potential nest sites with their long trilling calls. Other times, they copulated or perched quietly together on the same tree. Always, they were together.

The calls, displays, copulation, preening of each other's feathers, and the male's delivery of food to the female are all common parts of establishing or renewing the pair bond for owls and can continue for a few weeks prior to the female laying eggs. Copulation may occur frequently for weeks before the female drops her first egg. So, the following week, I was not surprised to find the female Northern Hawk Owl incubating in the broken top of a burned tree, eyes peering above the front rim and tail pressed upward at a 90-degree angle against the black bark at the back. This incubation period—the bird equivalent of gestation—lasts twenty-four to thirty-seven days, depending on the species of owls.

TERRITORIES AND HOME RANGES

The movement patterns of some species of owls vary depending on the location and year, with some migrating, some showing nomadic tendencies, and others remaining where they wintered. Most Short-eared Owls migrate, for example, but many populations do not return to the area where they bred the year before. Like Northern Hawk Owls, they sometimes winter in new places where food is plentiful and will stay there and try to breed in spring if an abundance of prey persists.

Short-eared Owls frequently winter on the west side of the Cascades, but I had not heard of them breeding in that area for decades. In the spring of 2015, I learned from a friend that they were nesting on a grassy strip between two runways at the Seattle-Tacoma International Airport, where I was able to photograph them. Apparently, construction on a runway allowed the owls to hunt over the winter. When spring came, high prey levels remained, and the grass was tall enough to provide nest sites, so the owls stayed and mated.

Since the more nomadic owls, like the Northern Hawk Owls and Short-eared Owls, do not retain or dependably return to the same breeding territories year after year, it is unlikely that they retain the same mate every year.

Once a male owl chooses where he wishes to spend the spring, he is driven to establish or re-establish a territory and defend it from other males, often before he can secure a mate. Owls have home ranges where the bird moves on a regular basis to find food, establish a nest, and raise a family, but they will defend territories. A territory is a part of a home range, normally comprised of an area around a nest, but sometimes an area around a food source when prey is scarce. For some owls, a territory is large, covering miles of terrain. For others, it is barely more than the immediate area surrounding the nest. Males will aggressively defend their territories, but that requires the expenditure of lots of energy. Sometimes when food is plentiful, territories shrink.

Some owls, including Elf Owls, Western Screech-Owls, Eastern Screech-Owls, and Whiskered Screech-Owls, are polyterritorial: They defend the area around multiple cavities but not the spaces between them. The cavities not used for nests are used for storing food (caching) and resting during inactive hours (roosting) and are sometimes used for renesting (second nesting attempts if the eggs or young are lost).

While Short-eared Owls and Long-eared Owls are known to tolerate nesting in close proximity to others of their species, each bird defends only the immediate area around its nest. Elf Owls and Burrowing Owls seem to prefer nesting close to others of their species, which helps the owls to alert one another to threats. Elf Owls are exceptional in that they often cooperate with neighbors of their species in driving away potential predators.

Owls along with other predatory birds are the targets of mobbing. Mobbing birds aggressively confront an unwelcome animal or bird with agitated calls, close flights, and even physical contact. In doing this, they could be trying to drive away an enemy from their territory, or older birds might be teaching younger birds about the potential predator. They also may be advertising the location of the threat for the benefit of all. These theories might help explain why owls are often mobbed by the same species that they occasionally prey upon. You can see chickadees or juncos mob Northern Pygmy-Owls and Gray Jays mob Northern Hawk Owls or Great Gray Owls. At other times, owls are mobbed by species that compete for food resources, such as Northern Harriers mobbing Short-eared Owls.

The choices of where to nest and where to find food most clearly define an owl's habitat for the first three months of its annual reproductive cycle, with overall habitat being the collection of elements, such as climate, species and structure of plants, and types and abundance of prey, in an area that allows for survival and reproduction. The location of the nest is the core from which an owl will defend its territory, advertise for a mate, and access hunting grounds to ensure breeding success. The choice of where to nest is normally made by the female from options the male presents.

{ *left* } Mobbed by a pair of Gray Jays, this Northern Hawk Owl pulls down its nictitating membranes, clear eyelids that protect its eyes while fighting, capturing prey, or during other dangerous encounters.

{ *right* } The Northern Pygmy-Owl has false eyes on the back of its head that can confuse mobbing birds.

{ *opposite* } Short-eared Owls engage in dramatic courtship flights. The male's elaborate displays include loudly clapping its wings together while descending in a steep dive above the female.

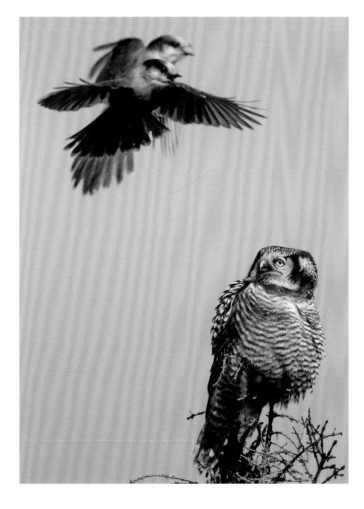

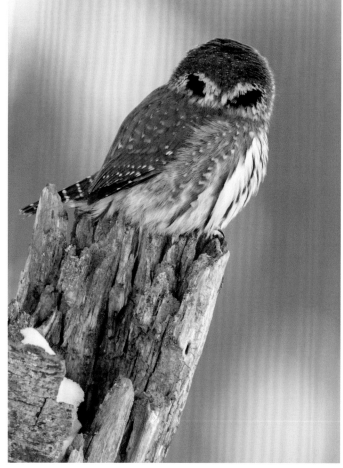

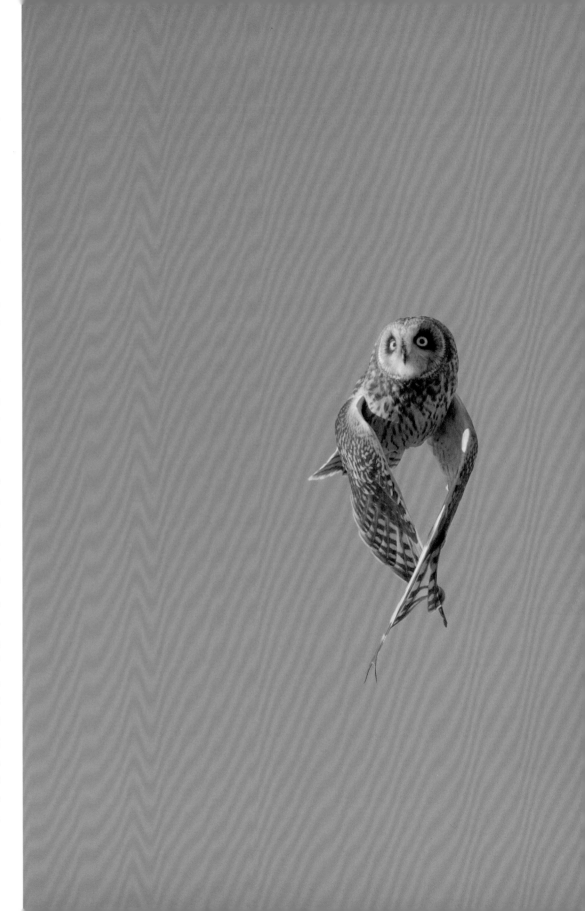

MATING

The male owl's next task—finding a mate—requires that he gets a female's attention and convinces her that breeding with him will be a successful use of her energy. His efforts frequently involve a combination of vocalizations and displays. Resident owls often begin calling during the winter, while migratory owls begin calling on their arrival at traditional nesting areas in early spring. This early calling serves to establish the boundaries of the territory and to advertise for a mate or reinforce pair bonds with an existing mate. With each purpose, the calls are similar, although territorial calls are usually made from prominent perches throughout the territory while advertising calls are frequently made from prospective nest sites.

Advertising calls differ by species but are often comprised of hoots, whistles, toots, trills, and bubbling calls. Some species rely on their distinctive calls to carry throughout their territory, and their calling posture often accentuates distinctive features, such as white markings on the throat or brow.

The particular combinations of calls and displays are influenced by habitat, with owls using the landscape to prove their health and vigor. Owls of treeless landscapes, such as the tundra, grasslands, and steppe, have adapted visual courtship displays that can be seen from great distances. The Short-eared Owls of our open, treeless habitats have perhaps the most impressive of all courtship displays, sky-dancing. When sky-dancing, a male owl ascends in small spirals, sometimes up to more than one thousand feet, where he emits a series of more than a dozen deep, evenly spaced *hoot* calls, while he hovers or flies forward with wings and tail spread wide. He then executes several short dives, during which he rapidly and audibly claps his wings several times under his body. The female, while perching on the ground below, sometimes encourages him with a *kee-up*. The male then returns to the ground with wings slightly raised, often rocking back and forth, and passes by the female, who sometimes gives chase. Copulation sometimes occurs after such a chase.

SNAGS

The scarcity of nest sites and access to prey limit owl populations and usable habitat more than any other factors. Snags, or standing dead trees, help alleviate both of these challenges for most forest owls, but it takes decades for trees to develop to the appropriate diameter and level of decay to be ready for providing nest sites.

Fifteen of North America's nineteen owl species commonly nest in snags because they provide the most suitable cavities in the form of woodpecker holes, hollow trees, and broken tops. Small cavity-nesting owls prefer woodpecker cavities, and only two of the twenty-two species of woodpeckers commonly create their nests in live portions of trees, leaving snags and dead limbs as the most common cavity locations available for owls. Owls that prefer to nest in the broken tops of trees also prefer the dead snags, because the rotted wood is more likely to form or be scratched into a soft recessed surface for eggs and young, and drains water far better than a live broken-topped tree.

Snags take a long time to become suitable hosts for owl nests, even with the help of woodpeckers. Normally, woodpeckers excavate cavities in trees that have been softened by rot, which takes a long time to develop. In the West, aspen is the most common tree for woodpeckers to make their cavities in, and it is not susceptible to heart rot for roughly one hundred years. Fire may help introduce sapwood rot to trees, but it might be another ten years before the wood is soft enough for woodpeckers. And it takes much longer for a tree to grow tall enough, die, and then become decayed enough to be suitable for a Great Gray Owl's broken-top nest.

Snags also allow owls to better access prey by providing listening, resting, and launching perches throughout a hunting territory. And, when snags eventually fall, they provide habitat for voles and other small mammals, which are the primary food source for fifteen of North America's nineteen owl species.

Unfortunately, many people innocently believe snags are expendable and use them for firewood. Even some well-intentioned parks and agencies permit the cutting of snags without realizing they often contain hidden nests, birds, or potential bird nests. Woodpeckers and owls are not the only birds that utilize snags. More than eighty-five cavity-nesting birds in North America commonly nest inside snags, and many raptors nest on top of them. The cutting of snags reduces bird diversity and density by eliminating nesting options and reducing the quantity of, and access to, prey for owls.

Northern Saw-whet Owl nestlings from the same nest cavity peer from two woodpecker-created entrances. As the tree rotted, the two once-separated cavities merged together.

The Long-eared Owl, which shares many of the Short-eared Owl's open habitats, also claps its wings to attract a mate or to warn intruders. Rather than deploying rapid, consecutive wing beats, the male Long-eared Owl gives a single wing clap as he zigzags through and around the nest grove, alternating among deep wing beats, glides, and wing claps.

With many species, courtship displays finish with a delivery of prey from the male to the female, often immediately followed by copulation. Frequently, the pair reinforces their bond through mutual preening. After the birds are paired, the female stops hunting and becomes dependent on the male to provide her food. This occurs perhaps to test the male's competency, but it certainly helps the female dedicate more of her resources to the development of the eggs. The male also often uses prey as a way to encourage the female to investigate nest options that he has identified.

Late one April day, I was driving down a gravel road in southeastern Idaho looking for Burrowing Owls. Most of the landscape was heavily plowed fields, so it would be easy to assume that very little wildlife could exist there. But a small, gargoyle-like Burrowing Owl on the fencepost belied that assumption. The bug-eyed, long-legged vertical owl rotated his body ninety degrees so that he was parallel with the ground, fluffed out his feathers to appear much larger, and displayed distinctive white feathers at his brows and beneath his bill. In this unusual posture, he filled his throat with air and forcibly repeated *hoo-hooo*, clearly an attempt to lure a female lurking somewhere in the sage across the road.

The scrap of land behind the owl's perch was not pristine. Beyond the barbed wire fence, every thirty yards or so, blue-green sagebrush bushes rose three to five feet out of the hard-packed brown dirt whiskered with short, stubby weeds. Firm mounds of tan dirt marked abandoned badger burrows, which were the nest and roost sites for Burrowing Owls.

Down the road, only trails of the sun's red glow remained on the horizon. To my right, six Short-eared Owls danced

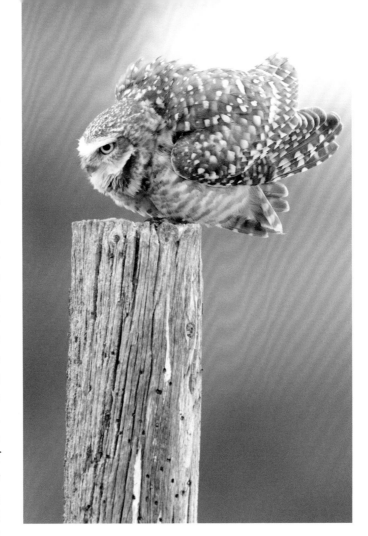

in the air above a rough brown patch of tall dead grass encircled by the green, sprinkler-watered rectangles. These owls had found homes on a scrap of ungrazed land beside heavy agriculture because of the tall vegetation. Within twenty-five miles, in the same habitat, a few pairs of Barn Owls nested in the spaces between straw bales surrounded by hundreds of cows and near other Burrowing Owls on adjacent public land.

Less than fifty miles to the north, two rows of trees roughly thirty yards deep and three hundred yards long, one composed mostly of cottonwood and the other predominantly Russian olive, separated by 150 yards of flat meadow, provided nesting habitat for owls that hunt in the grasslands, sage-steppe, and farmlands, but are often thought of as woodland species. The first shelterbelt hid nesting

A male Burrowing Owl calls in an attempt to attract a mate. Migratory Burrowing Owls normally choose a new mate every year.

Northern Saw-whet Owls (with a call sounding like the sharpening or whetting of a saw blade) and Great Horned Owls, while the second concealed eight nesting pairs of Long-eared Owls. In the adjacent wetlands, several pairs of Short-eared Owls thrived. And Western Screech-Owls were nesting successfully in another stand of trees less than fifty miles away in the same type of landscape.

These seven species of owls were drawn by similar prey—small rodents, which are abundant in and near agricultural lands and in wetland, grassland, and sage-steppe habitats—yet accessed that rich bounty from different types of nests that met their preferences.

NESTS

Nest sites and prey are often located only within a particular landscape within certain ranges of temperature, precipitation, length of seasons, and elevation. These places have a mix of plants of different species and ages and a range of woody debris on the ground that provides homes and shelter for an owl's prey, but also roosting cover and the proper nest surface a specific owl requires. Even the contour of the land and the soil and rock types can be relevant.

Owls rarely create their own nests and are, for the most part, cavity-dependent forest birds. While some owls use several types of nests, given a choice, each has a preference that helps define its ideal habitat. Owls may use one or more of the following nest types, depending on their preference and availability: woodpecker-created or naturally forming cavities in trees or cacti; platform nests, such as broken tops of trees, stick or leaf nests of birds or squirrels, or the platforms provided by ledges, cliffs, or manmade structures; tunnel nests such as burrows or holes underground or in the face of cliffs, stone, or farm forage; and ground nests directly on the ground.

Tree cavities are the most common nest preference of North American owls. Forest owls prefer nesting in large cavities with small entrances, usually on the vertical face of snags, trees, or cacti, although sometimes they select holes or cavities on the tops of trees. Cavities excavated by woodpeckers are used to some degree by ten of the nineteen species of North American owls and are the cavity of choice for eight of nine of the small owls. From an Eastern Screech-Owl in a maple tree in New York's Central Park, to an Elf Owl in a saguaro in Arizona, to a Western Screech-Owl in a red alder on Orcas Island in Washington's Puget Sound, small owls prefer the safety and comfort of cavities created by woodpeckers.

Woodpeckers find it easier to excavate cavities in some trees than in others, resulting in high-density living situations for secondary cavity nesters like owls. Aspen, for example, is a top tree choice because it is relatively common, short-lived, and susceptible to rot. Many small owls have adapted to nesting in woodpecker cavities in aspen stands even when those are not within their preferred hunting habitat. The highest density of small owls that nest in woodpecker cavities occurs in the mountain conifer forests of the western states and provinces, where eight species frequently use them. In these dry landscapes, stands of aspen are like blocks of apartment buildings, with cavity-nesting birds coming and going from holes in the trees at all hours of the day and night. In these areas, Northern Saw-whet Owls, Flammulated Owls, and Northern Pygmy-Owls can be found nesting in the same stands even though they each hunt in very different areas.

When woodpecker cavities of the right size are not available, cavity-nesting forest owls look for natural cavities. These are typically on the sides of trees and cacti, or in the chimney, or recessed top, of older trees where scars from a broken top, broken limb, knothole, lightning, or fire have allowed heart rot to soften and hollow out the inside of a tree. In addition to small forest owls, medium-size owls like Spotted Owls (Northern, California, and Mexican subspecies), Barred Owls, Barn Owls, Northern Hawk Owls, and even, occasionally, the very large Great Horned Owls use these types of natural cavities.

Great Horned Owls, Barn Owls, Long-eared Owls, Great Gray Owls, and, from time to time, Northern Hawk

Owls will nest on natural platforms. Platform-nesting owls tend to choose from the best options available in their preferred habitat. Long-eared Owls in the West often choose to nest in the abandoned nests of Black-billed Magpies, a species that often nests in groups; so the Long-eared Owls have adapted to living in close proximity, often with several pairs nesting in a single small grove. At other times, Long-eared Owls nest outside their grassland habitat in nearby open woodlands, where a solitary Cooper's Hawk's nest might suffice. Great Horned Owls and Great Gray Owls also use stick nests created by other birds when they are available. Great Horned Owls even use cliff ledges. All of these platform nesters will use manmade platforms.

Only six of the roughly two hundred species of owls in the world never use trees for nesting, and three of them—Burrowing Owls, Short-eared Owls, and Snowy Owls—can be found in North America. These owls make use of earth tunnels or the ground surface itself for nesting.

The best example of a tunnel nester is the Burrowing Owl, which uses the tunnels created by burrowing animals like prairie dogs, badgers, and ground squirrels, although Florida Burrowing Owls, a subspecies, often dig their own. And some owls that sometimes nest in trees will also use tunnels. Barn Owls dig and enlarge tunnels in sandy banks, just as they do in the notches between stacked hay bales. The advantages of living in holes and tunnels in soil or rock also appeal to Great Horned Owls, which, like Barn Owls, often nest in cliffside caves and enlarged animal burrows. Tunnel nests are often located in areas without large trees. In those areas, Barn Owls are even known to investigate the nest sites of their prime predator, the Great Horned Owl, in hopes of a vacancy, though the scouting effort could prove to be fatal. After witnessing Great Horned Owls nesting in one cliffside nest for several consecutive years, I was surprised to see Barn Owls later nesting in the same cavity, which apparently had been vacated by their fierce enemy. Spotted

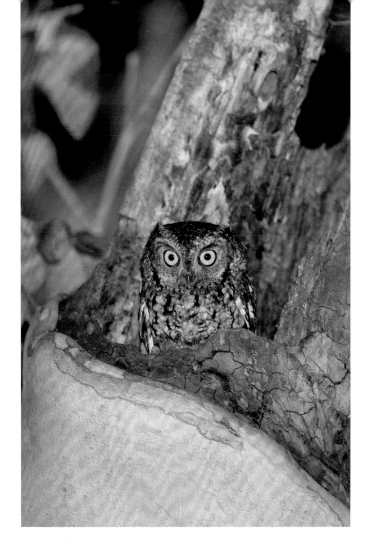

Owls, especially the Mexican subspecies, will nest in caves under the forest canopy.

Short-eared Owls and Snowy Owls have a different approach to nesting on treeless landscapes: they nest directly on the ground. Lacking the size and ferocity of the Snowy Owl, the Short-eared Owl must stay hidden and is limited to nesting where the vegetation can hide the brooding female and her nest.

While each owl has its nesting preferences and a degree of flexibility that varies from species to species, ultimately, owls choose nests that will best protect their eggs and young while at the same time be close enough to a rich source of prey. When the prey base is large and the nest options are plentiful, the diversity and density of owl species in an area can be surprising.

Natural cavities, such as this tree chimney (hollowed-out top) are preferred by Whiskered Screech-Owls, while most other small owls prefer woodpecker-created cavities.

{ page 28 } Two Northern Pygmy-Owls copulate on a limb near a potential nest cavity. Females are generally darker and more brown than males.

{ page 29 } A female Northern Pygmy-Owl looks in all directions before investigating a potential nest cavity presented to her by the male.

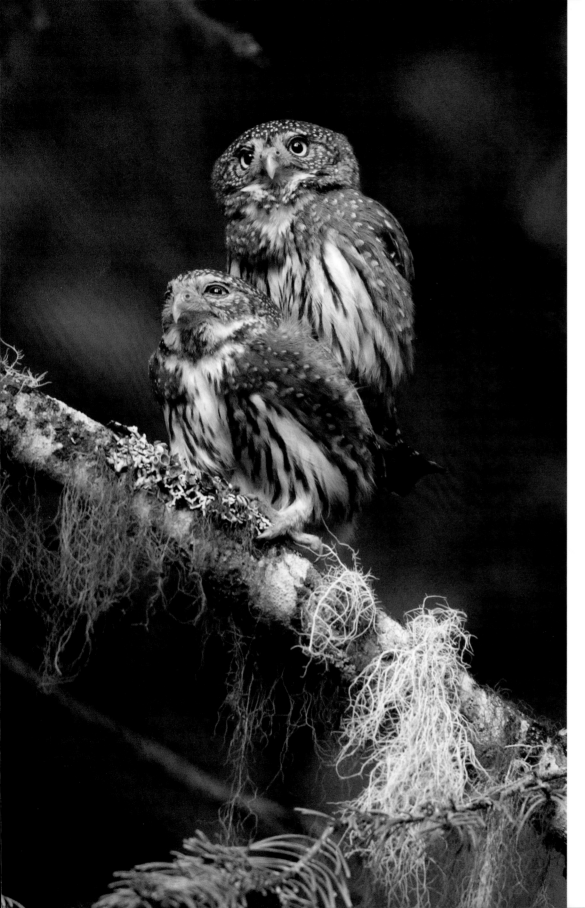

NORTHERN PYGMY-OWL

One day in late March, I was hiking in the Oregon Cascades. It was golden hour, the soft yellow-lit hour just before sunset. Each step broke crystals of frost as I traced the edge of an impressive stand of 125-foot-tall white firs. Dozens of beautifully scarred snags stood or leaned under the canopy, while small, pointed, glossy green kinnikinnick leaves poked through the thin snow in sunlit openings. A single hollow *toot* was unmistakable, as was a response call. These birds were courting. Upon answering the male, the female made a bouncy flight toward him. As she moved closer, the pair's calling increased in intensity. When the female made her twittering arrival, the male pounced on her back and they copulated for a few seconds.

They were Northern Pygmy-Owls, the second-smallest owl in North America. Northern Pygmy-Owls are diurnal (active in daylight) and live among large trees west of the Great Plains. They can be found in a diverse range of forest types, including the dripping-wet, moss-covered coastal rain forests of the Pacific Northwest, the snowy spruce and fir forests of the Northern Rockies, the giant redwoods of California, and the pine-oak woodlands of southern Arizona. Although these tree species and climates are diverse, the owls generally prefer older, structurally complex stands with snags and tall conifers at higher elevations, and sites with a mix of conifers and deciduous trees.

Under shifting light, the Northern Pygmy-Owl is like a forest spirit, almost invisible among the giant trees. The only sign of it may be its distinctive call, one or two *toot*s at twilight in the early spring when the ground might still be covered with snow. When it does appear, rather than shrinking from your gaze as you might expect from a sparrow-size owl, it looks directly at you with unblinking golden eyes, as if to challenge you. Or perhaps, it will be perched at eye level, with one oversized foot grasping an emerald green leafless branch of a vine maple and the other foot gripping a chipmunk twice its size. This owl is a ball of kinetic energy once it decides to move, with short wings

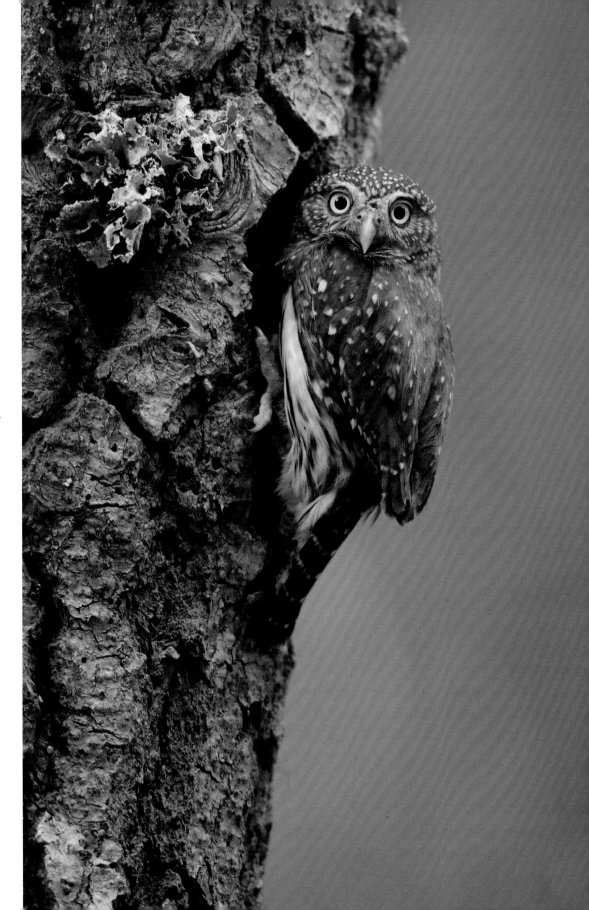

that risk no collisions and a long tail that serves as a rudder as it weaves through the forest. It alternates between quick wing flaps and gliding with wings closed at its side, creating a bobbing flight that looks more like that of a small woodpecker than an owl, before disappearing among the brown trees and green, mossy logs.

The Northern Pygmy-Owl is a small-headed brown owl that is roughly 6.75 inches tall. Its forehead sports white spots and its breast is white, streaked with brown. The owl's eyes are yellow and large, relative to its head size, and it has much less of a distinctive facial disk than most other owls.

Northern Pygmy-Owls' feathers display various tones of brown, red, and gray across their range, which is associated with the relative amount of humidity. The lightest and grayest birds live in the drier parts of the Rockies, and the darkest and reddest individuals live in the wettest parts of the coastal Pacific Northwest. In general, the slightly larger females are a bit browner and the males a bit grayer.

Several subspecies have been described in North America based on these color variances and differences in the advertising call, which can be a single or double *toot* at varying speeds. The most widely spaced tooters are from the Northwest and the faster tooters are in California. Most Northern Pygmy-Owls in Canada and the United States call with a single hollow *toot*, but Northern Pygmy-Owls in parts of southern Arizona and New Mexico advertise with a double *toot*. The combination of the double *toot* and a slight size difference has led some experts to consider these birds a separate species, the Mountain Pygmy-Owl.

The color range and small size help this owl to remain hidden in its forest haunts. It has two false eye spots on the back of its head that studies have shown confuse mobbing birds, which are not sure which eyes are real. It seems probable that these false eyes also confuse predators that are hesitant to attack birds that are looking at them, including nest predators. The false eyes may be especially valuable assets in the western forests, which host the greatest

GRASSLANDS, SHRUB-STEPPE, AND AGRICULTURAL LANDS

Grassland and shrub-steppe habitats are found in the rain shadow of the west's major mountain ranges and in Florida. The rain shadows rob moisture from the Great Basin, the Great Plains, Oregon's high desert, and California's Central Valley, leaving them with scorching heat in the summer, deep cold in the winter, frequent winds, and periodic fire. These harsh elements prevent the establishment of trees, except along waterways and lakes. The scarcity of water defines North America's open habitats, with deserts receiving the

least, followed by shrub-steppe and grasslands. These open areas are often rich in rodents, a big draw for the eight species of owls that spend a majority of the year there.

These are the most fragmented habitats in North America primarily because of the conversion of high-quality grasslands to agriculture, the trend toward denser farming methods, as well as recreation, housing and resort development, and energy generation. Tree planting in some areas alters and degrades habitat for owls of treeless

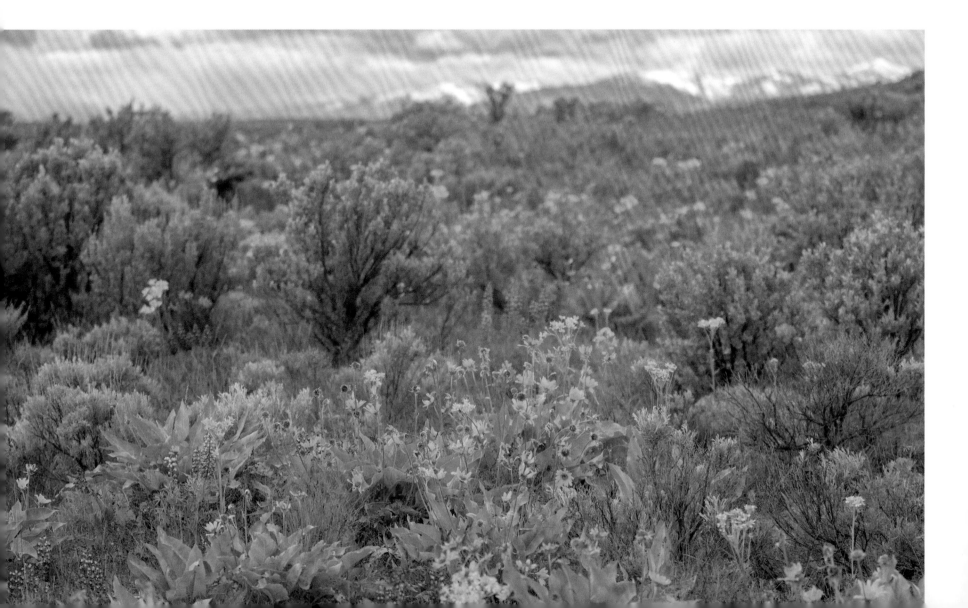

landscapes. Development has also introduced one of the most dangerous predators, the feral cat, and ill-advised agricultural interests have reduced populations of badgers, ground squirrels, and especially prairie dogs, which benefit one of agriculture's best pest-control agents, the Burrowing Owl. The drive to eradicate rodents with ever more powerful rodenticides has helped contribute to the demise of the rodent-eating Barn Owl. Long-eared Owls meanwhile have suffered from the degradation of riparian habitat. And collisions with vehicles have probably affected all owls.

Not surprising, the owls of our open landscapes have been hit hard. Burrowing Owls and Short-eared Owls are sensitive species, which have shown range-wide decreases in populations, attracting the concern of national wildlife agencies in the United States and Canada and of many individual states and provinces. Burrowing Owls are listed as "endangered" in Canada and in fifteen of the nineteen US states in which they occur. The Short-eared Owl is listed as a "species of conservation concern" in twenty-six states (twelve of which have listed it as "endangered or imperiled") and as a species of "special concern" at the federal level in Canada.

Meanwhile, the Barn Owl is listed as "endangered" in Canada and appears on the "special concern" lists in nearly half the US states, second only to the Short-eared Owl in this category. The Long-eared Owl, which nests in trees but hunts in the open country, has been given the status of "endangered," "critically imperiled," "special concern," or similar conservation status in fourteen states.

Each of these owls serves as a useful indicator species in open habitats, with all representing shrub-steppe and agricultural lands. Burrowing Owls best represent short-grass areas, Short-eared Owls best represent wet and tall-grass habitats, and Long-eared Owls best represent riparian areas within, and tree areas adjacent to, open habitats. Barn Owls are a good indicator species for agricultural lands.

All of these owls can survive alongside farming with specific considerations. Short-eared Owls require taller vegetation to hide their nests and young, making spring mowing or grazing dangerous for them. Burrowing Owls can benefit from moderate grazing and mowing, provided their nesting and roosting burrows are left intact throughout the year, and some Florida populations can even benefit

from moderate development. Long-eared Owls require trees or shrubs with the abandoned nests of corvids or hawks or nest platforms. Barn Owls and Long-eared Owls can be offered nest boxes and platforms, respectively.

Wintering Snowy Owls benefit from preserved Burrowing Owl and Short-eared Owl habitat, and Western Screech-Owls, Eastern Screech-Owls, Northern Saw-whet Owls, Barn Owls, and Great Horned Owls benefit from measures that protect Long-eared Owl nesting habitat.

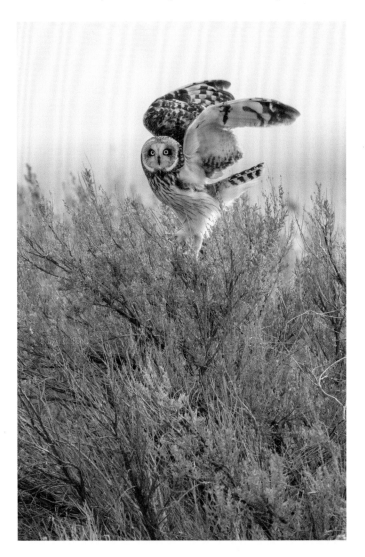

A Short-eared Owl lifts its wings just before taking flight over the sage.

{ *opposite* } Short-eared Owls nest in treeless habitats with vegetation that is tall enough to obscure nesting females. This is usually grassland or shrub-steppe.

diversity of owl species in North America, several of which occasionally prey on Northern Pygmy-Owls.

Twelve other owl species have ranges that overlap with the Northern Pygmy-Owl within at least part of its range, and seven of these are known to nest in the same stands and at least occasionally in woodpecker cavities.

I have located several nests over the years, and although Northern Pygmy-Owls often have nest requirements similar to other small cavity-nesting owls, they appear to have a few specific requirements as well. All the Northern Pygmy-Owl nests I have found have been in old-growth forests, with plenty of woodpecker-pocked snags, fresh water, and sunny openings nearby. Even within appropriate habitat Northern Pygmy-Owls are surprisingly uncommon and seem to leave many suitable areas vacant.

Northern Pygmy-Owls from Washington State south begin their annual spring cycle in February or March when the last major snow is a memory, with the days getting longer and warmer and the first woodland flowers just beginning to bud. Some Northern Pygmy-Owls remain in their territories all year, while others follow the frost line upslope.

The male will fly between prominent perches and nest cavities, sounding his clear hollow *toot* calls every several minutes for an hour or two throughout the day but peaking at dawn and dusk. If a female is around, she may respond. A successful male, upon receiving a response, will attempt to keep his potential mate engaged in a wandering duet through his territory, trying to interest her in him and his potential nest sites. At some point, the female may begin following the male, responding to his tooting with a flirtatious trill.

On an April day, I continued to watch the Oregon Cascades pair of Pygmy-Owls engage each other in a duet sixty feet above my head in the forest canopy. The male made a *toot*, and the female followed with a twitter call. As they moved closer, the calling became more frequent, until the male mounted the female, and they copulated. They then perched side by side on a branch and preened

each other. Soon, the male leaned forward, pulled his wings to his body, and darted in a seventy-degree dive to a small branch on a Douglas fir snag, where he resumed his calling. After a few moments, the female followed and landed a few inches from him, but he stayed only briefly before flying into an old woodpecker cavity, where his face filled the entrance and he again resumed calling. As he tooted, his white throat, normally hidden, was visible and vibrating. He flew out onto a nearby branch, and almost immediately, the female entered the cavity. She chittered from the round entrance for a few moments and then flew into the woods. I observed similar interactions and behaviors at sunrise and sunset for each of the next few days. Although I did not witness it on this occasion, males often use prey to motivate females to inspect potential nest cavities as they choose which one to nest in.

As courtship winds down, the birds resume their more secretive behavior, with the male doing all of the hunting while the female perches somewhere among the giant trees, near their nest. Most of the time, it is difficult to know if she is in the cavity or among a clump of pine needles.

As a naturalist, I try to observe without impacting behavior. I like to photograph courtship and life at the nest, but I largely leave birds alone during incubation, a vulnerable time. Once I discover when incubation begins, I can make note of the date, add the average number of days till the eggs hatch, and consider when to return. With cavity-nesting birds, particularly secretive ones, it is challenging to know when the female begins sitting on eggs. You may watch them copulate, but since they do so often and sometimes for several weeks, it is hard to guess when she might begin laying and incubating eggs. With Pygmy-Owls, unlike some other owl species, I know the female is incubating when she stays in the cavity all day and night, leaving only to receive prey or to defecate. Since she receives prey only once or twice per day, it can be a long wait!

These Oregon Cascade Pygmy-Owls were my photographic target every weekend for three months. I was

trying to establish exactly when incubation might begin by arriving near the nest every morning before the 5:30 a.m. sunrise and staying until after the 8 p.m. sunset. Each evening, just before sunset, the male delivered prey and flew off, and the female ate and then slept on a limb in front of the nest.

All this changed one evening. Four widely spaced soft *toot* calls in the distance told me that the male was coming. Flying in quickly, hc landed next to his mate and pushed his shrew-filled bill toward her. She yanked the shrew from him and began eating as he zipped into the forest. I watched patiently as she dismembered and ate the prey. She then preened herself just as she had the previous few days. This time, however, instead of falling asleep she fell forward, wings at her side, and dropped into a forty-five-degree descent to the lip of the nest cavity, spreading her wings at the last possible instant to break her fall. Pausing at the cavity, she perched like a woodpecker, peering at me before dipping into the pitch-dark hole. I waited until 9 p.m., well after dark, to confirm that she was staying inside and that incubation had begun.

GREAT GRAY OWL

It was early April, and I had been walking in the boreal forest of central Alaska. I could not sleep that night, after watching the broad five-foot-wide silhouette of the Great Gray Owl silently floating inches above my head before disappearing into the small gap between two spruce trees. It appeared to be drifting in the breeze, moving so low and slow that I could have easily lifted my hand and touched it. I was relying on moonlight reflecting off the snow to guide my way.

I trudged noisily in my snowshoes for a hundred yards or so and then stopped to listen. The first *hoo* was deep and resonant; I froze in place, and not just because it was an owl. The power of the sound grabbed me—not the amplitude, but the urgency. This was a call that demanded attention and a response. The timing of the call told me this

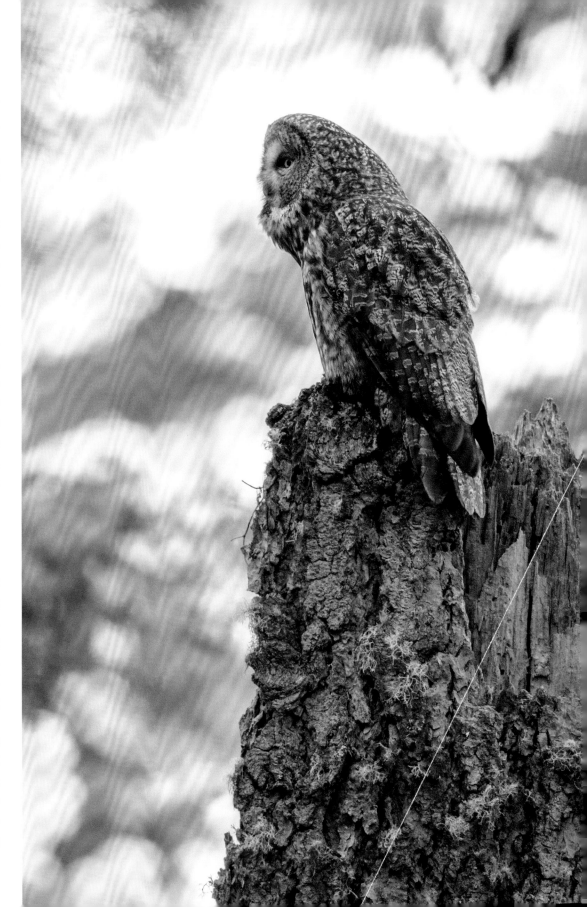

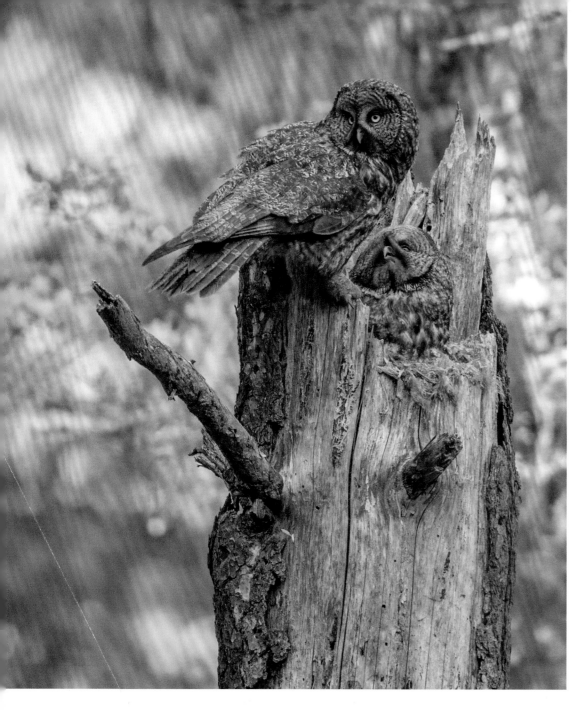

the forests are in the openings or the openings are in the forest. To understand the Great Gray Owl, you need to be acquainted with the features of the boreal forests where most of these owls live. The boreal forest is a vast blanket of green forests, shrubs, mosses, and other plants covering much of Alaska, Canada, and northern Eurasia. The mostly coniferous trees, looking like the wind- and snow-ravaged trees near tree line on high mountains, are striking in their asymmetry, each telling the story of a rough life. Snow covers the ground six months of the year, and temperatures often hit well below 30 degrees Fahrenheit for several days at a time, with nights sometimes eighteen hours long. Trees and other plants struggle to grow in the thin, acidic soil and slow growing seasons. And many of the small animals that Great Gray Owls, as well as Northern Hawk Owls and Boreal Owls, feed on experience cyclical booms and busts in their numbers.

Outside its boreal core, the Great Gray Owl also breeds in northern Minnesota and in some of the mountainous parts of Washington, Oregon, Idaho, Montana, Wyoming, and maybe in Utah. In California, an isolated and endangered subspecies of about 150 individuals lives in the southern Sierra Nevada. In most of these places, winters are cold and snowy.

Great Gray Owls are built to find food under the snow. This skill is aided by one of their most distinguishing features: a well-defined disk of feathers surrounding their bill and small yellow eyes. This facial disk works like a parabolic reflector to funnel sound to two slits—ear openings—on each side of the head. As with some of the most nocturnal owls, the Great Gray Owl's ears are offset, which allows it to pinpoint the exact vertical and horizontal location of prey using hearing alone in the darkest parts of winter and through more than a foot of snow. This sensitive hearing is made more deadly when combined with the force the Great Gray Owl is able to generate. In fact, research has shown that this owl can break through a crust of snow capable of carrying the weight of a 176-pound person! Surviving the

male was calling to his mate, and I was probably close to one of their potential nests. Reluctantly, I had to admit to myself that it was too dark to look for nests and decided to return at dawn to continue my search.

Great Gray Owls live in mature, sometimes dark forests interspersed with openings of meadows, bogs, or muskegs, sometimes to the degree that you are not sure whether

cold requires lots of insulation, and the Great Gray Owl has a bounty of warm feathers that make it appear massive.

The Great Gray Owl is North America's longest owl. It measures up to 33 inches in length and has a wingspan up to 5 feet, yet it weighs less than 3.75 pounds, making it just over half the weight of the Snowy Owl, and 10 percent less than the Great Horned Owl, which shares its habitat.

The Great Gray Owl's low weight per inch of wing surface, or low wing-loading, allows it to fly slowly without stalling, almost like a winged blimp. With its silent flight, bark-like gray-brown plumage, and soft, reflexive wings, the Great Gray Owl can disappear quickly into tight openings in the forests. Its ability to blend with and disappear into its dark forest home is hinted at in its Latin species name, *nebulosa*, which means cloudy or foggy, earning it nicknames like the Great Gray Ghost and Ghost of the Northern Forest.

Hailing from the land of severe weather, scarcity, and natural vicissitudes, boreal populations of Great Gray Owls must at times either respond or die. When food is scarce, they will sometimes skip breeding for a year or migrate to an alternate breeding territory up to five hundred miles away. Some Great Gray Owls in the mountains of the West, on the other hand, may not move more than thirty miles in their lifetime—about the same distance a migrating boreal Great Gray Owl might travel in a single day during one of its migrations.

Great Gray Owls are mostly solitary during the early winter, but become more social toward late February. In March, Great Gray Owls that migrated for the winter begin arriving alone in breeding territories, although this may be delayed during heavy snow years. When food has been plentiful during the winter, normally migratory owls in the boreal forest that were not compelled to move might again pair up. Less migratory birds in the mountains of the West typically retain the same mate every year unless one dies.

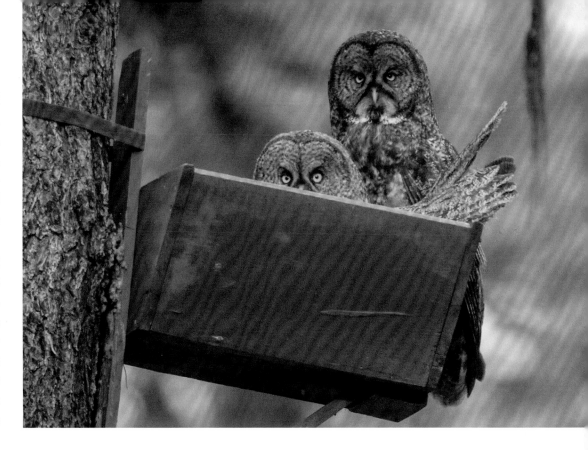

Snow covers the ground in much of the Great Gray Owls' range when they arrive in the early spring and begin courtship. Since they are most active at times of low light, most of their courtship and calling takes place between dusk and dawn. Males call with a low, descending series of hoots, and the females often respond with a higher and more nasal *woo*. When a mate is secured, the pair preen each other, visit nest sites together, and copulate. Renowned Great Gray Owl expert Dr. James Duncan told me that sometimes all of this takes place in as few as eleven days.

I have spent many dark evenings and mornings looking for Great Gray Owls and have had countless memorable experiences. A soft *hoo-oop* gave me hope one early morning in Oregon's Cascade Range; I recognized the call as a female's demand for food. It was early March. I had been looking for a pair of Great Gray Owls just before sunrise for several days, and this was the first promising sign. I moved quickly through snow in the open forest, looking ahead and up, alert to any sounds. The female called one more time and then I saw her, perched fifteen feet up,

Great Gray Owls (shown here), Barn Owls, Barred Owls, Great Horned Owls, Long-eared Owls, and even Northern Hawk Owls will utilize artificial nest platforms such as this one.

{ *opposite* } A male prepares to leave the nest after delivering food to the female that is incubating eggs on a fifty-foot-tall broken-topped snag.

WESTERN DRY MOUNTAIN FORESTS

The dry mountain forests are those blanketing the majority of mountains west of the Great Plains, with the exception of the west side of the Cascades and parts of the Coast Range, Selkirks, and Canadian Rockies. These forests have the greatest owl species diversity in North America, with fourteen of our nineteen species nesting there in some years. Several of these species serve as habitat indicators, since they rely on the sensitive elements of habitat (specific prey, snags, old-growth forests, meadows, species of trees or plants, nest-creating animals), and so their relative abundance can be used as a measure of ecosystem health. This owl diversity is partly the result of several high mountain ranges with their western slopes generally receiving more precipitation than their eastern slopes, resulting in a variety of tree species and a diversity of habitats within a short distance.

These diverse habitats begin with the western yellow pine zone (ponderosa pine, Jeffrey pine, and relatives), which, depending on where you are, begins just above the oak, pinyon-juniper, shrub-steppe, or even grassland habitats. At higher elevations and on north-facing slopes, these pines often mix with and eventually give way to Douglas fir, which in turn are joined and succeeded by other more cold- and shade-tolerant species. Eventually, they too are replaced by the stunted conifers of the subalpine habitats, and finally, at the highest elevations, by tundra rock and ice.

Where mature stands of ponderosa pine and Douglas fir come together, a wide diversity of Lepidoptera (moths and butterflies) species thrive and help define the prime habitat for one of the most specialized owls of North America, the Flammulated Owl. Insectivorous Flammulated Owls arrive in those areas from winter territories in Central America and Mexico in late April and early May, when nights are still cold and cold-tolerant moth species are often the only food available.

Flammulated Owls can be quite common in appropriate habitat, but they are a vulnerable species. Pairs produce small clutches of two to three young; males (sexually mature at one year), often do not breed until they are three to six years old; and pairs return to the same nest sites, which are most successful in stands that are two hundred to four hundred years old. They also migrate up to several thousand miles each year between commercially valuable—and therefore potentially threatened—forests in North America and Mexico or Central America.

Ponderosa pine and Douglas fir are fire-resistant trees that require open spacing and lots of sun to thrive, a condition naturally maintained by periodic (every five to ten years) fire. Fire also assists in the regeneration of aspen and attracts woodpeckers that create nest cavities. Nearly a century of fire suppression in most areas has allowed less fire-resistant trees to move in, creating denser, less healthy, and more flammable forests. When fire does hit, which will happen more often with climate

Flammulated Owls are a strictly nocturnal species that breeds in North American forests that have healthy moth populations in the early spring. This particular owl is bringing a moth into a woodpecker-created cavity in a ponderosa pine snag.

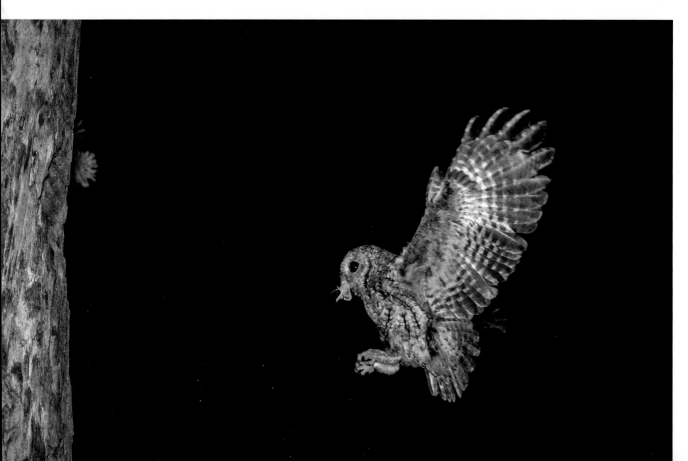

change, it burns hotter, and small trees provide ladders into the more vulnerable crowns. These often catastrophic fires burn larger areas, including the most fire-resistant trees, and could eliminate habitat for Flammulated Owls and other wildlife that depend on these forests. In addition, harvesting of large trees in ponderosa pine and mixed conifer forests has fragmented much of the best remaining Flammulated Owl habitat, leaving fewer owls in isolated pockets.

Dry mountain forests of the West that include Flammulated Owl habitat also provide habitat for the majority of Northern Pygmy-Owls and are home to Barn Owls, Western Screech-Owls, Long-eared Owls, Great Horned Owls, Northern Saw-whet Owls, Elf Owls, Great Gray Owls, Spotted Owls (all three subspecies), Barred Owls, Northern Hawk Owls, Boreal Owls, and Whiskered Screech-Owls.

Fire has long played a vital role in the maintenance of the dry forest habitats that all of these owls utilize. Forest managers must pay careful attention to restoring and maintaining forest systems in order to preserve the functionality of these habitats. This includes using prescribed burns and, in many cases, thinning or harvesting smaller, competing trees to maintain more open stands with larger, healthier trees.

The Flammulated Owl is recognized as a "sensitive species" by the US Forest Service and the Bureau of Land Management (BLM), and in Canada it is listed as a "species of special concern." Flammulated Owls serve as a useful indicator species for monitoring old-growth pine forests and the impacts of fire and climate change. Northern Spotted Owls (a federally "threatened" species) east of the Cascade crest, California Spotted Owls (California "species of special concern") in the Sierra Nevada, western US populations of Great Gray Owls (the BLM "surveys and manages"

species in northwest parts of California and western parts of Oregon and Washington as part of the Northwest Forest Plan), and Northern Pygmy-Owls are good indicators of the health of mature mixed conifer parts of these dry forests. Boreal Owls are listed with special conservation status in several states and are a good indicator of the health of high-elevation spruce-fir habitat, the existence of which is threatened by the combination of catastrophic fire and climate change. Rockies and Cascades populations of Northern Hawk Owls are a possible indicator species in some post-fire areas where they rely on large snags. Warming temperatures have resulted in the lengthening of vole cycles, with less frequent and smaller peak years, potentially impacting all but the Elf Owl, Whiskered Screech-Owl, and Flammulated Owl.

Flammulated Owl habitat in North America often includes voluminously crowned mature stands of ponderosa pine and Douglas fir interspersed with grassy or shrubby openings, particularly along ridges.

eyes closed, on a horizontal branch. I leaned against a tree and waited. An hour or two later, she made a more plaintive *hoo-oop*. Moments later, I heard the male's similar but deeper call, a low but soft *hoo-hoo*. Soon, he came flying in with a pocket gopher dangling from his bill toward the excited female, who was by now alternating between hooting and chittering while bobbing her head up and down and from side to side. The male flew to a perch directly in front of her, and she continued to beg before he eventually landed next to her. They leaned toward each other, joining bills and closing their eyes as he let her take the prey.

Female Great Gray Owls are normally much more aggressive than males, making food deliveries appear to be violent encounters, but this time was quite different. Over the next few days I watched as the male called to the female from different tall, broken-topped snags, one of which they later used as a nest.

Great Gray Owls are platform nesters, but the type of platform varies across their range. In the northern boreal forest, they often take over stick nests created by raptors or corvids (the family of birds that includes ravens and crows), squirrel drays (nests), or even "witches' brooms," (dense mats of twigs and branches that form in response to dwarf mistletoe infection). Farther south, in California and in some parts of Oregon and the Rockies where trees grow more quickly, taller broken-topped trees are more commonly used among Great Gray Owls. Great Grays also nest on manmade platforms.

Platform nests are in high demand because of their scarcity, particularly in slow-growing boreal forests, but also because the original builders of many of these nests, Goshawks, Red-tailed Hawks, ravens, and other raptors and corvids, will often attempt to reuse them. The supply of good nest options can limit Great Gray Owl populations. These owls do much better when Great Horned Owls and hawks are having bad years and not competing for available nests. Great Gray Owls do not seem to mind Northern Hawk Owls and Boreal Owls nesting nearby, since they do not compete for the same nests and tend to hunt in different areas and focus on different prey.

During courtship, males show females several nest options. While evaluating the alternatives, female Great Gray Owls scrape vigorously at the substrate of the potential nest and likely eliminate some that prove inadequate after such attention. The female likely chooses the year's nest for the pair.

After having seen Great Gray Owls nesting on platforms, mistletoe brooms, and Goshawk nests, I very much wanted to find one nesting on a broken-topped snag, and I spent several hundred hours during April and May over several years scouring open forests in the West. Often, I hiked or snowshoed between giant trees, looking up toward the tops of nearly identical broken-topped snags, trying to make out what might be the gray tip of a female's tail rather than just a slab of bark or a branch.

One May in Oregon, I finally found my first broken-topped snag nest. I looked at my surroundings in awe, thinking that I should let a Great Gray Owl choose my home. At the core of such a nest site are widely spaced giant trees often two feet or more in diameter, with an uncluttered green understory of moss, luxuriant grass, and a sprinkling of white trilliums, which would later be replaced by blue lupines, red columbines, and pink-flowered currant. Without thick underbrush, you can see for several dozen yards at a time, the view occasionally framed by moss-encased trees collapsing into soil or accented by jagged-topped snags. Each bird's call echoes in isolation— the occasional croak of courting Sandhill Cranes, the ethereal ascending, spiraling whistles of Swainson's Thrush, and the occasional low, powerful hoots of the Great Gray Ghost. From fifty feet up in the wood cradle of its nest, this Great Gray Owl had a commanding view of miles of green, interspersed with golden slivers of meadow only a short glide downslope. Generally, there are several of these grassy oases nearby. They are often wet, or even saturated, with an irregularly shaped boundary of both live and dead standing trees.

One year, I found three Great Gray Owl nests within two miles of one another. This is not unusual during peak prey years. Even though their home ranges can be more than fifteen thousand acres, pairs may nest as close as five hundred yards apart.

Great Gray Owls have strong preferences for where they nest. They prefer a broken-topped tree in a mature forest near a grassy opening, but not on the exposed edge of it. The nests I have seen were under the canopy of the forest, where trees are taller and denser than in surrounding areas. The nests have been approximately forty to seventy feet up, with the average height around fifty feet. The ground usually featured grass and wildflowers, with few thick, ground-obstructing shrubs.

When a Great Gray Owl selects a nest, it appears to be picky, since it wants a broken-topped tree that can accommodate its size at a minimum of forty feet up. The broken top needs to be soft enough to allow water to drain but not so rotted that the sides fall apart and endanger the eggs and young. Ideally there is a lip or edge that hides the brooding female and young birds. These requirements have concerned me, since it takes a long time for a tree to grow to roughly one to two feet wide, forty feet high, and soft enough to drain. How long can such rotting snags stand in areas with heavy snow and wind? To provide for Great Gray Owls in their forest homes in the Lower 48 states, we must not only retain snags, but in some cases, we must create nest options from living trees by topping them and creating a nesting depression or by building nest platforms. My concern has been validated over the years, as several nest snags fell during the year or year after I observed them.

As the courtship period begins to wane, both owls spend the majority of their time near the chosen nest, with the male delivering prey to the female at night and in the early mornings. One day soon, the female will settle into the nest platform, where she will spend most of her time for the next six weeks keeping her eggs and then her young warm.

BURROWING OWL

As I drove slowly along a dirt road looking for Burrowing Owls, the setting sun slipped behind the hills above the Idaho valley, while the richly melodic songs of meadowlarks poured from the grass and the mating hoot calls of Short-eared Owls punched at the sky. In the shorter grasses closer to the dirt road, a sand-colored Burrowing Owl perched like a statue on sagebrush, occasionally fluffing out its feathers and filling its white throat with air. Lunging

Unlike all other owl species, Burrowing Owl males are usually slightly larger than females and, as a result of spending more time in the sun than their mates, they also frequently appear lighter in color.

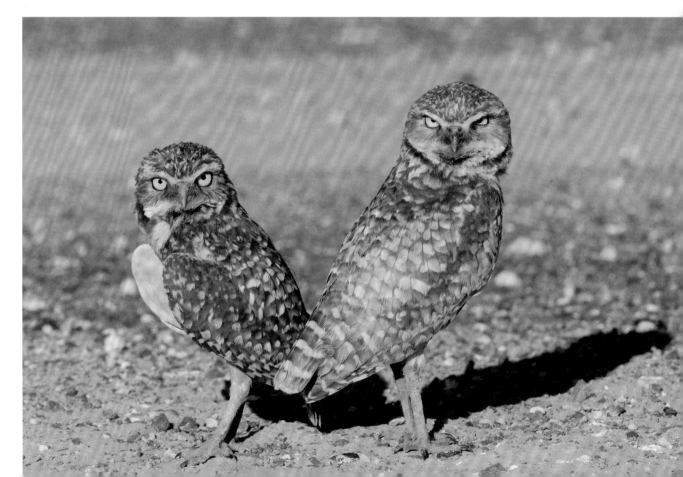

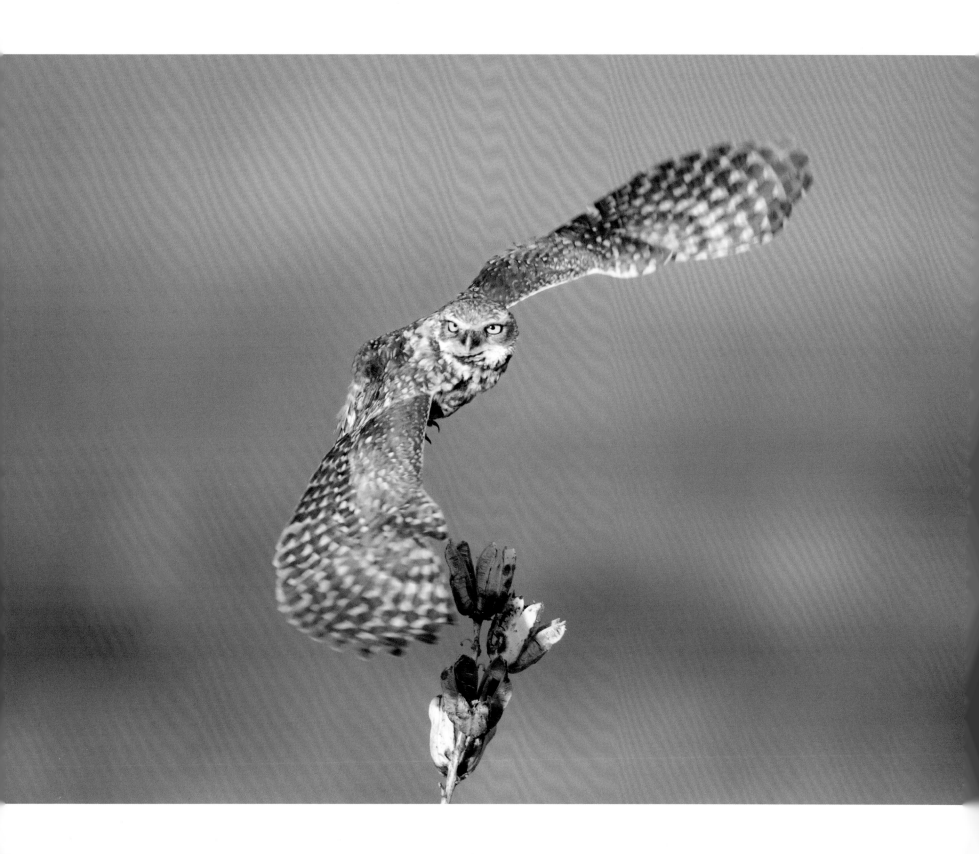

down and forward, its body was almost parallel with the ground while it belted out high-pitched *coo coo*s. Around the owl, several light-brown mounds of dirt were piled around badger tunnels in the ground. Between the badger tunnels was a spread of gray soil and stubby grasses.

"There is no such thing," the researcher responded, when I asked where I could find untouched, natural Burrowing Owl habitat in California. Burrowing Owls live where vegetation is short and dry, including grasslands, shrub-steppe, agricultural land, and even desert across much of North America. And as I have often seen, they live in less than pristine situations. You are more likely to find them at a truck stop or under a concrete irrigation ditch than on an ungrazed prairie. This has more to do with their inability to live in tall grass areas and the scarcity of short-grass habitat with burrows than it does with a preference for these places.

Burrowing Owls have thrived through eons in the short-grass prairie where bison grazed and prairie dogs were abundant. Badgers, who make a new burrow every day in the summer, concentrate their activity near prairie-dog towns where they prey on their industrious neighbors. Prairie dogs also create tunnels the owls use for nests and help bison keep the grass low. Although the Burrowing Owl species name *cunicularia* means "miner," only Florida Burrowing Owls regularly dig their own nest tunnels. Burrowing Owls across the rest of North America live in tunnels dug by prairie dogs, badgers, ground squirrels, skunks, marmots, armadillos, tortoises, foxes, and other burrowing animals. Today, Burrowing Owls can benefit from cattle grazing on large ranches and farms in much the same way they benefited from grazing bison, as long as animal burrows are retained. In fact, some Burrowing Owls do better in agricultural areas than in nearby wildlands, because of the greater prey concentrations in the agricultural landscape. Studies in Florida have shown that Burrowing Owls there do better with development up to a point, after which they decline rapidly.

When you see the Burrowing Owl, it is easy to understand how it has adapted to its open grassland habitat. The round little owl has disproportionately long, stilt-like legs that enable it to see predators and prey over the short grass of its treeless home. The long legs also allow it to scamper quickly on foot in pursuit of lizards, grasshoppers, beetles, and other potential food. The legs are lightly feathered, a common feature of owls of warm climates. Their plumage is pale brown with white bars, perfect for blending in with the light brown summer prairie grasses and dirt mounds around burrows. This comical-looking little 9.5-inch-tall owl seems to be always bobbing its head when it sees something new, including people, thus earning the name of "howdy owl" among early settlers. Some believe the bobbing is a sign of agitation, while others believe it helps the bird gauge distance.

Some Burrowing Owls are migratory, while others are residents, and some other populations show a mix of patterns that varies by sex and age. Most are on the breeding grounds by March or April. Upon arrival, males get to work with some housekeeping at the burrows. After conducting some minor excavations with their feet and bill, they bring mammal feces to the nest mound and shred it for partially lining the walls of the nest cavity. Some have speculated that Burrowing Owls do this to mask their scent, while others have suggested that it attracts dung beetles as a food source. More recent research suggests that neither theory is correct. In addition to collecting dung, Burrowing Owls often decorate the ground around their burrows with a wide array of collected items, including pieces of fabric, insect parts, golf tees, and animal fur. These collecting behaviors defy explanation.

The majority of Burrowing Owls find a new mate every year, although nonmigratory owls in Florida and some nonmigratory individuals in California retain their mates from the previous year. Males establish territories as they court. While Burrowing Owls are assumed by many to be diurnal, they are actually both diurnal and nocturnal. Much of the courtship occurs during the evening and begins with the male calling near the most desirable burrow, attempting to attract the attention of females. The males enhance their

{ *opposite* } A Burrowing Owl launches into flight in hopes of attracting a mate.

chances by conducting flight displays. They sometimes fly several dozen feet into the air and hover for several seconds before quickly falling halfway to the ground and rising again. Some males also make circular flights around potential nest sites.

When a female shows interest in a male's calls by flying toward him on the nest mound, the male calls with even more enthusiasm. When the female arrives, the male strikes an impressive pose. He stands tall and looks down at her while expanding his feathers to make him look larger, exposing the normally somewhat obscured white patches above his eyes and at his throat. His neck and shoulders take on an almost mane-like appearance. The female responds by showing the same white patches but keeping the feathers on her body more compact, creating the impression that she is much smaller. In truth, with most owls, the females are 20 to 30 percent larger, but with Burrowing Owls, males average slightly larger and slightly lighter than females. It is often noted that males are lighter in color than females, but this is simply a result of the sun bleaching the males' feathers, since they spend more of the year out of the nest while the females brood and protect the young underground.

If the interest is maintained, the male flies toward the female and mounts her. After a few seconds of copulation, the male quickly runs into the burrow before he returns and joins the female on the nest mound. Much of the other parts of courtship, such as mutual preening and prey delivery, occur very much as they do with other owls.

The ideal Burrowing Owl territory has a high concentration of burrows close to one another and surrounded by dirt and low grass, allowing some to be used for the nest, roosts, and as retreats for young owls as they gain their independence or seek safety.

As more owls arrive at their breeding grounds, the birds may nest in close proximity to one another. Burrowing Owls can have large home ranges but often defend only small territories, with males sometimes tolerating other males nesting within thirty yards of their nest. Although males accept other Burrowing Owls in some common hunting areas, they aggressively prevent adults from getting closer to nest burrows.

As many owls do, Burrowing Owls give cues as to where they are in the breeding cycle. One spring in Idaho, I watched Burrowing Owls arrive and set up nests. A sleek light-brown male immediately began calling from two favorite sites, a fencepost beside the road and a badger excavation that later became his nest.

Within days, females began arriving. I watched as the male's first mating attempt ended in failure. He succeeded in calling a female close and gaining her participation in a mutual display of throat and brow, but when he tried to preen her, she backed away and flew across the road to the territory of another male. He must have fared better later, since when I returned, he was not alone at his burrow. Both the pale male and his darker and slightly smaller mate were standing near the entrance to the nest cavity, preening each other. The next week, he had moved to a roost cavity and no owl was visible at the nest, an indication that incubation had begun.

SNOWY OWL

Early May is a transitional time in lands where the ice-sheeted Arctic Ocean collides against the treeless, snow-blanketed tundra. I had witnessed this firsthand, on two trips to observe and photograph Snowy Owl courtship on the tundra of Alaska's North Slope. One day, the wind ripped across the icy terrain at fifty-two miles per hour, but the next day was sunny, before an ice fog rolled in, reducing visibility to less than one hundred feet in a matter of minutes. As days grew longer, the time between sunset and sunrise decreased, so that by the end of my first week, the two periods blended together into a surreal swirl of constantly changing sky colors—from oranges to pinks to purple to gold—all intermixing on the sea, snow, and ice—as if buckets of color were being poured into a tank of clear water and stirred.

{ *opposite* } While trying to attract mates, two male Snowy Owls confront each other in a territorial squabble.

The tundra was frozen solid in most places, with a surface so slick that only the metal claws of my snowshoes kept me from toppling. In every direction, what appeared at first to be undulating plain was in reality a relatively flat landscape studded with large mounds of tundra, created by the unending arctic freeze and thaw cycle. At 4:30 a.m., the rising sun cast pink shadows on the ice and on the blades of vegetation resisting snow cover atop the highest of the scattered mounds. I could hear only three sounds: the whipping of the wind, the melodic call of Snow Buntings, and the deep, ghost-like hooting of an unseen male Snowy Owl, pulsing forcefully through the frigid air as I searched for it.

In the Arctic, the sun does not rise from the middle of November to the middle of January, and average temperatures stay below freezing from the end of September until the end of May. In the middle of the arctic winter, lows of negative 35 degrees Fahrenheit are common. Some Snowy Owls stay in arctic and some subarctic tundra environments year-round, and all of them spend at least half the year there. By early May, most owls are back in breeding areas. Although I know places where Snowy Owls occasionally breed, they are highly nomadic, and an owl might nest in Alaska one year, Russia the next, and Canada the following year.

The Tundra Ghost Owl, as it has sometimes been called, has heavy white feathers that not only cover its body but also cover much of its bill, toes, and even its talons, providing a degree of protection against the arctic chill. The Snowy Owl is the largest owl in North America by weight, with females weighing 4 to 6.5 pounds, which helps them to stay warm. The much smaller males, 3.5 to 4.5 pounds, are, on average, whiter in color and less heavily marked than females. Juvenile owls, which are the most commonly seen by people, are normally more heavily marked than adults of the same gender, but there is a lot of overlap. The Snowy Owl has a relatively small head and piercing yellow eyes. Although it has, on average, the fifty-six-inch wingspan of the Great Gray Owl, it is more compact, averaging more than a pound and a half heavier on a body that, at

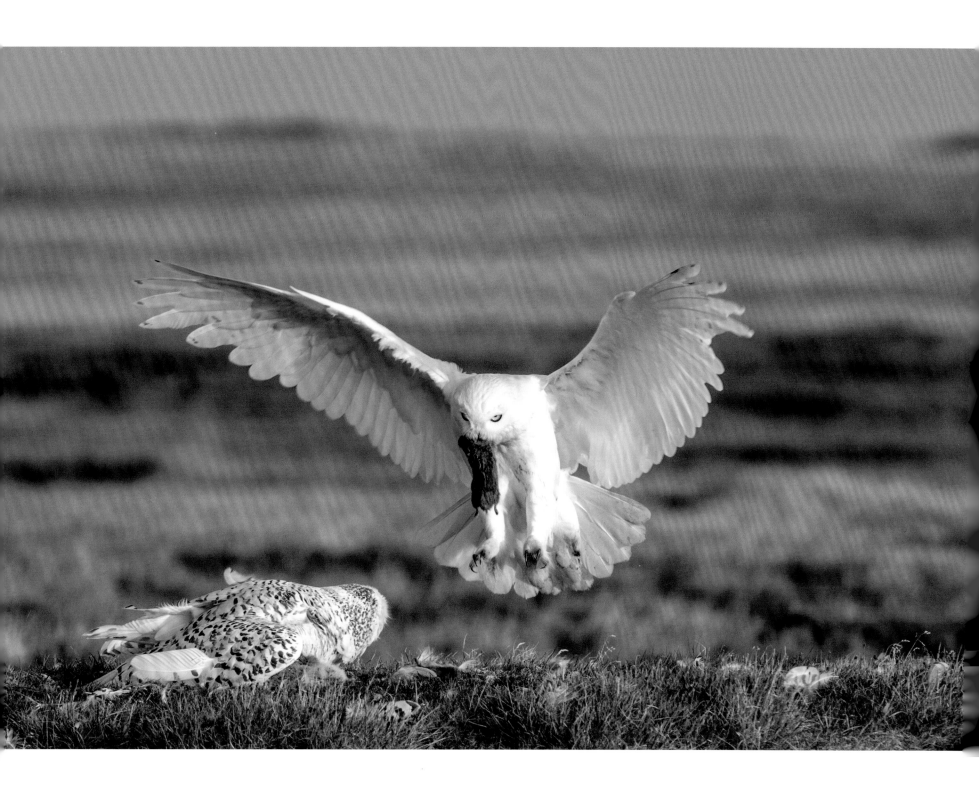

23.5 inches, is several inches shorter. Males, on average, are roughly three-quarters the size of females.

Males begin calling almost immediately on arriving on their arctic breeding grounds, or in late April if they stayed through the winter, in an effort to establish territories and secure mates. Given their nomadic behavior, it is unlikely that Snowy Owls show any fidelity to their mates from the previous year. Unless lemmings, the prey of choice, are abundant, most if not all males will be unsuccessful, so competition is fierce for the most lemming-rich sites. The presentation of lemmings as food is an important part of courtship displays and may convince a female to expend valuable reproductive resources.

Territories range between a few and several square miles and vary throughout the year, in response to the availability of prey and features of the landscape like hills and bodies of water. Males call to establish their territories while facing each other from prominent perches several hundred yards apart, leaning forward with their eyes partially or completely closed and simultaneously lifting their tail and bowing their head with deep, foghorn-like *hoo hooo*s. Haunting is the only word I can use to describe this extremely powerful voice, which I have both heard and felt. It has given me a better appreciation for all the superstition surrounding owls. The impressive call is reported to carry more than a mile, and after hearing it, I have little doubt.

Although physical confrontations between males are infrequent, they can be quite dramatic. While I watched a male displaying for a female in his territory, he suddenly halted his display and flew swiftly, almost falcon-like, to confront another male. The two met talons to talons, with the attacker rolling over and grasping at his rival, before the intruder retreated. Once he had settled the territorial dispute, he returned and continued his ground display for a female.

Normally, Snowy Owls fly directly between two points, so courtship flights are quite noticeable. The male I watched picked up a lemming in his bill and flew steeply into the air with slow, deliberate wing beats. At the peak of his climb, he lifted the tips of his wings into the air, forming a distinctive V-shape, causing him to fall diagonally across the horizon, before regaining altitude with deep wing strokes. This created the impression of a bouncing, shallow flight over the landscape. Oftentimes, the display ended with the male spreading his tail at the top of the V so that he drifted in the breeze to the ground, where he began a ground display.

In a ground display, the male raises his wings and lets the outer halves of its wings hang from above his head so that from behind, the wings almost form a broad M. In this position, the wings and tail are mostly spread, creating a large, white, reflective surface that includes his wings, back, and tail. He keeps his back to the female to get her attention and walks or rotates to display his back and side, but keeps any lemming he may hold in his bill hidden from her during most of the display. If she is close, he may lean forward, fan his tail a bit, and peer around his wings at her. If she is interested, she will fly toward him and fluff her feathers, with her tail slightly fanned and wings loose at her side. She keeps this posture prior to, during, and after copulation, and the posture in turn often elicits more ground displays from the male.

Once a Snowy Owl female has paired with a male, she likely chooses a nest location from limited sites on the ground that are snow-free at that time of the year. Commonly, these nesting sites are the tops of mounds at least three feet high and are often not far from the coast. These exposed locations not only receive less snow but are constantly windswept, which in the summer may help owls stay cool and keep insects away. Such locations offer commanding views of the surrounding landscape, allowing the female to see potential predators and her approaching mate.

After choosing a nest location, the female does something unusual for an owl: she digs a fairly circular nest bowl in the soil, three to four inches deep, with her talons and bill. She may later expand the nest as needed to accommodate her growing young. But she does not add anything to line the nest before she begins laying her eggs and incubating them.

{ *opposite* } Snowy Owl nest sites are selected from prominent high points on the tundra and are the center of all activity for three months, from the time males begin calling and displaying for mates through the time the last owlet walks off the nest for the last time. Once the female agrees to mate, the male assumes the role of hunting for her, as well as for himself and any eventual young.

The male Snowy Owl raises his tail, closes his eyes, fills his throat with air, and then expels the air with powerful *hoo*s that can be heard from over a mile away.

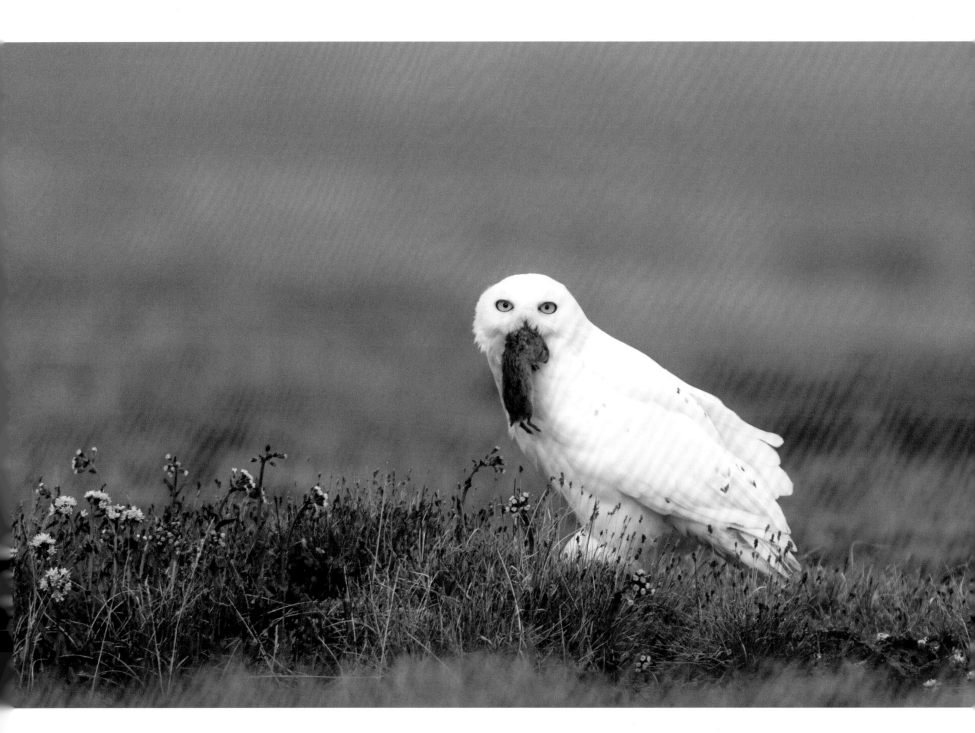

The ability of males to capture and deliver lemmings helps determine if females will agree to breed and how large their clutches will be.

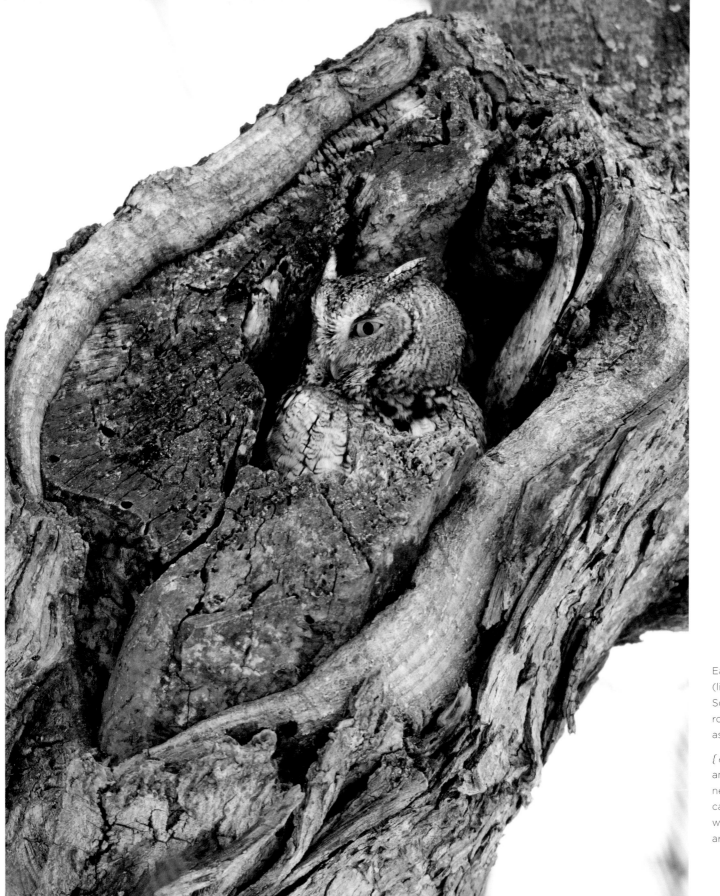

Eastern Screech-Owls (like this one) and Western Screech-Owls will nest and roost in tree cavities as well as in woodpecker cavities.

{ opposite } Boreal Owls—and other small, cavity-nesting owls—utilize natural cavities, such as knotholes, when woodpecker cavities are not available.

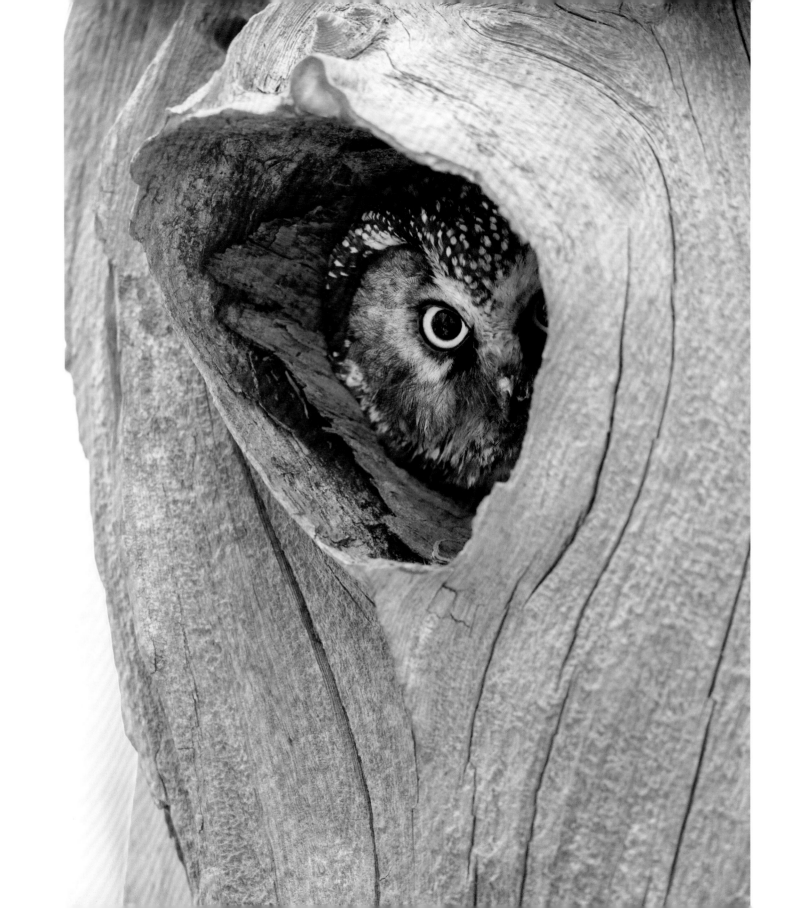

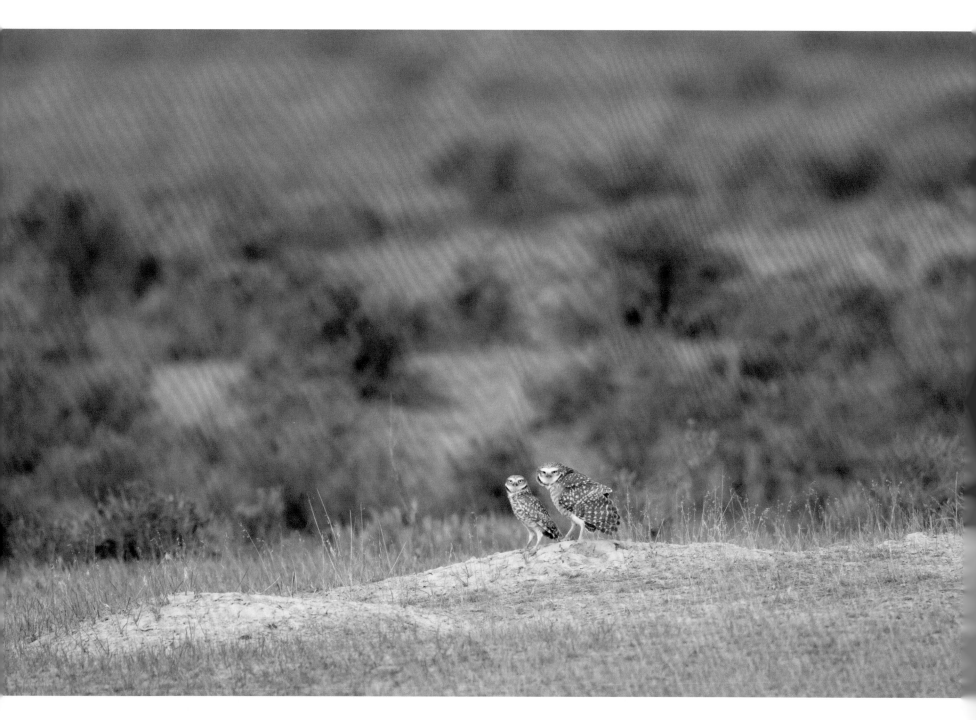

In much of the Intermountain West, typical Burrowing Owl habitat features short, often grazed, grass and many badger burrows for nesting and roosting.

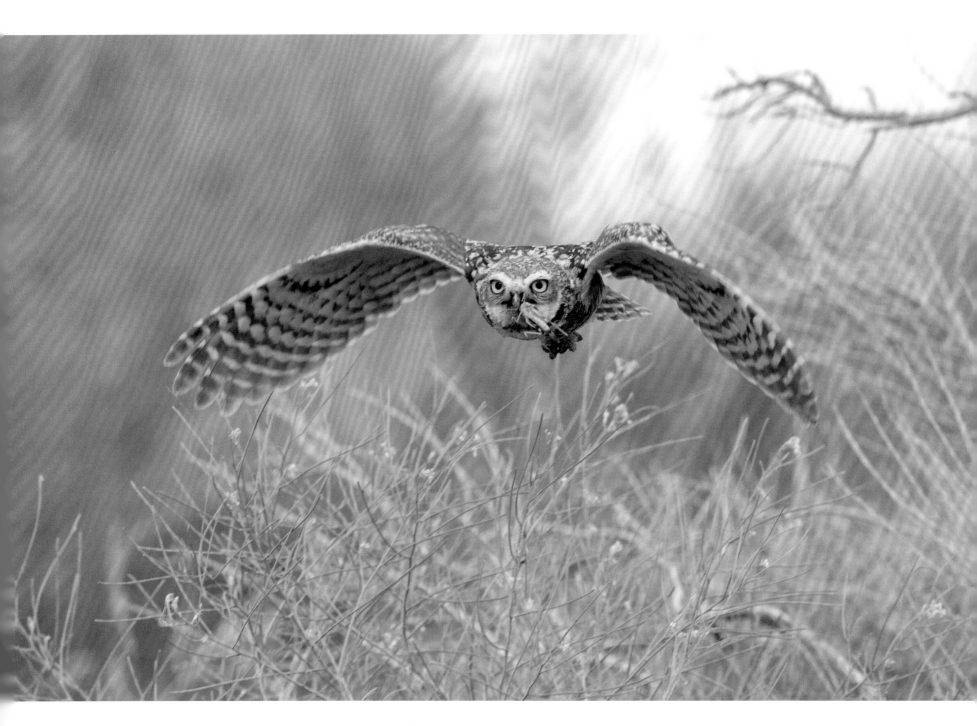

A Burrowing Owl flies toward the nest with a grasshopper for his mate, hidden in the nest burrow.

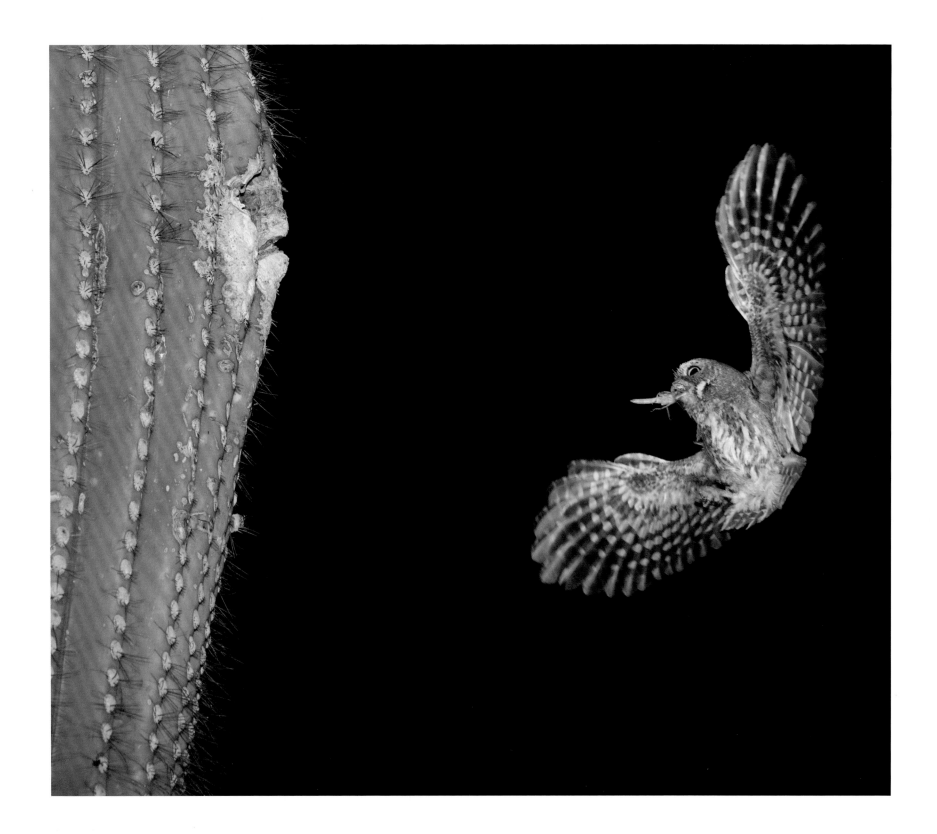

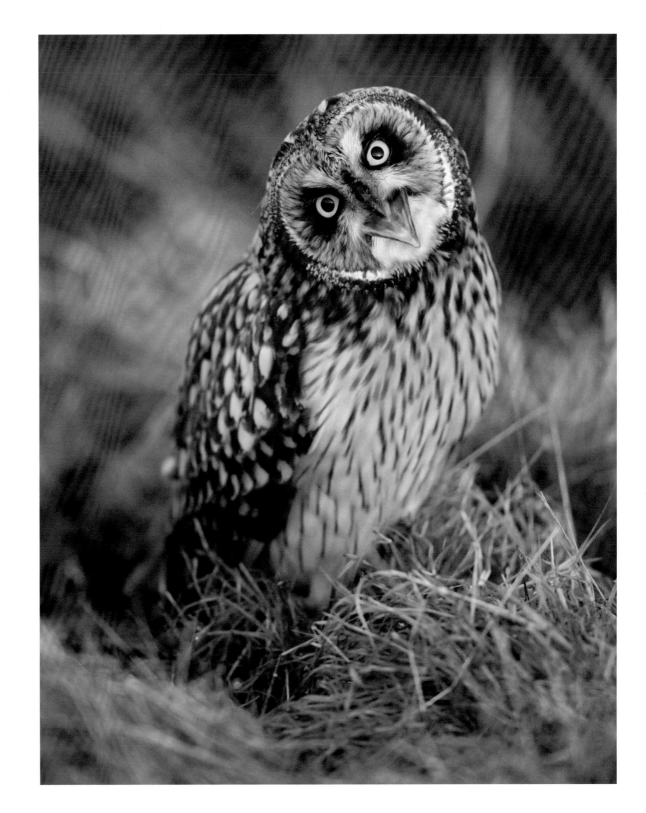

The territorial Short-eared Owl will scream warnings at interlopers.

{ *opposite* } An Elf Owl arrives at the nest cavity with food for his mate. Males feed females during courtship, through incubation, and while nestlings are small.

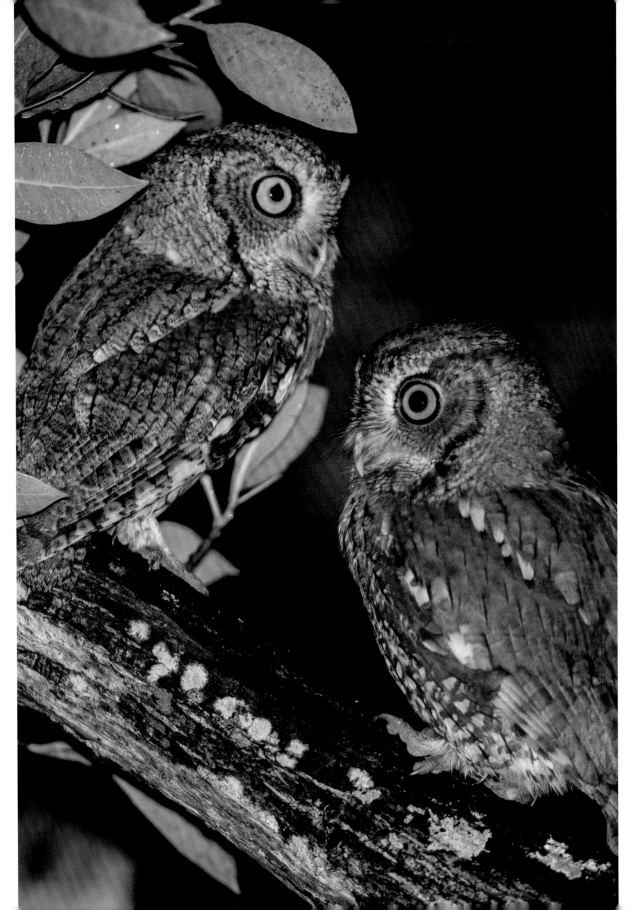

Eastern Screech-Owls present the most extreme example of color variation in all North American owls. Rufous individuals are most common in more southerly, humid, hardwood forests, while gray birds are seen to the north, in drier, cooler, more coniferous habitats. Color morphs are not tied to age or gender, and can appear within the same clutch of chicks.

{ opposite } Many nonmigratory owls, like this pair of Northern Spotted Owls, mate for life or until a mate dies.

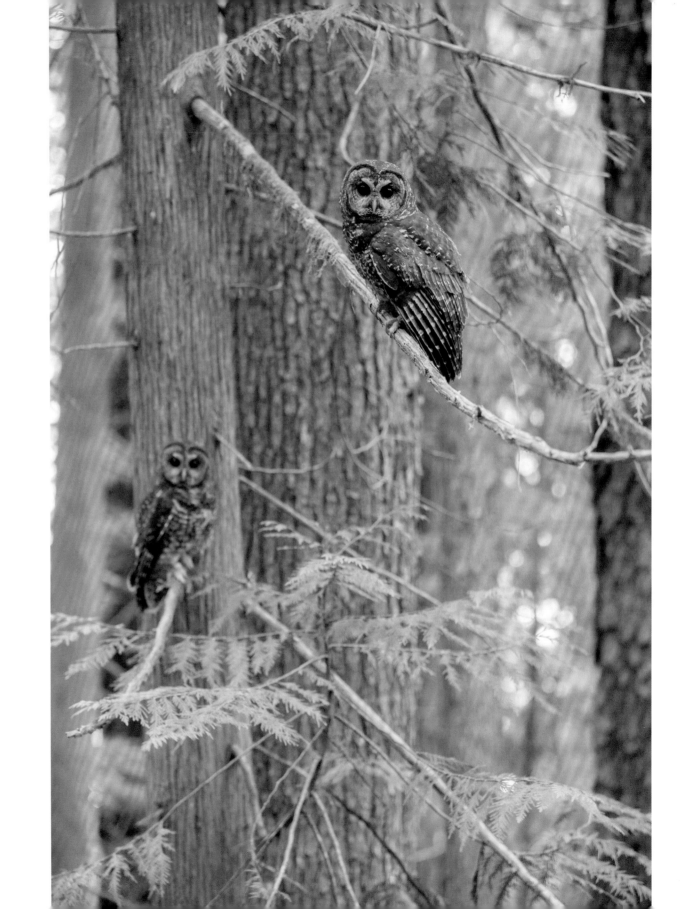

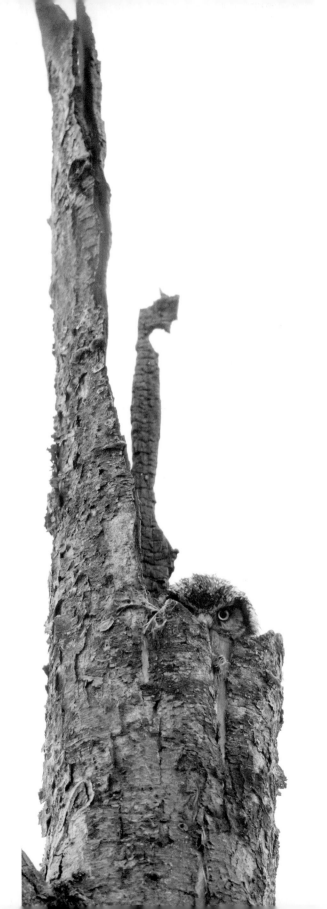

{ *left* } Owls are often incredibly well-camouflaged by plumage that matches their environment. This Northern Hawk Owl, which is incubating eggs, is difficult to see even out in the open—in the hollowed-out top of a burned snag.

{ *right* } Whether on eggs or roosting in the grass, the Short-eared Owl will often raise its ear tufts and squint its eyes, a strategy used by all eared owls to remain hidden.

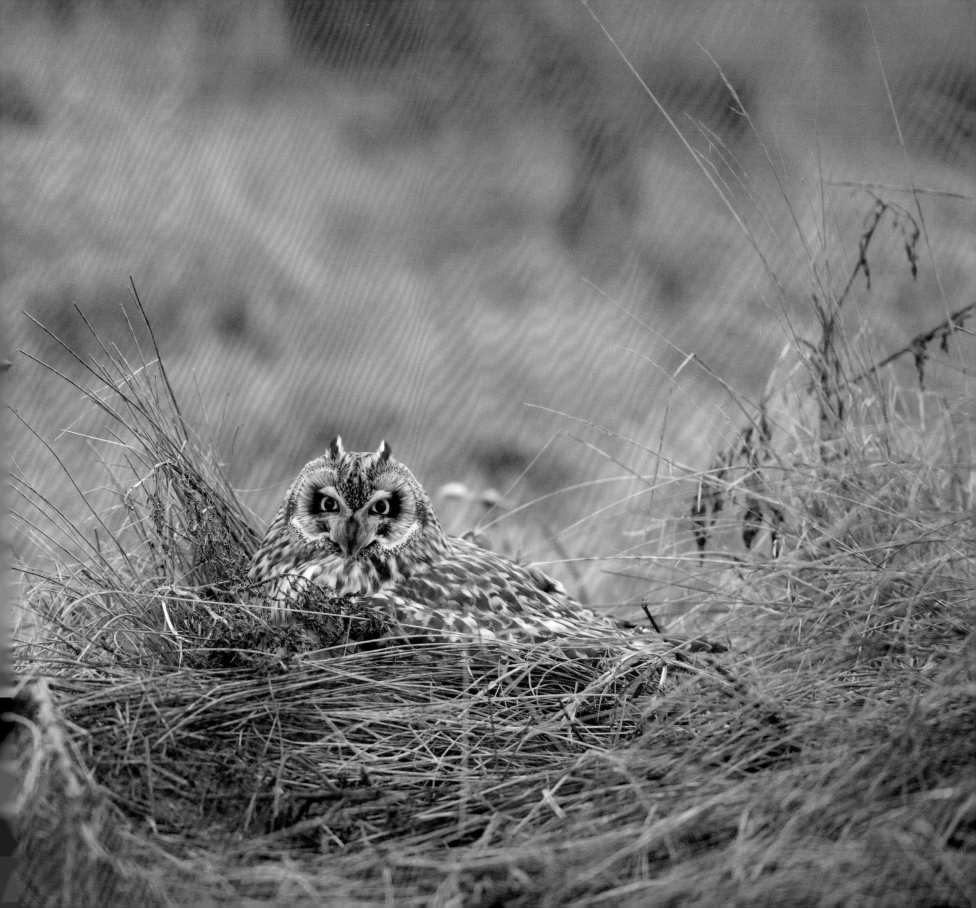

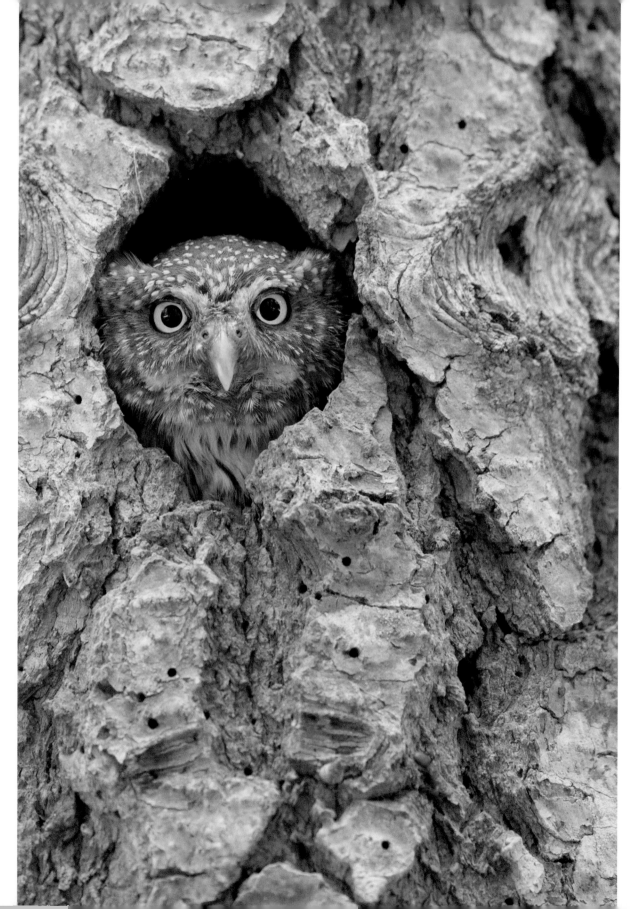

Northern Pygmy-Owls are commonly described as "earless," but they can compress their facial disks and raise some feathers to break up the outline of their head, presumably resulting in better concealment.

{ opposite } A Cactus Ferruginous Pygmy-Owl arrives just below its nest cavity with prey. The small Gila Woodpecker–created cavity in the spiny saguaro keeps the nestlings safe from all predators.

{ page 60 } In the ground courtship display, a male Snowy Owl, with a lemming in his bill, lifts his wings and lets them hang while walking or rotating his body to ensure that the female sees him and the lemming.

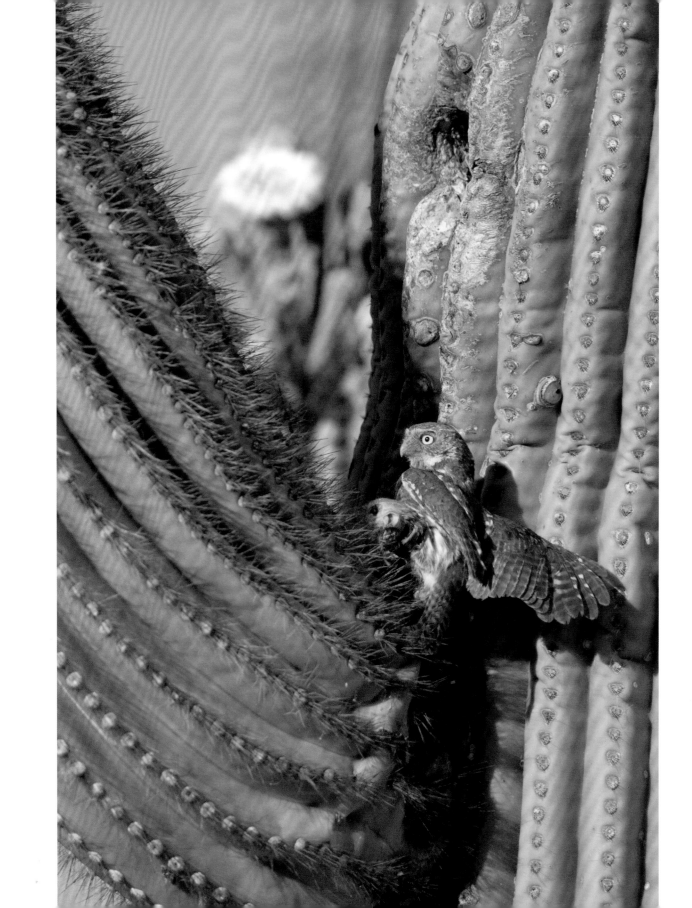

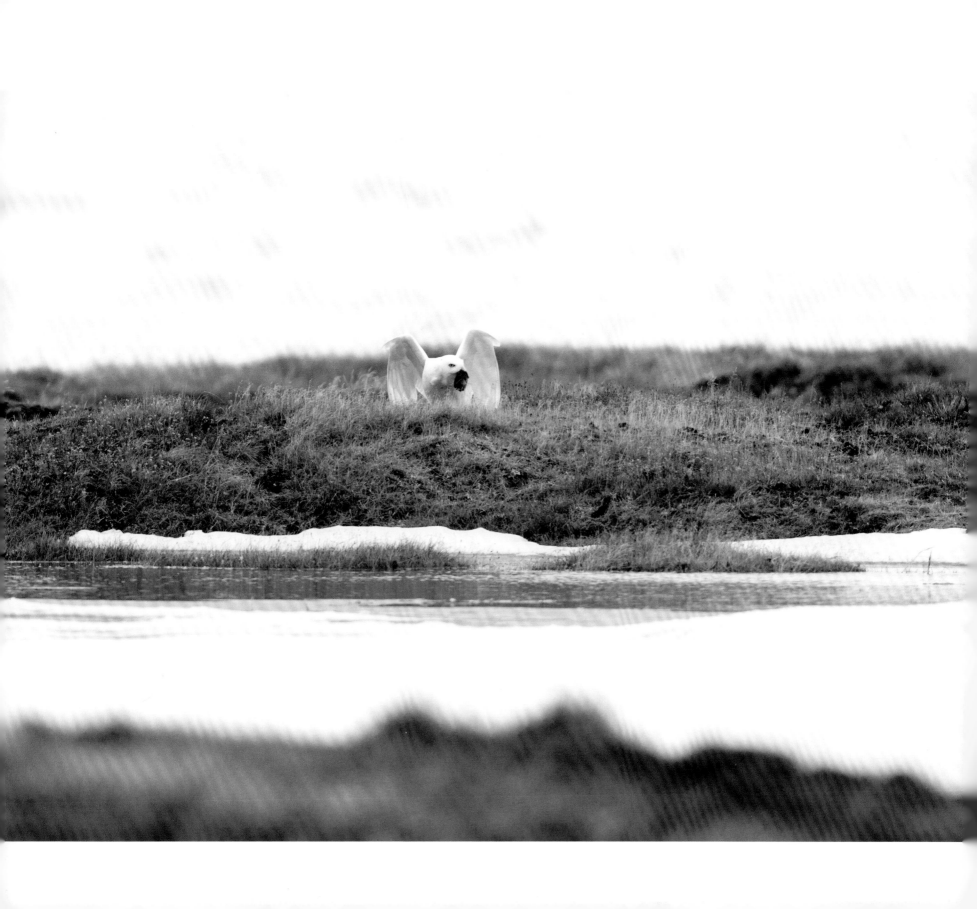

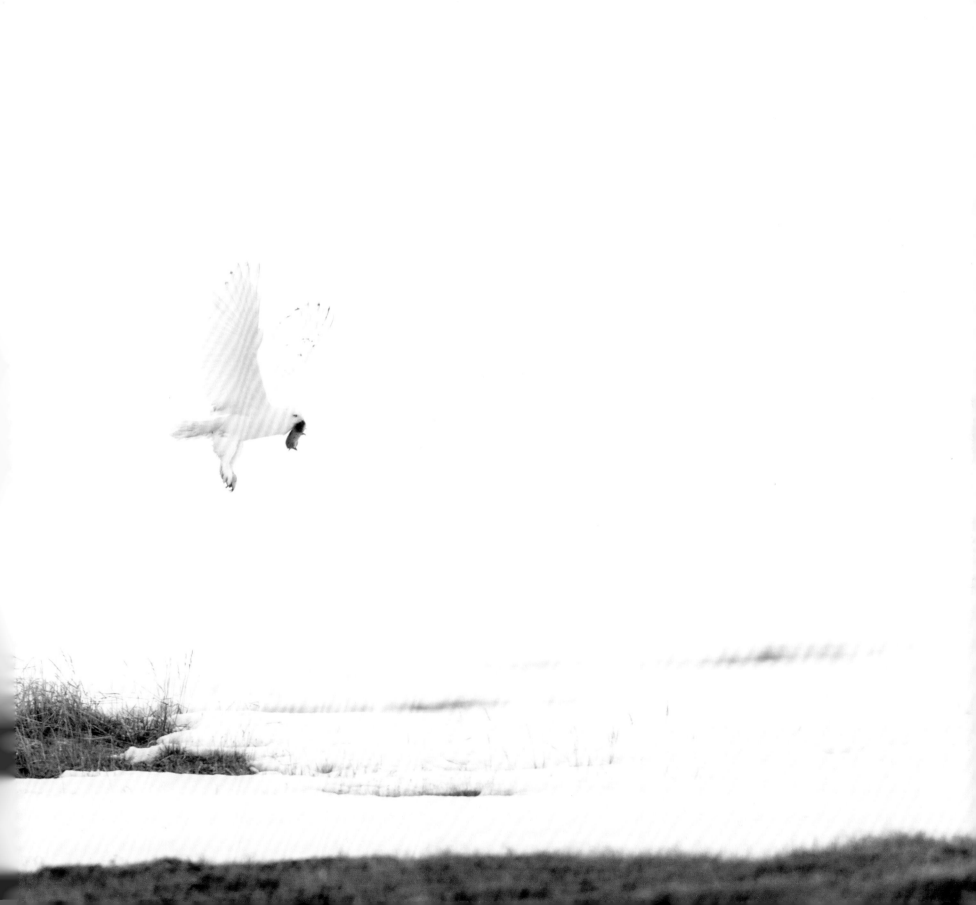

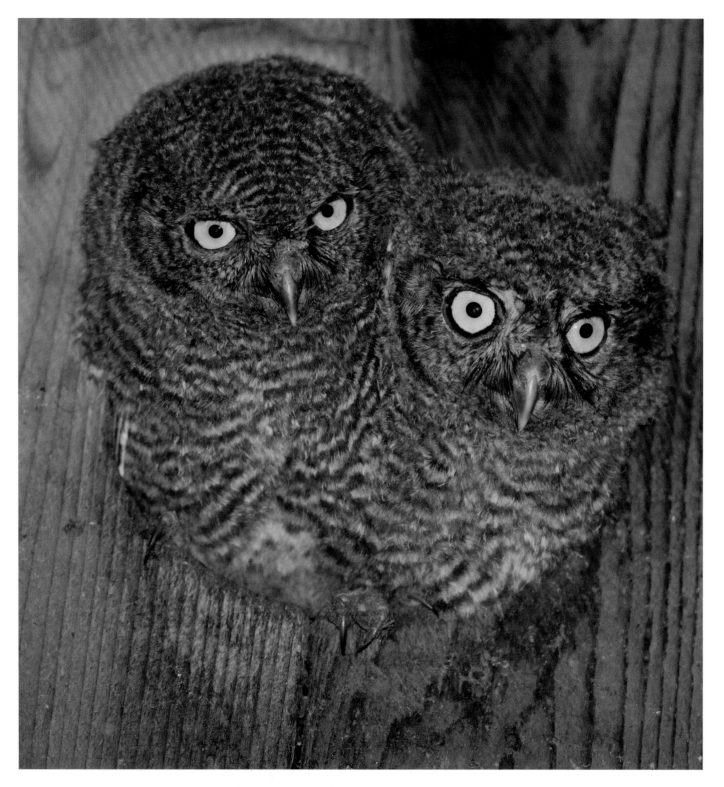

Two Western Screech-Owl nestlings peer from the entrance of a nest box. Northern Saw-whet Owls, Boreal Owls, Western Screech-Owls, Elf Owls, Eastern Screech-Owls, and even Ferruginous Pygmy-Owls will utilize bird boxes if they reflect the size of the woodpecker cavity they use in the wild.

{ *opposite* } A Western Screech-Owl looks out of a flicker-created cavity in a red alder tree on an island in Puget Sound. Western Screech-Owls show a range of color morphs. The brownest and darkest individuals are found in the wet coastal areas from northern Oregon to Alaska.

{ *page 61* } Male Snowy Owls often carry a lemming in their aerial display: The male flies with stiff, slow wing beats, causing him to fall between delayed downstrokes. Light reflecting off of the white wing surfaces can be seen by a prospective mate from a great distance.

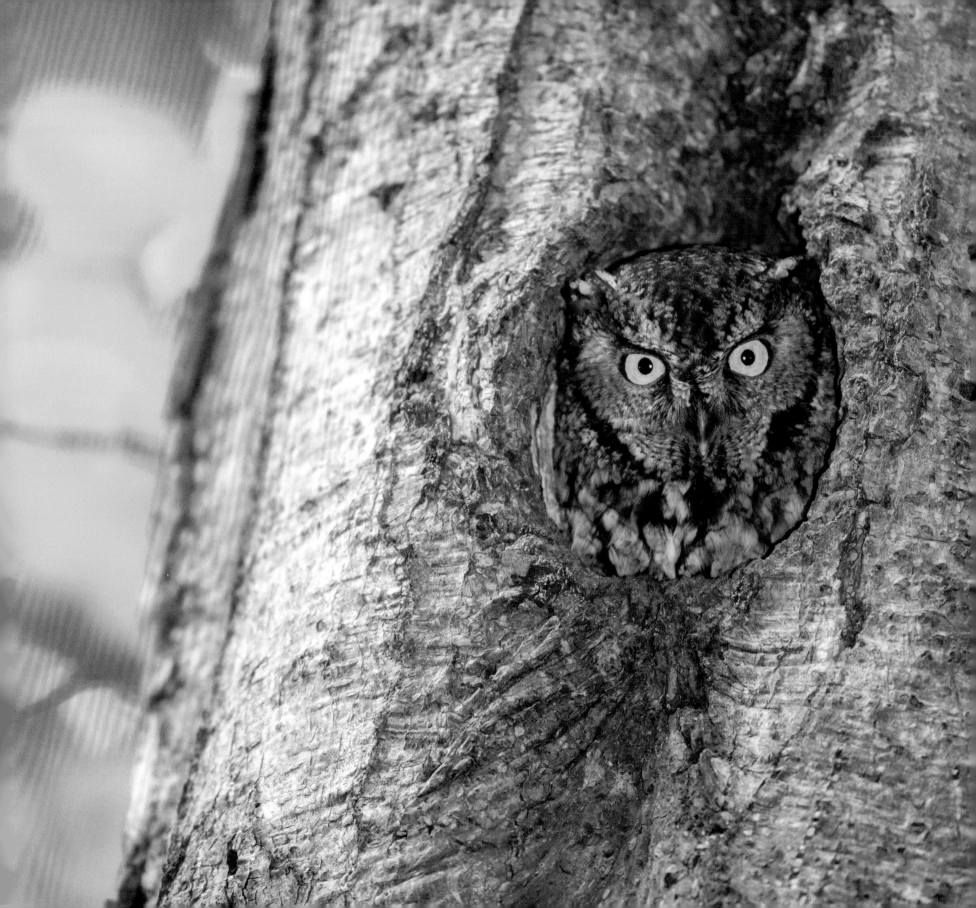

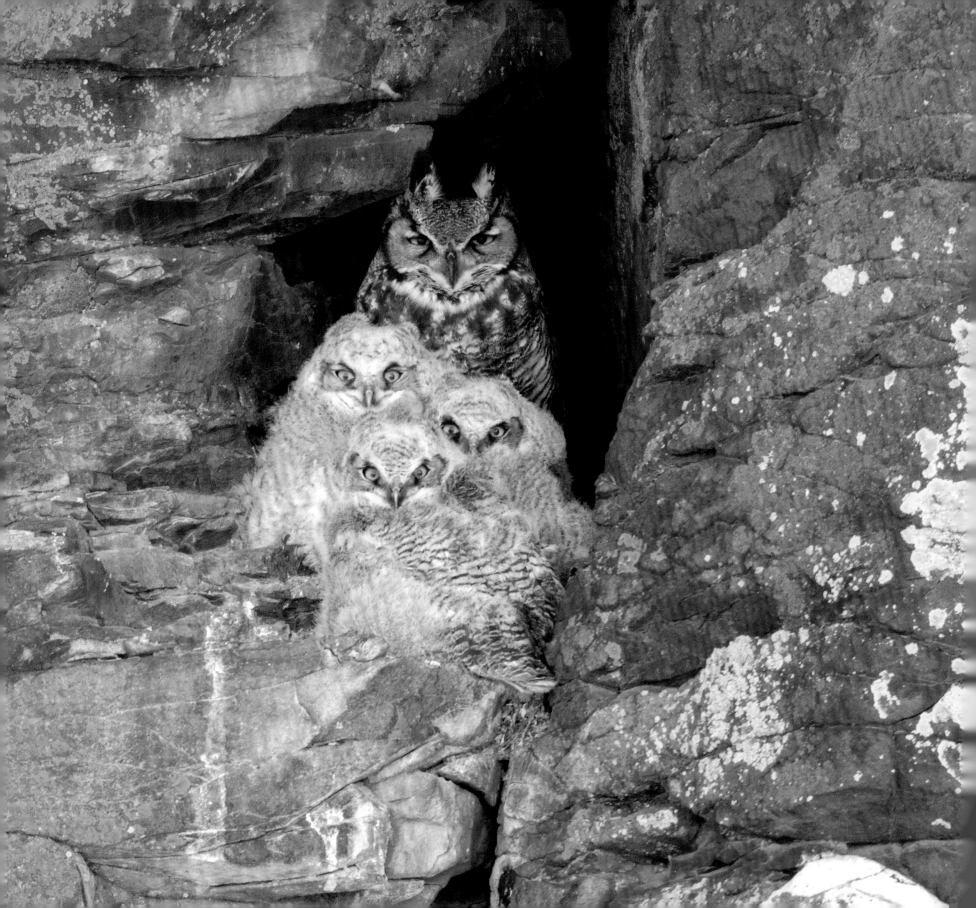

LIFE IN THE NEST

Once owls have established a territory, secured a mate, and selected a nest for raising their young, they follow a similar pattern in their parental roles regardless of species. There is a great difference among owl species, however, in where and when the parents hunt and what kind of food they bring to their young. These differences determine their foraging habitat, the second key habitat element (the first being their nesting habitat) that an owl needs for its survival.

FOOD AND HUNTING

Foraging habitat is where an owl finds its food and differs depending on what an owl hunts and where that prey is most abundant within an economical distance from a nest or roost. Owls pursue a wide range of prey, but each species has preferences, if not requirements, that generally place them into one of three categories: small-mammal specialists, which eat primarily voles, mice, and rats; arthropod specialists, which prefer invertebrates such as insects, scorpions, and crustaceans; and opportunistic hunters, which prey on a wide range of mammals, insects, reptiles, amphibians, and birds that they can subdue.

Great Horned Owls are highly adaptive and able to live in nearly every North American habitat. They occupy many types of nests, including cliff-face caves.

Barn Owls, Long-eared Owls, Short-eared Owls, Spotted Owls, Great Gray Owls, Boreal Owls, Northern Saw-whet Owls, and Northern Hawk Owls are all small-mammal specialists that rely almost entirely on rodents, with voles comprising the majority of the diet for several of these species. Snowy Owls are small-mammal specialists during the breeding season but much more opportunistic during the winter when they eat birds or rodents depending on local opportunities. Elf Owls, Flammulated Owls, and Whiskered Screech-Owls specialize in arthropods, although the Whiskered Screech-Owl will also eat mammals and reptiles. Northern Pygmy-Owls, Ferruginous Pygmy-Owls, Great Horned Owls, Barred Owls, Western Screech-Owls, Eastern Screech-Owls, and Burrowing Owls are the more opportunistic species.

You can guess quite a bit about how an owl detects its prey by looking at its face. When the feathers framing the face are arranged in a distinctive disk shape, like in the Barn Owl, Short-eared Owl, and Boreal Owl, the disk acts like a parabolic reflector and funnels sound to the owl's ears, allowing these owls to hunt by using their hearing. Not surprisingly these owls also have the most silent flight. Owls with indistinct facial disks, like the Northern Hawk Owl and Northern Pygmy-Owl, tend to depend more on their vision.

The surface area of an owl's wings and the length of its tail are clues about how it hunts. Owls that live in open habitats with fewer elevated perches, like the Snowy Owl, Short-eared Owl, Barn Owl, Burrowing Owl, and Long-eared Owl, tend to have longer wings, allowing them greater buoyancy for effectively hunting on the wing. Northern Pygmy-Owls and Northern Hawk Owls are adapted to pursuing prey in wooded areas, unencumbered by long wings that might collide with trees and aided by long tails that act like rudders, allowing for sharp turns around obstacles.

An owl's feet provide hints about its diet. Owls with relatively large feet tend to capture relatively large prey. Great Gray Owls, which hunt voles, for example, have smaller feet relative to their size than Ferruginous Pygmy-Owls, which can take prey larger than themselves. Talons offer another clue: The long, razor-sharp talons of the Northern Hawk Owl, for instance, allow it to take snowshoe hares, and the small, lizard-like talons of the Elf Owl are suited to catching arthropods.

An owl's hunting behavior also gives clues regarding what prey it might be pursuing. One June in central Alaska, I was able to watch male Northern Hawk Owls and Boreal Owls hunting voles to bring back to their young, giving me the opportunity to compare their methods. The Northern Hawk Owl was hunting in a muskeg to feed five fledglings. He darted to perches at the top of thirty-foot-tall spruce trees and pursued prey up to seventy feet away. His head was constantly swiveling and tilting as he scanned the saturated ground. At times, he leaned so far forward that his head and tail were almost

A Short-eared Owl carries a freshly caught vole before caching it in the grass and resuming its hunting.

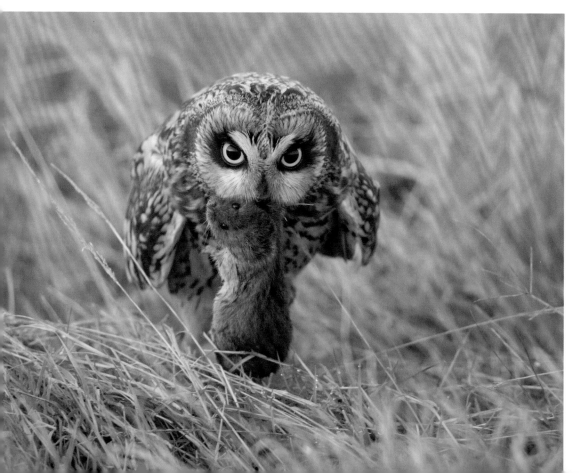

parallel with the ground, sometimes needing to flap his wings to regain his balance. When he spotted prey, his entire body snapped into a rigid position, before he dove headfirst, while either folding his wings in tightly against his body and dropping like a bullet or extending his wings and gliding down steeply until just above the ground, then flying swiftly like a falcon toward its prey. Northern Hawk Owls hover over potential prey frequently and skillfully, much more like a kestrel than an owl. The Hawk Owl's hunting behavior, particularly the use of high perches and greater striking distances, are typical of owls that mostly utilize their vision rather than their hearing to find prey. Northern Hawk Owls are known to have eyesight keen enough to enable them to spot a vole from almost half a mile away. The Northern Hawk Owl hunts during the day, another beneficial approach for owls that primarily use their vision to find food.

The Boreal Owl was hunting at night, taking advantage of low perches and shorter striking distances, common behavior for owls that locate prey primarily with their hearing. As I watched the owl hunting alongside a pond, he flew every three to five minutes between perches not more than four feet off the ground. He seemed intently focused on the area directly below his perch, rotating his head from time to time. Each time, his facial disk contracted or expanded as he attempted to hone in on the sounds of prey. While the Northern Hawk Owl looked ahead to find prey to chase, the Boreal Owl moved to new perches and waited for the sounds of prey moving directly below him.

Although these two owls employ very different hunting methods, they, like many North American owl species, are small-mammal specialists, dependent on a narrow range of prey that is prone to population booms and busts. Owls with more diverse diets, such as Western and Eastern Screech-Owls, Northern Pygmy-Owls, Barred Owls, and Great Horned Owls, are less vulnerable to fluctuating food supplies and, therefore, are more predictable breeders.

INCUBATING THE EGGS

The relative abundance of an owl's targeted prey and the ability to capture that prey during the spring influence how many eggs are laid and how many owlets survive to leave the nest. Barn Owls are unique in that they can nest at almost any time of the year and even have multiple clutches in a single year if prey is especially abundant.

All owl species lay white or whitish unmarked eggs shortly after the nest is selected. What owl eggs lack in color they make up for in size variability, with Elf Owls laying eggs of only 7.4 grams and the Snowy Owl laying eggs of up 64.5 grams, which is slightly heavier than large chicken eggs. There is also diversity in clutch size ranging anywhere from one to three eggs, which is common for Flammulated Owls, Barred Owls, Great Horned Owls, and Spotted Owls, to more than seven eggs during good prey years for Snowy Owls, Short-eared Owls, Northern

When owl nestlings, like these two Long-eared Owls, are only a few days old, their eyes are closed, and they retain an egg tooth, a hard nodule on the end of their bill, that helps them break through the egg.

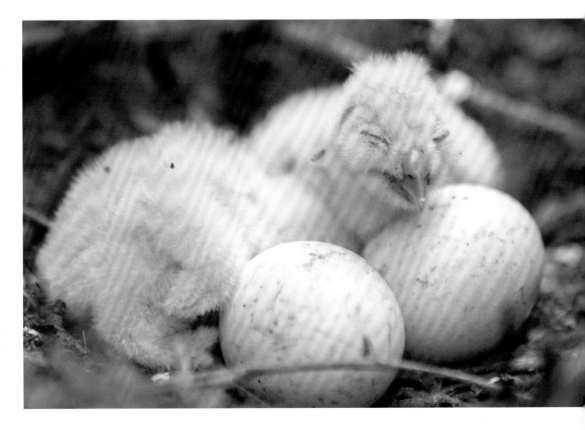

Hawk Owls, Long-eared Owls, Northern Saw-whet Owls, and Burrowing Owls.

Once the female owl begins laying eggs, she spends almost all of her time keeping the eggs warm, and she leaves them only to defecate or receive food from her mate. For most owls, the incubation time averages one month. Depending on the species, incubation may be as short as twenty-four days (Elf Owls and Flammulated Owls) or as long as thirty-seven days (Great Horned Owls and Short-eared Owls).

To facilitate keeping the eggs warm, the female develops a brood patch—an area of her underside where feathers have fallen out to expose a bare patch of skin with a high concentration of blood vessels close to the surface—for transferring heat to the eggs when incubating. Often, the feathers that once covered this patch will end up in the nest, adding to the warmth of the nest and giving some viewers the perception that the owl intentionally added those materials.

Most females begin incubating their eggs after one to two eggs have been laid, which can lead to dramatic differences in the ages and developmental stages of the young in the nest, especially when the clutch is large. Short-eared Owls, for instance, usually lay eggs every one to two days, so if seven eggs are laid, then they may hatch and develop with a two-week difference in age.

While the female is incubating the eggs, the male does the hunting, not just to keep his mate fed, but also to stockpile enough food to keep the female healthy. This allows the female to focus her energy on laying eggs and protecting the young, and in some cases, encourages her to keep laying eggs. The male will also store food to compensate for times when prey is less plentiful. When the male is not hunting, he often roosts close enough to protect the female, eggs, and nestlings from any predators.

THE OWLETS

The young hatch aided by an egg tooth, a temporary hard, white nodule on the end of the bill that helps young owls break out of the egg. The hatchlings emerge with uniform whitish feathering and closed eyes. At this point, they are extremely vulnerable to the cold, requiring the female to constantly cover them with her feathers to keep them warm, a behavior called brooding. The nestlings will gradually gain the ability to thermoregulate, or keep themselves warm, so that by the time they are nine to fifteen days old, the female can begin spending more time off the nest, especially during warm weather or when she needs to supplement the male's hunting.

The differing demands on males and females during nesting is one of the prime reasons given for the tendency in owls for females to be larger than males. Brooding females, if bigger, are better able to carry more eggs, keep the young warm, and protect the nest, and males, if smaller and more agile, are better able to defend a territory and catch more food. Another line of reasoning is that each mate is able to specialize in different prey, essentially expanding the prey base during the period of greatest need—when the young are getting ready to leave the nest and over the next several weeks.

Even if the male has captured enough food to temporarily satiate the female and young, he continues to hunt to stockpile food in the nest with the female, or caches food near the nest so he can deliver it to the female later when she or the young beg. Caching occurs with most owls year-round, whereas stockpiling occurs only when a female is on a nest. Stockpiling is especially common in species that have a wide range of brood sizes, such as Snowy Owls, Short-eared Owls, Burrowing Owls, Boreal Owls, and Northern Saw-whet Owls; it helps the female to stay healthy and to lay more eggs during the rare times when prey is plentiful. I have frequently found the number of stockpiled food items in a nest to exceed the number of eggs or nestlings of Snowy Owls, Boreal Owls, Saw-whet Owls, and Short-eared Owls. Such nests contain fat, healthy young and result in high survivorship.

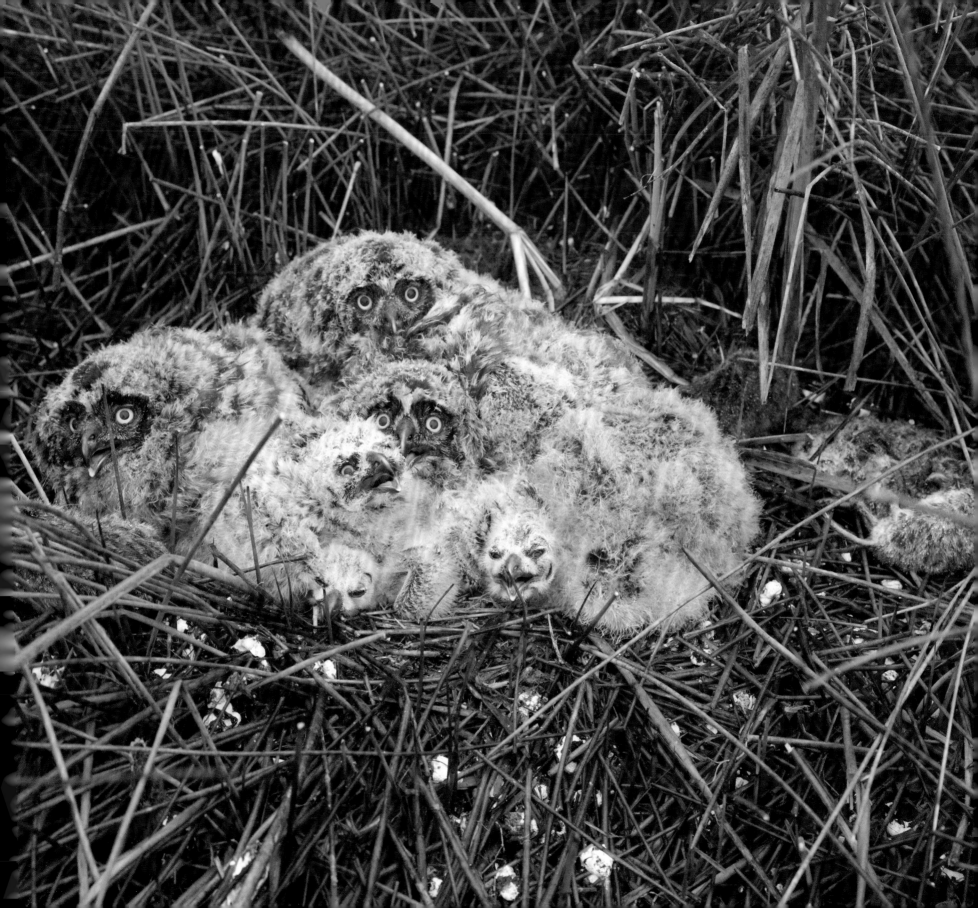

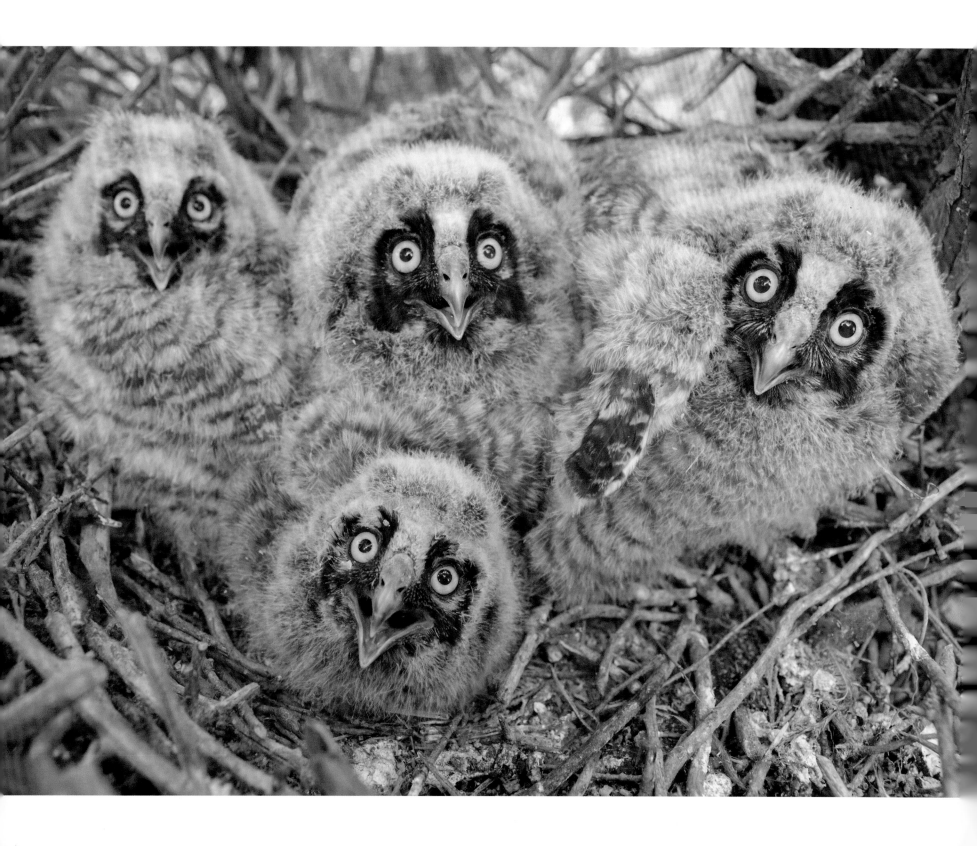

When owlets reach about two weeks old, they begin to develop a thicker and warmer coat of feathers. At this stage, the white features are replaced by gray, brown, or new white feathers, sometimes with species-distinctive markings.

During this time, all nestling owls are loud, incessantly begging for food when they are not sleeping. The young owls are experiencing their fastest growth and greatest increase in food demand. Hearing the begging, or perhaps instinctively knowing their needs, the male hunts longer, sometimes into the day for nocturnal owls or deeper into the twilight hours for diurnal owls.

When females leave the nest, most stay close enough to hear the male's food delivery call as he approaches with prey and to defend the nest if needed. The female meets the male away from the cavity to intercept the prey and deliver it directly to the nestlings. With large prey and small nestlings, the female breaks or tears the food into smaller pieces, but with larger youngsters, she feeds the prey to them whole. Sometimes, both male and female owls prepare prey by removing the intestines or dangerous parts, such as stingers and pointed feet that might injure nestlings. When a male and a female share hunting duties, they often pursue different prey in different areas; for instance, with Flammulated Owls, the male looks for prey among the needles and leaves in mature pine-fir forests, whereas the female forages in grassy areas beneath the trees. This division of labor allows the pair to meet the food demands of the family without traveling far from the nest and makes them less dependent on one food source.

By early in their third week as nestlings, most owls are large and active and are able to keep themselves warm in most weather. Because of this and also because there is little room left for her in the nest, the female perches nearby. She will come back frequently to brood the nestlings at night, when the weather is poor, or if there is a potential predator nearby.

By the beginning of the fourth week, most young owls are flapping their wings, either against the walls of the cavity, on the edges of a more open nest, or in the case of ground-nesting owls, walking or hiding in the grass or on the tundra. Many young will be hopping or even attempting to fly from one side of the nest to the other, exercising and perhaps testing their wings. Nestlings in cavities will peer out the opening, fighting one another for the best view or for the best chance to intercept the mother delivering food. The owlets are preparing to leave the nest.

NORTHERN PYGMY-OWL

The best foraging habitats for Northern Pygmy-Owls are the edges of mountain forests between mature stands of conifers, replete with downed trees and snags, and wet openings created by streams, ponds, rivers, or meadows. In these two adjacent habitat types, they can harvest a bounty of animals to feed themselves and their young. Owlets are typically in the nest during June, the first reliably snow-free month of the year, and just as wildflowers are approaching their peak. The air is warm and fragrant, and the forest is alive with flashes of color and a variety of songs as birds gather food for their young. At the same time, snakes hunt the shallows for tadpoles, lizards court in bright patches of sunlight, and small mammals gather food for their young.

I revisited the Northern Pygmy-Owls I had been studying in the Oregon Cascades in early June. It had been almost four weeks since I had seen or heard either of the two owls.

I had watched the owls copulate from the last week of April through the first week of May, and I had seen the female fly into the nest just after dark that last week. Since Pygmy-Owls nest in cavities but do not roost in them, I knew she had chosen this cavity to be her nest. Since owls are most vulnerable during incubation, I had left them alone for those weeks. I arrived at the nest again before sunrise, and the sun had set—and there was no sign of the owls. A nagging worry crossed my mind: Had the nest failed?

Two soft *toot* calls startled me. And then I heard shuffling in the cavity, and the female's broad face suddenly

{ *opposite* } As with most owl species, these Long-eared Owl nestlings thermoregulate quite well at about three weeks old, and they often fill the nest, making it difficult and unnecessary for the female to roost with them.

NORTHERN SPOTTED OWLS AND THE PACIFIC NORTHWEST COASTAL FORESTS

The coastal forests of the Pacific Northwest are wet forests found along the Pacific Coast from the coastal redwoods of northern California north through the conifer forests of cedar, hemlock, and spruce west of the Cascade crest to Southeast Alaska.

The majority of Northern Spotted Owl nests in Oregon and Washington are in mature, closed-canopy forests that are between eighty and eight hundred years old, with most of the nest trees being at least one hundred forty years old and some up to 260 feet tall and 10 feet in diameter. These forests typically have plenty of large trees with natural cavities, snags, and coarse woody debris on the ground that provides cover for prey species.

Whereas Northern Spotted Owls prefer older forests, their success in these stands is related more to the structure of the forest, the prey base, and the absence of Barred Owls than it is to the age of the trees. Important structural components include giant tree snags for nesting and a multilayered canopy, which the owls use to regulate their body temperature. They may roost very low when it is warm to take advantage of the cooler air lower in the canopy; conversely, when it is colder, they roost higher in order to get out of that same cold air.

Washington and Oregon populations of Northern Spotted Owls west of the Cascades feed primarily on flying squirrels, whereas those in California and east of the

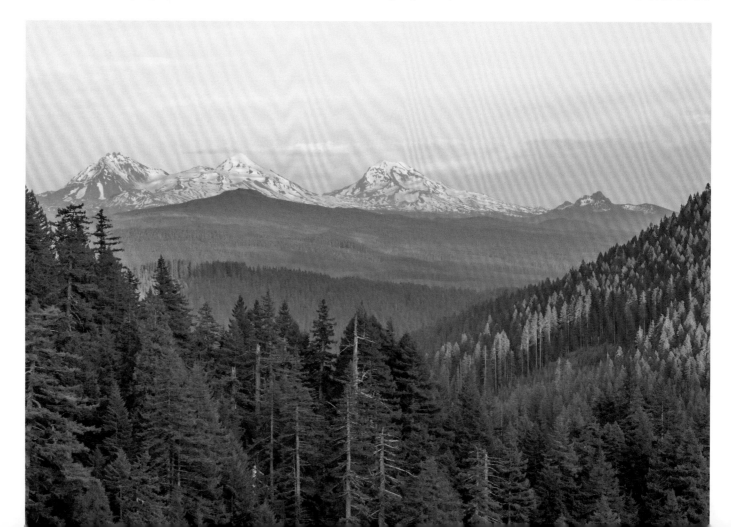

Cascades consume more woodrats. Studies show that owls require larger territories when they focus on flying squirrels as prey. Tree voles, red-backed voles, pocket gophers, snowshoe hares, mice, and brush rabbits are also important prey.

Northern Spotted Owl populations are precariously low. After experiencing a loss of anywhere from 80 to 90 percent of suitable habitat in the preceding hundred years, Northern Spotted Owls experienced a range-wide decline of 3.8 percent per year between 1985 and 2013. According to the most recent study (December 2015) Northern Spotted Owls showed significant declines in all three states (Washington, Oregon, California) and all study areas, with Washington experiencing the most significant declines (55 to 77 percent), and Oregon and California showing declines of between 31 and 60 percent, depending on the location. The only study areas that showed an increase in Northern Spotted Owls were the ones where Barred Owls were removed.

The primary reasons for this predicament are changes to quality habitat and the dramatic incursions from Barred Owls in their territories. Timber harvest has dramatically reduced the number of suitable nest sites and fragmented remaining suitable territories.

Barred Owls, the Northern Spotted Owl's larger and more aggressive eastern relatives, have greatly expanded their range, arriving in Northern Spotted Owl habitat in the 1970s. Since then, they have been increasingly replacing Spotted Owls in the best territories and on the best nest sites. Being more of a generalist, Barred Owl populations are denser, and some research shows that when they call, Spotted Owls fall silent, making it more challenging for them to bond with mates and breed. Meanwhile Barred Owls produce many more young and have a higher survival rate than Spotted Owls. Finally, the two species sometimes interbreed, creating "Sparred Owls," further diluting the gene pool.

Saving the Northern Spotted Owl requires protecting and connecting the remaining western old-growth forests. Barred Owls are being removed or eliminated in Northern Spotted Owl territory in a controversial experiment currently being conducted by the US Fish and Wildlife Service.

Protecting Northern Spotted Owl habitat will benefit other wildlife including the Marbled Murrelet, red tree voles, Pacific fisher, the torrent and Pacific giant salamanders, and an entire ecosystem that also relies on the health of Pacific Northwest old-growth forests. The removal of Barred Owls will also benefit coastal Northwest populations of Northern Pygmy-Owls and especially Western Screech-Owls, whose populations appear to be taking a big hit from predation by Barred Owls in some areas.

Northern Spotted Owls were listed as "threatened" under the provisions of the US Endangered Species Act, and in 2015, the US Fish and Wildlife Service announced that it was considering reclassifying them as "endangered." The species is currently listed as "endangered" in Canada. Northern Spotted Owls west of the Cascades and in the Coast Range help assess the health of complex, structured old-growth forests.

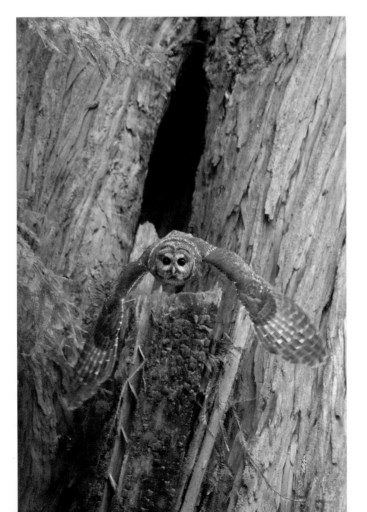

A Northern Spotted Owl flies from a lightning-created scar in an ancient redwood.

{ *opposite* } Northern Spotted Owls require mature conifer forests with abundant snags and complex structures. Clearcuts and other over-harvesting still threaten their survival.

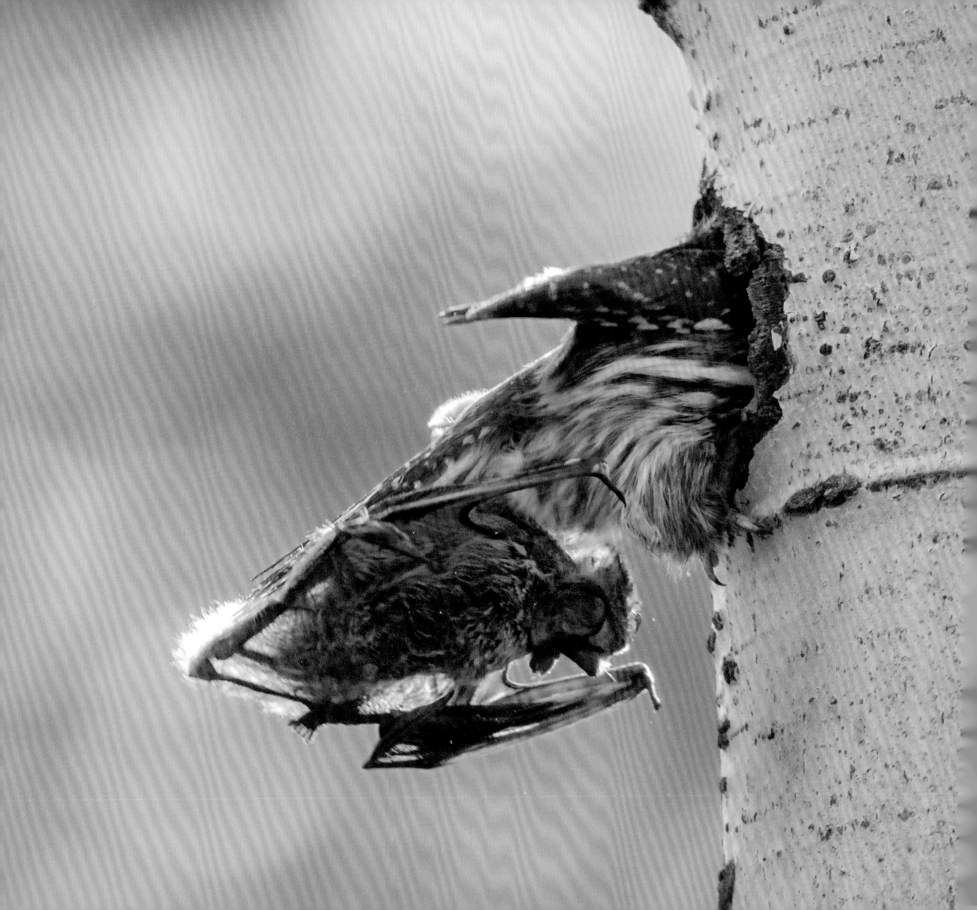

filled the cavity opening. She flew out, disappeared for a few minutes, and returned with a small shrew, essentially proving she now had at least one youngster.

Northern Pygmy-Owls lay two to seven eggs, with an average of about five. Females incubate the eggs for about twenty-eight days before the young hatch. As the young grow in size, feedings become more frequent, peaking around day fourteen of their twenty-three days in the cavity (after twenty-eight days inside the eggs). As the nestling period progresses, larger and more diverse prey is brought in, with the parents less frequently beheading or partially eating the prey before delivering it. The youngsters are now confronted with the full forms of the animals they will eat and have witnessed their parents preparing these for them.

Northern Pygmy-Owl diets are difficult to describe. Although most of the literature categorizes these owls as small rodent and bird specialists, my experience watching the nests has shown that they will eat anything they can subdue, no matter what size or phylum. Their extremely large feet allow them to tackle and grasp most animals smaller—and some larger—than themselves, and their keen eyesight enables them to scan their surroundings and to attack quickly from higher and farther than most other owls. Since they utilize diverse habitat types, these owls have access to a greater variety of prey, making them less vulnerable to prey cycles and allowing them to retain a territory and to breed most years. And the Northern Pygmy-Owls' diurnal behavior helps reduce their vulnerability to predation by one of their prime predators, the nocturnal Great Horned Owl.

Near the Northern Pygmy-Owl nest in the Cascade Range of Oregon, I witnessed the pair bringing in prey. Watching a Northern Pygmy-Owl nest is the closest I can come to taking an inventory of the small birds, mammals, reptiles, and large insects of any habitat. Remote cameras could not do a better job of revealing the various small animals that live nearby. They arrived with voles, jumping mice, shrews, chipmunks, Mountain Chickadees, Hermit Warblers, fence lizards, alligator lizards, and even a western

skink (a snake-like lizard), an animal I had not seen in the two months I had been there doing field studies full time.

At a nest in Colorado, I watched Northern Pygmy-Owls bring in voles, chipmunks, Black-capped Chickadees, a Black-headed Grosbeak, young Robins, fence lizards, a green snake, and even a hoary bat. To capture the large nocturnal bat, the owl may have had to fly into a cavity or push behind a piece of bark, subdue the bat, and carry it with its talons through the air and into the nest cavity. This hoary bat had a wingspan of about seventeen inches, while the Northern Pygmy-Owl's wingspan was probably closer to fifteen inches. While I watched this nest, a friend was watching a Northern Pygmy-Owl nest about sixty miles away. He saw mostly voles brought to the nest, with an occasional chipmunk, but no lizards, snakes, or bats—perhaps indicating the number of prey varieties available in the two areas, or maybe chipmunks and voles were preferred or more plentiful.

The Northern Pygmy-Owl nest in Oregon was just several hundred yards from a Great Gray Owl nest, offering me a special opportunity to compare the hunting behavior of the two species during nesting season. The Great Gray Owl weighs more than fifteen times as much as the Northern Pygmy-Owl, yet both were pursuing prey of roughly the same size. The Great Gray Owl was typically perching less than fifteen feet off the ground and listening for any sounds coming from below.

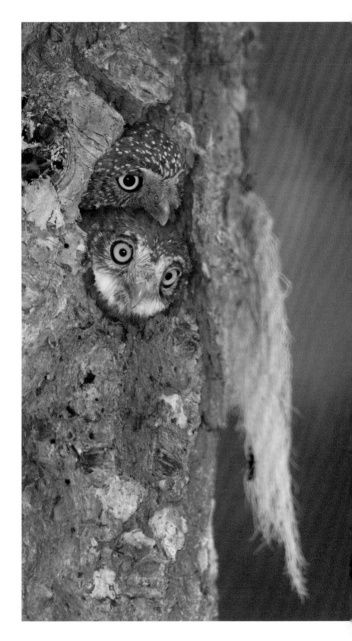

After delivering prey, a female Northern Pygmy-Owl attempts to push past a nestling blocking the entrance to their cavity.

{ opposite } A Northern Pygmy-Owl drags a hoary bat into the nest cavity to feed to her young.

In contrast, I followed a female Northern Pygmy-Owl and watched her hunt from a perch at least thirty feet above the ground. She constantly turned her head, scanning the landscape, looking for any signs of movement. When something caught her attention, she pulled her wings against her body and fell to a perch a few feet off the ground. From there, she continued to watch her prey, an alligator lizard, waiting for it to move into a vulnerable position. Then she made a lightning-quick pounce, pinned the lizard to the ground, killed it with a quick bite to the head, and flew back to her nest and her young.

When three unsteady, irregularly feathered Northern Pygmy-Owl nestlings were six days from leaving the nest, they could be seen bobbing at the cavity entrance. Day by day, the white, downy feathers streaking their skinny heads were replaced by thicker, juvenile-looking gray-brown feathers, and their faces became progressively rounder. The youngsters soon spent much of their time competing for a spot at the cavity entrance. It must take significant energy to cling to the inner cavity wall while looking out, because eventually the dominant one seemed to tire and dropped down, to be replaced by one or two weaker looking siblings.

A day before they left the nest, while I watched the three owlets fight for a spot at the cavity entrance, the mother flew in carrying an alligator lizard by the head. The lizard whipped dramatically against the cavity entrance when she landed. Even after being whipped by the long tail of the lizard, one owlet stood its ground, begging while it blocked the mother's entrance. She could not fly straight into the cavity as she normally did, but was forced to cling to the front of it, like a woodpecker, with her tail pressed against the tree for support, only to have the young owl bite her feet. Ultimately, she withheld the food until the tiny gray owlet backed down into the cavity so she could enter and help the young with this challenging meal.

GREAT GRAY OWL

An impossibly blue wildflower meadow in the Canadian Rockies looked like a lake from a distance, but what was even more surprising was the two-foot-tall Great Gray Owl perched above the flowers, atop a foot-tall lodgepole pine sapling. After listening for several minutes, he took flight, silhouetted by the rugged, snow-covered Rocky Mountains, before hovering low over the flowers and drifting into the giant trees. The Great Gray Owl requires large mature trees for its nests, but once the male begins hunting for the family, meadows—particularly irregularly shaped ones with lots of listening perches—that provide access to voles and pocket gophers will have the greatest impact on how many young will survive to leave the nest.

Great Gray Owls normally lay one to three eggs in their nests when spring is just beginning and the broad, white blooms of trillium are persisting through the last light dustings of snow. Each day, the rays of sun that slice between the giant trees shine brighter and warmer and linger longer. The female incubates her eggs for twenty-eight to thirty-six days. During that time, she rarely leaves the nest, and when she does, she returns quickly.

One April, I was observing a female Great Gray Owl on her nest in the Oregon Cascades. She seemed cold and vulnerable as she endured the wet snow in the open cavity fifty feet up atop a leaning snag. Pesky ravens, aggressive goshawks, and curious black bears kept constant surveillance of her nest. I had been watching her from a distance for several days while she incubated her eggs, and she never left the tree in daylight. She was deep in the nest, with only the soft mound of her head, the tops of her eyes, and the point of her long tail sticking up above the top of the snag. Occasionally, she shifted in her high pocket and looked down at the eggs, turning them with her bill before settling back in. From time to time, she let out a soft call that vaguely sounded like *whoo-up*, a reminder to her mate that she was hungry.

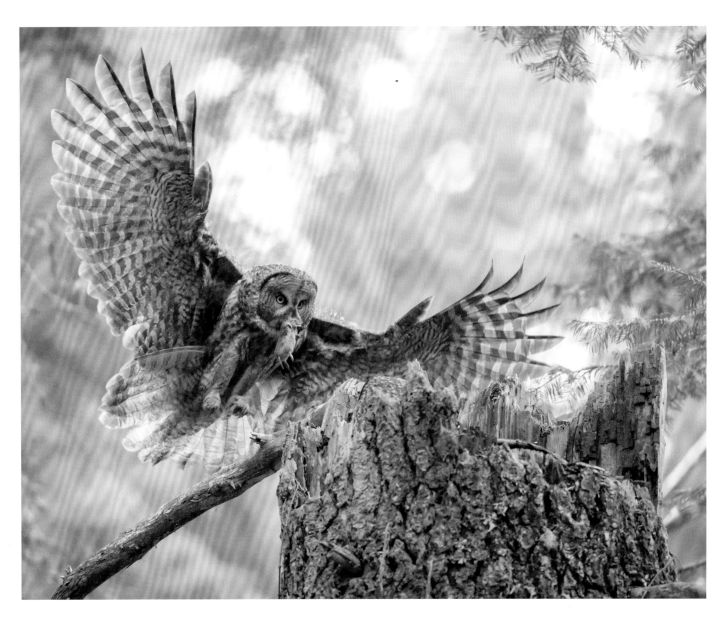

Great Gray Owl nests often disappoint photographers who hope for dramatic action photos in scenic settings. The nests are among tall trees and often have the forest canopy over them, rendering them partly shaded and partially lit with intense rays. Photographs of diurnal Great Gray Owls in the winter seem to contradict the fact that these birds are far more comfortable in low light, driven to hunt in bright light only when freezing evenings make finding enough food impossible otherwise.

I was sitting in a blind nearly thirty feet up a tree in front of the Oregon nest, and I was enduring a test of will as I tried to be alert to any possible indicative behavior of the owls. Eight hours often went by without so much as a twitch from the female. Usually she looked at me with eyes half open and lids drifting toward closure while I struggled

While the female is incubating eggs and when the young are small, the male Great Gray Owl delivers prey directly to the female who is hunkered down in the nest.

{ *page 78* } A female Great Gray Owl feeds her nestlings who are roughly one week old. At this stage, they are pinkish-white and lightly feathered.

{ *page 79* } A male Great Gray Owl delivers a gopher to his mate who waits near the nest and nestlings. As with most species of owls, female Great Gray Owls are significantly larger than males.

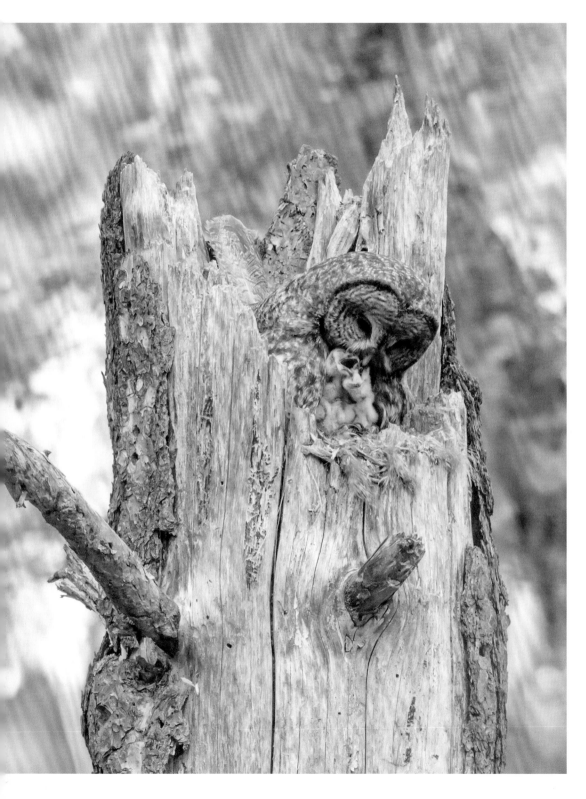

to keep my own eyes open. With long days spent photographing, I typically had only two to three hours of sleep at night. I often had to climb down from the tree and move around to avoid falling asleep and tumbling to the ground.

As her eggs started to hatch, the female shifted in the nest, and within a day or two, the first white nestling's shaky head with sealed eyes could be seen over the lip of the cavity, joined by a second nestling two days later. These thin-necked, bony, large-billed youngsters looked more like baby vultures than owls.

During the second week, the nestlings started looking like owls and displayed the gray rings of their facial disk. By the end of the second week, the young can thermoregulate well enough for the female to spend more and more time roosting away from the nest when it is warm and dry. Day by day, she spent less time in the nest but still brooded the youngsters when it was wet or especially cold and would until they left the nest. She also returned when there was any sign of a nest predator, such as a goshawk or raven. By the third week, vigorous flapping and flying from side to side inside the nest was common, with the young testing their wings in preparation for leaving.

One day during the owlets' second week, the normally quiet female unexpectedly squeezed out a couple of deeper than normal *whoop whoop* calls in a tone I had not heard previously. Suddenly, she was off the nest. As I struggled to watch through the small square windows of my blind, I heard a loud repeating squeal, like one might hear from a scared pig. Soon I saw the huge cinnamon rump of a black bear as it leaped three feet over a downed log while being struck by the talons of the female Great Gray Owl. She pursued the bear with two more strikes over several dozen yards before it disappeared into the forest. Although I found the bear's den forty yards from my blind and some one hundred yards from the nest, I did not see the bear again in the next three weeks I spent at the site.

As the young grew, the frequency of prey deliveries increased, but not the breadth of prey species. I have seen

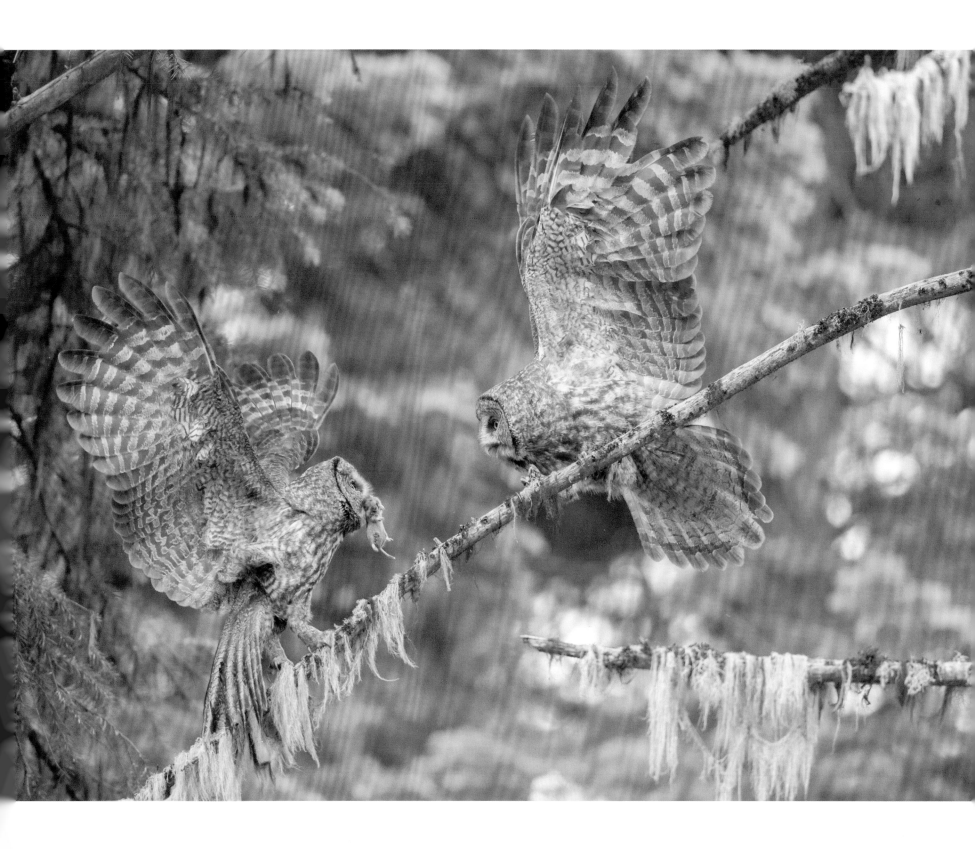

EASTERN SUBURBAN AND RURAL WOODLAND HABITATS

East of the Great Plains, there is a wide range of wooded habitats, including the mangrove swamps of Florida, the pine forests along the southeast coast, the hardwood forests of the northeast and Midwest, and mixed forests in the mountains and adjacent to the boreal forest. Several owls can be found in these habitats, but the Great Horned Owl, the Barred Owl, and especially the Eastern Screech-Owl are most common. These owls often live close to people, and in most of these places, they are faring quite well.

Eastern Screech-Owls are the most abundant—and sometimes the only—raptor in most eastern US suburban habitats. Studies in Texas and Manitoba have shown that Eastern Screech-Owls can fare better in suburban environments than in nearby rural areas. They prefer hardwoods and mixed woodlands broken up by openings (including residential yards) and streams. Barred Owls, Great Horned Owls, and even Northern Saw-whet Owls can tolerate the association when it provides nest options, wooded retreats, and plenty of prey.

All four of these species will take advantage of nest boxes and platforms provided by people. Parks, reserves, and residential yards serve as potential extensions of, or connections to, surrounding wilder habitat as long as mature tree snags, particularly those with cavities, are retained and clean water and roosting cover are available.

Eastern Screech-Owls can serve as a valuable measure of the health of wooded suburban habitats in the eastern United States. Eastern Screech-Owls, Barred Owls, and Great Horned Owls eat rodents, so they can help control pests while at the same time alerting us to any widespread environmental ills, including dangers associated with the ingestion of rodenticides present in their prey.

Eastern forested areas, like this oak woodland, with snags and grassy openings provide habitat for Eastern Screech-Owls, Barred Owls, Great Horned Owls, and Long-eared Owls alike.

dozens of prey deliveries in thousands of hours at Great Gray Owl nests in Oregon, Washington, Idaho, Alberta, and Alaska. No matter the location, they were almost always (90-plus percent) voles and pocket gophers, with a few chipmunks, red squirrels, flying squirrels, shrews, moles, birds, and one red-legged frog added to the diet. I have also seen the feet of snowshoe hares on the ground below a nest, but I could not be certain that an owl was the predator. The vast majority of these prey deliveries occurred at night, with the exceptions happening in early mornings or late afternoons on cloud-darkened days.

Only the male Great Gray Owl hunted until the nestlings were roughly two weeks old, and then the female occasionally hunted opportunistically in the immediate vicinity of the nest. The male did not feed the youngsters directly when they were in the nest but announced his presence to the female and then transferred the food. For the first two weeks, she received the prey at the nest. After the beginning of the third week, when she heard or saw the male with prey, she intercepted him on his path to the nest for an aggressive bill-to-bill exchange before pausing and delivering the prey to the young. When the young are small, she typically tears up the prey and distributes it, but as they grow larger, she feeds them whole animals.

Even though there may be only four to six prey deliveries in a twenty-four-hour period, with most occurring when it is too dark to photograph, it is well worth the wait to watch one unfold, particularly if there are hungry nestlings to be fed. Usually, Great Gray Owl nests are relatively quiet, except for an occasional begging screech of a nestling or the contact *whoop* of a female.

There were hours of silence until the male's lower *whuup* was heard. Immediately, a cacophony of owl calls broke the silence, and the whole nest became animated. The female's louder and higher pitched *whoop* rang out faster and faster, the nestlings begged, bounced, and flapped frantically, and the male responded with a deeper but softer call as he approached. The female flew to an intermediate perch, leaning low, wings extended, belting out her *whoop* calls as the male flew in, vole in bill, as fast as he could. He landed with an improbable balance of urgency and self-protection, pushing the vole toward his much larger, screaming mate but leaning back with the rest of his body so as to lessen the impact of the collision. As the female lunged forward to snatch the prey from his beak, the noise hit a crescendo. A moment before she took control of the vole, her mate was already turning toward retreat, and he disappeared moments after the exchange. Meanwhile, she continued to tremble and scream, leaning forward with wings out, vole in bill. The begging in the nest increased in volume as she paused before submitting to the nestlings' demands and delivering the meal.

One day, I decided to follow the male after a prey delivery and watch how he spent his time. Since it was 4:30 a.m., I had to follow a black shadow flying through the trees to a nearby meadow. For the next two hours, he hunted the edges of the grassy forest opening. After arriving at a low perch, usually less than fifteen feet off the ground, he stared intently into the grass for several minutes at a time, occasionally tilting his head and fixing his eyes, but his body otherwise was rigid as a statue. This often happened just before he attacked. His target was usually less than one hundred feet away, which kept him from hunting in the middle of the meadow where there were no perches for listening or watching. Clearly, he was reliant on the irregular edge of the opening, with its snag-studded fingers reaching into otherwise inaccessible stretches of grass, which was hiding voles.

The owl typically flew silently toward potential prey and hovered momentarily, with his wings, tail, and legs raised and his face closest to, and almost parallel with, the ground before appearing to lunge face first into the grass. Only photos reveal that, at the last possible moment, his long legs spring down and forward, pinning the prey to the ground. If he failed, he took off and flew one hundred to three hundred feet before landing on another perch, perhaps four to ten feet off the ground, where he continued

listening. The owl avoided the rising sun, focusing his hunting in areas still shaded by the edge of the forest. Once the meadow was lit, the Great Gray slipped into the forest and disappeared under the boughs of an ancient white fir.

I then watched the Great Gray Owl snuggle up against a tree trunk. He closed his eyes, lowered his head, and folded his facial disk, forming a vertical line, which made him blend in closely with the tree trunk. I was just twenty feet away and also starting to nap while leaning against a much smaller fir. I shook myself awake, not wanting to lose track of the owl, and saw that he was preening his wing feathers. I watched for another hour until he took off, floating deeper into the forest. Under the dark canopy, he moved from snag to snag, choosing perches ten to twenty feet high and surrounded by open or grassy ground interspersed with downed trees, retreats for his prey. For hunting, he disregarded spots with thick shrubs or sticks that might impede his legs and talons. Although he changed perches every twenty to thirty minutes, he made only a few attempts at catching prey.

As the sun set and the meadow was again shaded, the owl moved back to the perimeter and resumed his hunt. He captured a small shrew and ate it on the spot. An hour and a few failed attempts later, he captured his first vole. I could see him feel around with his feet and push down abruptly to kill his prey before looking down to confirm his success. He then flew directly to the nest site. I could hear the ruckus as he delivered the prey. Clearly, he spent most of his hunting energy targeting voles in the open field and looked for opportunistic prey in the shady forest when the meadow was lit. Apparently, he did not bother to carry small prey back to the nest but saved the effort for larger items that might better satisfy his mate and the nestlings.

Young Great Gray Owls make it known when they want to leave the nest. During the evening and early in the morning, the largest owlet could barely be contained, pushing against every physical and parental boundary that had kept it inside the nest. It gripped the nest edge and flapped vigorously, wings slapping the faces of its nest mates.

Test flights from one side of the nest to the other can end in the youngster losing its footing and falling over the edge, and fluttering awkwardly but usually safely to the ground. Owlets in stick nests often jump and climb onto surrounding branches, either for good, or to return, sometimes after several hours. At other times, the female flies to the nest, seeming to block the path of a youngster getting close to leaving, as if forcing it to wait for a better time.

BURROWING OWL

As I looked out over the sea of vibrant green sage-steppe in Idaho, the joyful cry of a Long-billed Curlew set the perfect tone. The landscape was far more verdant than I expected in early June, but spring rains had encouraged soft new leaves on the aromatic sage, new grass, and blooming wildflowers. The abundance of new growth was certainly good for rodents and grasshoppers, key prey in Burrowing Owl foraging habitat, whose numbers help parents meet the demands of growing young.

I wondered whether the Burrowing Owls had succeeded in nesting. It was a positive sign that the female was perched on sagebrush just above the burrow. I had seen a female about seven weeks earlier and was hoping to see some youngsters. I timed my return knowing that owls pair up within a week or so of arriving at nest sites, incubation lasts around thirty days, and the young are active at the nest entrance after ten days. This seemed like an ideal time to witness active owlets.

Burrowing Owls lay from one to eleven eggs, so when I first arrive at an occupied nest, it always feels a bit like a lottery. The size of the brood, like for many owls, depends on the supply of food early in the nesting season.

Burrowing Owls are not nearly as insectivorous as nocturnal Elf Owls and Flammulated Owls, but they are far more so than any other owl that does a large share of its

{ opposite } A Burrowing Owl prepares to take flight from a sagebrush snag.

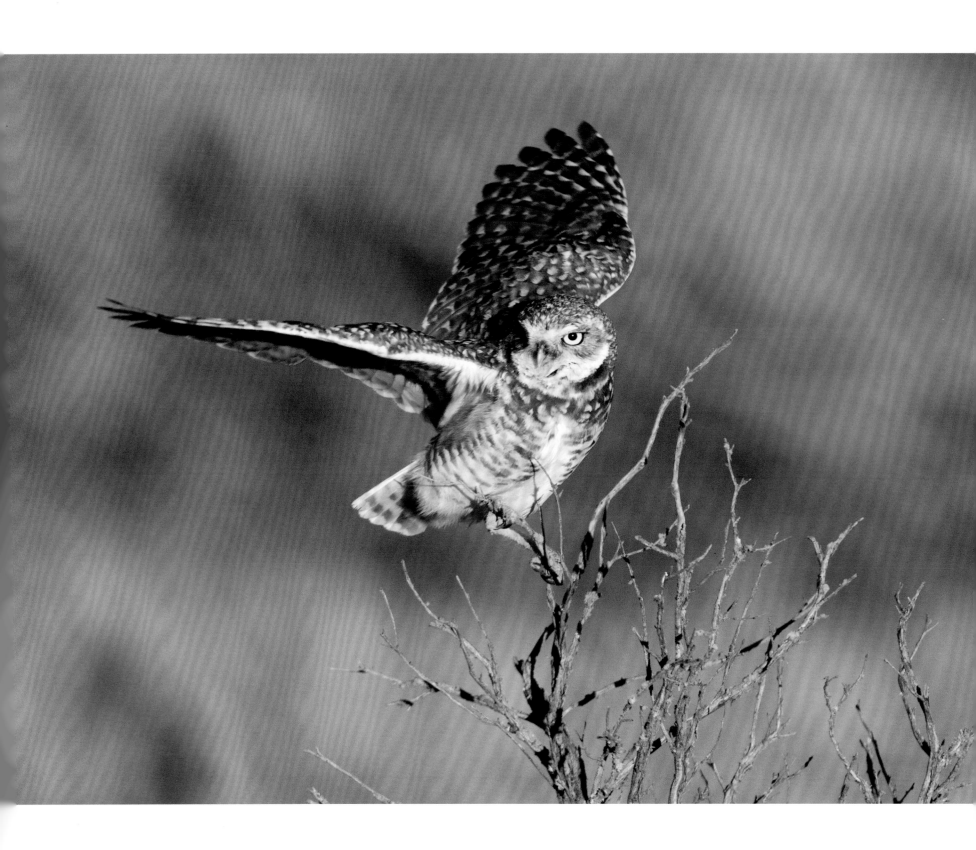

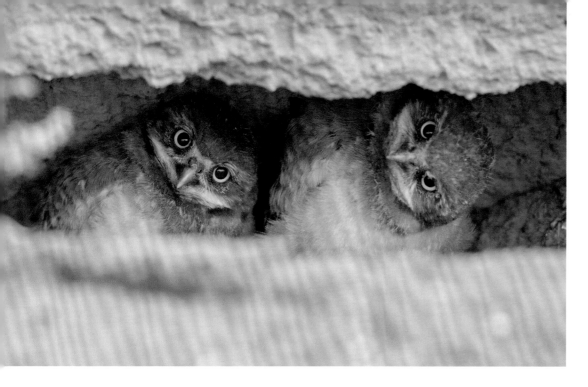

Two Burrowing Owls, roughly two weeks old, peer from their nest under an irrigation ditch.

Even though Burrowing Owls lay an egg every twenty-four to thirty-six hours, they often do not begin brooding the eggs until half are laid. So even in the largest Burrowing Owl families, the young hatch within a week of one another, adding to the spectacle of large families. By the time the owlets are old enough to move about outside the cavity, they look like clones of one another. This adds to the amusement of watching individuals in a large group interact, since they are at similar development stages and actively engage on pretty much equal terms.

Burrowing Owls are often skittish, and the mother is quick to give her chattering alarm call, sending any young owls scurrying to the safety of their burrow for some time before venturing out again. Predictably, the female owl made the alarm call as I approached the nest. I set up my blind quickly in the 95 degrees Fahrenheit sun and hoped for the best. I let the female dictate how far away to put the blind, knowing that if she were still chattering, I was too close. Now, the waiting game began. For the first hour, nothing happened. Shortly after, a small brown cap with thin white streaks rose from the shade of the burrow. For several minutes, it teetered, retreated, and came back, but never peeked out of the burrow high enough for me to see its eyes.

Finally, with a bold forward thrust, one owl leaped into view. Chocolate brown with large, bright gold eyes, the youngster was the sole animated element in the parched, static landscape. With long, slender, unfeathered legs and a plump, fluffy body, the owlet looked as though it was wearing a tutu. It stood up straight, stretched its wings and legs, and stepped forward as if onto a stage, where it was quickly joined by one, then two, then three more, until there were six little ones, heads turning in all directions like strangers at a bus stop.

Soon the female gave me the ultimate sign of trust by flying off to hunt and leaving the young alone with me. After landing on a sprinkler some forty yards away, she screamed and dove low across the road, landing talons-first

hunting during the day. This is an advantage of hunting in an open, grassy landscape with plenty of grasshoppers, beetles, and other insect prey. As with the other grassland owls, the majority of the Burrowing Owl's prey mass consists of rodents, prey that is more active on darker days and at night. Although they are believed by many to be completely diurnal, Burrowing Owls are actually active at any hour, although the peak of their activity when nesting is in early morning and early evening in both the light and the dark. This flexibility allows Burrowing Owls to adapt to available prey and makes their populations less cyclical than the populations of other owls of the grasslands and shrub-steppe.

Their nocturnal activity was highlighted one evening while I was driving in southeast Idaho. During the day, I had watched a family of young Burrowing Owls scampering at the sandy edges of their burrows. That evening, I had not planned to visit the burrows because it was too dark to take photos and the owls' diurnal peak had passed. Suddenly my headlights illuminated one tiny gargoyle-like youngster on a fencepost. Laughing to myself as I continued driving, I noticed the next post had another owlet, as did the next one, and so on. Seven consecutive posts sported diminutive skirted sentries.

PREY

Owls feed on a variety of prey ranging from small insects to large skunks and including many species of small mammals, birds, reptiles, and amphibians. *Top row:* alligator lizard, Townsend's Warbler; *Second row:* northern flying squirrel, tunnels of meadow voles after snow has melted, Willow Ptarmigan; *Third row:* Greater White-fronted Goose nestlings, montane vole.

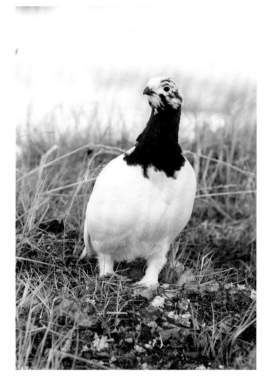

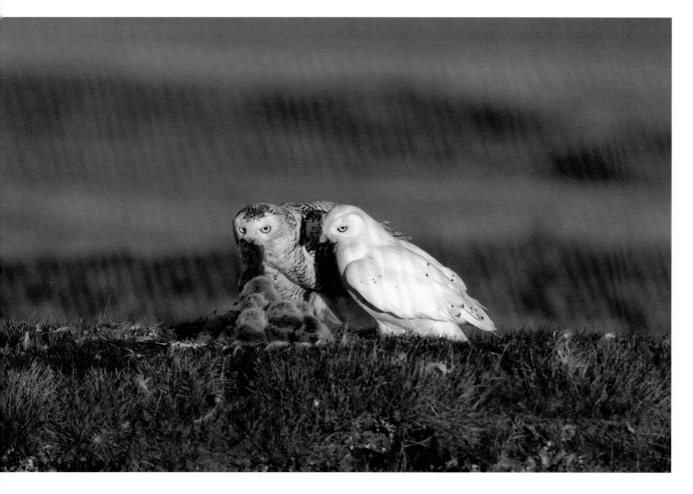

Burrowing Owl youngsters are unusual among owls in several respects. While owlets that grow up in a tree cavity are tied to that cavity until they leave the nest at three to four weeks old, owls that nest on the ground or in tunnels loosen their ties to the nest much earlier. While cavity- and platform-nesting owls are walking around their nests or moving inside their cavities at the end of the second week, Burrowing Owls are already taking forays outside their nests and even exploring adjacent nest holes and interacting at the burrows of other families. This can make it difficult to ascertain how many young belong to a particular family.

Burrowing Owls begin running, hopping, and flapping their wings at three weeks. At this time, they engage their siblings to a much greater degree than I have seen with other owlets, which seem oblivious to one another except when competing for food. Young Burrowing Owls will follow one another in and out of the burrow, jump on each other, watch a sibling take flight, and pounce on regurgitated pellets (undigested parts of prey coughed up in lump form by owls and other carnivorous birds), scraps of food, and even twigs and drag them into the burrow. Frequently they dig inside the burrow, spraying their siblings with clouds of dirt.

Much like other small owls, Burrowing Owls are able to fly weakly at their fourth week. Unlike any other owl species, Burrowing Owls fly from their natal nest frequently at this point, only to return to engage their siblings at the nest. Should a predator approach, or should their mother sound the alarm call, bring food, or encourage them to roost for the evening, they will, for now, return to their nest.

Male owls normally depart moments after delivering prey to their mate at the nest, but this time a male lingered a bit longer watching his five nestlings as they stared expectantly at their parents.

on the back of a badger, which scrambled off into a drainage culvert. Badgers provide many Burrowing Owls with homes but are also capable of digging up a nest hole and consuming all of the owls. The dangerous encounter was quickly over and the female returned to survey the fields from the pipe. She was so intent on hunting that she did not see the weasel sneaking up behind her. It was about a foot away from her and a short twelve-inch jump below her. Fortunately, she flew off to hunt before it could get any closer. Surprisingly, in my next five days at this nest location, I saw the badger only once more and I did not see the weasel again, although the winged threats, Red-tailed Hawks and Swainson's Hawks, were common visitors and elicited alarm calls and rushes into burrows.

Frenetic is the only way I can describe my visit to the arctic tundra in June 2006. Birds were singing, cackling, crying, flying, flashing, and courting in every direction. Each individual of each species was advertising its best traits during a window of time barely long enough for even the most successful to breed.

This drama was played out on an otherwise tranquil plain: A blend of warm but subtle tones of green, brown, gold, and red grasses, sedges, wildflowers, mosses, and lichens bisected by ribbons and patches of chilly blue water, all resting on the underlying permafrost and abutting the Arctic Ocean. Each step was an adventure, as I tried to determine whether my feet would squish several inches into the spongy wet tundra until gaining a foothold, or continue sinking until the water was at my hips and my feet met slick permafrost. As I made my way, there was

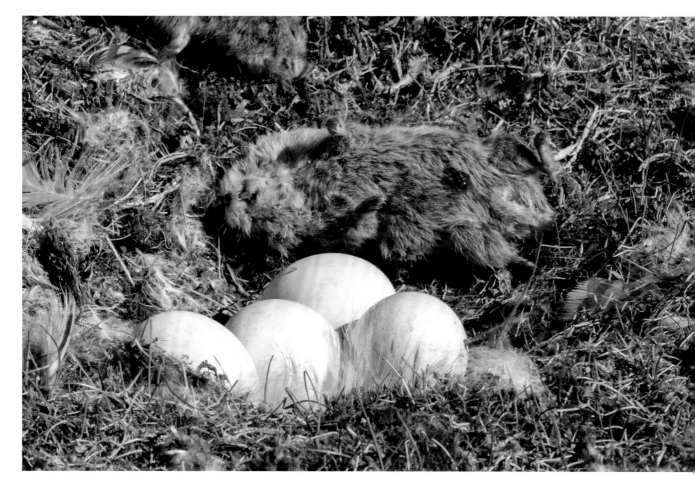

no warm air to ease the chill of water on my legs. Even summers are cold here, with the warmest days on Alaska's North Slope averaging 36 to 47 degrees Fahrenheit.

After pulling my feet from the wet sod and stepping up onto drier turf, I immediately saw the lemmings. Brown lemmings seemed to be everywhere, running in the open between their tunnels. I was even able to reach down and capture one. Brown lemmings are, in my opinion, one of the most appealing rodents; they look like little teddy bears. They are also one of the most important animals in the arctic tundra ecosystem, particularly in the arctic coastal areas of Alaska and Canada where Snowy Owls nest.

The plethora of lemmings that year had resulted in one of the largest concentrations of nesting jaegers and Snowy

Owls in years. Lemming populations experience unpredictable booms and busts, often with predictable success or failure for arctic foxes, Sandhill Cranes, falcons, jaegers, Snowy Owls, and the many other animals on the arctic tundra that prey upon them. In fact, 2006 was one of the best breeding years for Snowy Owls on the North Slope since my host, the Owl Research Institute, began studying them in 1992. Many years, no Snowy Owls nested in their one-hundred-square-mile study area, and in other years, they found only a few; but more than thirty nests were found in that particularly successful year.

Snowy Owls usually hunt within view of their nests in areas where lemmings are found. This characteristic can take them to coastlines, rivers, lakes, ponds, or to other

To encourage his mate to continue laying eggs, a male Snowy Owl brings her as many lemmings as he can; she stockpiles them at the nest.

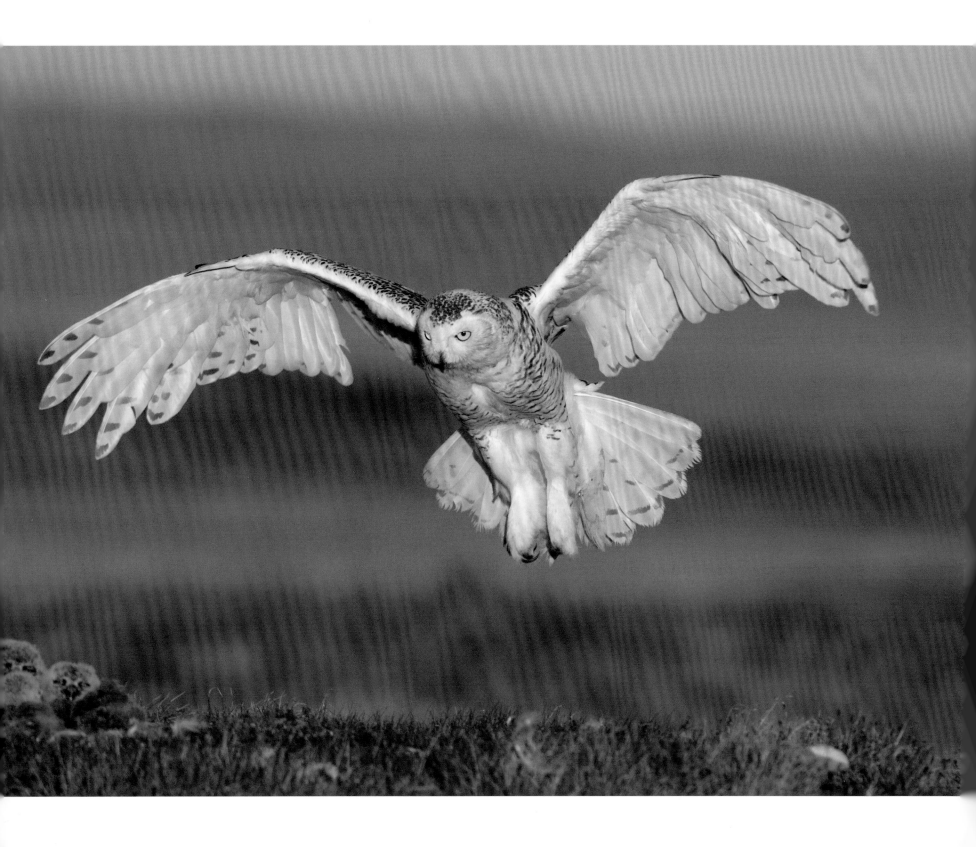

tundra mounds where lemmings might have their nests. Snowy Owl males catch as many lemmings as they can, regardless of the demands of the female. Extra lemmings are often stockpiled at the Snowy's nest and enable, and perhaps encourage, the female to lay more eggs. As I assisted a researcher at nests in the study area, I saw that a few held four to five eggs in the center and at least that many lemmings stockpiled around the edges.

Females usually lay three to five eggs, but their clutches can be anywhere from one to fourteen. With the boom in lemmings, the Snowy Owls were having huge clutches. Many of the nests we visited contained five to seven youngsters, and some even had more. The nests were occupied by a far greater variety of ages and sizes than I had seen in any bird, let alone any owl.

Snowy Owl females begin incubating as soon as they lay their first egg, and there are normally at least forty hours between eggs. As a result, some nests that we looked at held small, white owlets of less than a week old, with their eyes still closed, squished against birds that were a week to two weeks old, with the oldest many times larger and darker. It was easy to imagine some particularly large broods having eggs hatching at the same time as older siblings were preparing to leave the nest for good. Given that lemming crashes can happen within a breeding season, this range of ages improves the chance that some owlets will live and survive during a time of plentiful lemmings.

While lemmings drive the Snowy Owl's nesting success, particularly brown lemmings on Alaska's North Slope, this owl will eat other prey when lemmings are in short supply. Snowy Owls are opportunistic hunters during the nesting season and will take shorebirds and even passerines (perching birds) on the wing. They have been observed bringing in prey as small as Lapland Longspurs and as large as Eider Ducks. Snowy Owls have also been known to prey on ptarmigan, Short-eared Owls, and even carrion, including dead animals pulled from traps.

As with other large owls, the Snowy Owl female delivers almost all of the food to the nestlings. The vigilant female sees the smaller male long before he arrives at the nest and lets out a call that sounds like half-whistling and half-begging. The call intensifies as the male comes nearer. Occasionally, particularly if the female is forced by hunger to hunt, the male will arrive when she is not with the youngsters. In these instances, the male seems ill prepared, walking toward the begging youngsters and swinging the lemming back and forth. The young try to follow the prey with their heads but are unable to grab it. The female, upon seeing the male at the nest, emits a more desperate scream-whistle. She then flies aggressively toward the male and rips the prey from his bill before successfully delivering the lemming to the nestlings.

While arctic foxes, wolverines, wolves, and perhaps even polar bears harass Snowy Owls from time to time, Pomarine Jaegers were the only aggressors I witnessed. On most occasions, the jaegers attempted to steal food from the female Snowy Owl as she returned to feed her young. Often, she flew away from the nest after catching food or accepting food from the male, only to come under attack from a jaeger. She had to drop the lemming so that she could somersault upside down and have her talons facing the threat. The jaeger or its mate then grabbed the lemming while the Snowy Owl was coming back to the ground, and the young owls lost an opportunity to eat.

Even though the arctic tundra experiences twenty-four hours of light during most of the Snowy Owl breeding season, the owls do the majority of their hunting during the evening hours. Snowy Owls can spot prey from a mile away and use their keen vision to scan the landscape either from an elevated perch or the tundra. They also hover over potential prey with hearing that is sensitive enough to allow them to track and capture prey moving beneath eight inches of snow.

I returned to Alaska's North Slope in 2014, and it looked like it might be another good lemming year, with

{ opposite } As she returns to her nest and young, a female Snowy Owl's brood patch, the temporarily defeathered area of her stomach used to warm her eggs and young, is visible.

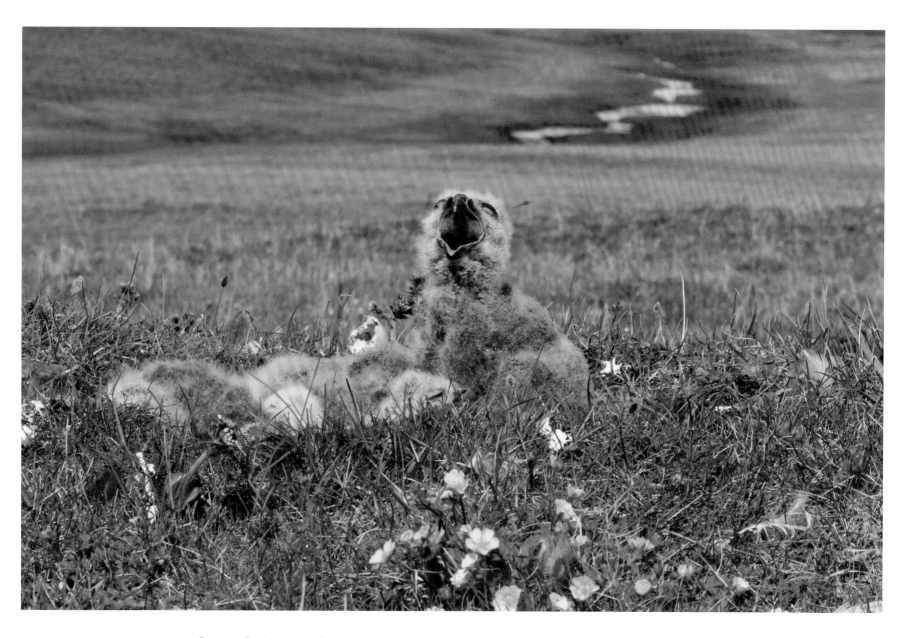

A hungry Snowy Owl nestling begs to be fed while its siblings duck behind the shielding lip of the scrape to get out of the Arctic wind.

Snowy Owls successfully establishing a large number of nests. But unfortunately, the year turned out to be heart-breaking. The initial high populations of lemmings meant that many Snowy Owl males had successfully courted and established nests with plenty of eggs. As eggs began to hatch, however, things changed. For reasons that are still poorly understood, lemming populations began to drop. I watched solemnly as one female's wavering, high-pitched cry pierced the eerie stillness of the tundra. She frequently begged from the nest and endured several hours at a time with no prey delivery. The normally incessant loud begging of nestlings became weaker and feebler by the day. Usually the female stays and broods nestlings as young as hers were, since they are too young to keep themselves warm, but this mother left them alone, shivering on the nest, as she attempted to find food. Making matters worse, a Pomarine

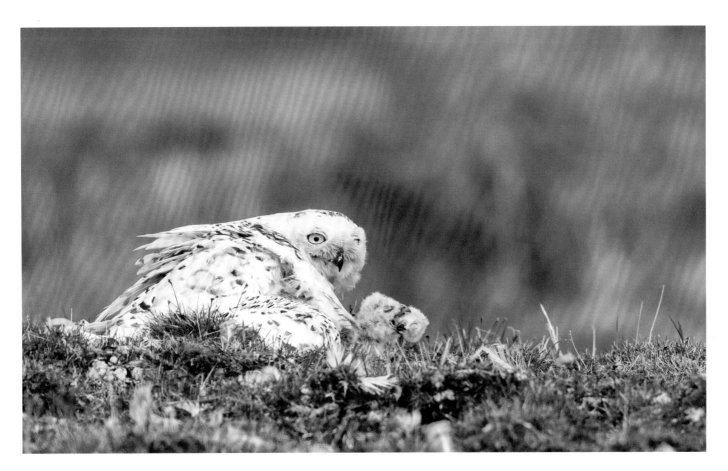

Jaeger, normally driven away from the young by a fierce, well-fed female, flew to the nest while the female was hunting, grabbed a nestling, and carried it a few feet from the nest before dropping it as the female finally returned.

During most successful years, both jaegers and Snowy Owls hunt lemmings and limit their conflicts to fights over catches, but this time it was clear that the jaegers, also stressed by the low lemming numbers, were willing to take more risks. On one occasion, two jaegers attacked the nest, but neither came away with any young. On another day, I watched the female owl attempt to consume what looked to me like a jaeger wing, a less than ideal food item with very little meat, but this was a desperate time.

The lack of food finally accomplished what jaegers could not. In a scene played out in other places in the area that year, two of the four nestlings starved. The distant location of my blind prevented me from knowing this until I tried to identify the prey the female was feeding to her nestlings. It was clearly the head of the youngest, which appeared in the bill of the mother and was handed to and quickly dispatched by the oldest nestling. The second youngest was consumed in a similar fashion.

Whenever winds hit the nest hard, the female moved the young to the downwind side of the nest mound. After the winds subsided, the family moved back into the nest. Owl researcher Denver Holt observed that Snowy Owls sometimes dig alternate nest scrapes nearby but lower than the primary nest just for this purpose. This maneuver and the loss of competition from more nestlings were probably two factors that contributed to the two larger nestlings eventually succeeding in walking off the nest and onto the tundra to begin the next stage of their lives.

A nestling Snowy Owl feeds upon the head of a sibling.

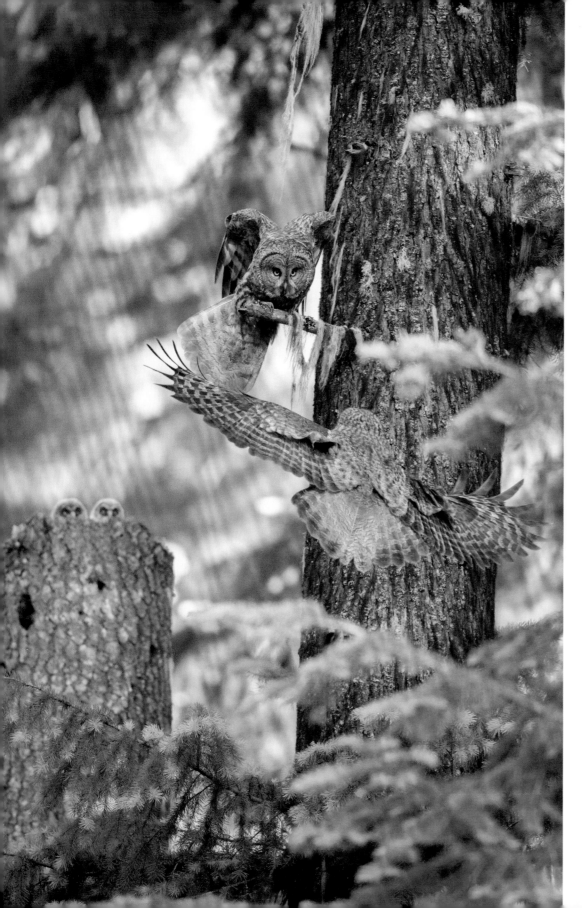

A female Great Gray Owl flaps her wings in anticipation of receiving prey from her mate while two owlets look on from the nest.

{ opposite } A female Great Gray Owl and her two-week-old nestlings are sunk into the rotted cavity of a treetop nest, difficult to see behind the rim of the cavity from the ground forty-five feet below.

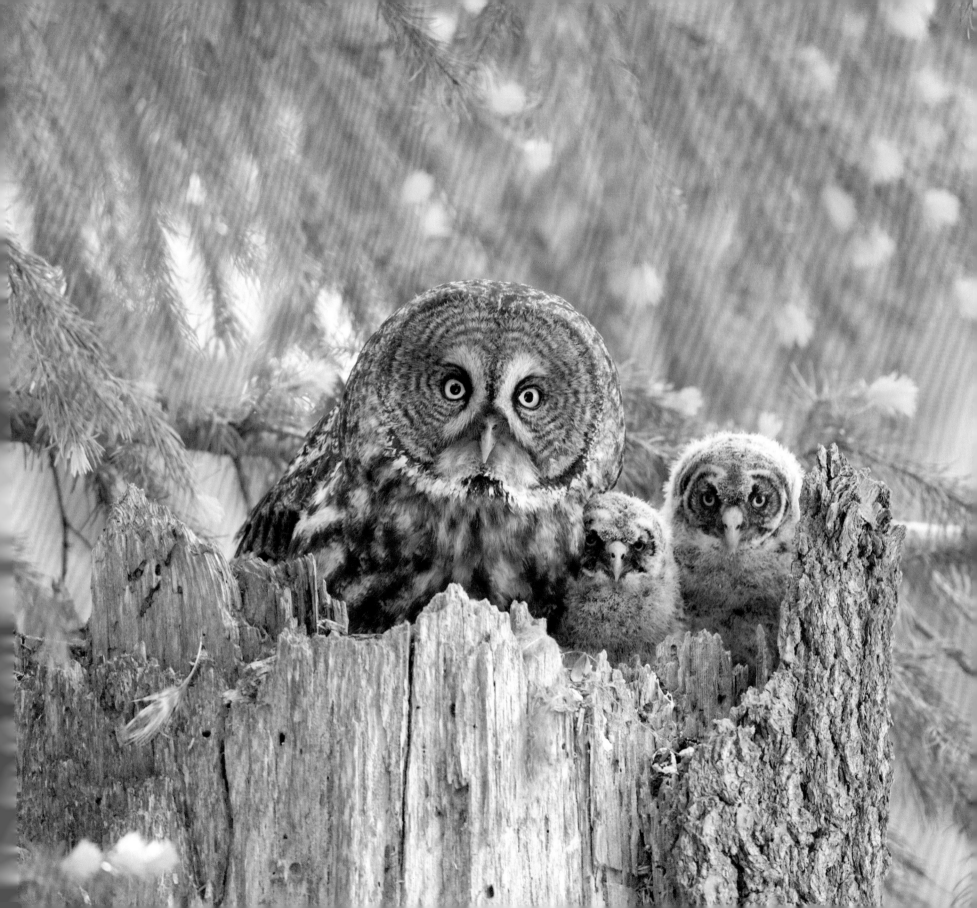

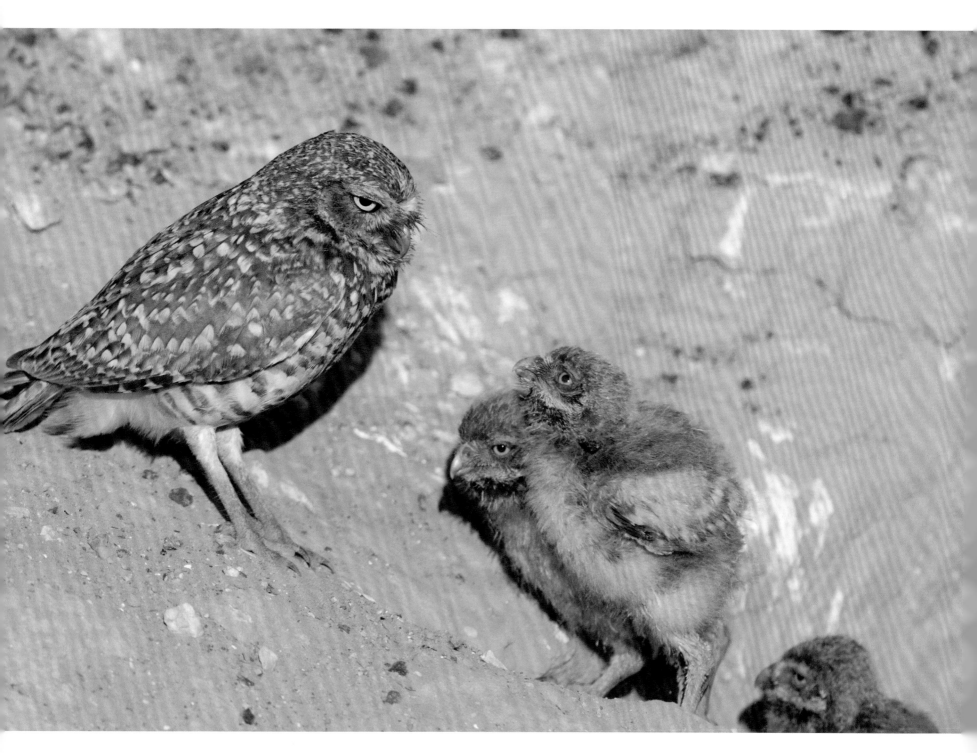

A female Burrowing Owl encourages her owlets, just over a week old, to explore outside their burrow. Young nestlings can be identified by the fine white feathers streaking their heads.

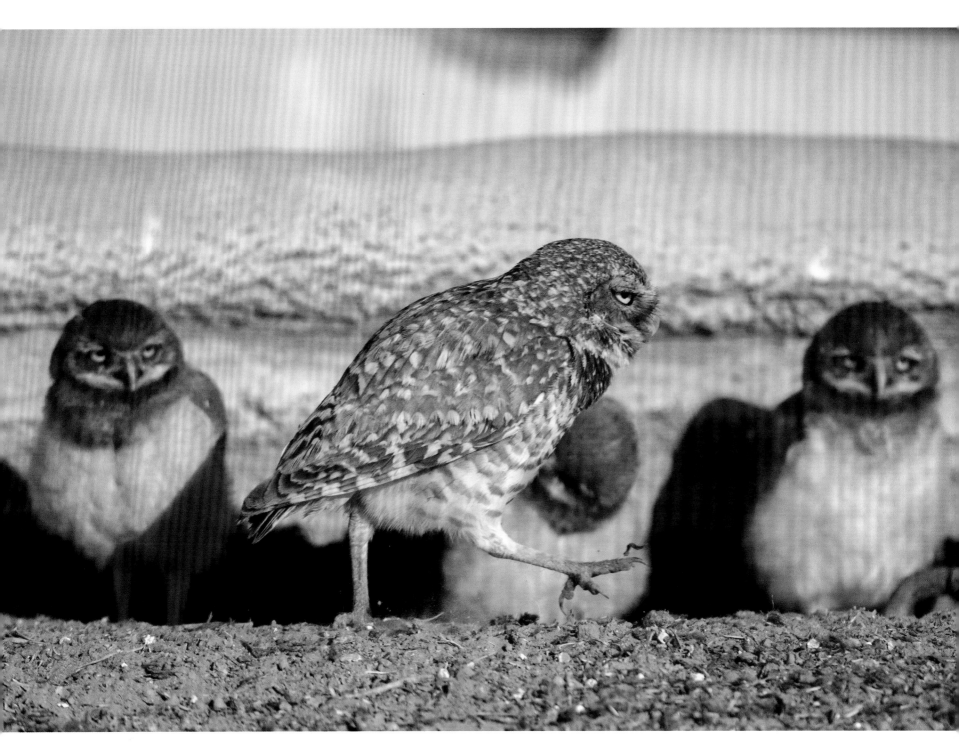

A female Burrowing Owl appears to march in front of her youngsters who wait at the entrance to their nest beneath a concrete irrigation ditch. The female maintains constant vigilance over her young to ensure their safety.

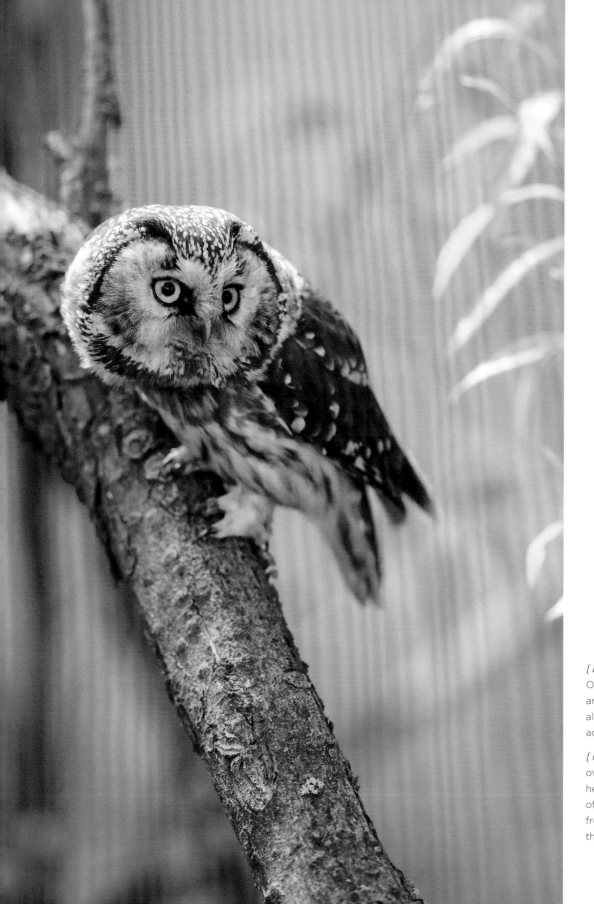

{ left } Owls like this Boreal Owl can manipulate the ruff around their facial disk to allow them to listen more accurately for sounds of prey.

{ right } In common with other owls that hunt using their hearing, Great Gray Owls often listen for their prey from very low perches, like this lodgepole pine sapling.

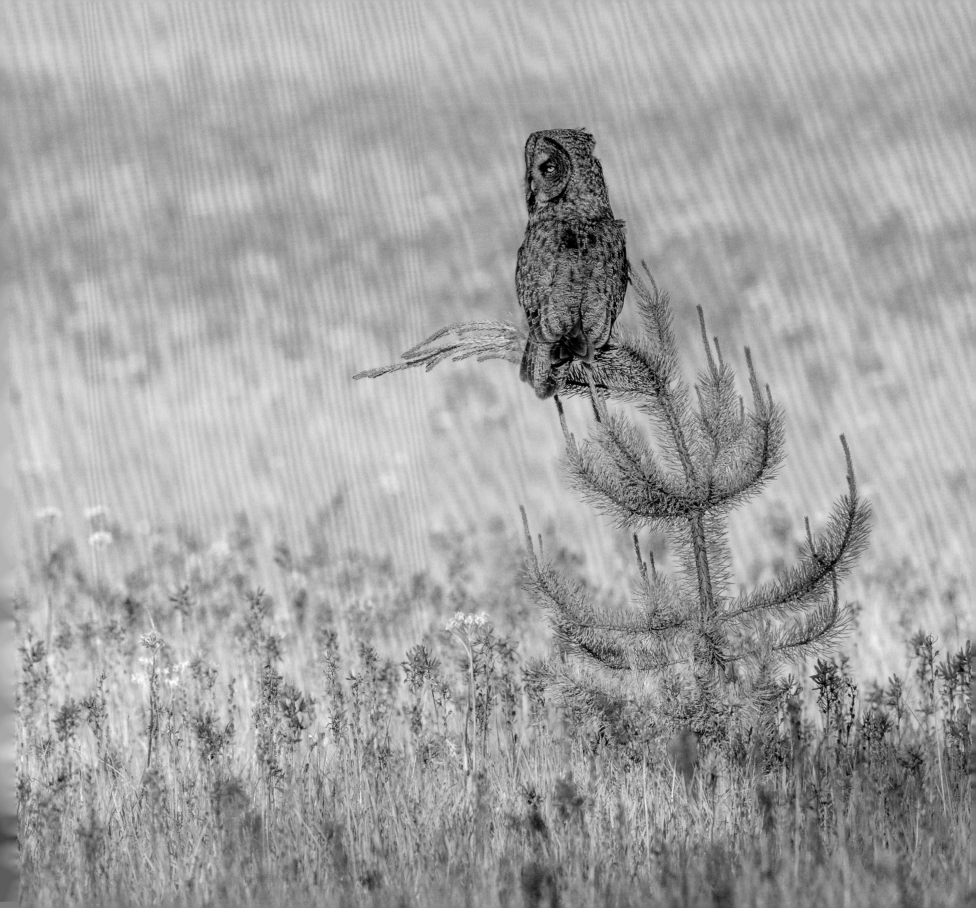

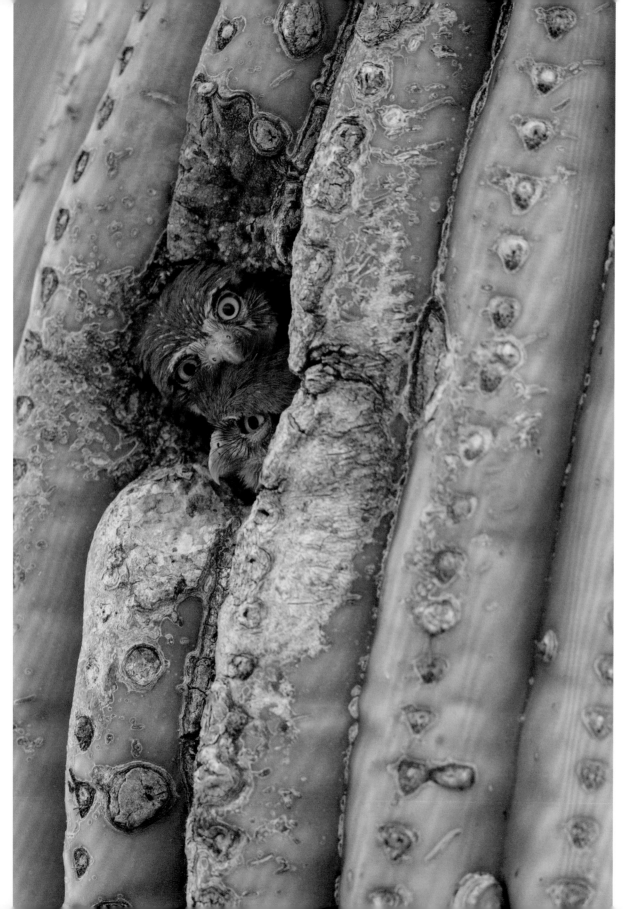

Two rare Cactus Ferruginous Pygmy-Owls struggle for premium positioning at the cavity entrance, as each strives to be the first to receive food when a parent arrives.

{ opposite } The smallest owl in the world, Elf Owls like this one prefer to nest in the smaller cavities created by Gila Woodpeckers but will also use those created by Gilded Flickers in the desert and Acorn Woodpeckers at higher elevations.

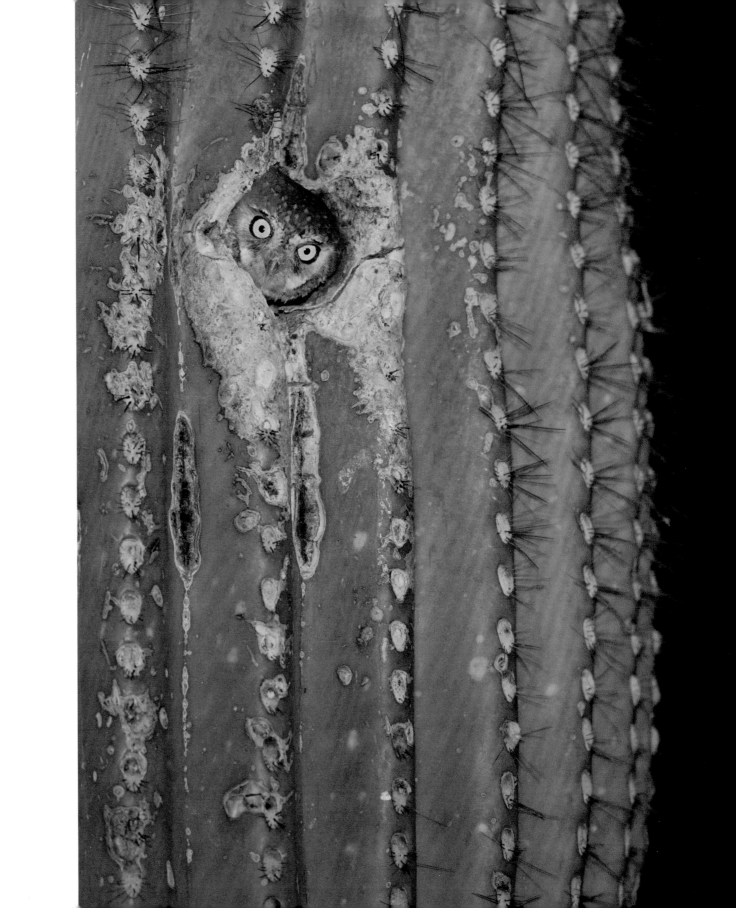

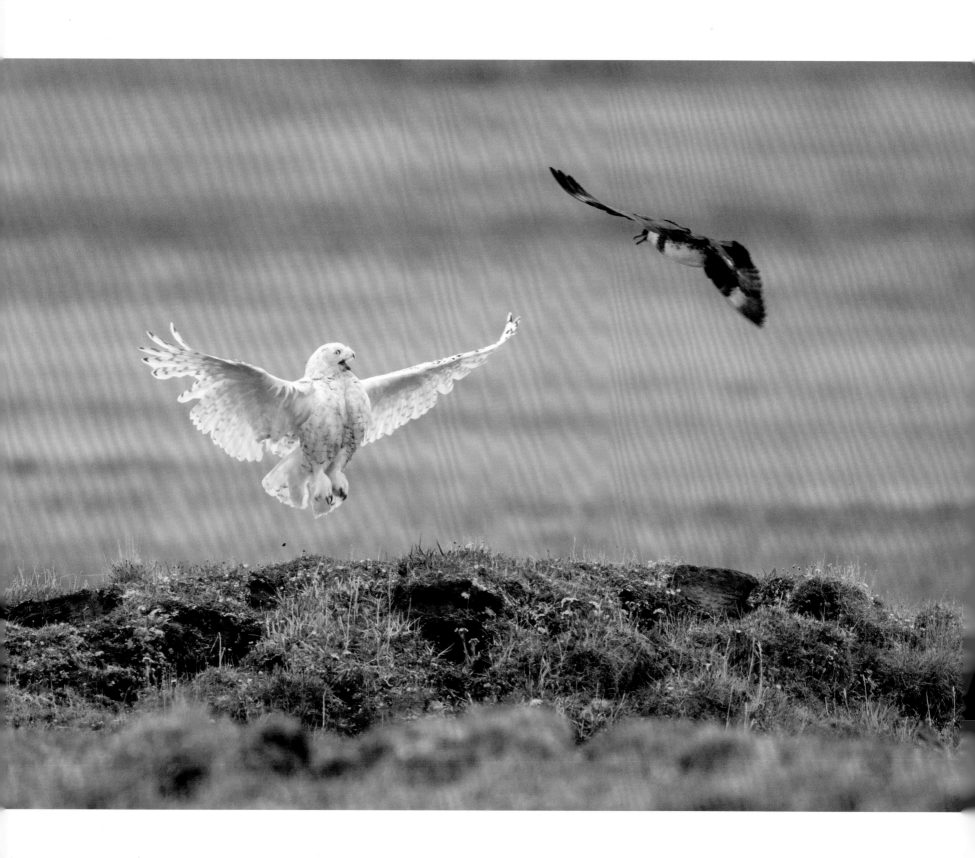

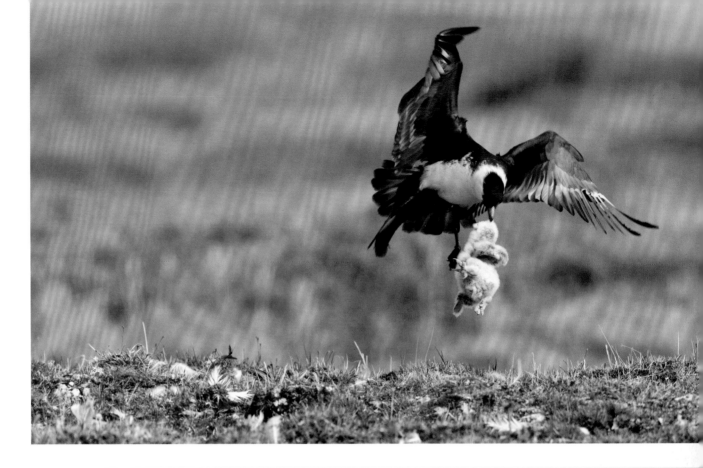

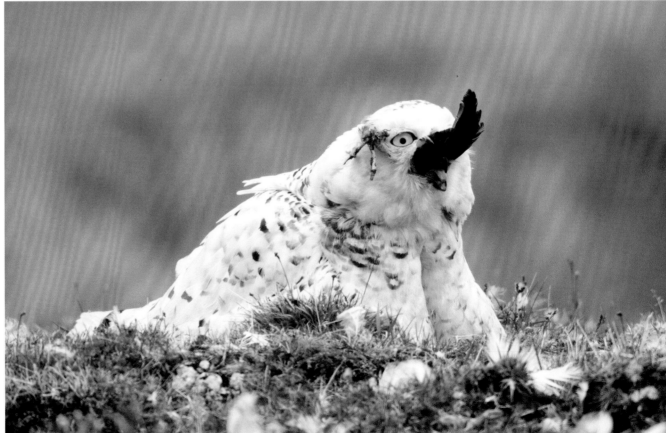

{ *top* } A Pomarine Jaeger attempts to carry a Snowy Owl nestling away from the nest.

{ *bottom* } A hungry Snowy Owl struggles to swallow the bones and wings of a jaeger.

{ *opposite* } A Pomarine Jaeger attacks a Snowy Owl near her nest on the Arctic tundra.

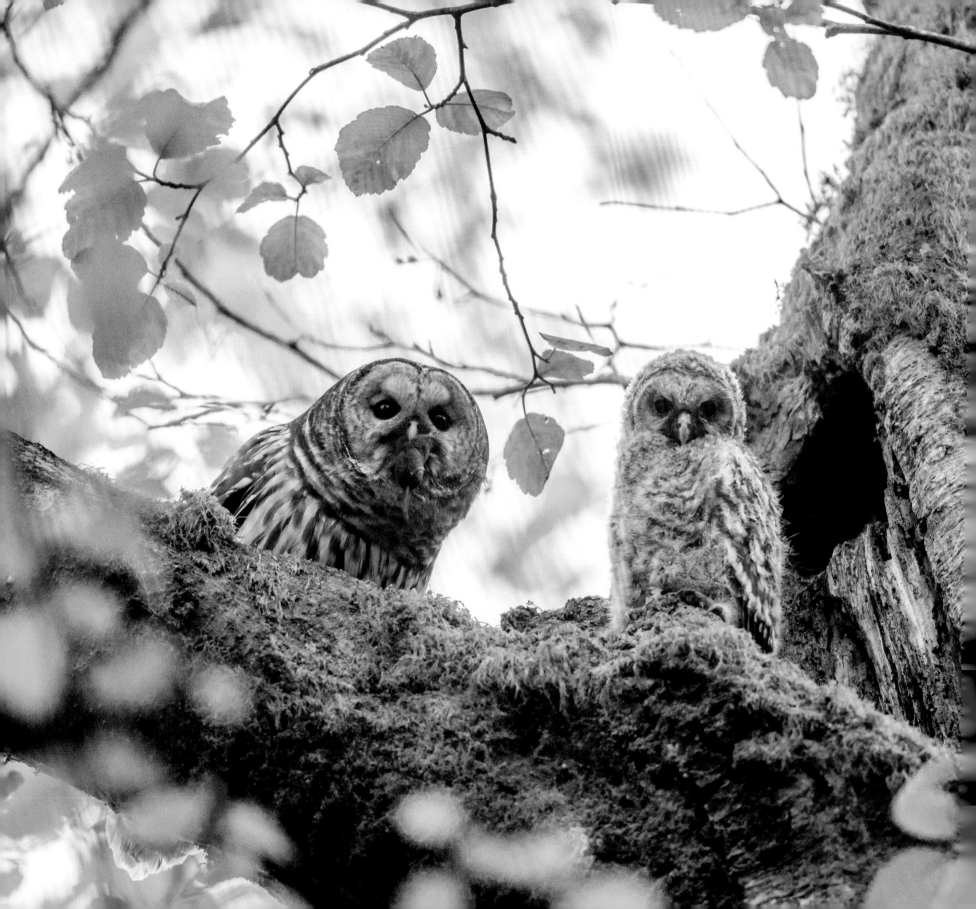

After they're about two weeks of age, young owls, such as these Northern Hawk Owls, have seemingly insatiable appetites, putting great pressure on their parents.

{ opposite } Larger forest owls, like Barred Owls, leave the nest at around four weeks after hatching. The owls then spend time on adjacent limbs, a process known as "branching."

{ page 104, left } A Northern Saw-whet Owl prepares to deliver a mouse to young waiting inside the nest cavity.

{ page 104, right } A nestling Northern Saw-whet Owl peers from its nest cavity a few hours before leaving for good. Nesting owls choose cavities with small entrances, leaving no room for a predator to reach in with talon, bill, or claw.

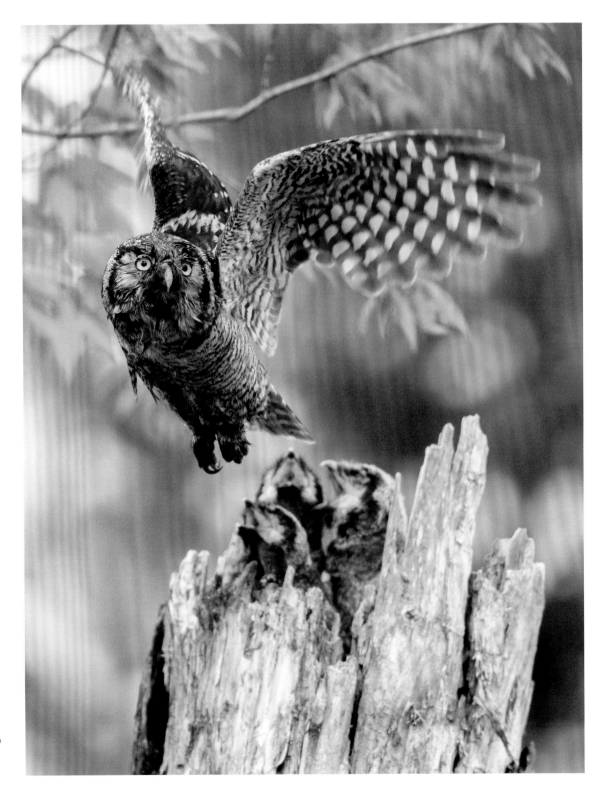

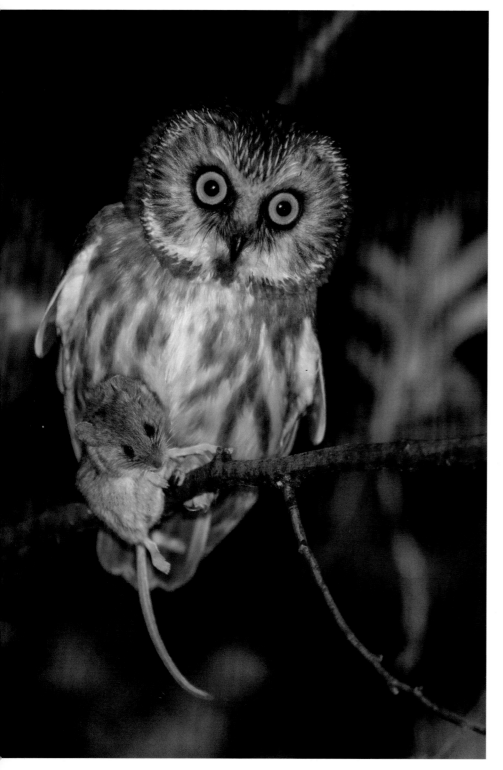
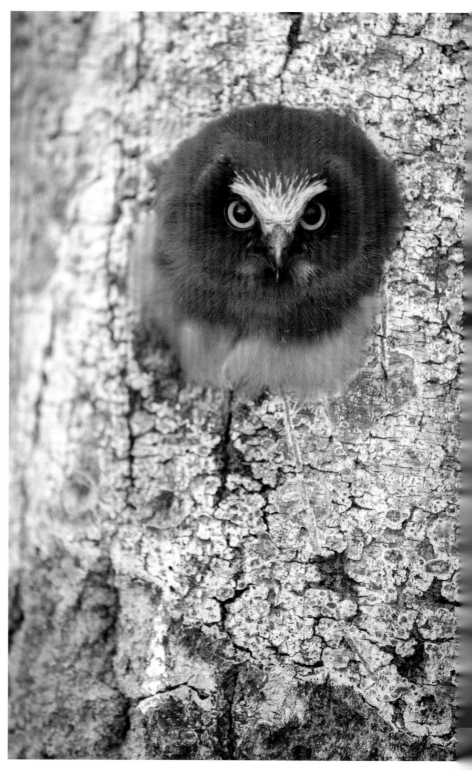

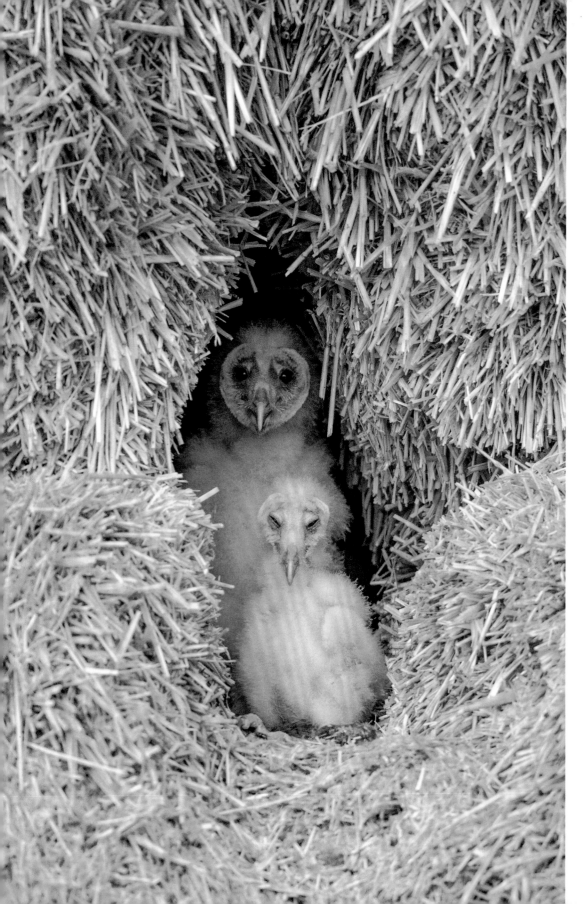

{ *left* } Two Barn Owl nestlings peer from a cavity between several straw bales on agricultural land in Idaho.

{ *right* } Nest cavities are often scarce, forcing this family of Barn Owls to choose a cave used by their main predator, the Great Horned Owl, several years in a row.

{ *page 105, left* } Woodpecker-created cavities, like this Screech-Owl nest originally excavated by Northern Flickers, are often quite spacious inside and offer a great deal of traction for young owls to utilize when scaling the walls to either peer out or leave the nest.

{ *page 105, right* } The gray morph of the Whiskered Screech-Owl found in the Southwest looks almost identical to the gray morph of the Western Screech-Owl, save for its smaller size and long thin extensions to its facial disk feathers; it is most easily distinguished, however, by its distinctive call.

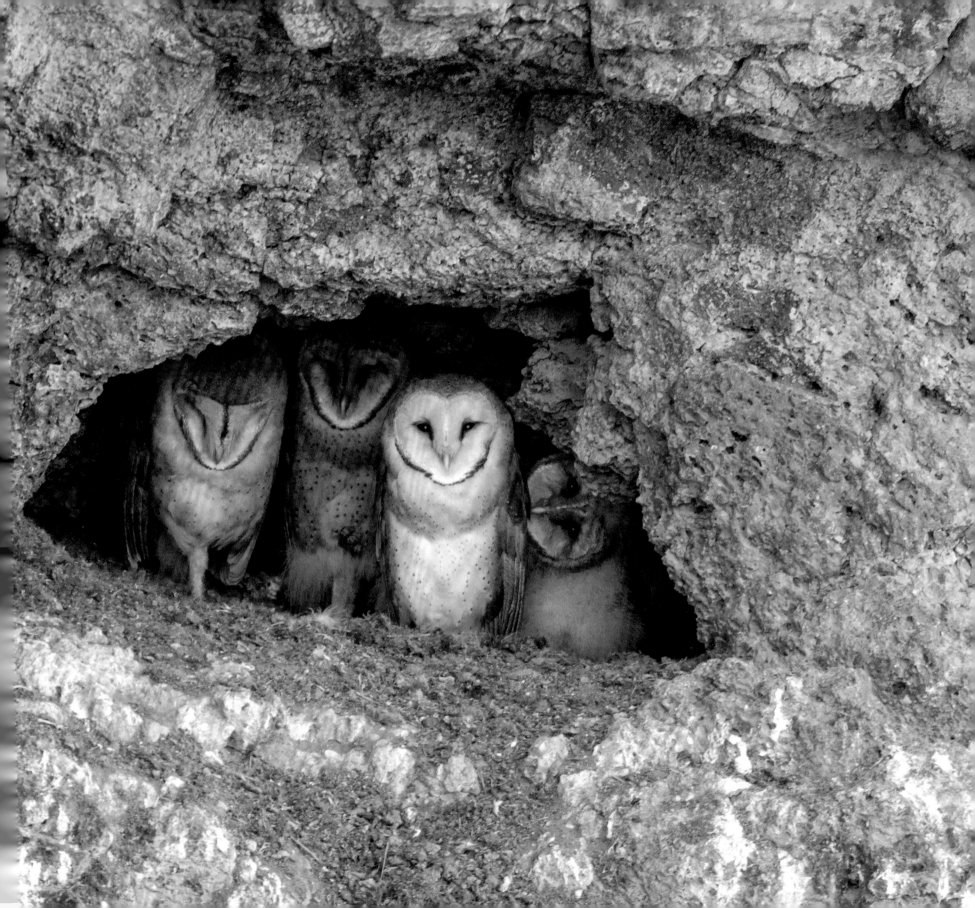

A Great Horned Owl keeps
a watchful eye on her young
who are in a nearby cave.

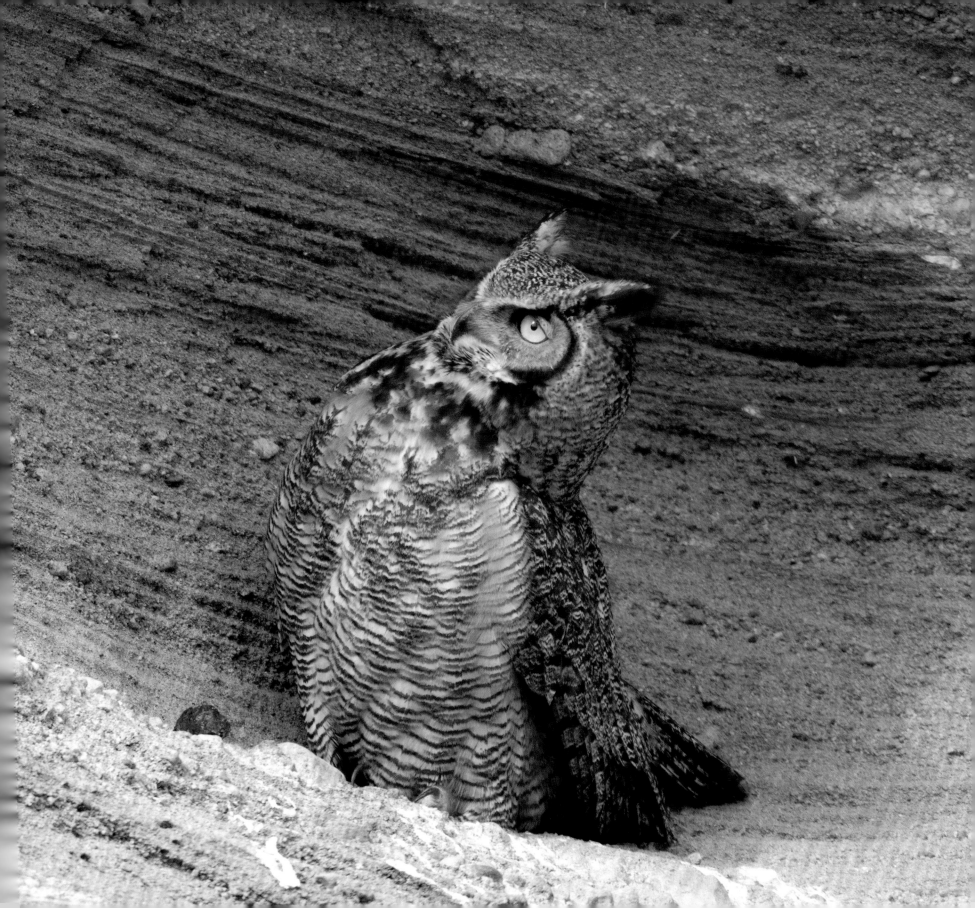

GAINING INDEPENDENCE

Young owls must learn to fly, hunt, and become independent before winter, but they must first leave the protection of the nest. Each owl's habitat at this vulnerable juncture must enable them to leave without injury, remain hidden, and move out of the reach of predators as they build their strength and survival skills.

As nestlings grow, the begging calls and the scent of decaying food and waste make the nest more obvious and vulnerable, which can attract the attention of predators. There is a tenuous trade-off between the risks of the owls staying in the nest too long, and therefore being discovered by predators, versus leaving too early, before they can survive on their own. Owls that nest in woodpecker cavities or other natural cavities on the faces of tree trunks and cacti are most secure, and they often leave at about four weeks old, when they can, or are very close to being able to, fly. Owls that nest on the ground leave the earliest, between two and three weeks old. Platform nesters are often high off the ground, but they are often visible from the air and sometimes from the ground, so they normally leave at three to five weeks, when they can glide or at least have some buoyancy to their fall. Quite simply put, young owls leave at the time that is generally safest.

I refer to this step in the process of gaining independence as "leaving the nest" rather than "fledging." Fledging is considered by many to be the moment when the young bird gains flight,

A juvenile Long-eared Owl spreads its wings in order to look more formidable to potential predators.

HEARING AND HUNTING

Owls possess extremely sensitive hearing, with some species able to locate prey through hearing alone. Owls hear mostly in the same sound range we do, but they can hear in the upper frequencies (3 to 10 kHz), beyond our capability, which aids them in detecting high-frequency noises made by prey.

The openings to an owl's ears are two elongated half disk–shaped openings on either side of the head, hidden by feathers. Owls are able to manipulate their facial disk, the concave arrangement of feathers around the face, to funnel sound to those ear openings, which lead to often offset ear canals. Human ears are on the same plane, allowing us to turn our head in response to sound and figure out the direction of a noise on the horizontal plane. By having ears on a different horizontal plane, owls can better locate the particular vertical and horizontal location of sound and prey, a necessary asset when trying to capture prey hidden by snow or ground cover. Ear asymmetry varies by species and, when present, is most extreme in species that rely more on hearing than vision to hunt.

Several owl species, including many of the most easily recognized, possess very distinctive ear tufts, which rise on the head like the ears of a mammal but, surprisingly, have no relationship to hearing. The "tufts" are feathers that can be controlled by muscles, allowing the owl to raise or depress them. These tufts, displayed by Great Horned Owls, Long-eared Owls, Western Screech-Owls, Eastern Screech-Owls, Whiskered Screech-Owls, Flammulated Owls, Short-eared Owls, and, to a lesser extent, Snowy Owls, may be valuable parts of an owl's camouflage. Northern Pygmy-Owls lack true ear tufts but can raise the corners of their facial disk to achieve a similar effect. All owls attempt to blend into their environment when they are afraid, and they tend to close or squint their eyes, elongate their body, and either raise their ear tufts, contort their facial disk, partially raise a wing in front of them, or try to otherwise break up the distinctive shape of their head and bodies.

{ *left* } An owl's ears are openings on the sides of the skull, hidden beneath the feathers of its facial disk. On occasion (as with this Barred Owl) the feathers part, creating a temporary gap in the feathers where the opening to the actual ear canal begins.

{ *right* } Ear tufts, like the ones found on this Long-eared Owl, as well as on Great Horned Owls, Flammulated Owls, and all three species of Screech-Owls, serve no purpose in hearing but rather are believed to help break up the owl's shape, allowing it to more easily blend into its environment..

and some owls are still several weeks from flying when they leave the nest.

Owls leave their nest in many different ways, depending on the type of nest. For instance, young Short-eared Owls that nest on the ground walk away from the nest, one at a time. I have watched young Great Horned Owls leave their different types of nest in three different ways: nestlings in a cave above a river climbed the sandy wall behind the nest to the sage-steppe above; nestlings in a hawk nest in a maple walked onto surrounding branches in a process called "branching"; and nestlings on top of a snag jumped from the nest. No matter the method, each owl will continue moving farther away from the nest either by walking, jumping, or fluttering to adjacent branches, waddling on the ground, climbing trees, hiding in tunnels, or some combination of these.

Nests located high in broken-topped snags or in woodpecker cavities in cacti are perhaps most secure from predators, but when it comes time to leave, young owls must make the jump or make their first flight, with the inherent risks.

One morning just before sunrise in northern Minnesota, I witnessed four young Northern Hawk Owls leave their nest on the broken top of a poplar snag. One by one, the owls flapped their wings, looked down toward the ground, stretched, and without warning, jumped and fluttered from the cavity. For each, the jump was a combination of falling and flapping. All four owlets made it at least to the flying stage by the time they left the area with their parents.

Each species pursues the same objective: to move away from the immediate vicinity of the nest. Parents will try to lure their young to areas with an abundance of prey and shelter. I once observed four Cactus Ferruginous Pygmy-Owls leave their nest in southern Arizona. All owlets left the nest within a two-hour period on the same evening. The youngsters surprised me a few hours later when they fledged, one at a time, in response to the calls of their mother, who led them into the safety of a dense, thorny thicket of mesquite.

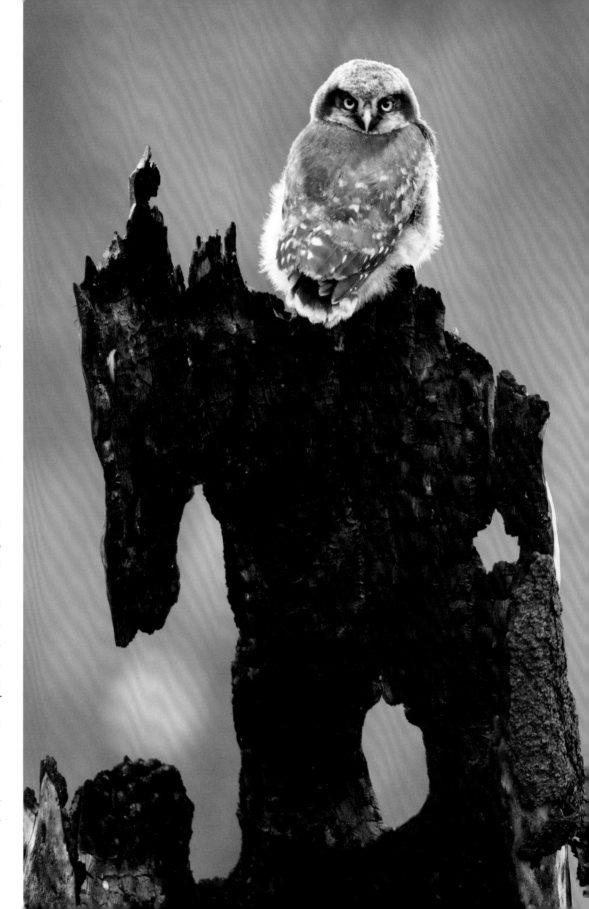

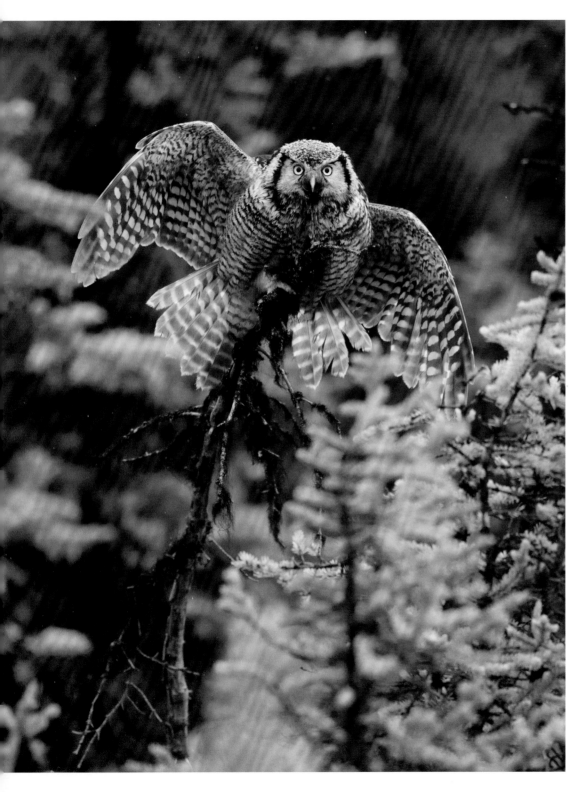

By comparison, Northern Hawk Owls are not able to fly horizontally until about thirty days after hatching, which is still relatively fast for a large owl and as much as two weeks shorter than Great Horned Owls in the same habitat. Flying allows owls to avoid risky falls, move quickly away from the nest area, and stay out of reach of predators.

Many owls fall from the nest to the ground where they become extremely vulnerable to predators like coyotes and foxes. Most owlets lift their torso and make a bow-legged waddle toward a tree or snag, using instinct to determine which to climb. For young, weak, inexperienced owls, vertical trees are too difficult to climb, making leaning trees, stumps, and snags essential if the owls are to advance to the next stage of their lives and gain independence from their parents. They walk up the trunk of a leaning tree using their beak, talons, and vigorous flapping to gain altitude and safety from ground predators.

Adult owls shift their behavior shortly after the young leave the nest. In many species, the male begins to feed the young directly and protect them, while the female of some species starts to lose interest in the family and sometimes disappears for long periods of time.

The parents are aware of the vulnerability of the young, even when the youngsters themselves are not. During mid-June one year in central Alaska's boreal forest, I found a group of seven young Northern Hawk Owls being looked after by an adult. The young owls were about six weeks old and able to fly quite well. As I approached, the youngsters paid little attention to me while the adult immediately tried to lure me away from the young. After I ignored his efforts, the male flew to a short black spruce tree, pressed his body against it, and flailed his wings as he screamed. He climbed the tree in this manner, and reaching the top, flapped his wings vigorously atop the tree, while continuing to scream until I moved toward him and away from the owlets, at which point he flew a short distance, attempting to get me to follow.

While the parents hunt, owls of most species guide the young into habitat that allows them to find safety close to

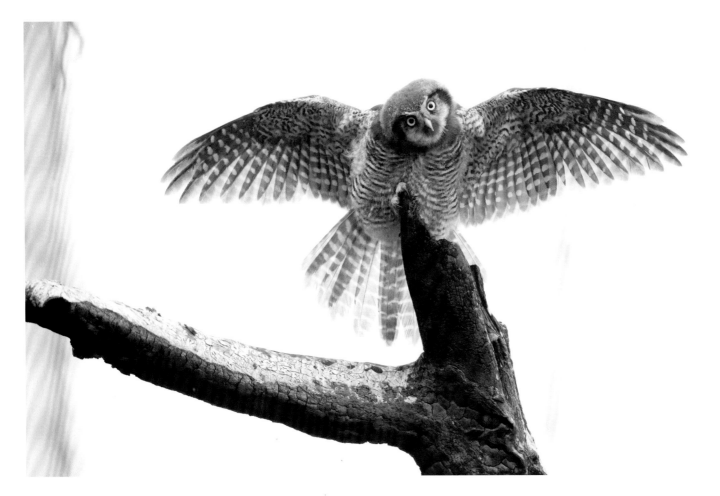

A juvenile Northern Hawk Owl holds out its wings to dry them after a rain. When they are roughly three months old and near independence, juveniles look much like adults. They are, however, darker in color overall with less contrast between the dark and light colors and their head appears smaller than that of an adult and lacks spotting.

{ opposite } A Northern Hawk Owl flails its wings and calls out in a distraction display meant to lure predators away from its young.

{ page 113 } A fledgling Northern Hawk Owl settles in for the night atop a burned snag. Young Northern Hawk Owls must quickly learn to climb snags or leaning trees in order to get off the ground and avoid predators. They are dependent upon uncut mature burned forests.

where the adults can find abundant prey, until the young are able to fly. For many species it is important to get away from the immediate area of the nest, since the concentration of odors, noise, and activity from the previous weeks likely attracted potential predators. For Short-eared Owls, Snowy Owls, and Burrowing Owls that may mean taller vegetation, more irregular ground, or more burrows respectively, but for most other species, it is habitat with leaning trees and snags and denser branch cover.

Parents provide food less frequently to their young when they can hunt on their own. Very little research has been done on how owls learn to hunt, but it is widely believed that it is mostly instinctual, perhaps aided by what they learn while playing in the nest. The fact that Elf Owls

are able to capture crickets almost immediately after fledging reinforces that assumption.

The larger the owl species, the longer it takes the owlets to look like adults. During late July, in the mountains of southern Idaho, I watched Northern Hawk Owl youngsters that were two to three months old and within a few weeks of independence. They could fly freely and called like adults, but they still did not look like their parents. Their small, fluffy heads fit awkwardly with their adult-like tail and wings, as incongruous as boys wearing their father's oversized suit. By contrast, smaller owls like Pygmy-Owls, Screech-Owls, and Elf Owls look almost exactly like adults by the time they are independent, which occurs in half as much time.

WESTERN MOUNTAIN MEADOWS

Large mountain meadows adjacent to mature conifer forests are a critical component of Great Gray Owl habitat in the western mountains. These meadows, which are normally within eight hundred yards of their nests, provide prime habitat for the voles and pocket gophers that together comprise the vast majority of the Great Gray Owl's diet in the western states. In North America, voles may comprise as much as 80 percent of the Great Gray Owl diet, but vole populations are cyclical, forcing many birds to move to places with more food or perish when numbers are low. With pocket gophers as a food alternative, and in some cases the majority of their diet, western Great Gray Owls are able have more stable and less migratory populations.

The species of voles and pocket gophers favored by Great Gray Owls are most common in open habitats like meadows. Voles, especially the meadow vole preferred by the Great Gray Owl, prefer wetter areas where they find cover in taller vegetation, while pocket gophers tend to be found in drier areas where they rarely appear aboveground, often requiring the Great Gray Owl to break through their earthen tunnels with clenched feet to catch them. Both rodents create underground tunnels, which play an important role in meadow ecology by aerating and retaining moisture in the soil, and their feces add nutrients to the soil. These functions help maintain healthy mountain meadows and assist in their survival during droughts and their recovery after fire. Irregular edges, with extensions into the open areas, lined with snags or other perches, give the Great Gray Owl, an auditory hunter, access to otherwise unhuntable stretches of these meadows.

Meadows in western mountain forests serve not just the needs of Great Gray Owls. Elk, moose, mule deer, Sandhill Cranes, as well as Northern Pygmy-Owls, Great Horned Owls, Long-eared Owls, Northern Saw-whet Owls, Northern Hawk Owls, and Boreal Owls also utilize these meadows. Mountain meadow habitats are threatened by fragmentation, because these are often the easiest places to build houses, cabins, or other developments. Primary prey species, especially voles, can be adversely affected by cattle grazing in meadows.

Great Gray Owls are considered to be a solid indicator for the health and function of mature forests of the western mountains but they require meadows and other openings to thrive. Great Gray Owls are listed as "imperiled" in Wyoming, "vulnerable" in Montana, and are currently listed as a "survey and manage" species by the Bureau of Land Management in Oregon. The Great Gray Owl Sierra Nevada subspecies, found in the Yosemite National Park area, numbers only one hundred to two hundred birds and is listed as "endangered" in California.

Open meadows surrounded by mature forest are utilized by several species of owls that feast upon voles and gophers. Irregular edges lined by trees and snags provide access to more prey.

Even the largest and slowest maturing owls gain their full independence before the end of fall, at which time most owls begin dispersing from their natal territories.

NORTHERN PYGMY-OWL

Young Northern Pygmy-Owls begin peering from their nest cavities in early summer, when the days are longest, the young saplings around and beneath the nest have completed their annual growth, and the yellow arnica and red columbine are in full bloom.

As the sun rose in the Oregon Cascades during the first week of July, I was watching a Northern Pygmy-Owl nest cavity from an elevated blind. Razor-sharp talons gripped the lip of the cavity and the fuzzy, gray protruding head inspected an ant circling the round entrance. Something was happening behind the nestling, but I was having a hard time seeing what it might be. It was the mother. That nestling was so ready to leave, it would not let anyone, even its mother, get in front of it. With some effort, she squeezed past her nestling and flew out to resume her hunting.

Cavity-nesting owlets take great interest in the world outside their nest as they prepare to leave what has been, up to this point, their entire world. When the cavity entrance is occupied half of the time or more, that is a pretty sure sign that the owlets are ready to leave the nest.

Knowing the sun would rise at 6:00 a.m., I arrived the next morning at 5:30, hoping to catch the young jumping from the cavity. I set myself up some sixty yards away, a much greater distance than ideal for good photographs but close enough to see it all unfold. A gray head was already bobbing up and down, side to side, in the cavity entrance. At 6:30, the mother swooped to a limb in front of the nest with a Dark-eyed Junco in her talons. Rather than coming directly into the cavity, she called with a soft twitter while the nestling leaned farther and farther out of the cavity in the Douglas fir snag. After a few minutes, the youngster pulled in and the mother delivered the bird into the nest.

Almost as soon as she left, the cavity entrance was filled with another owlet.

At 9:00 a.m., the mother came in again, this time with an alligator lizard. Just as before, she perched for several minutes in front of the cavity, twittering to a youngster teetering on the lip of the cavity. This time, however, the nestling blocked the opening, so she delivered the lizard at the cavity entrance to the screaming little one. At 9:30 a.m., she was making soft *toot* calls from dozens of feet in front of the cavity, and to my surprise, the nestling at the entrance jumped and glided some ten yards to a branch on a nearby Douglas fir, where it landed awkwardly, desperately trying to hold onto the branch. Immediately, another owlet filled the cavity entrance. At 9:55 a.m., the mother returned with a vole. Again, this new pattern of chittering on a branch in front of the cavity entrance with the nestling teetering at the edge of the cavity played out. Each time, it seemed as if the mother wanted the nestling to fly toward her for food, but this time, she gave in, flew into the cavity, and delivered the vole.

Fifteen minutes later, she again softly *toot*ed from a distance, and again an owlet made a sudden leap, landing on the ground in some kinnikinnick twenty yards to the left of the nest tree. No more than five minutes later, the last of the owlets made a similar leap in the same direction as the previous owlet and also landed on the ground. By the time the third owlet fledged, the first one was already thirty feet up in the Douglas fir and climbing higher while the second one had walked to the base of a leaning ponderosa pine and was beginning to climb. Quickly, the last youngster waddled awkwardly toward the same ponderosa pine. Eventually the two ended up side by side on the same branch.

At around 11:00 a.m., the mother came in again with a vole and called to the youngsters from a branch above all of them. They began climbing angled branches and made hopping flights toward their mother before the most aggressive owlet reached her and was fed. What ensued was the most frequent feeding I ever saw in the three weeks

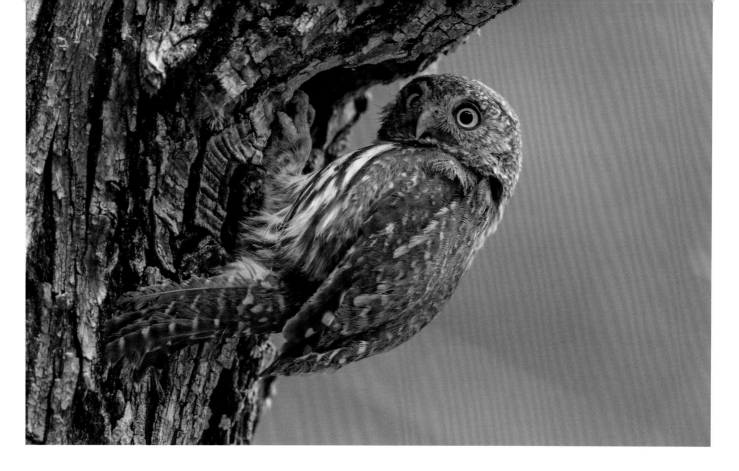

I watched the nest. During this time, both parents fed the young, and each time they made it more difficult, making the youngsters climb, flutter, and fly higher. By 2:00 p.m., all the owlets were some sixty feet up in an old ponderosa pine. Although I could not predict how far they could fly, by late afternoon, they were gliding from limb to limb without falling and were stronger and getting better at it.

This quick succession of leaving the nest, climbing, and flying was the fastest and most adept movement away from the nest I have ever seen by any owl. I was struck by how the parents, particularly the female, seemed to choose when the young fledged and encouraged them only when I was hidden well away from the nest. Even in cases of large broods, most young owls leave the nests over a period of not more than two days.

After witnessing four separate broods of Northern Pygmy-Owls leave their nests, I realized that the owls reached safety more quickly when they were able to fly to a limb rather than to the ground. The fledglings on the ground were vulnerable to many kinds of predators for far longer. Their small size meant that any obstacle was large and walking was slow. By contrast, movement on and up the branches was quick, and every move led to greater safety. Leaning dead and live trees help those on the ground reach safety more easily.

Northern Pygmy-Owls develop quickly. By the time it leaves the nest, a Northern Pygmy-Owl has a shape and profile very much like those of its parents, except for a much shorter tail, a grayer head, and fewer spots. By the end of the second week after fledging, juveniles are able to fly almost as well as their parents and capture their first small prey. Sometime during the next two weeks, the adult female permanently leaves the family group. As long as the juveniles are dependent on one or more adults, they normally roost within four hundred feet of one another—and often within as little as one hundred feet. Early in the fifth week, the adult male leaves the youngsters who disperse shortly thereafter.

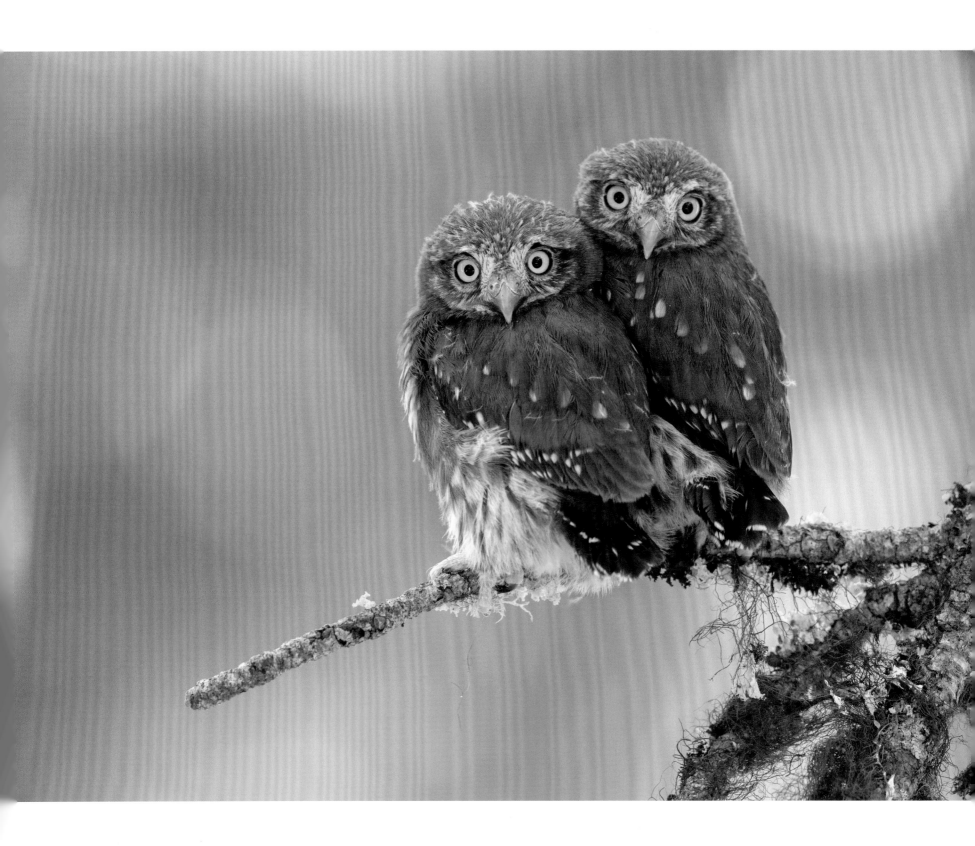

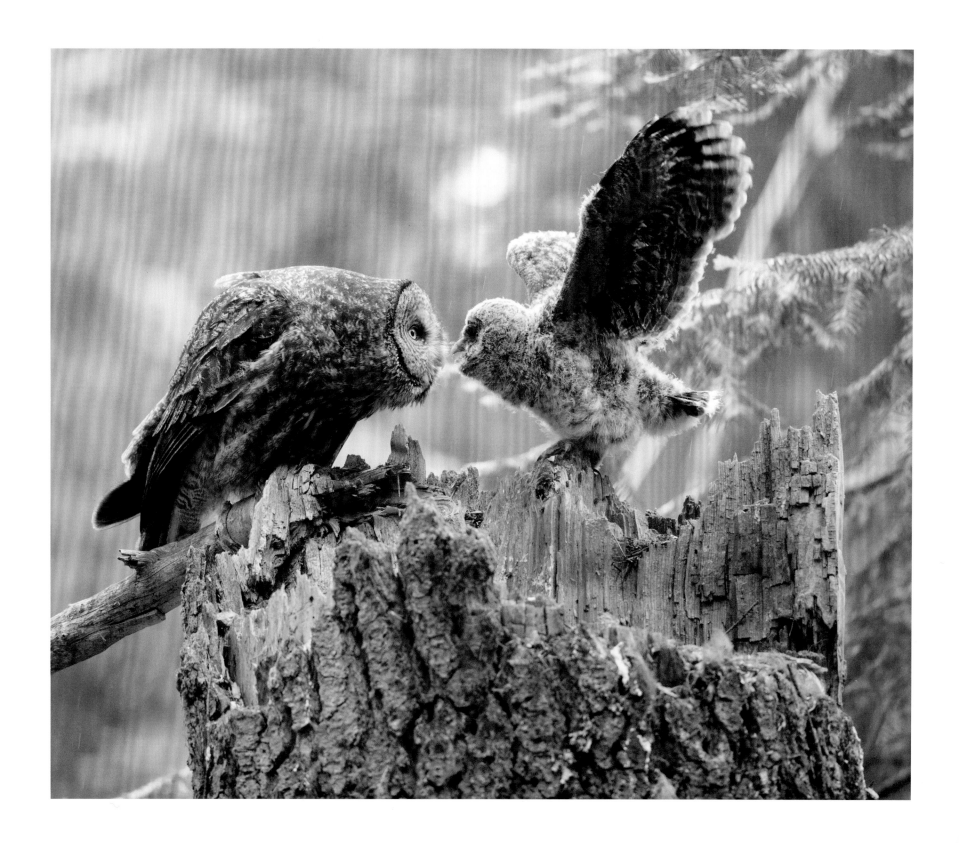

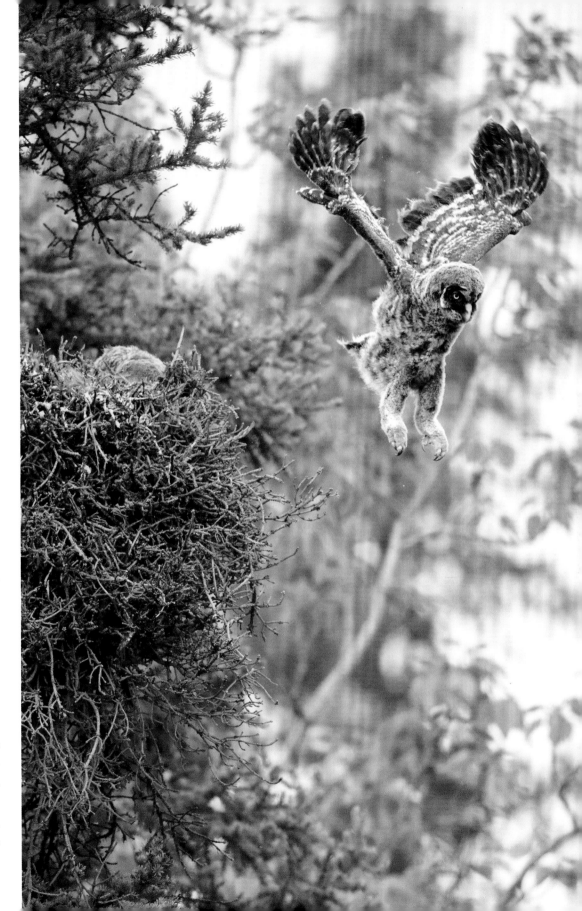

GREAT GRAY OWL

It was 4:00 a.m. and I was monitoring the nest of a female Great Gray Owl in the boreal forest of central Alaska. Everything felt different that morning. The weather was the same, but the atmosphere was much more raucous. Red squirrels chattered from every direction. Common Ravens flew over often, cawing their warnings, and Gray Jays made noisy sorties in small groups. With each fly-by of her inquisitive neighbors, the owl flew to her nest, protesting with loud *whoop* calls. After an hour, she called softly from a new perch forty yards away, or nearly twice as far as the two perches she normally used. The nest was on a witches' broom more than fifty feet up in an old white spruce. All three youngsters in the nest were moving around and periodically flapping vigorously.

Over the previous five years, I had watched several Great Gray Owl nests, hoping to witness that magical moment when a nestling stood at the edge of the nest and made a brave leap, flapping toward a new life. It never quite happened that way. Most of the time, the owls left the nest during the dark of night. Other times, after watching them for sixteen straight hours, I took a noon lunch break only to discover after my return that they had left while I was gone. On a few occasions, I observed the owlets climbing to adjacent branches, only to misstep and make a flapping fall fifty feet to the ground, uninjured. My friends and I had reached the conclusion that the Great Gray Owl mothers would not allow their young to fledge while I was watching.

As I studied the scene on that early morning in central Alaska, the first owlet walked off the nest using the surrounding branches, where it floundered and quickly disappeared into the spruce needles. Shortly after, the second owl peered down over the side, stretched its wings a bit, and jumped. One, two, three, four wing strokes and it had made its first flight before landing roughly on the ground some fifty yards away.

The Gray Jays erupted in a frenzy. A group of them flew over the remaining nestlings, calling loudly, and the

BOREAL FORESTS

Boreal forests circle the globe and cover much of Canada and Alaska, with small fingers extending into the Great Lakes and northeast regions of the United States. This intact forest ecosystem is the largest in the world and one of the ones being most quickly altered. These forests are home to the majority of North America's Great Gray Owls, Boreal Owls, and Northern Hawk Owls.

The most distinctive visual feature of the boreal forest is the stunted, conical-shaped spruce trees, which are often joined by aspen, birch, balsam poplar, tamarack, and pine trees. The understory is a soft, cushion-like layer of moss covered in small plants that tolerate acidic soils and deep freezes. Water lies just beneath the soil in much of the region, forming innumerable lakes, ponds, muskegs, and bogs.

The boreal forest contains several different habitats for owls. Boreal Owls prefer the densest stands with the oldest trees, often with aspen or balsam poplar as a component. Great Gray Owls prefer less dense conifer or mixed conifer stands adjacent to forest openings. Northern Hawk Owls prefer open spruce woods interspersed with muskegs, bogs, and burns. These three owls might nest in the same stands, since conifers can grow ten times more slowly than they do in temperate regions, and nest options are often limited. In this situation, they often hunt in different habitats. Northern Saw-whet Owls, Barred Owls, and Long-eared Owls also nest in boreal forests.

Owls, like other boreal predators, are spread thinly on the landscape but exhibit boom and bust breeding years following the even more erratic populations of their primary prey species: voles and snowshoe hares. Other animals typically sharing these owls' boreal habitat include moose, red fox, Canada lynx, wolf, and wolverine.

There are many threats to the boreal forest, with the primary ones being resource exploration and extraction and timber harvest, which fragment habitat, as well as the impacts of climate change. The warming climate is resulting in massive tree die-offs from insect pests that are able to go through more annual population cycles every year. It also threatens to increase evaporation and decrease surface water, making the boreal forest drier and less hospitable to its native trees and more vulnerable to catastrophic fire. Studies in Scandinavia suggest that vole populations are negatively impacted by a warming climate.

Individually, each of these changes will have different effects on each owl species. Taken together, the dramatic changes are certain to have unpredictable long-term impacts on a system already challenged by scarcity of prey and trees large enough for nests. Given their subtle niches in boreal forest ecosystems, the relative populations of Great Gray Owls, Northern Hawk Owls, and Boreal Owls can serve as indicator species for monitoring changes in boreal conifer forests, muskegs, bogs, and burns, as well as stands of aspen and poplar.

Boreal forests are not a uniform blanket but include meadows, ponds, lakes, and muskeg, as well as vast stands of hardwoods, conifers, and mixed stands of trees.

{ page 121 } The first of three Great Gray Owlets leaps from the nest.

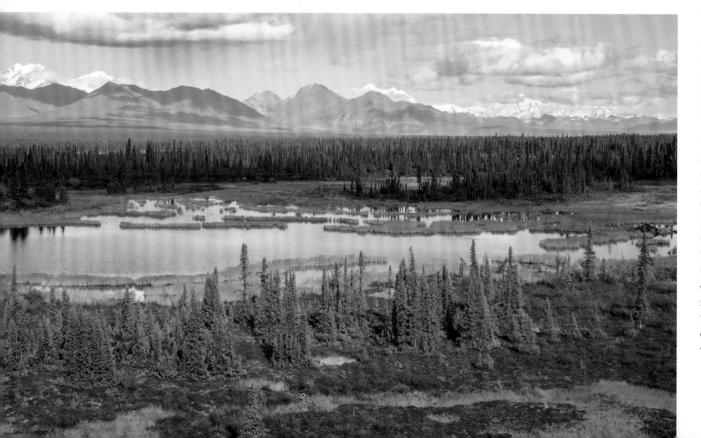

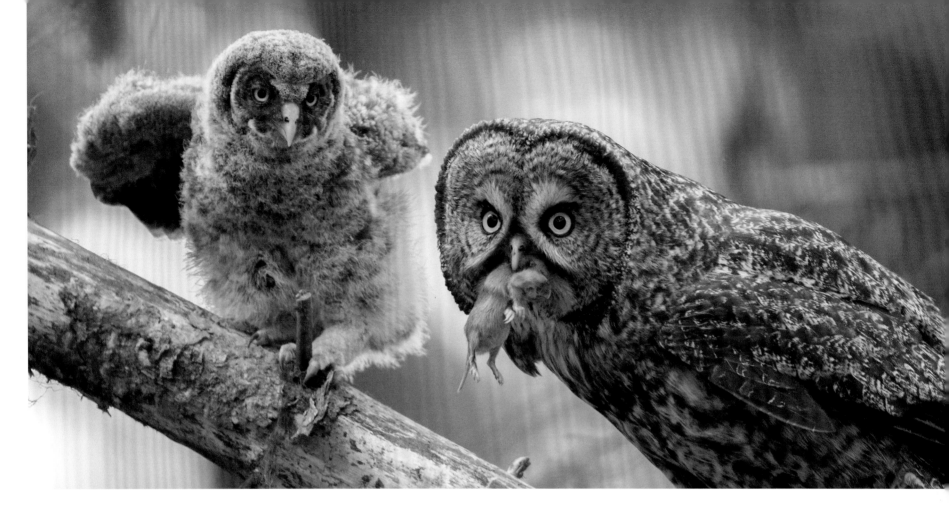

mother quickly flew to the nest to scare them off. She put her head down and peered into her nest. It looked like she was counting to confirm that just one owlet was left.

I stayed in my distant hideout, knowing I was being given a great gift, one that had eluded me for several years. After an hour, the remaining owlet circled the nest's edges, looking down cautiously, and jumped. Five flaps of its roughly formed wings brought the youngster to the ground, where it crouched motionless before moving toward a leaning snag.

The first nestling was now climbing into view atop a bending branch of the white spruce. After about an hour of moving back and forth along the bouncing branch, it too jumped and flapped, but this youngster landed fifty feet high in an adjacent tree, in the opposite direction from its siblings.

What puzzled me most about this magical experience was what drove these owlets to leave the nest. Was it the mother's soft calling? Was it the attention of the ravens and jays? Or was it just the right time? And why did these youngsters fly rather than walk out onto the branches and fall, as others had? Why did they leave in the daylight rather than at night?

The nest that these young Great Gray Owls had left was at the edge of a bowl of very tall but widely spaced poplar and white spruce trees. The three owlets moved uphill into a denser stand of white spruce. By evening, one fledgling was in an adjacent tree, the second was one foot off the ground on a downed snag leaning at a forty-five-degree angle, and the third was three feet off the ground on top of a snag leaning at about twenty degrees. I knew from past experience that all three owls would head in the same general direction but remain far apart on different snags and trees until they could fly.

Although Great Gray Owls frequently nest in mature stands of trees close to an opening, when the young leave

A Great Gray Owl prepares to feed a pocket gopher to her youngster.

the nest, the parents often lead them away from the opening and toward the denser stands, where there are leaning trees and snags to climb. These trees and the intact mature forest habitat are critical at this stage of their lives.

When I returned to the Alaskan youngsters seven days after they left the nest, the owlets had reached an important point in their development. They had moved a quarter of a mile into a thick stand of white spruce, with some giant, straight, sturdy trees and lots of smaller black spruce and leaning trees. The ground was mostly open, with foot-deep moss interrupted by rivulets, springs, and ponds. The young owls were trying to climb leaning trees with mixed results, but they had reached more than twenty feet up, and there they perched, begging to be fed. By day nine, they had mastered the tree-climbing skill, no longer falling to the ground, and were even able to fly-glide from one tree to another.

While observing her family, the mother stayed perched mostly within twenty yards of the youngest fledgling. She continued to receive prey from the male and deliver it to the young. Great Gray Owl mothers become more aggressive when the young are out of the nest, making it dangerous for people to look for fledglings. You are more likely to find talons coming at the side of your head than a youngster on the ground during your search, and some people have even lost eyes to these fierce birds. Great Gray Owls can float slowly through the forest, but when protecting young or pursuing prey, they can fly surprisingly fast.

One year in the Tetons, I watched as an alert Great Gray Owl mother noticed a Northern Goshawk taking an interest in her young. Goshawks are fast and ferocious, and along with Great Horned Owls, are some of the most lethal predators of Great Gray Owl young. The mother did not wait for further developments. With urgent, echoing *whoop whoop* calls, she pursued the Goshawk, bill to tail, weaving through the forest. The Goshawk could have injured the owl, but it would not have escaped her fury without being hurt as well. It quickly moved on.

A couple of weeks after young Great Grays leave the nest, the parental roles change. The female loses interest in the young and begins to wander, even visiting other family groups, and returns only periodically. The male takes over the hunting and protection duties. Male Great Gray Owls have been observed feeding the young of other families that they come across.

The young can fly at about fifty days, or roughly three weeks after leaving the nest. Up to this point, they perch alone, higher and higher in the trees. Once the young owls are able to fly, they follow their parents to open areas where most of their food is captured. At this time, they perch closer to the ground, as their parents do, where they can begin to listen for prey and hunt on their own. From this time until they disperse, they often roost close to, and sometimes next to, their siblings.

Young Great Gray Owls begin hunting on their own at about three months of age. By this stage, they look very much like their parents but with slightly darker plumage, a less distinctive white "bow-tie" at the bottom of the head, and a less pronounced facial disk.

I was watching two juvenile Great Gray Owls in large trees at the edge of a meadow in northeastern Washington; they were screaming and begging incessantly, even though the parents were encouraging them to hunt on their own and were feeding them less and less frequently. Following a half hour or so of begging with no response, they began to hunt. After two days, the male no longer delivered food or visited the youngsters, but they continued to beg. Their constant drops to the grass surprised me, and I wondered how there could be so many voles or pocket gophers. When I looked closely at my resulting photographs, I saw that they were hunting grasshoppers!

By the middle of the next week, one juvenile had disappeared, followed by the second by the end of the third week. Although I like to think that both survived, studies have shown that only about 60 percent of young Great Gray Owls make it to the flight stage before facing their final hurdle: surviving the winter.

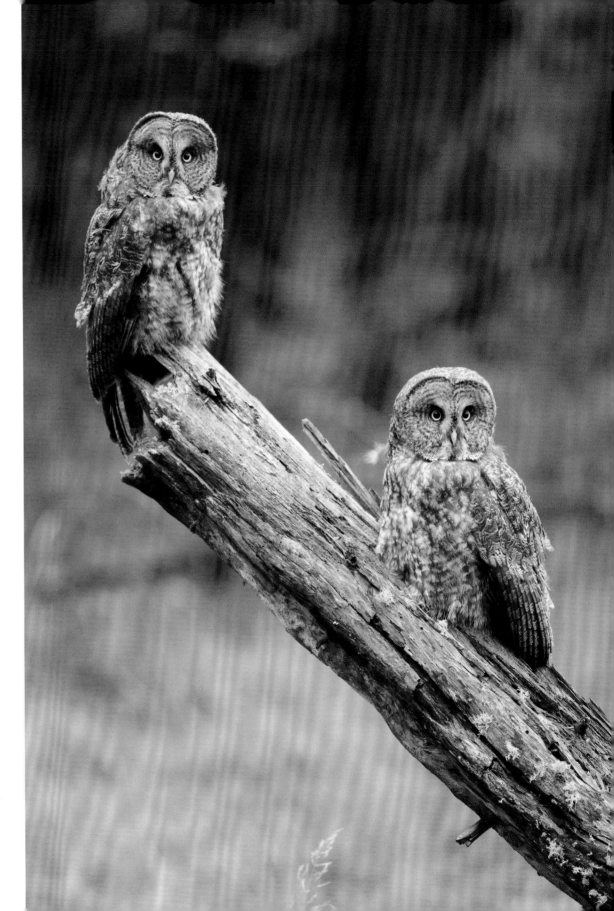

Juvenile Great Gray Owls begin spending more time near one another as they gain flight skills. In late fall, they finally disperse from their parents, one another, and their natal territories.

SOUTHWEST DRYLANDS

Several unique warm and dry habitats are found in the southwestern United States, ranging from southeastern California to southern Texas, and including pockets in Utah, New Mexico, Colorado, and Arizona. While these vary from arid deserts to forested canyons, all share the distinction of hosting owls found nowhere else outside Mexico, including both North American subspecies of the Ferruginous Pygmy-Owl.

Sonoran Desert and the Rio Grande Valley

The Sonoran Desert lies south of the shrub-steppe and grasslands of the interior west in extreme southeastern California, southern Arizona, and northwestern Mexico. The combination of rocky soils and less than five inches of rain annually eliminates most of the grasses and trees found farther north, but is perfect for the most important nest component for Sonoran owls, the saguaro cactus.

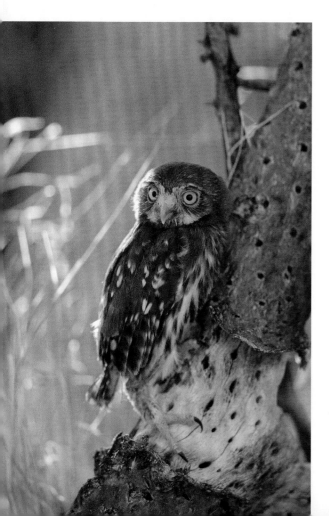

Among the owl species found in the Sonoran, the cactus subspecies of the Ferruginous Pygmy-Owl serves as a strong indicator species for threatened riparian habitat. This owl, an Arizona subspecies of the Ferruginous Pygmy-Owl, nests in cavities in saguaros made by Gila Woodpeckers and sometimes Gilded Flickers. These cavities also serve as nests for Elf Owls, Western Screech-Owls, Ash-throated Flycatchers, Brown-crested Flycatchers, Great-crested Flycatchers, Purple Martins, and many other creatures of the desert. Great Horned Owls will also nest on top of saguaros on stick nests made by Red-tailed Hawks.

Cactus Ferruginous Pygmy-Owls were once a common species along rivers and streams of the region, but development and grazing degraded much of the habitat. Now, small remnant populations are found in Sonoran desert scrub and semidesert grasslands along dry stream washes. After summer monsoon rains, dry-washes and streams carry lots of water and soil, which help create impenetrable thickets of thorny trees and shrubs that usually include ironwood, paloverde, and mesquite. These thickets attract a wide variety of prey species, such as lizards, rodents, arthropods, and other birds, and provide safer roosting habitat than the surrounding landscape, especially for vulnerable young owls after they fledge and for roosting adults.

In the Rio Grande Valley of southern Texas, the Ridgway's subspecies of the Ferruginous Pygmy-Owl breeds in dense live oak–mesquite forests and mesquite brush areas adjacent to open habitats. It nests in cavities carved by Golden-fronted Woodpeckers, in natural cavities, and in nest boxes. Both the Ridgway's and Cactus Ferruginous Pygmy-Owl subspecies usually nest where natural or man-made water sources are nearby.

The Cactus Ferruginous Pygmy-Owl is a rare subspecies with possibly only forty to fifty birds remaining in the United States. There may be 250 to 300 of the Ridgway's subspecies in Texas, but they are also rare. Like other species at the edge of their range, this subtropical species is vulnerable to changes in its habitat. Small remaining populations and changing rain patterns challenge both subspecies, while the Texas populations must also contend with the border wall that has further damaged riparian ecosystems along the Rio Grande. Fortunately, a captive breeding effort is under way in Arizona that could supplement populations of Cactus Ferruginous Pygmy-Owls.

Although Ferruginous Pygmy-Owls are adapted to arid lands, seasonal rains are needed to grow and maintain the trees and shrubs they rely upon for nests and shelter and to ensure a larger prey base. Droughts and changing weather patterns are threatening their habitats.

The Ferruginous Pygmy-Owl is "threatened" in Texas and "critically imperiled" in Arizona. Meeting the needs of this species will surely help many species that share its habitats, including Elf Owls and Western Screech-Owls, as well as other arid-land species such as Green Jays and Golden-fronted Woodpeckers in Texas and Gila monsters and Gila Woodpeckers in Arizona.

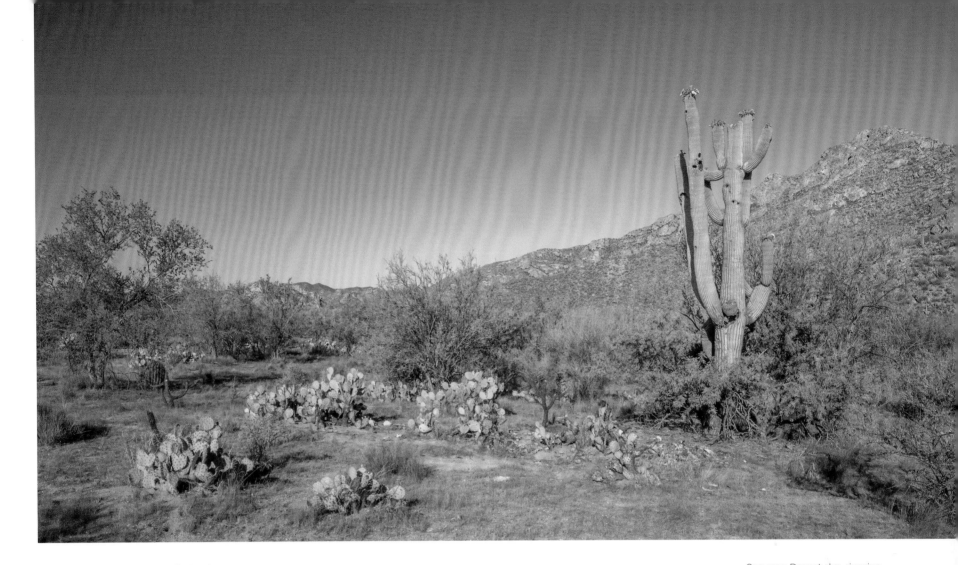

Southwest Forested Canyons

Rising above the deserts and other arid lands of the Southwest, from southern Utah and Colorado south to Arizona and West Texas, are mountains blanketed with mature dry forest habitats and incised with deep canyons. Particularly when combined with a perennial water source, these habitats can provide shade and shelter and create a wide range of temperature regimes within a relatively small area.

A rare subspecies of Spotted Owl, the Mexican Spotted Owl finds refuge where it can find nest cavities in both cliffside caves and in the natural cavities of large mature trees. This subspecies uses the shaded parts of canyons and their trees to prevent heat stress in the same way that the Northern Spotted Owl uses the multiple canopies in Pacific Northwest coastal forests.

In southeast Arizona and adjacent New Mexico, the canyons that host Mexican Spotted Owls also serve as habitat for another otherwise Mexican species, the Whiskered Screech-Owl, as well as the "Mountain" Pygmy-Owls, the southern Arizona and Mexican subspecies of the Northern Pygmy-Owl, plus Elf Owls, Western Screech-Owls, and Great Horned Owls.

The Mexican Spotted Owl is listed as "threatened" under the US Endangered Species Act, with just over two thousand left in the country, and their pockets of dry forest habitat surrounded by hot arid lands are vulnerable to fire. Mexican Spotted Owls are found only in isolated pockets and are challenged by their small numbers. Climate change, drought, and bark beetle infestations are fueling more catastrophic fires, further reducing remaining habitat and owl numbers. To improve the owls' prospects of surviving these challenges, we must at the very least protect all remaining habitat.

Sonoran Desert dry-riparian habitats are renewed with water and soil after monsoon rains. The result is luxuriant thickets of thorny trees and shrubs that include saguaros as well as ironwood, paloverde, and mesquite. This makes ideal habitat for Ferruginous Pygmy-Owls, Elf Owls, Great Horned Owls, and Western Screech-Owls.

{ opposite } A Cactus Ferruginous Pygmy-Owl fledgling climbs a cholla cactus just moments after flying out of the nest and to the ground.

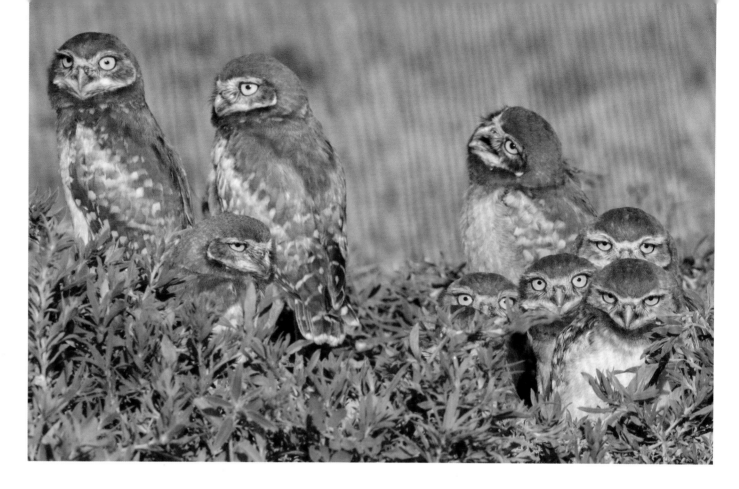

BURROWING OWL

After watching the Burrowing Owls and the prairie dogs on a small patch of grassland on the Great Plains of Kansas, I knew where to set up my blind to give myself the best chances at good photos. It was late in June, and I only had a small window of time that day to photograph there. Prairie dogs are important to Burrowing Owls because they dig the majority of the tunnels that these owls use for homes in much of the United States and Canada.

Young Burrowing Owls gain their independence during some of the warmest months in many of the hottest places in North America—Florida, Texas, Arizona, California, and the Great Plains—places too hot even for reptiles, including the four foot-long snake that was trying to escape the heat by pushing into my blind on that one-hundred-degree day.

Burrowing Owl families are tied to their nest sites longer than any other North American owl, yet unlike other owls, they often leave their nest and return repeatedly throughout the day for a few weeks. This makes it difficult for a photographer to figure out who is related to whom.

The first owl appeared in an hour, and then others popped from their burrow and lined up beside one another pretty quickly, and still others scrambled from several other burrows. Within minutes, eleven flat-headed owls crouched shoulder to shoulder at the edge of a burrow. I had no idea if this was a nest burrow, and if so, which owls belonged to it. Soon, one owlet noticed that a female had captured a grasshopper, causing them all to make wobbly flights toward it.

Female Burrowing Owls begin joining males in the hunting when the nestlings are about two weeks old, and their participation is particularly pronounced once the young begin to leave the nest burrow for long periods of time. The females focus mostly on catching grasshoppers, beetles, and other insects, which they deliver in their bill one at a time. Males continue to hunt as well, and although the majority of food items hunted are arthropods, the greatest

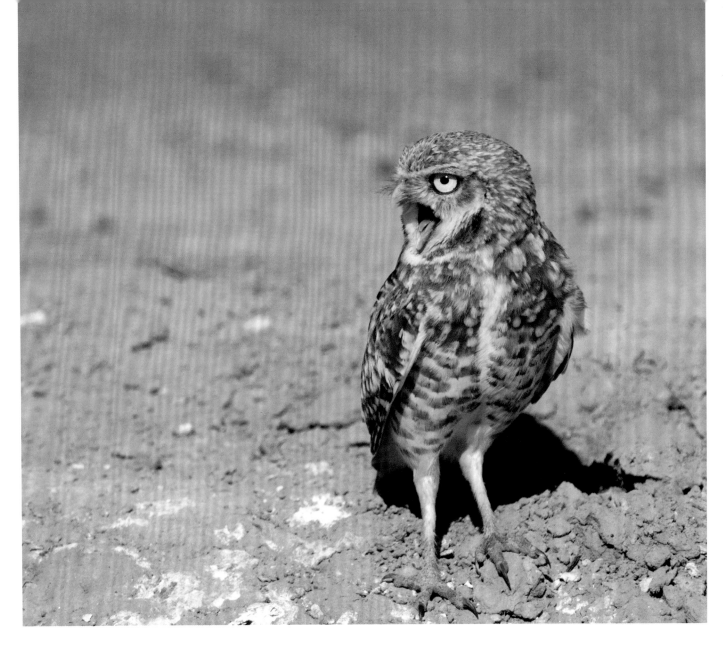

amount of prey in terms of mass consists of small rodents, which they bring in with their talons. Males also tackle lizards, salamanders, small birds, and sometimes even baby prairie dogs. The male's generally larger size in relation to the female, unique among North American owls, may be related to this division of hunting.

Predators are abundant in the open habitats where Burrowing Owls nest. Large groups of active small owls make a conspicuous target for hungry animals. Badgers are the most common predator of Burrowing Owls, a threat that is reduced when Burrowing Owls are nesting in dense prairie-dog colonies. The prairie dogs are quick to sound a high-pitched alarm bark, which announces predators and also causes many of these small rodents to scamper, creating alternate targets for predators. Other predators include domestic cats and dogs, weasels, skunks, opossums, Ferruginous Hawks, Swainson's Hawks, Golden Eagles, and Merlins, as well as Great Horned Owls and Barn Owls.

To minimize danger when young are active outside the burrow and the vegetation surrounding the nest is at

When an adult female Burrowing Owl calls, the whole family reacts. The male returns to the nest to prepare to defend the family and the young dart back into the nest cavity from wherever they may be.

{ opposite } After retreating in response to their mother's alarm call, eight Burrowing Owls tentatively emerge, one by one, from a prairie-dog burrow, where they line up and beg to be fed.

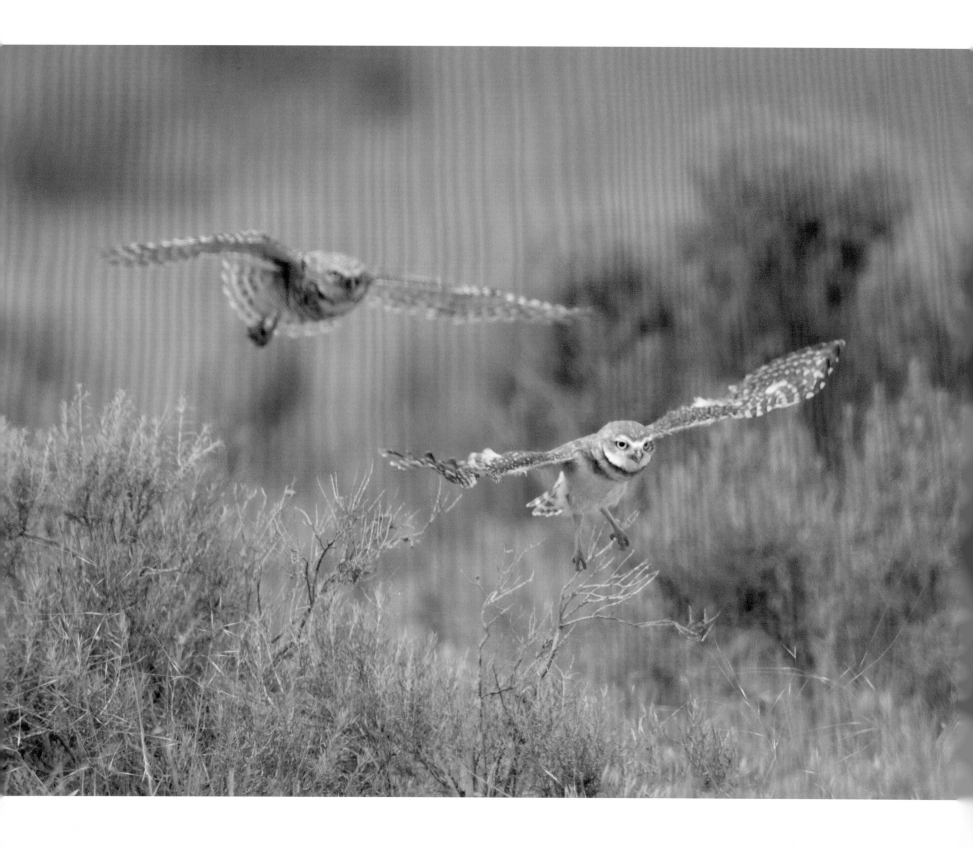

its tallest, good Burrowing Owl habitat must have elevated perches that enable the owls to see a predator approach. This perch might be a fencepost, a sagebrush snag, the seedpod of a yucca plant, or in the least-adequate cases, an extra-tall mound of soil behind the burrow mound.

When parents see a threat, they sound the alarm, a loud, high-pitched, chattering call that sounds like *REECK, reeck, reeck, reeck,* with several to a couple dozen calls emitted in a quick burst lasting a few seconds. Every Burrowing Owl reacts immediately, with the young spraying sand as they dash from every direction into the nest hole and the male quickly flying over and perching nearby in case he needs to defend his family. If the predator starts to enter the burrow, the female and the nestlings make a raspy, hissing noise that sounds convincingly like an angry rattlesnake.

The family's behavior changes noticeably every day. More than for any other North American owl, the transition from a hatchling to an independent flying juvenile moves smoothly for the Burrowing Owl. There is no jump from a nest, or sudden desperate run into the surrounding landscape. When the broods are large, you can see that each sibling is at a slightly different stage of development. Some nestlings are timid and shy at the burrow opening and move slowly, only to quickly retreat, while others dart out and line up, while still others flap their wings or chase one another. In the middle of the day, or when there is trouble, all of them roost together in the burrows.

Beginning at about two weeks old, young Burrowing Owls become more curious, tilting or rotating their heads to see what's around them more and more frequently each day. They seem to do this more than any other owls; they seem curious about everything, including people. At two weeks, most other owls are still one to three weeks from leaving the safety of the nest, while Burrowing Owls leave the nest cavity regularly and explore adjacent burrows and interact with other families. This degree of independence is afforded by quick development of agile running skills, allowing them to reach the safety of

numerous alternate burrows once a parent or neighbor emits an alarm call.

To fully appreciate the advantages of nesting underground, it is helpful to look at the Short-eared Owl, a neighbor in grassland, shrub-steppe, and agricultural habitats that often faces the same climate and predators as the Burrowing Owl. Short-eared Owls have the shortest time in the nest of any owl and are ready to leave their ground nest for good when they are just twelve to eighteen days old. Unlike Burrowing Owls, they disperse one by one, often days apart, and head in different directions. I once found five juvenile Short-eared Owls within days of their having left the nest; they were twenty to forty yards apart. At this point, the owls must get as far away from the odorous nest as they can, but they can only walk and rely on the grass and shrubs to hide them. Leaving the nest so early and separating from one another reduces the chance that a predator might eat all of the young. Yet at night, they betray their locations by making begging vocalizations so their parents can find them, and there is no burrow to retreat into. As a result, survival is low.

Burrowing Owls, by contrast, can retreat to the safety of burrows when predators approach as well as to sleep. This secure refuge allows them to stay together in larger groups and develop the skills they will need during the relative safety of day.

At four weeks of age, the youngsters gain rudimentary flight and practice hunting by pouncing upon half-live insects, dead mice, and even owl pellets. I have watched them pick up and fly around with dead mice, their siblings in pursuit. At this same time, they begin perching off the ground, often competing with one another for the female's favored spot while she is hunting. From this point on, the young begin to follow their parents on hunting sorties at night, often landing on the same or adjacent plants or fence posts.

Young Burrowing Owls fly well by six weeks and look similar to their parents, except they have fewer markings on

{ opposite } A juvenile Burrowing Owl (foreground) and an adult take flight. Young owls frequently practice their flight near their nests and can easily be distinguished by their wobbly wings, smaller tails, and more awkward landings.

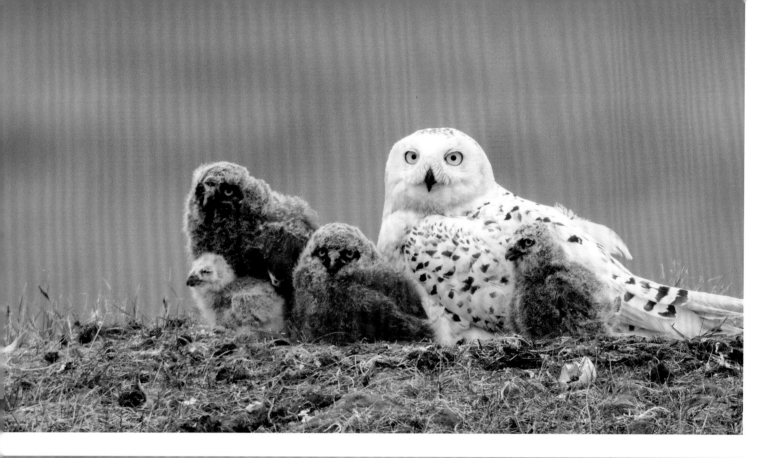

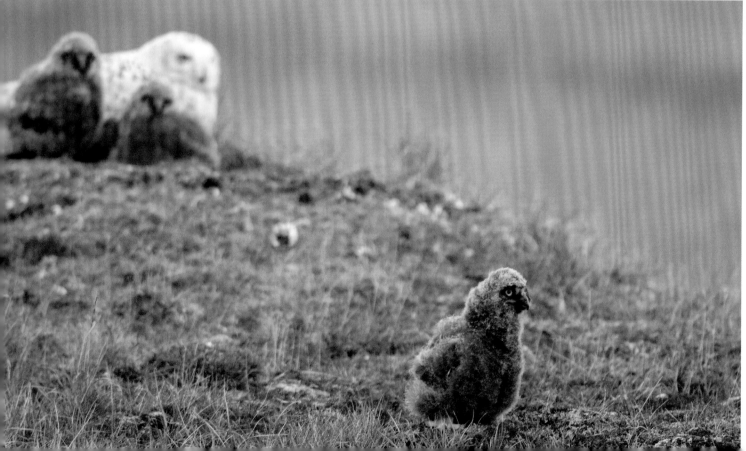

{ top } Like all owls, Snowy Owls begin incubating when the first or second egg is laid. The result—youngsters of various ages—can be a hedge when food is unpredictable.

{ bottom } A nestling Snowy Owl pauses after running from the nest mound. One by one, nestlings leave the nest for good, with days or even weeks between the first and last departure.

the breast, back, and head. Within a week of gaining strong flight, the young begin to chase live insects and utilize burrows away from their nest. When their nest is in a large patch of rich habitat, the young move progressively farther away.

SNOWY OWLS

One July day on the arctic tundra, I was watching a Snowy Owl family. Restless is the only way to describe the large dark-gray owlet that constantly moved between the nest bowl and the lower slope of the nest mound. Three siblings and the mother paid little attention as the owlet wandered farther and farther from the others, stopping where the mound flattened out into the thicker vegetation and saturated ground of the tundra. The final foray started out the same as the others, except for the watchful gaze of the owlet's nest mates. After pausing for several minutes, the youngster kept running, beyond the mound, over a couple of low mounds, and disappeared into the tundra vegetation. The others followed, with each leaving on its own day.

The arctic tundra is a complex mix of water and vegetation, and in dryer places is accented with mounds of various sizes. To keep dry, I was wearing hip waders, which make walking several miles grueling. You feel your exertion with each step, as your foot sinks several inches into the saturated turf before you pull it out and stride forward. Although it appears to be a flat grassy plain from a distance, much of the solid land consists of irregular mounds separating deep, narrow, ankle-spraining depressions, many filled with water. I cannot imagine how young Snowy Owls manage to find their way safely.

At about two weeks of age, Snowy Owl chicks explore the nest mound outside the nest bowl, and at about three weeks, each owl independently begins to leave the nest mound for good. From that point, they move autonomously on the tundra and must thermoregulate on their own, although they still rely on their parents for food and protection. Though the young may wander up to five hundred yards from the nest and rarely end up together, they stay relatively close to one another. And the parents, particularly the mother, are always close by on watch.

On a late July day, I was looking for more nests, when I realized I was close to where I had seen the young owls wandering far from their nest a week earlier. Where could they be? I knew these now four- to five-week-old owls were nearby because the parents were both perching in view. It took a good thirty minutes before I found one: it looked like a small clump of gray feathers or fur blown against a tuft of grass, but on closer inspection, I saw the back of a young snowy owl hunched inside one of the myriad natural pockets in the tundra. Using that visual cue, I was able to find the other four.

When Snowy Owls leave the nest, they are nearly completely covered in fluffy, dark gray feathers. But by the end of their fourth week, the area around their eyes begins to fill in with white feathers, making them look as though they are wearing goggles, and the primary feathers on their wings and tails become white, spotted and barred with gray and black like those of the adults.

Aware they had been discovered, the young owls flapped their wings and hopped away from me, gaining flight for only a few moments at a time. One even swam across a water-filled depression. When I did not follow them, each soon settled back down into a groove in the tundra and disappeared.

True flight does not occur for another three weeks, when the young are fifty to sixty days old, at which time the "goggles" and black-barred white primaries are quite pronounced and contrast with the owl's charcoal-gray head and neck, making the young look like adult females in hooded black balaclavas. Six weeks later, typically around October, the young owls lose the hooded look, and their parents no longer feed them. They are on their own and fly in search of food.

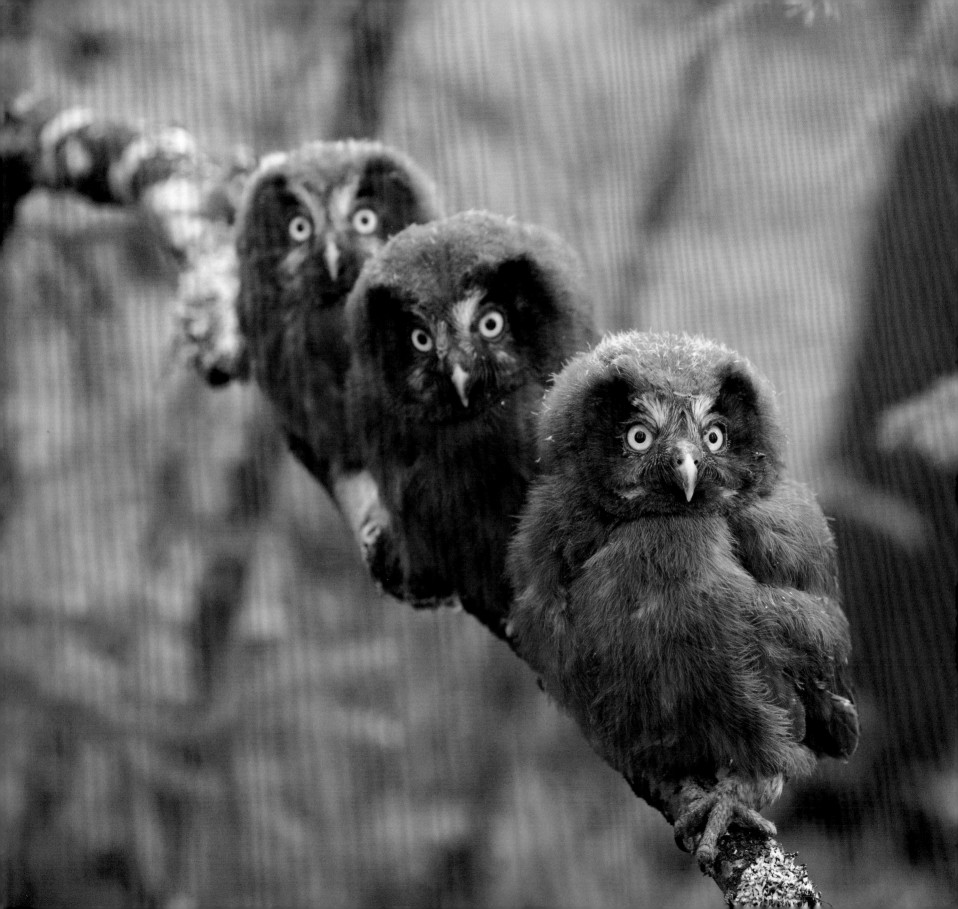

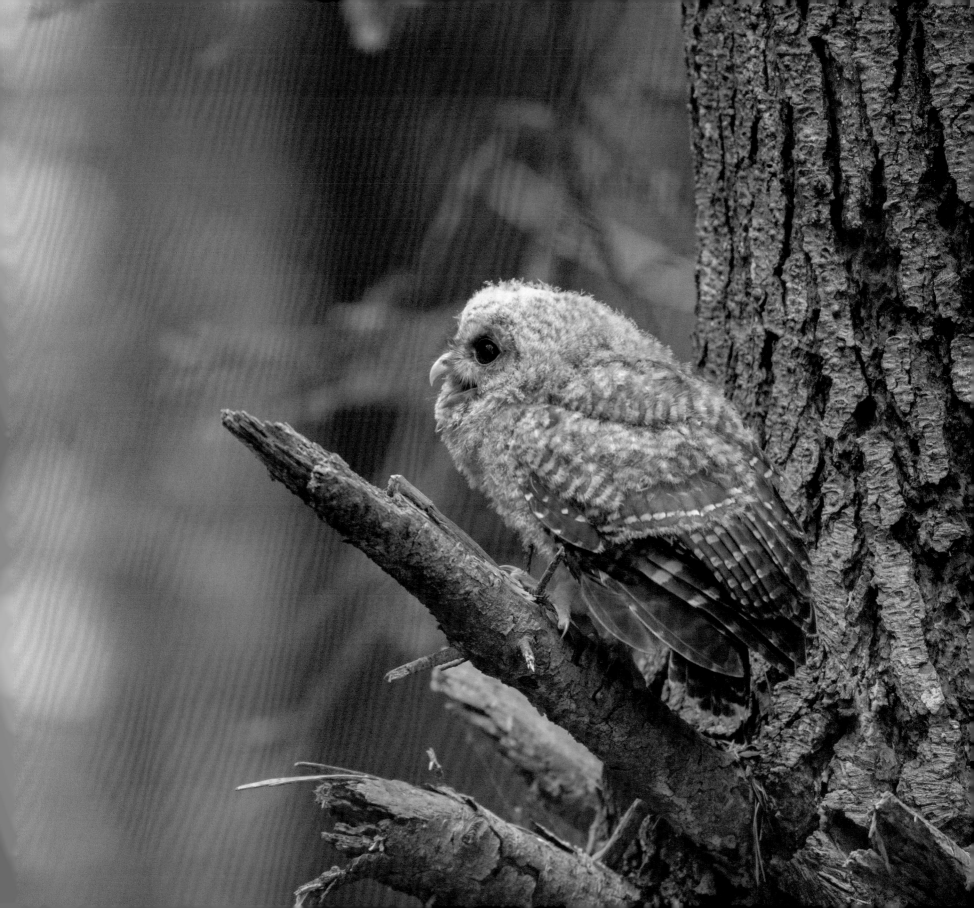

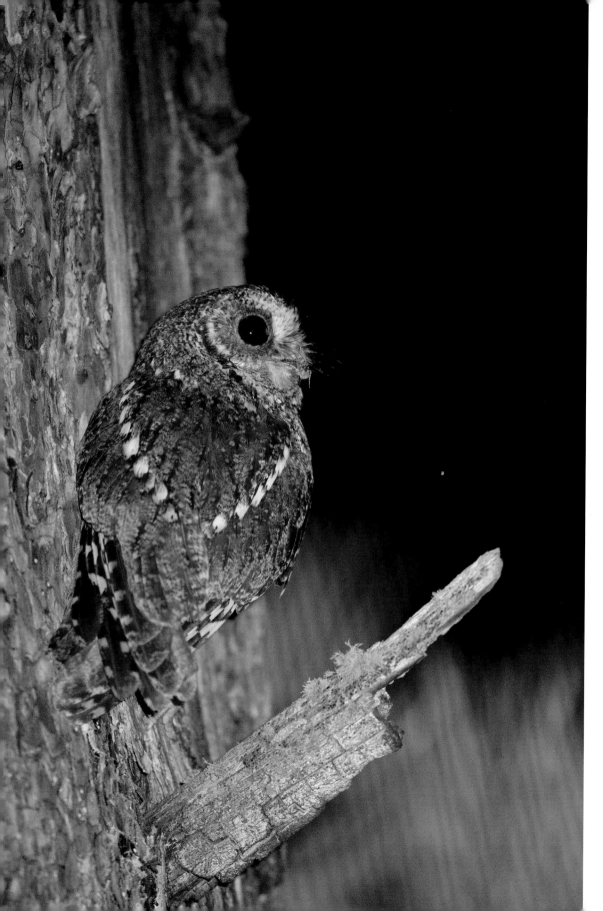

An adult Flammulated Owl prepares to deliver a spider to fledglings perched near the nest. While Flammulated Owls are dependent upon an abundance of moths early in the nesting season, other invertebrates are delivered as they become available.

{ opposite } Three four-week-old Flammulated Owls perch upon a ponderosa pine branch after being banded by a researcher.

{ page 134 } Many cavity-nesting species, like these recently banded Boreal Owls, leave the nest at about four weeks of age.

{ page 135 } A Northern Spotted Owl fledgling begs to be fed by its parent. Like other young owls that can fly, it will also actively chase a parent that clearly has prey.

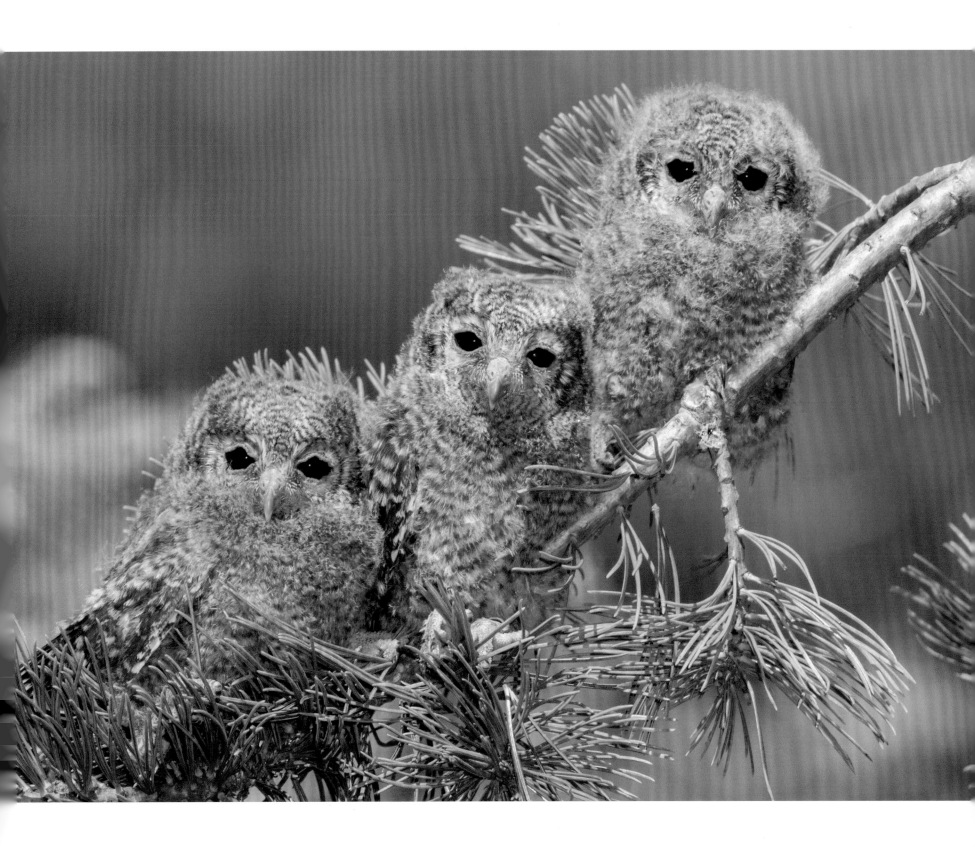

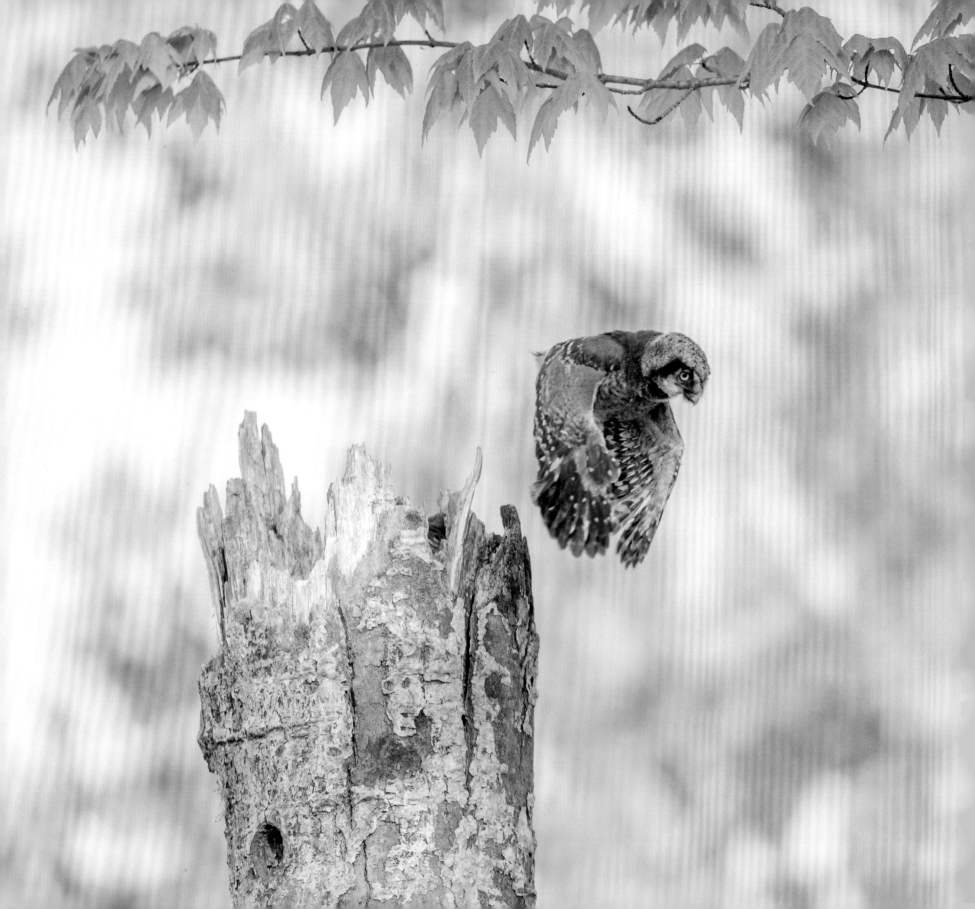

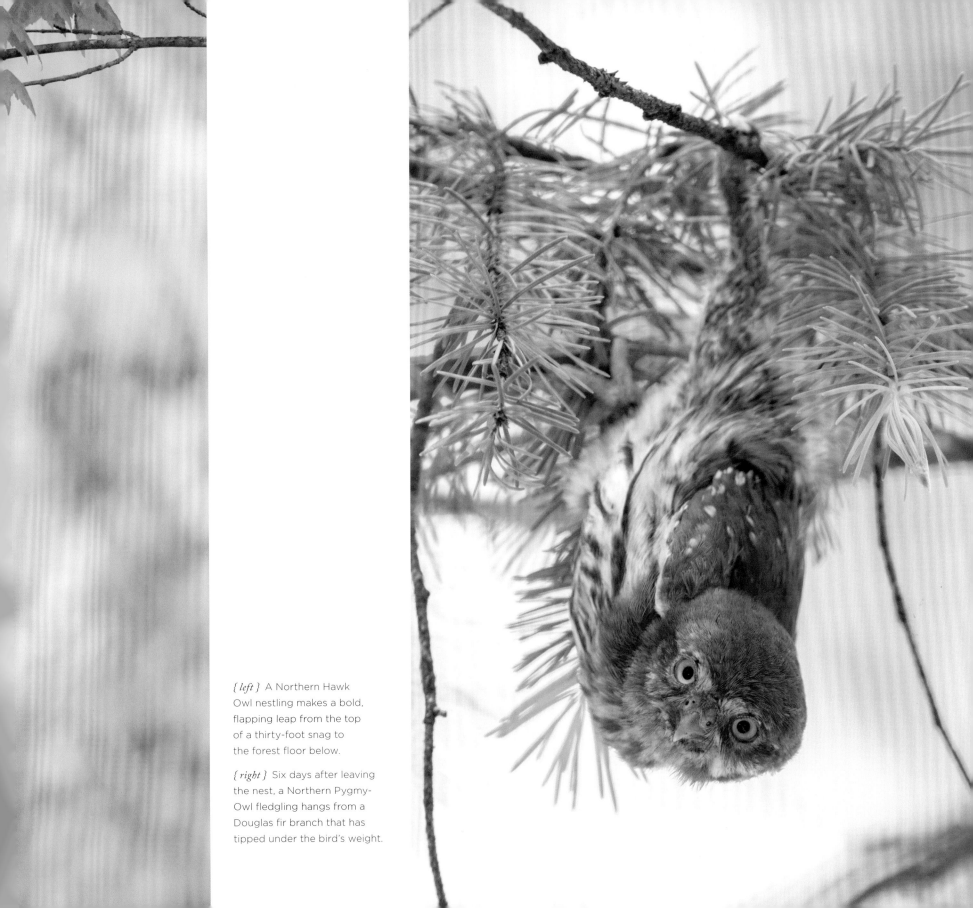

{ left } A Northern Hawk Owl nestling makes a bold, flapping leap from the top of a thirty-foot snag to the forest floor below.

{ right } Six days after leaving the nest, a Northern Pygmy-Owl fledgling hangs from a Douglas fir branch that has tipped under the bird's weight.

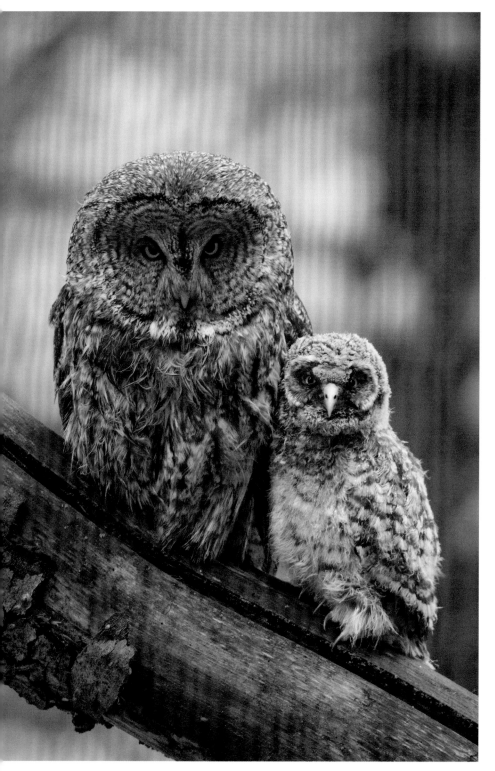
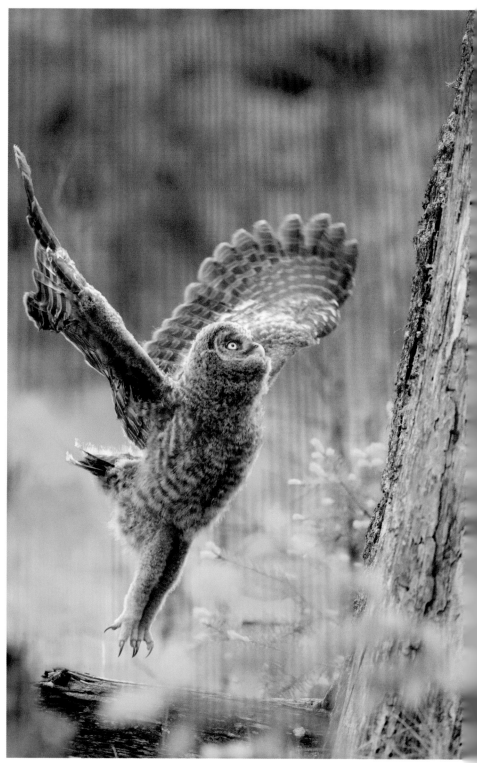

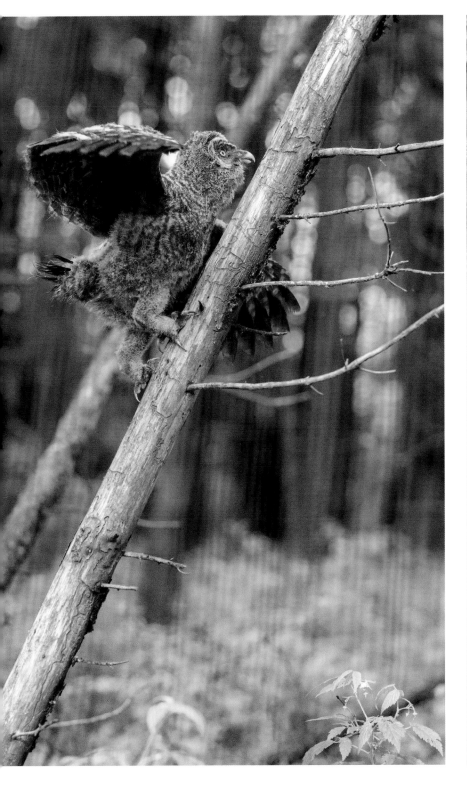
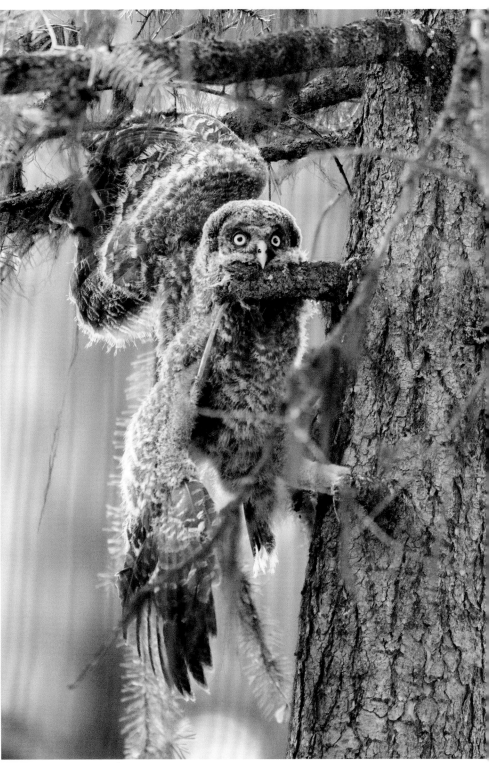

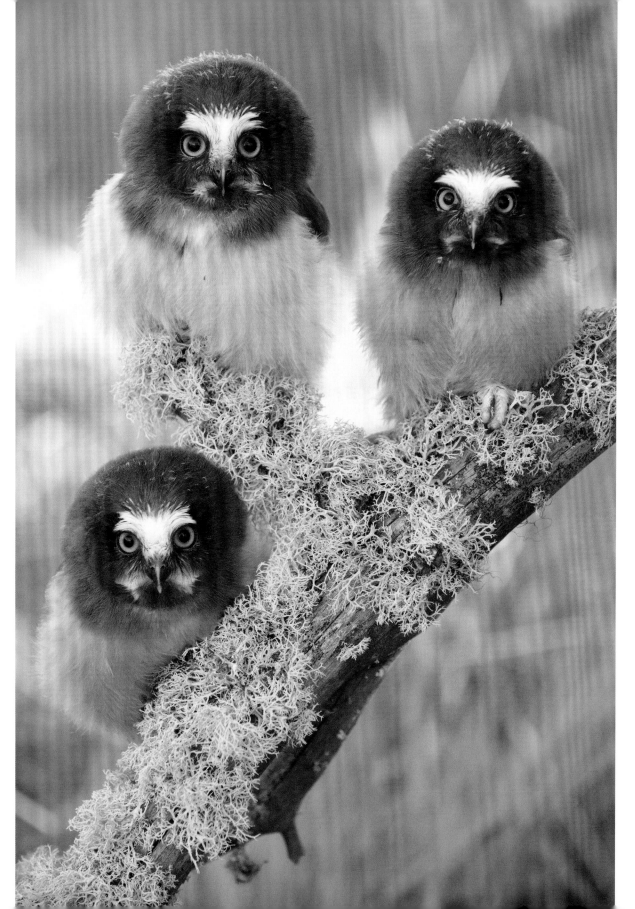

Northern Saw-whet Owls, like these recently banded four-week-old owlets, have perhaps the most distinctive juvenal plumage.

{ *opposite* } A Burrowing Owl, perhaps ten days old, stretches after emerging from the nest at dusk.

{*page 140, left* } A Great Gray Owl sits next to its young, protecting it and keeping it warm on its first evening out of the nest.

{ *page 140, right* } A Great Gray Owl juvenile leaps toward a tree it will climb to reach safety.

{*page 141, left* } A juvenile Great Gray Owl climbs a tree to get off of the ground and avoid predators.

{ *page 141, right* } A juvenile Great Gray Owl arrests its fall by hooking its bill on the stub of a Douglas fir branch.

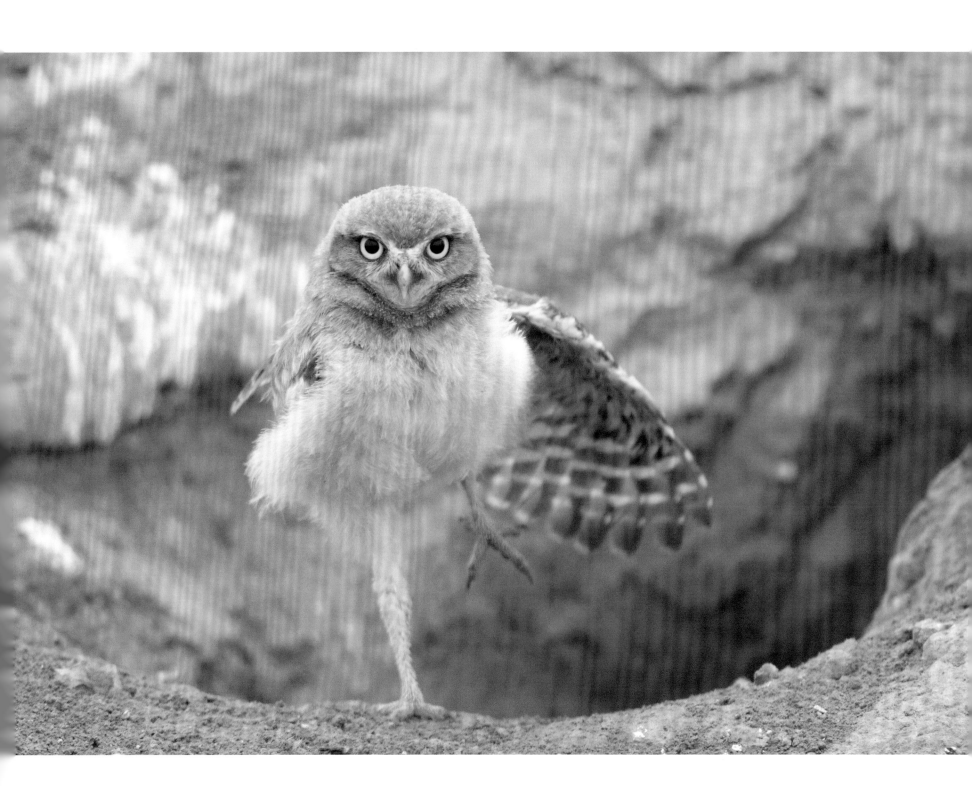

After walking away from its nest, its parents, and its five siblings, a two- to three-week-old Short-eared Owl must find deep vegetation to keep it hidden from predators and avoid being hit by vehicles. Short-eared Owl populations in the Lower 48 are rapidly declining as their grassland habitat is fragmented and converted to other uses. These populations are heavily dependent upon public lands and ungrazed and unmowed agricultural land.

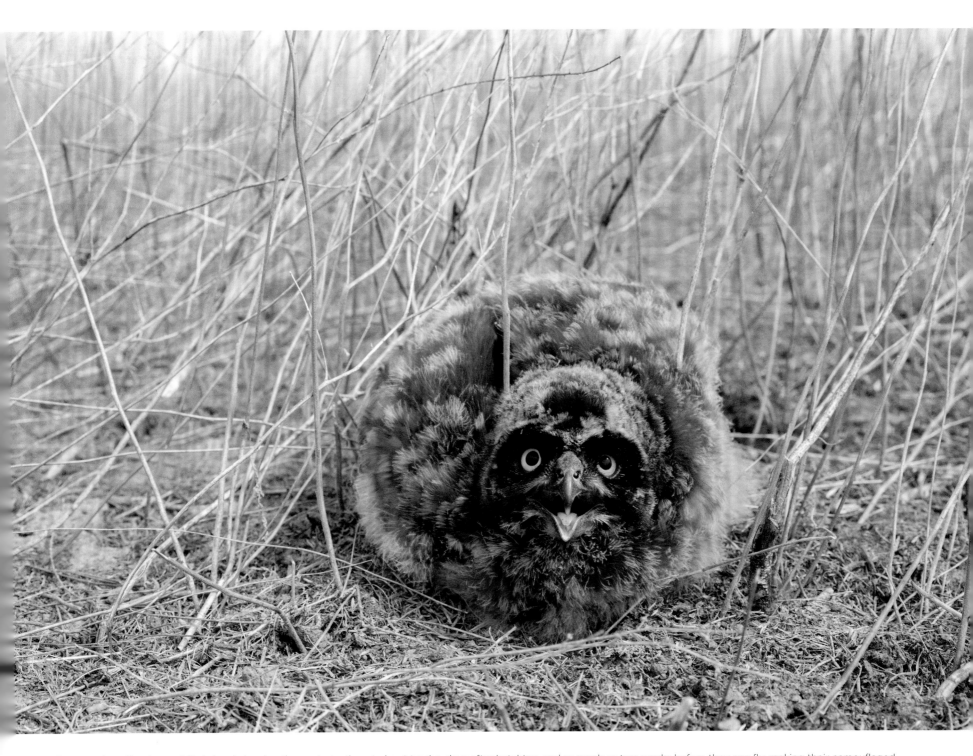

One at a time, Short-eared Owls begin leaving the nest, starting at about twelve days after hatching, and as much as two weeks before they can fly, making their camouflaged juvenal plumage very important.

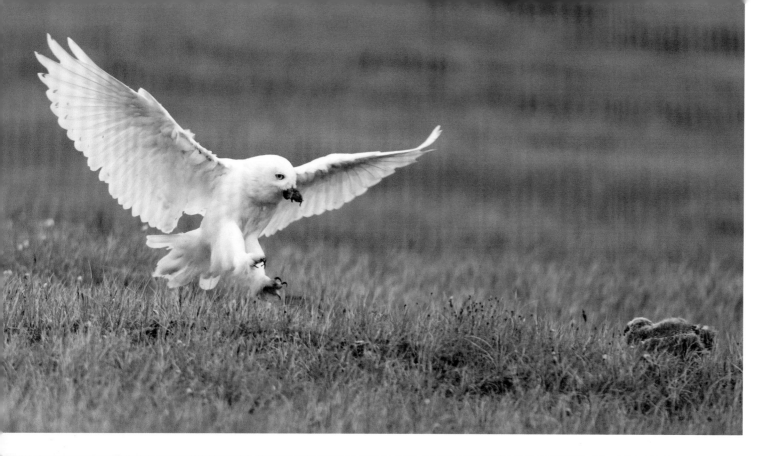

{ *top* } A male Snowy Owls flies in to deliver a small lemming to a three-week-old owlet that left the nest just a few hours earlier.

{ *bottom* } For juvenile Snowy Owls like this one, concealment is the best way to avoid predation; they may crouch low behind tundra mounds to hide until they are capable of sustained flight.

{ *opposite, top* } A juvenile Snowy Owl pauses after crossing a tundra pond.

{ *opposite, bottom* } Juvenile Snowy Owls look like adults by the time winter arrives. As they near four weeks of age, juvenile Snowy Owls develop mature-looking white feathers at the ends of their tails and wings and a "white-goggled" appearance above their bills.

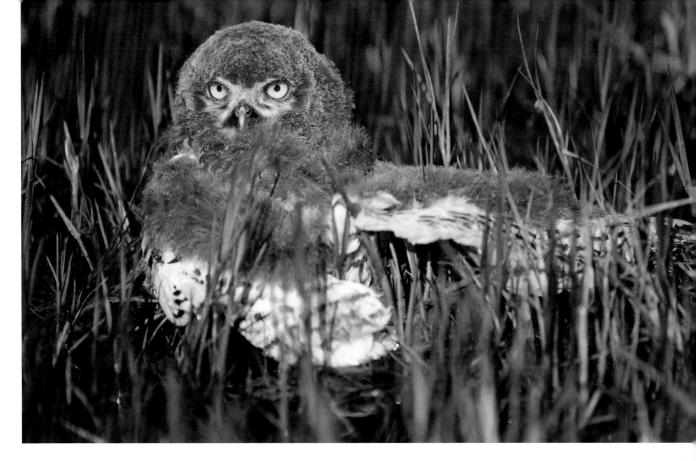

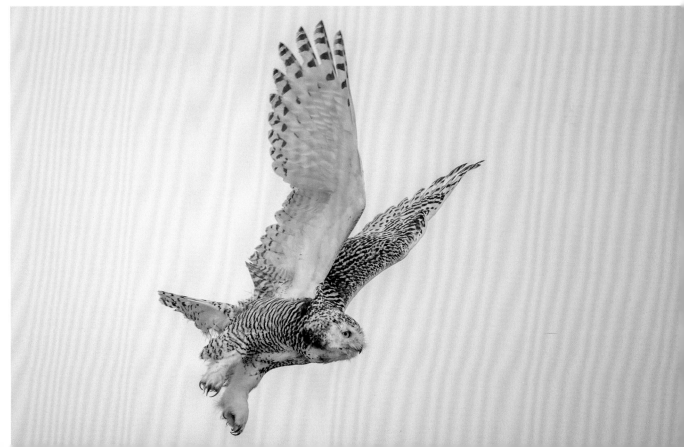

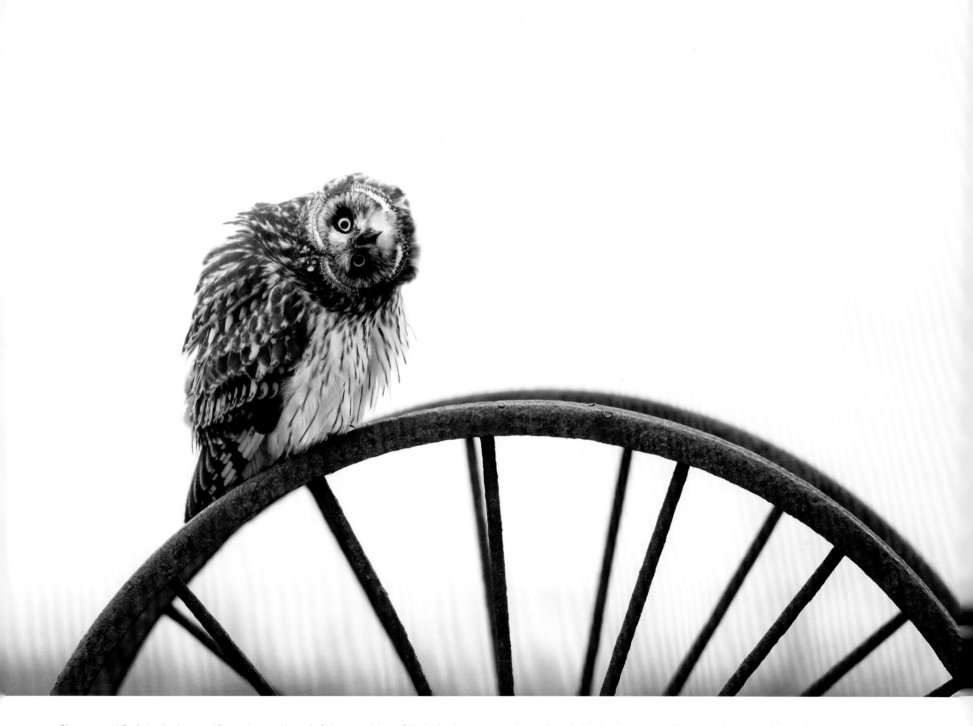

Short-eared Owls in the Lower 48 require our thoughtful stewardship of their shrub-steppe and grassland habitats. Short-eared Owls can be compatible with agriculture as long as vegetation remains high enough to conceal nests, juveniles, and roosting adults.

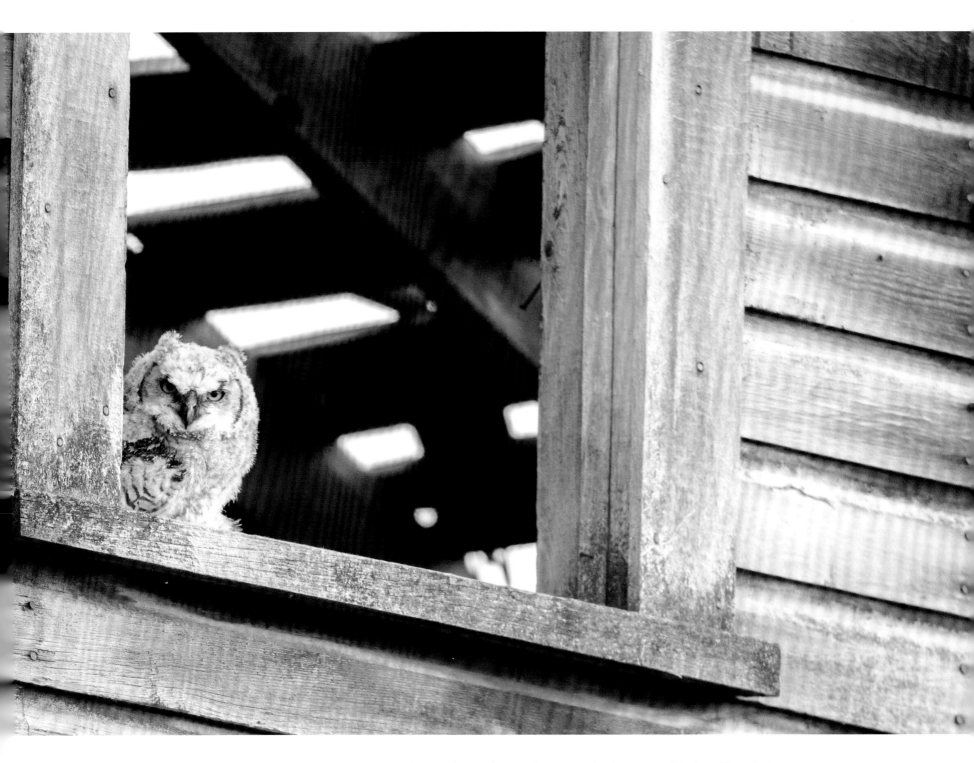

Human structures like barns, silos, garages, steeples, nest boxes, and platforms make good nest and roost sites for Great Horned Owls and Barn Owls.

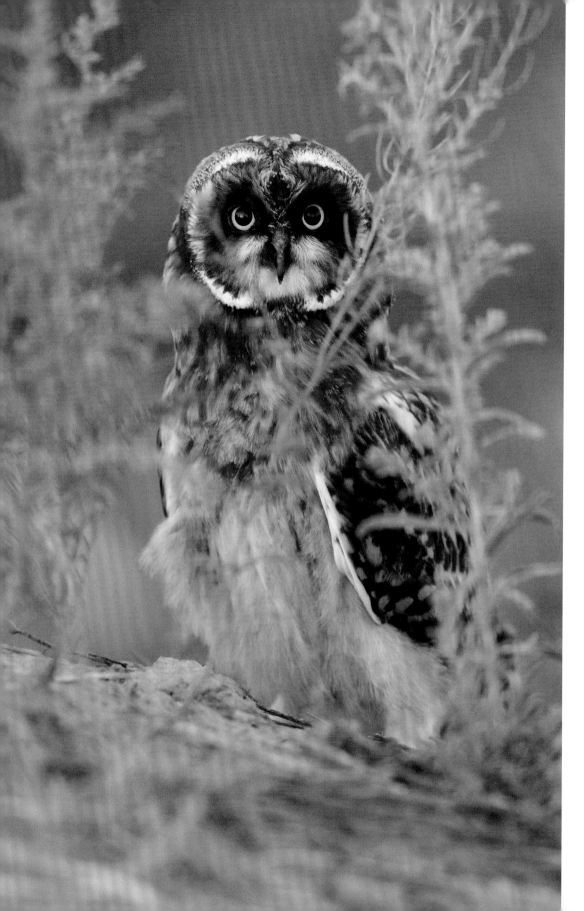

Two months after they leave the nest, Short-eared Owls look like very much like adults, although they have darker faces and less-distinct markings.

{ opposite } A juvenile Burrowing Owl flaps its wings while its more sedate siblings stand by.

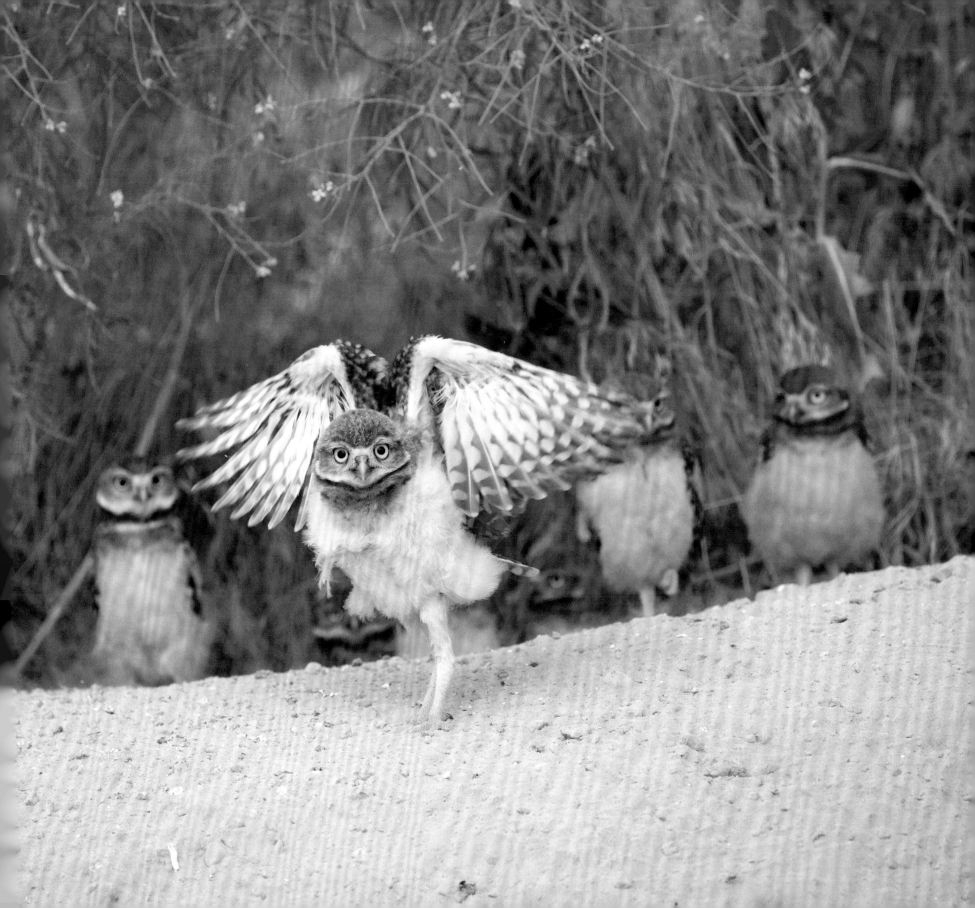

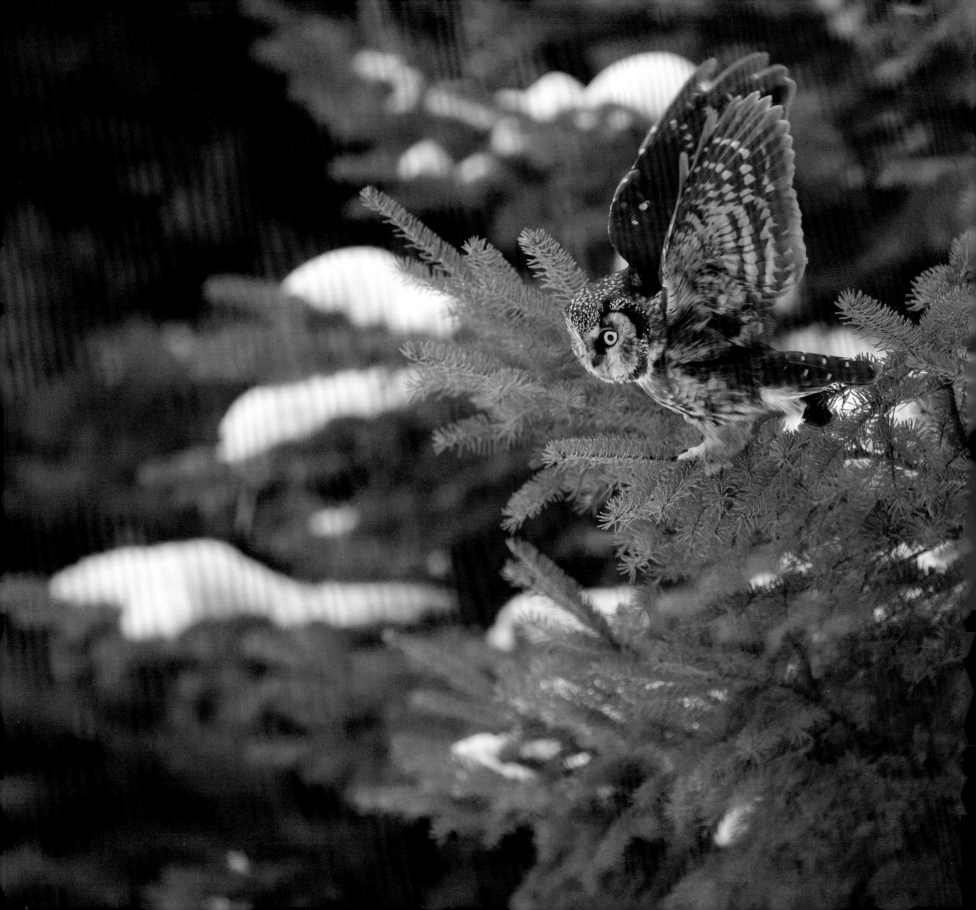

SURVIVING THE WINTER

Winter is the most challenging time of year for an owl. The cold weather and snow make food more difficult to find. Owls must either enlarge their territories or move to where prey is more easily captured, or they will starve.

The winter migrations and other movements of owls are often mysterious, and we do not fully understand what drives some to move to particular places in certain years. Their movements are sometimes as subtle as flying downslope, where snow cover is thinner, as predictable as annual migrations of hundreds or thousands of miles, or as complex as irruptions or nomadic wanderings. These adaptations vary by species and even within species, with northern owls often moving farther than members of the same species that breed to the south where it is more habitable.

Surviving the winter is the final test for young owls. Within only a few months of learning to hunt, they must capture their own food in new environments at the most difficult time of the year. Some owls establish their own territory, while others live on the edge of a territory of a more experienced bird that is willing to fight to defend it. Some, called "floaters," take a bigger gamble and live secretively inside an established territory.

A Boreal Owl lifts its wings an instant before taking flight in pursuit of prey.

In the winter, owls move to where they can find enough food to survive. Elf Owls and Flammulated Owls, for example, must migrate hundreds of miles into Texas, Mexico, or Central America, where their prey—insects, scorpions, and other arthropods—are still active and abundant.

Northern Hawk Owls, Boreal Owls, and Short-eared Owls, which feed on a limited number of small mammal species with populations that skyrocket and plummet, are adapted to wandering up to thousands of miles in the winter in search of areas with an abundance of prey. Other small-mammal specialists, such as Northern Saw-whet Owls and Long-eared Owls, show a mixture of approaches, with some dispersing and some migrating, depending on latitude and habitat. Barred Owls, Spotted Owls, the three Screech-Owl species, most Great Horned Owls, and other resident owls simply enlarge their territories to find enough food.

In winter, owls and other birds are often found in unusual concentrations where their common prey is plentiful, provided they can find proper shelter. Owls of multiple species from the boreal forests, separated by thousands of miles during the summer, may find themselves talon to talon at the southern edges of their winter ranges where trees border farmlands. Owls that nest in different watersheds of the same mountain forest may seek shelter in thick riparian cover along the same lowland stream. Owls from different open habitats—the arctic tundra, grasslands, shrub-steppe, farmland, and even open woodlands—leave the cold Arctic or frigid interior to compete with one another in the moderate climates of open coastal areas. Every hour of every day is a struggle. In many cases, competition for survival may force the owls to hunt at unusual times. Winter territories that provide enough food are defended as long as they can sustain the owls.

Irruptions occur in the winter, when a plethora of a particular owl species moves outside its normal wintering range. Irruptions are complex and show some variation among species. They are often tied to fluctuations in prey availability

and in some instances to the success of the previous breeding season. Wide variations in abundance of prey are one of the harsh realities of boreal and arctic habitats in Canada and Alaska. When populations of lemmings, voles, or snowshoe hares are low or hard to access under snow, owls must travel. If a bust follows a productive breeding year, great numbers will be on the move. These movements are often, but not always, southward, with many owls of several species and of subtly different habitats arriving in the same wintering grounds.

During irruption years, Great Gray Owls, Northern Hawk Owls, and Boreal Owls can be found hunting during the day very close to one another. Winter, in effect, condenses the owls' landscape, funneling them from the huge swatches of boreal forest into a limited number of places that feature the shelter of woods adjacent to open areas with a rich supply of accessible prey.

Open habitats like tundra, grasslands, shrub-steppe, and agricultural lands of the plains and the Intermountain West also become inhospitable to many owls in the winter. Some, but not all, owls fly to more moderate open habitats along the coast or farther south, sometimes replaced by owls of their own species from farther north. Meadows, farms, fields, ranches, public lands, and especially coastal estuaries often have the most accessible rodents and waterbirds in the winter and attract a broad array of species from a wide range of places. Owls from the Arctic may be forced to compete with, tolerate, or combat owls from the boreal tundra, the Great Plains, or the neighboring farm.

I have witnessed nine Long-eared Owls roosting together like Christmas tree ornaments in the winter in California's Central Valley. Even prey species are forced to take risks: I saw three Barn Owls roosted in a stand of cottonwoods with two Great Horned Owls one winter in southeastern Washington.

The largely nonmigratory Barn Owl is adapted to warmer climates, so low winter temperatures determine the extent of its northern range, where they can suffer die-off. At the very time when Barn Owls struggle the most to survive, they

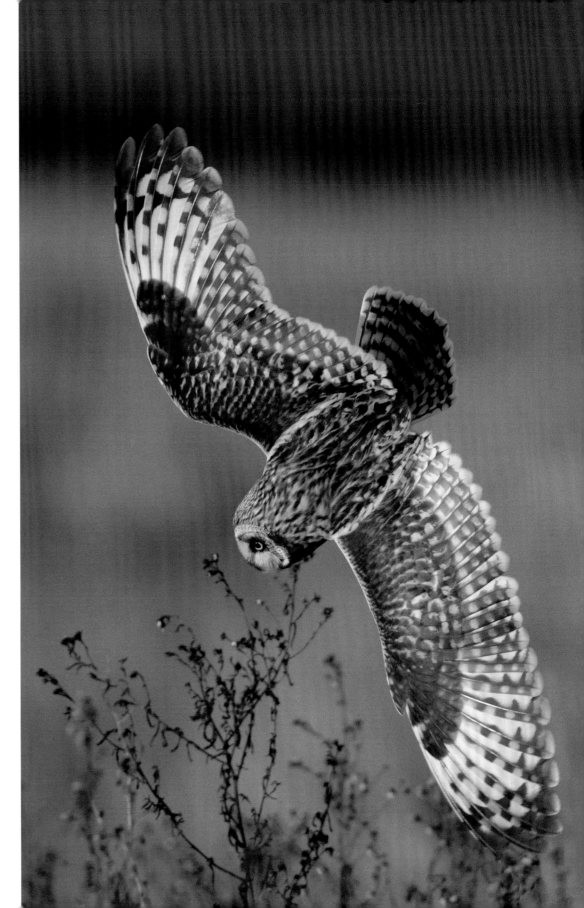

FRIENDS OR FOES

Owls, for the most part, do not make their own nests, so they rely on the work of other animals to help them out. Sometimes a "helper" is also the owl's worst enemy, and sometimes the owl is also a predator of the "helper."

Burrowing Owls and Badgers

Burrowing Owls and badgers both live in the grasslands and shrub-steppe of the Great Plains, Intermountain West, and Great Basin. Both animals live in tunnels in the ground, but since Burrowing Owls cannot create their own burrows, they must rely on those created by other animals such as prairie dogs, ground squirrels, and badgers.

The badger is a ferocious member of the weasel family that digs hundreds of tunnels every year. During late summer, badgers often dig a new burrow every day. Many of these burrows, or tunnels, make ideal nest sites for Burrowing Owls. Unfortunately for Burrowing Owls, badgers can easily dig into a Burrowing Owl nest and eat eggs, young, and sometimes even adults. In one study, badgers accounted for 90 percent of Burrowing Owl predation, and another showed that more than 7 percent of broods were lost to badgers.

Long-eared Owls and Black-billed Magpies

Long-eared Owls and Black-billed Magpies share much of their habitat and range in the grasslands and shrub-steppe of the west. Long-eared Owls nest primarily in the stick nests created by ravens, crows, and particularly Black-billed Magpies. These three birds are often predators of the eggs and nestlings of other birds, including Long-eared Owls. Fortunately, healthy Long-eared Owls are usually able to deter magpies from dislodging them and accessing their eggs and young.

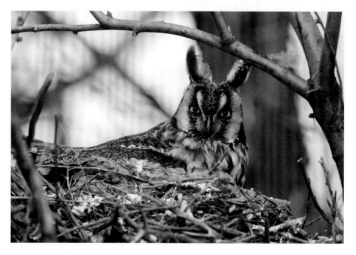

Counterclockwise from left: A badger pauses while digging a burrow that might later be used by a Burrowing Owl; a Long-eared Owl broods her young in an old magpie nest; a Black-billed Magpie prepares to fly from its domed nest.

are often joined by more cold-adapted competition. During these times, they must hunt when their prey is most active or easiest to catch, forcing this normally nocturnal owl to occasionally hunt during the warmer daylight hours.

Short-eared Owls are perhaps the most exciting component of hospitable open landscapes during the winter, when they float out of the grass with the fog at the day's last light. One late afternoon by a meadow in coastal British Columbia, I watched in awe as long-winged Short-eared Owls with their moth-like flight hovered close to normally nocturnal Barn Owls and Long-eared Owls, while dangerous Great Horned Owls and Snowy Owls prepared their evening hunts from nearby perches.

Prey-rich coastal estuaries, often close to major cities, can host Short-eared Owls, Barn Owls, Long-eared Owls, Great Horned Owls, Northern Harriers, Rough-legged Hawks, Red-tailed Hawks, Peregrine Falcons, Prairie Falcons, Gyrfalcons, American Kestrels, Bald Eagles, Northern Shrikes, and even Snowy Owls drawn from across the continent. The competitors aggressively defend loose territories against members of their own species. They also object to intrusions by other species, particularly those that compete for the same prey or that are potential predators.

If the wintering grounds were a theater stage, the Short-eared Owls would be the stars, or at least the best performers. They have so little weight per inch of wing surface that they appear to simply step into the air when they leave a perch. Seemingly of the sky, they lift off, slice, dive, tumble, hover, and float without any perceivable effort. They can instantly change their course or angle of flight. Their acrobatic flying can make them difficult to track with binoculars or cameras, particularly in their favored low-light conditions. This owl of the sky, so vulnerable on the ground, is extremely well camouflaged, making it disappear as it flies low over, or prepares to melt into, its identically colored and patterned grassy habitat. There, it often roosts close to other Short-eared Owls, sometimes in communal roosts that may include Long-eared Owls.

On one occasion, I watched a Bald Eagle that did not have a chance against a much smaller Short-eared Owl. After days of incessant hovering, aerial confrontations, screams, and talon grappling, the Short-eared Owls had created an uneasy truce among themselves. They had divvied up several territories on winter wetlands in Washington State's Skagit Valley, and the Bald Eagle was not welcomed. The eagle landed on an uprooted segment of cottonwood that had washed ashore. Almost immediately, a Short-eared Owl darted out of the grass straight at the raptor, veering off just before contact, and rising sharply after each pass, fixing the eagle's attention as it hovered just out of reach of the eagle's sharp open bill. The owl then dove behind the eagle and launched a threat from the other side. As successive challenges continued from seemingly every angle, the eagle, ten times the size of the owl, was repeatedly forced to raise its wings, crank its head, and shift its position. Eventually it tired and flew off.

Northern Harriers are up to the challenge, however. Whereas these hawks bubble out of the grass at sunrise, Short-eared Owls tend to rise from the same places in the late afternoon, a time for squabbles. These two similarly sized raptors practice the same hunting strategy to pursue the same prey in the same habitat. They both course over grassy areas for small rodents, which brings them into frequent conflict on common wintering grounds, especially when one catches food.

In a drama that plays out dozens of times each evening in such places, a Short-eared Owl, with its silent flight and acute hearing, will drop upon a vole, carefully covering it with outstretched wings in a common raptor strategy called mantling. A Northern Harrier, aware of what this means, dives at the Short-eared Owl, trying to force it to fly. If the owl takes flight, the slightly larger harrier seems to have the advantage as it comes straight at the Short-eared Owl, threatening contact. By the time the Short-eared Owl raises its talons to defend itself, the Northern Harrier has already changed its target to the falling prey. The Short-eared Owl

{ page 154 } A Long-eared Owl reacts to a Northern Harrier flying overhead as it prepares for its evening hunt. Normally Long-eared Owls are nocturnal, but a long stretch of sub-freezing evenings forced this owl to make an earlier start.

{ page 155 } A Short-eared Owl, hunting at sunset, turns and dives instantaneously after hearing a vole moving through the vegetation below.

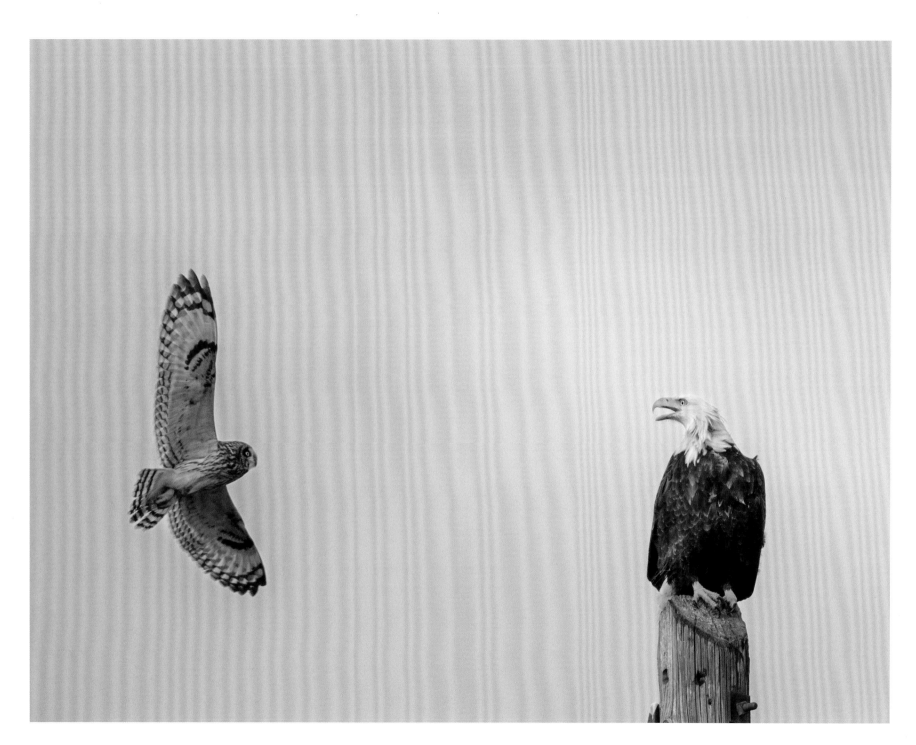

The smaller but more maneuverable Short-eared Owl dives incessantly at the head of a Bald Eagle that finally leaves after enduring a couple dozen near misses.

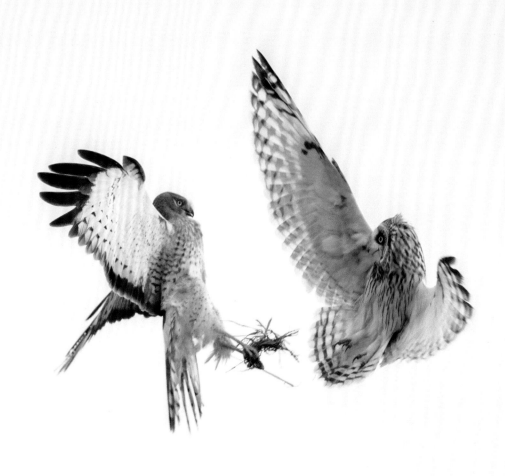

A Short-eared Owl confronts a Northern Harrier that just stole and dropped a vole that the owl had captured. The faster Northern Harrier was able to dart to the ground and recover the fruits of its thievery.

normally gives chase, but the harrier tends to flee rather than defend and risk losing the prey.

Although there are many great places to see such winter scenes unfold, the assemblage of numbers and species is unpredictable and irregular, influenced by the birds' breeding success in the preceding months, the accessibility of prey in normal home ranges, and the abundance of prey species, especially voles, on wintering grounds. When vole numbers continue at high levels, visiting Short-eared Owls might even stay and breed the following spring.

Wintering owls often show up on farmlands and in parks, refuges, and other public lands close to large coastal cities, where they serve as reminders of how interconnected our habitats are, and of human impact on owls' ability to survive and return to their home ranges to breed.

NORTHERN PYGMY-OWL

Northern Pygmy-Owls must enlarge their territories in the winter when prey becomes less abundant. Small mammals are harder to find, reptiles and amphibians are in hibernation, and many small birds have migrated. And so these owls often move downslope to places along waterways or near bird feeders, where there is a greater concentration of passerines and rodents.

One December, a friend living in the eastern foothills of the Washington Cascades told me of a Northern Pygmy-Owl that periodically visited his backyard feeder to take California Quail attracted by the seed. A few weeks later my friend called to tell me, "The owl is back and it's got another quail!" When I arrived, the Pygmy-Owl was not there, but my friend showed me where it had cached what was left of the two quail. On a follow-up trip, I set up my camera and waited for a couple of hours in the snow, focusing on the most recent kill. Finally, the owl returned and began eating.

That evening brought a couple of additional feet of powder snow, which covered the remains of both quail. The next day, I watched in the blowing snow and freezing

temperatures, but saw no sign of the owl—or any other birds, for that matter. I began to worry about the owl and its ability to survive the unusually harsh storm.

Usually I am opposed to interfering with nature, but worrying about the owl's ability to survive, I uncovered the most recently cached quail and placed it on top of the snow. Without warning, the owl dropped from a tree and into the now partially filled depression. After looking around, it began digging with its face and feet, the front of its head covered with a mask of white. When it had dug to the depth where the prey had been, it spread its search a little bit wider before jumping to the edge of its excavation. It then shook off the snow vigorously, completely ignoring the partially submerged quail carcass in front of it, and flew off. So much for doubting the owl's ability to survive the snow. After a few minutes, the owl flew to the site of the older quail, dug in exactly the right spot and to the proper depth, and began eating. I sneaked over to the fresher quail and nudged it back into the hole, covering it with snow. To my surprise, after struggling to get meat off the older quail, the owl flew back to the fresher site, dug into the snow, found its original target where it belonged, and began eating.

That encounter reinforced two ideas about Northern Pygmy-Owls: that they move downslope during winter snow and find areas with unusual prey abundance, and that owls have exceptional spatial memories. I had seen Northern Pygmy-Owls and Northern Hawk Owls cache food on many occasions, but I had not imagined the degree to which they memorize the exact locations, even when visual cues are hidden—a life-saving skill for birds that depend on fluctuating food supplies.

This owl was wintering in Washington's Central Cascades at about two thousand feet along a stream that leaves a quaking aspen–ponderosa pine woodland and drains into shrub-steppe. A few other friends in this area also shared similar experiences with Pygmy-Owls moving downslope for the winter to "manage" their bird feeders at this time of the year.

{ *opposite* } Northern Pygmy-Owls are renowned for their ability to capture prey larger or heavier than themselves.

Many mid-elevation mixed-conifer riparian areas throughout the western United States host unusually high concentrations of Northern Pygmy-Owls during winters with heavy snow. One year in this type of habitat in Washington, I located five Northern Pygmy-Owls within three miles of a small tree-lined stream at the transition point between shrub-steppe and ponderosa pine habitat. During the rest of the year, I would be extremely lucky to find one pair in such a small area.

I have also had the pleasure of seeing winter-wandering Northern Pygmy-Owls show up on public lands in the suburbs of Vancouver, B.C., and Seattle. One February, I observed two Northern Pygmy-Owls that had made a winter home of a restored riparian area in the Cascade foothills east of Seattle. The site provided dense mature conifers for shelter, while a beaver dam and surrounding wet meadows attracted passerines and voles. The owls sought cover in the dense canopy of the mature forest of red cedar and big-leaf maple but spent early mornings hunting in the restored wetlands.

The Northern Pygmy-Owl has a habit of rhythmically twitching its tail back and forth when it is excited, particularly when it has its eyes on prey. While I was watching one of these owls for an hour as it changed high perches, the bird's aggressive tail-twitching conveyed that it had found something of interest. A sudden dive took the owl to the low branches of a western red cedar. After again twitching its tail, it dove into the shallows of the beaver pond below. After a splash and a pause, it dragged itself into the air, struggling to fly with the weight of its quarry, before settling onto a branch three feet above the pond, where it rested with a vole that appeared to be bigger and heavier than the owl itself.

Only some Northern Pygmy-Owls migrate downslope when food is difficult to find in their normal territory. Often they do so in response to cold or excessively deep snow. Sometimes visiting Northern Pygmy-Owls remain downslope only until snow at higher elevations retreats, whereas at other times, they stay until courtship begins in March.

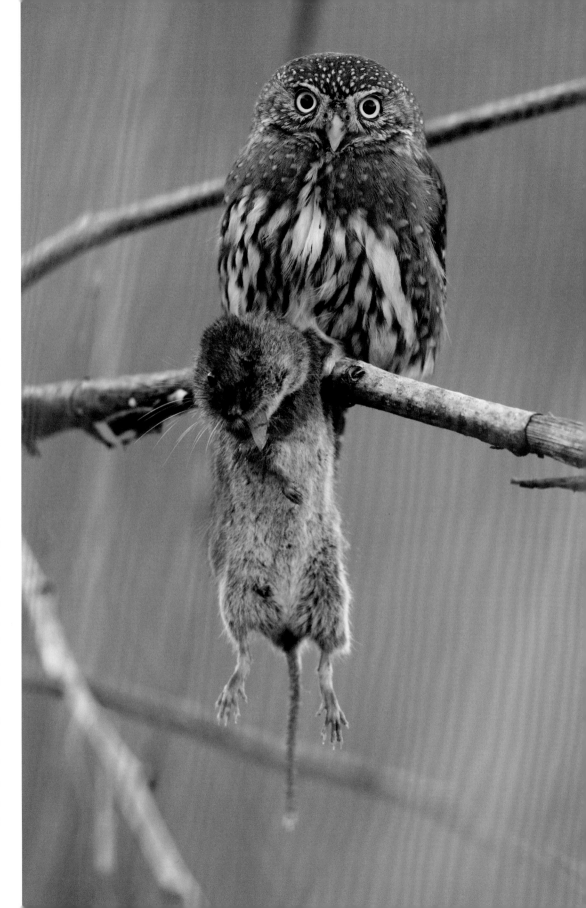

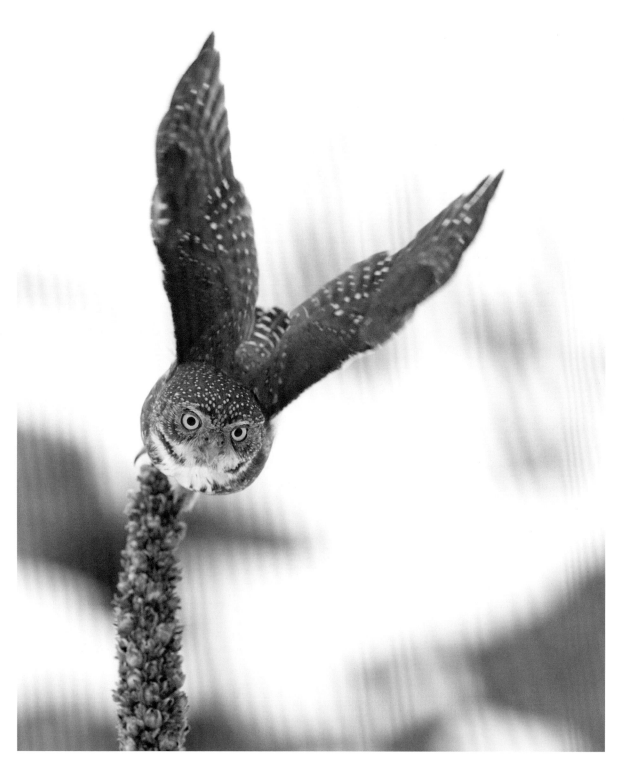

With lightning-quick movements, a Northern Pygmy-Owl's wings explode from its body, and the bird darts like a bullet towards unsuspecting prey below. The owl's small size and unpredictable movements make it the most difficult North American owl to photograph in flight.

{ opposite } The Great Gray Owl initiates a hunt by simply stepping off of its high perch and floating silently over the prey it hears moving under the snow below.

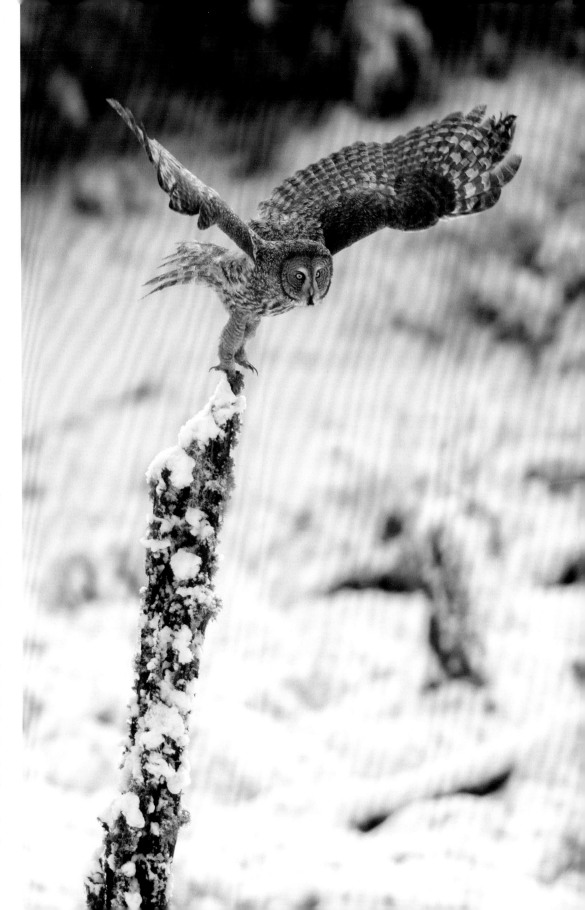

GREAT GRAY OWL

Winter impacts Great Gray Owls in the western US differently from their kin to the north. Owls in the mountains of the western states often remain on their home range year-round, although deep snow may encourage them to move downslope in search of food. Northern populations migrate to look for food following prey declines but do not necessarily seek places where snow is shallower. Historically these movements by northern birds were seen as nomadic wanderings, but research by Dr. James Duncan suggests that these are actually movements between distinct breeding home ranges as distant as five hundred miles apart. Surviving owls will often return in later years to previously used breeding home ranges. In winter, without young to look after and with food as their prime focus, Great Gray Owls are found in more open habitats, such as mountain meadows, farm fields, and ranchlands, where they have the best chances to find their prey—voles and pocket gophers.

One frigid February in Manitoba, the thermometer registered negative 38 degrees Fahrenheit as I observed five Great Gray Owls hunting around a three-mile stretch of road. The landscape stretched into the distance, white, gray, and bitter cold. There was so little contrast between the gray of the tangle-branched cottonwoods and the Great Gray Owls that when the snow was blowing or the light was low, it was nearly impossible to spot them unless you were within a few feet or they moved.

Great Grays, more than any other owl, are well adapted to hunting in deep snow. Their acute hearing, silent flight, and long legs enable them to reach moving prey up to about eighteen inches beneath the surface. Like other birds that rely on their hearing to hunt, they perch low to be closer to their potential prey. One icy morning, I found a Great Gray Owl dozing where he had last hunted, on a branch less than a foot off the ground. He was so low that the end of his tail was actually in the snow.

With the freezing weather and thick crust on the snow at night, the five owls were active during the day. As three

of these impressive birds with five-foot wingspans rose off the icy tree limbs, the featureless white canvas of the field was soon host to three independent spirits, each transforming from amorphous gray cloud to bird as it left the trees, floating with wings raised and head down, pausing in the sky, and then quickly thrusting downward before dissolving into the snow to capture prey.

Photographs often help me see what otherwise happens too quickly to be discerned, and the clean, white snow helps distinguish features that might otherwise be lost in grass or brush. My images have given me a much better sense of how a Great Gray Owl finds and secures its prey. Fortunately for me, Great Grays can be quite indifferent to human presence during the winter, and these owls have frequently hunted close to me.

Watching a Great Gray Owl reminds me of watching an expert do card tricks. It can drift effortlessly over a meadow the majority of the time, giving the impression that all its movements are slow and deliberate, and then suddenly, within a fraction of a second, the legs and talons swing forward toward their quarry, just as the owl slams into the snow or sod.

After the pounce, there is a pause and then a search. The owl's sharp claws and forceful strike are so quick and violent that the disheveled owl often comes up with more than a vole or pocket gopher; it may also grasp clumps of sod. The owl will feel around with its talons to see if it has indeed seized its intended quarry, and if not, it reaches deeper for it. If the owl does not locate its prey, it will try again. Sometimes it can hear its prey retreating under the blanket of snow, and will hop along in pursuit.

As February turns into March, the gray ghosts vanish back into the colorless woods, eventually returning to their breeding grounds.

In grabbing its prey, a Great Gray Owl reaches so deeply into the snow that its tail and body nearly disappear.

{ *opposite* } One of the largest owls in North America, the Great Gray Owl can nonetheless disappear into tight spaces in its forest haunts, thanks in part to its very flexible wings and feathers.

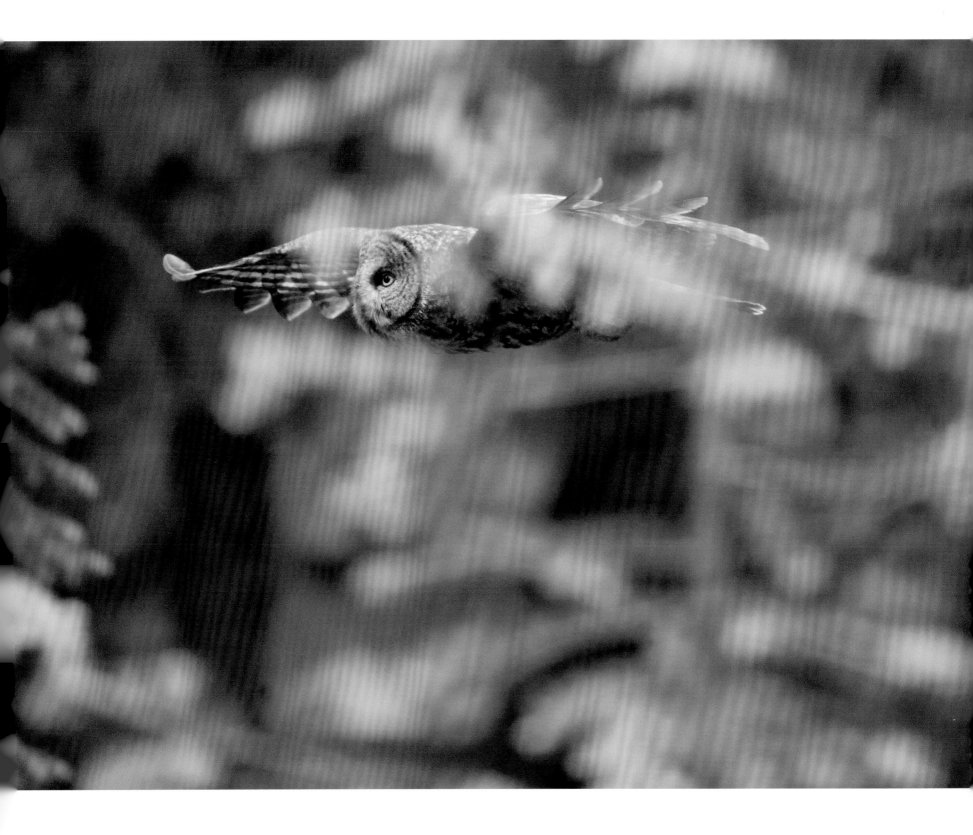

MORE FRIENDS OR FOES

Great Gray Owls and Northern Goshawks

Great Gray Owls nest on a variety of platforms, including the nests of raptors, and they are particularly fond of Northern Goshawk nests. Northern Goshawks are found throughout the entire range of the Great Gray Owl. Their nests are often of the preferred size and in the optimal location within the forest to meet the needs of the Great Gray Owl. The Northern Goshawk is also a predator of large-bodied birds and one of the main predators of juvenile Great Gray Owls.

Owls and Woodpeckers

Most forest owls prefer to nest in tree cavities, but it takes trees several decades to develop cavities created by natural forces like lightning, fire, and rot. Cavity-nesting owls prefer cavities on the vertical faces of trees with small entrances and large interiors—exactly the type of cavities woodpeckers create. Twenty-two woodpecker species create nest and roost cavities, and most of those species create at least one new cavity each year in dead trees or in large dead branches of live trees. Ten North American owl species benefit from at least one type of woodpecker that shares a common habitat and can create a cavity that an owl can immediately use as a nest. Woodpecker excavations may also indirectly benefit five other species of cavity-nesting owls by introducing heart rot to trees, enlarging the opening and volume of the cavities, as well as hastening the creation of natural cavities where woodpeckers excavate.

Woodpeckers may benefit from owls to some degree, because owls can help to keep populations of nest-predating rodents low. But that benefit comes with great risk, since the tree cavities of woodpeckers are sometimes usurped or preyed on by their owl neighbors. Woodpeckers, like passerines, mob owls to reduce the risk of predation to themselves or their young.

Left to right: Three Great Gray Owl nestlings prepare to leave a nest originally constructed by a Northern Goshawk. A Northern Goshawk, with an avian victim in its talons, calls as it takes flight. An Eastern Screech-Owl nestling peers nervously from its woodpecker-created nest in response to the efforts of a Red-bellied Woodpecker to reclaim the cavity and drive away the potential predator.

BURROWING OWL

Most Burrowing Owls in the northern part of their range begin their winter migration in August or September, four to eight weeks after the young become independent. These Burrowing Owl migrations are complex and vary by habitat, geography, and even gender. Florida Burrowing Owls, which are considered to be a separate subspecies, are year-round residents, and since they are not on the migration path of Burrowing Owls from the north or west of them, they do not experience any significant influx of Burrowing Owls from elsewhere during the winter.

Most populations outside of Florida and southern California are migratory to some degree, although exceptions include some owls in the Southwest and some urban owls in Washington, Idaho, British Columbia, and California. The Southwest birds have a higher degree of variability in their migration patterns by individual population and within these by gender, age, and from year to year. In some parts of the Southwest, males are more likely to stay in place, whereas females migrate. You might expect male birds in Texas and southern Colorado to follow that pattern, but most of them migrate or wander quite far in the winter.

Burrowing Owls that breed in Canada and the northern United States normally winter from the southern plains into Mexico. Many northern Burrowing Owls likely winter in the Southwest or Mexico, and migrating birds that breed in Washington, British Columbia, and California migrate south along the Pacific Coast, but we do not know

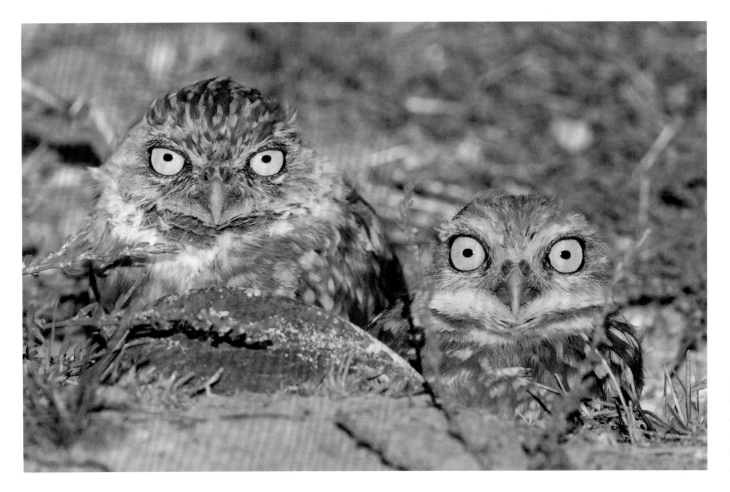

In the fall, young Burrowing Owls, looking much like adults, disperse and migrate; they often hide in unusual cavities such as pipes (seen here) and even tufts of grass.

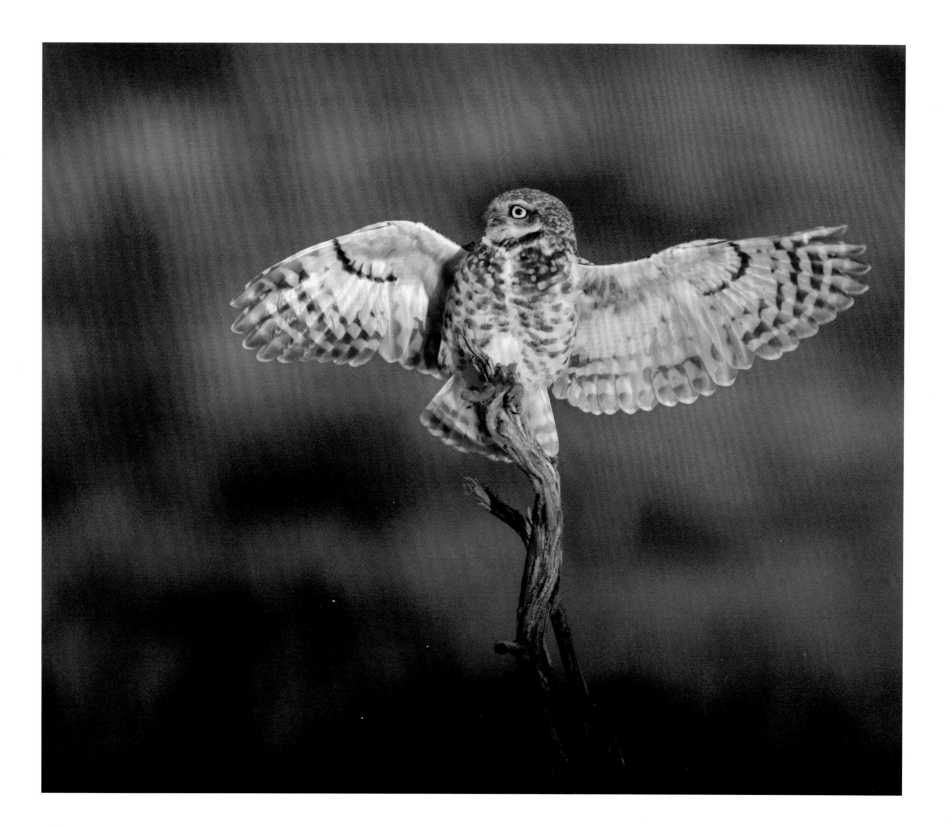

the exact migration paths or even the destinations for most populations. We do know that northern Burrowing Owls typically migrate to areas south of where resident birds live. It is likely that a bit more than half of the young live long enough to make their first migration.

Young Burrowing Owls, even those that don't migrate, disperse from natal areas which are maintained by males. In Florida, adult males often experience a high mortality rate from collisions with vehicles, predation by cats, and other urban dangers, which is probably one reason a large percentage of juvenile males are able to remain on their natal territories through the winter.

Normally, wintering locations for these owls look very much like where the birds breed and nest and have similar weather. Most locations are open, grassy, or sandy places with short vegetation, some raised perches, and holes for hiding or roosting. For these owls, simple holes, sometimes even rock piles, pipes, culverts, and even dense tufts of grass will suffice, even when a burrow is nearby.

I first photographed Burrowing Owls one winter near the Washington coast. An owl was roosting in a natural cavity on a sandstone bank, which was unusual. This bird of the interior was very near the marine environment of Puget Sound, so it may have been stopping over on its migration south, or perhaps it got lost along the way.

One November, many years later, I visited the San Francisco area to observe more typical wintering Burrowing Owls. Local volunteer Burrowing Owl monitors told me that Burrowing Owls in San Francisco and to the north were migratory, whereas Burrowing Owls south of the city were mostly residents.

The migratory Burrowing Owls I watched there presented a great contrast to the nesting owls I had watched in Idaho, Washington, Colorado, and Kansas. Instead of perching erect among a group of other Burrowing Owls before a backdrop of sage, dirt, and grass, these owls crouched alone among piles of rock, with the Pacific Ocean or San Francisco Bay behind them. Further south, near San Jose,

the residential owls were in more typical habitats among other owls and ground squirrels, their primary nest burrow creator in California. But like the birds directly to the north, they were difficult to find while the sun was up. The owls spent most of the hours it was light during the winter inside of their burrows, only rarely flying between the openings in the ground. During daylight hours, they seemed to ignore the insects and rodents that might be the subject of their attentions at night. Just as the sun was setting, however, the owls opened their eyes, stretched, and made low flights to nearby cover. By sunrise, the majority of the hunting was completed and the owls had disappeared.

The approach of these California owls to hunting was also quite different. During the summer, Burrowing Owls with the pressure of supplying a mate and offspring with food, might hunt at any hour and use one of several methods to spot and capture food. Most of the time, they visually scan the surrounding landscape from elevated perches where they can spot prey or predators. Upon sighting prey, they fly to or hover over their target before striking. Occasionally, adults also chase prey on the ground. In contrast, wintering Burrowing Owls begin most of their hunting from their burrows, making low direct flights between ground squirrel holes or shrub cover, or even hopping or running after prey. They rarely utilize higher perches or hover. In short, more of their hunting activity occurs nearer to the ground and closer to their burrows.

This nocturnal activity and low hunting flights and pursuits make Burrowing Owls much more difficult to detect in the winter. While their method of hunting limits the food they might locate, their burrows, being more dark and moist than the surrounding open landscapes, are natural retreats for some of their primary prey. Not surprisingly, it is nocturnal prey such as voles and beetles that dominate their winter diets. Other prey taken during the winter includes rats, mice, bats, Jerusalem crickets, toads, salamanders, earthworms, and even some small birds. While the list of potential targets is large, studies have shown that Burrowing

{ opposite } A Burrowing Owl lands on a sagebrush snag where it is lit by the last rays of the winter sun. In the winter, Burrowing Owls are very secretive and nocturnal.

Owls prefer small mammals and will stop pursuing other prey when these preferred rodents are abundant.

Burrowing Owls continue to be primarily nocturnal hunters until they migrate to breeding grounds in March.

SNOWY OWL

One November day on Alaska's North Slope, I was photographing Snowy Owls when the first major snows of winter hit. Overnight, gold tones gave way to blues. Every sound was muffled. The young owls disappeared. During these times, only the hardiest of creatures, including polar bears, arctic foxes, ptarmigan, and some adult Snowy Owls, remain.

While freezing temperatures can hit during any month, the average high is below freezing and falling beginning in October. On November 19, the sun dips below the horizon and remains there for more than two months. By February 21, the average low is negative 21 degrees Fahrenheit.

It takes a hardy, experienced bird with sufficient prey to survive these extremes. Many Snowy Owls and all Short-eared Owls leave the Arctic by November. While Short-eared Owls move south, the movements of Snowy Owls are much more complex and are poorly understood; they involve a mix of migrations, irruptions, and nomadic behavior that varies by year, population, sex, and age. Some remain near breeding sites, especially when lemmings are plentiful, while the wanderings of others may bring them to between Alaska and Russia. Some Snowy Owls migrate north, often going dozens of miles out to sea, where they prey on seabirds as well as Eiders and other sea ducks that feed along openings in the ice. Snowy Owls that stay in the Arctic through the winter will also eat ptarmigan, hares, and even some carrion killed by other animals.

We know that many North American Snowy Owls migrate to the northern Great Plains of southern Canada and the northern United States every year, but other southerly movements are less clearly understood. During some winters unusually large numbers of Snowy Owls occur irregularly and unpredictably when they move south of their breeding grounds, often showing up outside places where they normally migrate. Contrary to popular opinion, which blames this phenomenon on a lack of prey, experts agree that the largest Snowy Owl irruptions are probably a result of a lemming spike during the prior breeding season that helped the owls raise an unusually large number of young that then fanned out over treeless expanses in the winter. With many young, more birds fly over the boreal forest and appear in larger numbers just south of the forests on the Great Plains, and around beaches and agricultural areas near the Great Lakes, Northeast, and Northwest. This theory is bolstered by the fact that, in such years, the majority of the irruptive birds are juveniles. Other factors, such as weather patterns, quantity of snow, and populations of alternate prey, may play a role as well. Bird banding and satellite data are providing information on individual birds and should help us better understand these movements over time.

I witnessed my first Snowy Owl irruption in the Pacific Northwest in the winter of 2005–2006. A smaller "echo" irruption occurred in the Northwest in 2006–2007, with yet another and much larger one nationwide in 2011–2012 that brought Snowy Owls to every province in Canada and to thirty-one of the fifty US states including Hawaii. The winter of 2013–2014 brought an irruption to the Upper Great Lakes and Northeast Coast but very few owls to the West. Apart from those years, not many Snowy Owls have been found outside their typical areas during the winter.

By the time of the irruption in 2011, I had already been to the Arctic several times and had discovered how difficult it is to find Snowy Owls in their breeding habitat. It struck me that people have a better chance of seeing Snowy Owls just outside many large northern North American cities during an irruption than they do in the best of tundra habitats in a good year.

When Snowy Owls first arrive at their wintering grounds in November and December, they move around quite a bit, being seen in new places every few days. By late

PREDATORS

Northern Goshawks, Great Horned Owls, and raccoons are probably the most common predators of owls, but other raptors, canines, and members of the weasel family (fishers, martens, weasels, and badgers) also take owls. *Clockwise from top:* Arctic fox, Cooper's Hawk, weasel, Ferruginous Hawk.

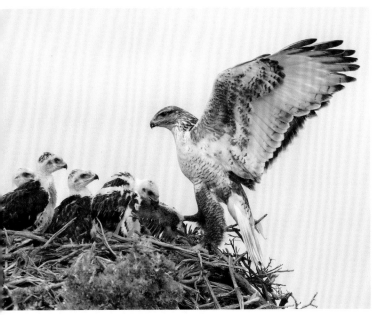

ARCTIC TUNDRA

The arctic and subarctic tundra is an herbaceous habitat covering the land between the boreal forest and the Arctic Ocean. The dry ground that Snowy Owls and Short-eared Owls nest upon is an intricate weave of the green, yellow, red, and white fibers of mosses, lichens, sedges, grasses, wildflowers, liverworts, and some low shrubs.

Only plants with short roots can survive on the thin layer of soil that rests on a frozen layer of subsoil, the permafrost. Very little precipitation falls on the arctic tundra, and most of what does fall is snow. The permafrost prevents the water from soaking deeper into the ground, resulting in the presence of innumerable openings of fresh water that serve the needs of millions of nesting and migrating birds.

Caribou, musk oxen, Rock Ptarmigan, and most importantly, brown lemmings and collared lemmings feed on the vegetation uniquely adapted to this tundra ecosystem. In turn, Snowy Owls, Short-eared Owls, and arctic foxes have population cycles dependent on the lemmings. Polar bears, wolves, and wolverines also feed upon lemmings and other animals that rely upon the tundra for their dens and nests, while musk oxen and caribou require the tundra for their feeding and migrations.

Oil drilling in the coastal plain of the Arctic Refuge and the National Petroleum Reserve (one of the richest known nesting areas for Snowy Owls) would disrupt the function of these biologically rich areas, with unknown consequences for significant populations of Snowy Owls and Short-eared Owls.

Climate change threatens the arctic tundra ecosystem by shrinking the area covered by permafrost, causing a loss of standing water, allowing deeper rooting plants like woody shrubs and trees to grow farther north, eliminating lemming habitat. Lemmings may also lose the insulating layer of snow that allows them to survive and multiply during the arctic winter.

Lower lemming populations challenge owls, especially the Snowy Owl, which breeds only on the Arctic and subarctic tundra and relies on lemmings to drive productive breeding years. Changes in humidity and winter temperatures in Norway and Greenland have already caused lemming collapses. Given this interrelationship, the long-term success of Snowy Owls is a good barometer for the health of tundra ecosystems.

Snowy Owls nest on tundra mounds but often hunt near ponds, streams, or ocean.

December, they often find places with a solid prey base, where they will spend the majority of their time over the next several weeks.

Slumber must wait when Snowy Owls are irrupting. While I was walking one day before sunrise on a beach trail in British Columbia, it was dark enough that I could not see whether I was stepping on ice or dirt, so I walked carefully while my eyes adjusted. Although there was not enough light for good photography, my 600-mm lens made serviceable "binoculars" as I strained to make out shapes in the dark over the tidelands. I scanned quickly, not wanting to waste time on anything but owls. The dozen or so white blobs were obviously gulls, so I skipped them and continued to scan the rest of the beach. On second thought, I decided to bring my lens back to the driftwood where the white blobs were, and instead of gulls, I realized I was focusing in on nineteen Snowy Owls! That serendipitous moment quickly passed, as a low-flying Bald Eagle dispersed the owls.

When we see Snowy Owls during the winter in southern Canada and the Lower 48 states, they are often younger Snowy Owls. That said, it is nearly impossible for even an owl expert to positively discern the age and sex of any owls, except older adult males, without having them in hand. On average, adult Snowy Owl males are whiter than females, with some males appearing almost completely white, but some young males look convincingly like small females. Younger owls are generally more heavily marked than adults of the same sex but there is tremendous overlap.

Snowy Owls choose to winter in places that have much in common with their arctic nesting habitats. They select broad, open landscapes like beaches along oceans, sounds, and large lakes, as well as farm fields, wetlands, and even airport grounds. These places not only offer plenty of prey but also allow the owls to hunt and roost in the same way they do on the tundra. Snowy Owls have strong vision: They can see prey from a mile away. Although they typically

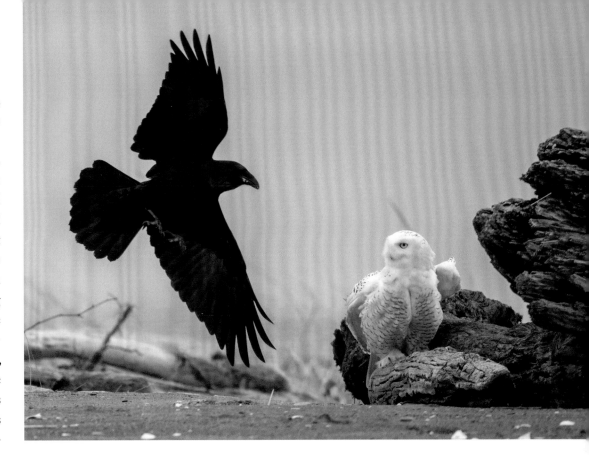

A Snowy Owl prepares to hunt as the sun sets against the snow-covered mountains. Snowy Owls are usually nocturnal and begin their hunting at dusk.

{ page 173, top } A Raven flies toward a Snowy Owl in a deliberate attempt to dislodge the owl from a preferred roosting area.

{ page 173, bottom } A Snowy Owl wastes no time when another Snowy Owl intrudes on its winter territory.

hunt from mounds on the tundra, they also use driftwood, snags, or even telephone poles as hunting perches.

Snowy Owls are opportunistic hunters in the winter but often target birds and small rodents, including lemmings, voles, rats, and mice. They prefer to pursure prey at night but are most active when their primary prey is most easily captured—including in the daytime, if opportunities arise.

During January of 2012, I was studying irrupting Snowy Owls on the Washington coast. It became a ritual for me—arriving at a dark, empty parking lot at 3:30 in the morning and pushing the car door open against the gusts and rain to collect my gear. I trudged through the soft sand at the surf's edge, toward the point where the owls were hunting, leaning into the wind and salt spray in the dark, using the horizon as my guide. As I approached, I walked in surf, sinking into the wet sand, and watched the horizon for the silhouettes of owls. I tried to figure out which perches they were using before choosing where to stand. Once I select a place, I try to stay put, to learn about and capture photos of the owls' natural behaviors as the sun rises.

One owl watched Sanderlings as they flew erratically over the wet beach, now bathed in pink light. The owl showed little interest for ten minutes or so, until suddenly his head bobbed up and down, left to right, and then froze for a moment before he took off on a chase. I never saw the owl with a Sanderling meal, but the three pellets I found near his perch were analyzed by bird expert Dennis Paulsen at the University of Puget Sound's Slater Museum and showed evidence of five Sanderlings and one Horned Grebe.

Another morning, being careful not to trip over logs or tumble into the ocean, I followed a Snowy Owl hunting in the inky-gray twilight. Hearing a sudden splash and a struggle in the distance past some driftwood piles, I headed cautiously and quickly in that direction. After wading in the surf and climbing over some wet driftwood in the dark, I came upon a Snowy Owl with a White-winged Scoter, a 3.5-pound duck with a thirty-four-inch wingspan.

Snowy Owls are not alone in these sought-after wintering spots. They compete with and sometimes hunt Short-eared Owls. One morning while looking for Snowy Owls north of Seattle, I crept slowly toward a known roost site, only to be saddened to find two pairs of Short-eared Owl talons among the owl pellets.

Over the past few winters, I spent some time photographing migrating Snowy Owls rather than irrupting ones and witnessed slightly different scenarios. Whereas the irrupting Snowy Owls frequently perched

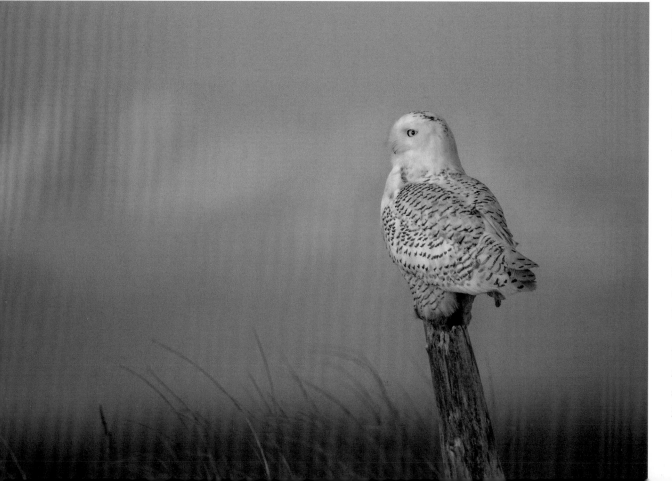

in groups of four or five, particularly during the early winter, the migratory owls of the Great Plains were usually alone, and when two were in close proximity, one drove the other off. Also, the best territories were often held by large lightly marked birds, which kept surveillance from atop barns, grain silos, or the tallest tree in a windbreak. These prime territories typically featured large, flat wheat fields bordered on at least two sides by irrigation ditches.

The relative abundance of adults and prey probably explains these behavioral differences. Many of the Snowy Owls wintering on the Great Plains are migratory and return to the same areas every year, defending a territory large enough to meet their feeding needs. A large percentage of these owls are also adults, which seem to have less patience for other Snowy Owls on their winter territories.

Irruptive birds, on the other hand, are often young birds with a less developed sense of territory in novel lands, and they appear to tolerate closer proximity to one another. In these places at these times, there are other Snowy Owls, appearing more like adults, that do not tolerate perching next to others or within a parliament (group of owls).

In southern Canada and the northern United States, many of the wide-open or lightly wooded expanses that allow Snowy Owls to find enough food to survive the winter are on public lands such as parks or beaches, or on agricultural lands inhabited by, or in close proximity to, people. Snowy Owls are dependent on these lands under our care if they are to survive the winter and return to the Arctic to breed in the spring.

A Snowy Owl steps forward as it lands on a beach at sunrise.

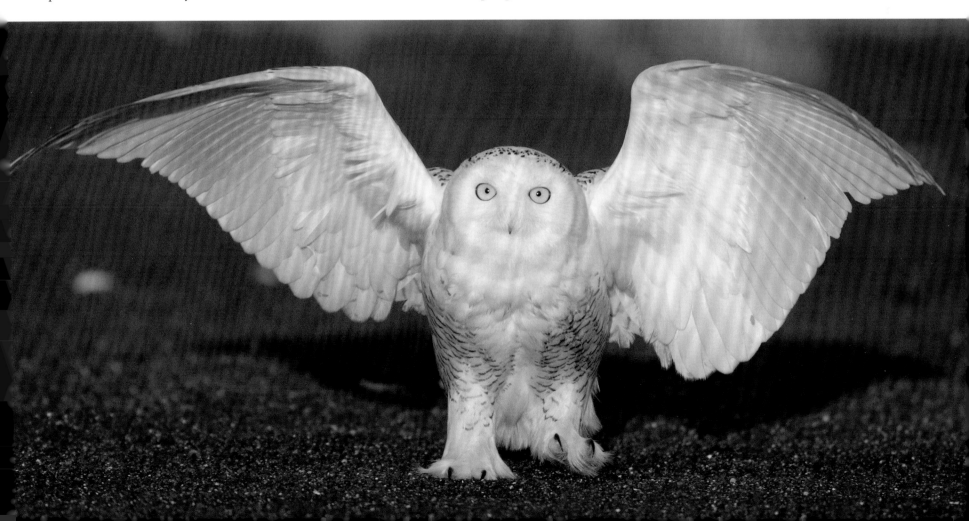

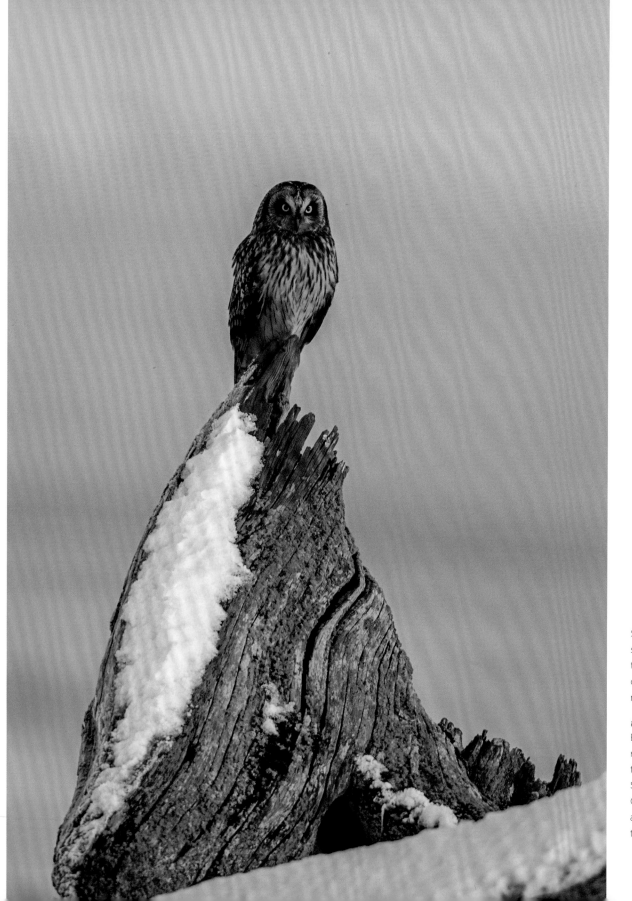

Short-eared Owls can be seen in the early morning, in the late afternoon, and on cloudy days, but they become most active after sunset.

{ opposite } A wintering Burrowing Owl perched on rip-rap prepares to hunt as the sunset reflects on the San Francisco Bay. Burrowing Owls are known to be active at all hours, but in the winter they are mostly nocturnal.

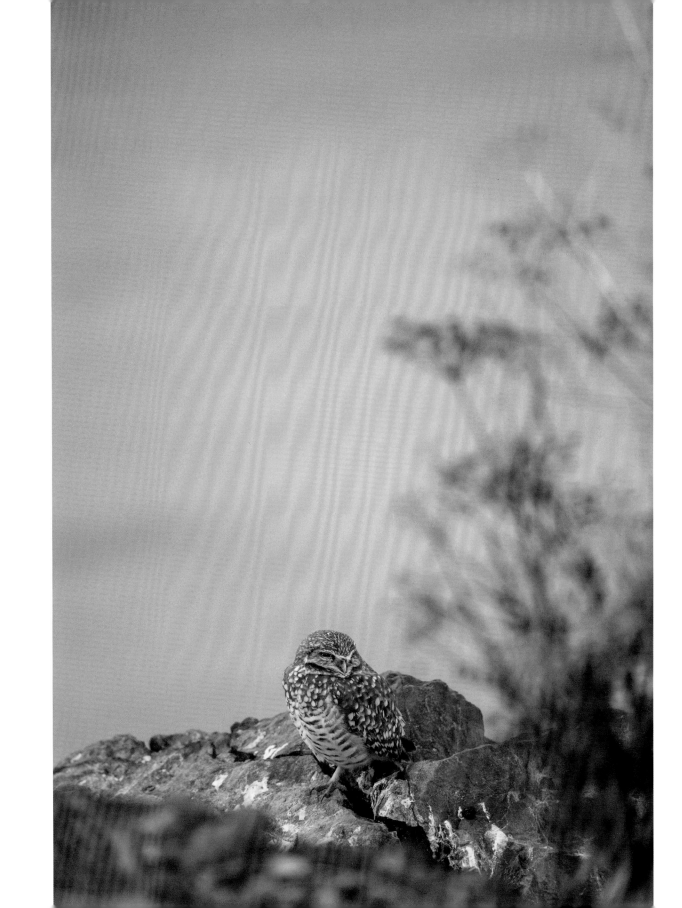

With their ear tufts depressed in flight, Long-eared Owls are difficult to distinguish from their close relative, the Short-eared Owl. Both owls possess long wings, relative to their body size and weight, providing great buoyancy in flight—a useful asset for hunting on wing in open habitat.

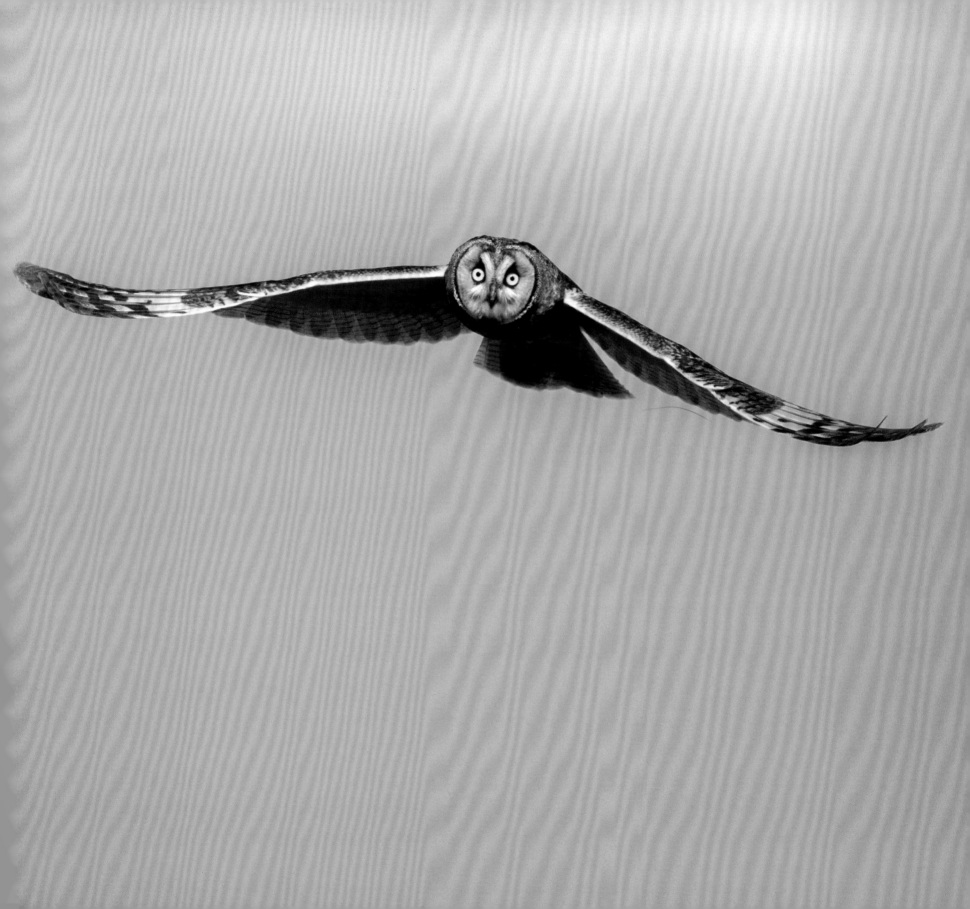

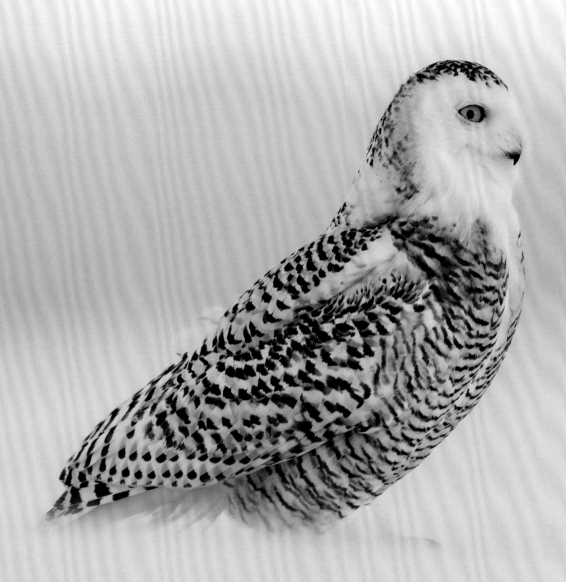

Epilogue: The Future of the Owl

All of the nineteen species of owls that lived in North America when Europeans first arrived survive today. Although some are doing relatively well compared to other wildlife, many have much smaller ranges and numbers every decade, and several are experiencing precarious declines. The most threatened owls are challenged by the elimination of habitat as a result of residential or commercial development, alteration of riparian areas, conversion to agriculture, grazing, timber harvest, and salvage logging. Other owls lose nest sites and food sources when people cut down snags or kill animals they perceive as pests. Climate change will certainly alter owl habitat and impact owls in ways we cannot fully predict.

As our continent becomes more populated, the fate of owl habitats and the owls themselves is very much in our hands. There are many things we, as individuals, can do to help, including landscaping for wildlife, providing nest and roost sites, and supporting organizations that help owls and protect their habitats.

While some core owl habitats are protected, other nesting, hunting, roosting, and winter habitats will certainly become farmland, ranchland, or suburban yards as more land is developed—benefiting some owls that are generalists but challenging those that require more specialized habitats. By retaining snags, large trees, wetlands, and existing riparian and intact meadow and steppe areas when possible and otherwise landscaping with native plants and sustainable water, we can make our property an extension of owl habitat. These efforts are important during all seasons, including the winter months, when most owls increase the size of their territories or migrate and move downslope in the western mountains. During irruptions, owls you may never have seen before—such as Snowy Owls, Great Gray Owls, Northern Hawk Owls, or Boreal Owls—may show up on your land and need your stewardship to survive the winter.

When we host owls, they often return the favor by eating many kinds of rodents and insects that we might consider pests. Rodents and insects become immune to poisons over generations but they never become immune to owls. Unfortunately, we continue to develop increasingly stronger chemicals such as new anticoagulant rodenticides that can be lethal to owls and other animals that eat poisoned rodents. For dealing with problem rodents around our homes, better alternatives are owls, supplemented by indoor cats, mousetraps, nonchemical methods, and, as a last resort, rodenticides that do not include powerful anticoagulants like brodifacoum.

We can also help owls by providing nesting options. While retaining snags is the best place to start, many owls will nest in manmade boxes or platforms. Of these,

In blowing snow, a Snowy Owl carefully scans the horizon for competing owls.

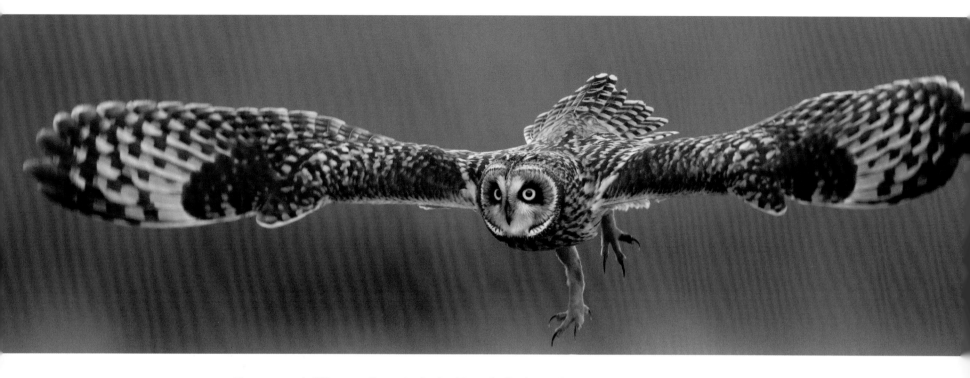

With its impressive wing-surface-to-weight ratio, the Short-eared Owl has great buoyancy, allowing it to step off a perch and straight into flight.

{ *opposite* } The paucity of giant ancient trees limits the nest options for Spotted Owls, like this one nesting in a rotted-out lightning scar in a 250-year-old Douglas fir.

Eastern and Western Screech-Owls, Barred Owls, and Barn Owls are most tolerant of suburban properties and dwellings. Great Horned Owls, Long-eared Owls, and Great Gray Owls will use manmade platforms. Barred Owls, Barn Owls, Northern Saw-whet Owls, Western Screech-Owls, Eastern Screech-Owls, Elf Owls, and Ferruginous Pygmy-Owls will use nest boxes. Since these owls also require cavities for roosting and even caching, you will have the most success if you install several of these boxes close to one another on your property. Each of these species prefers boxes of specific types with a particular size and shape of entrance hole. Local Audubon chapters can provide specific information, or visit http://nestwatch.org /learn/all-about-birdhouses.

Conservation of habitat and learning more about owls will matter most in securing their long-term survival. Protecting and connecting habitats can ensure that owls not only survive nesting but can subsequently disperse and find their own territories. Continued research ensures

that we are up-to-date on our understanding of these relatively little-studied animals. Consider supporting the work of nonprofits that preserve habitat used by owls and other animals and plants that share their ecosystems, as well as organizations and individuals who conduct research to help us better understand the habitat needs of owls.

Owls will always retain mystery for us. When that mystery engages us deeply, we will learn more about their lives and heed the message they have for us—a message that can teach us to protect them and other integral elements of the natural world.

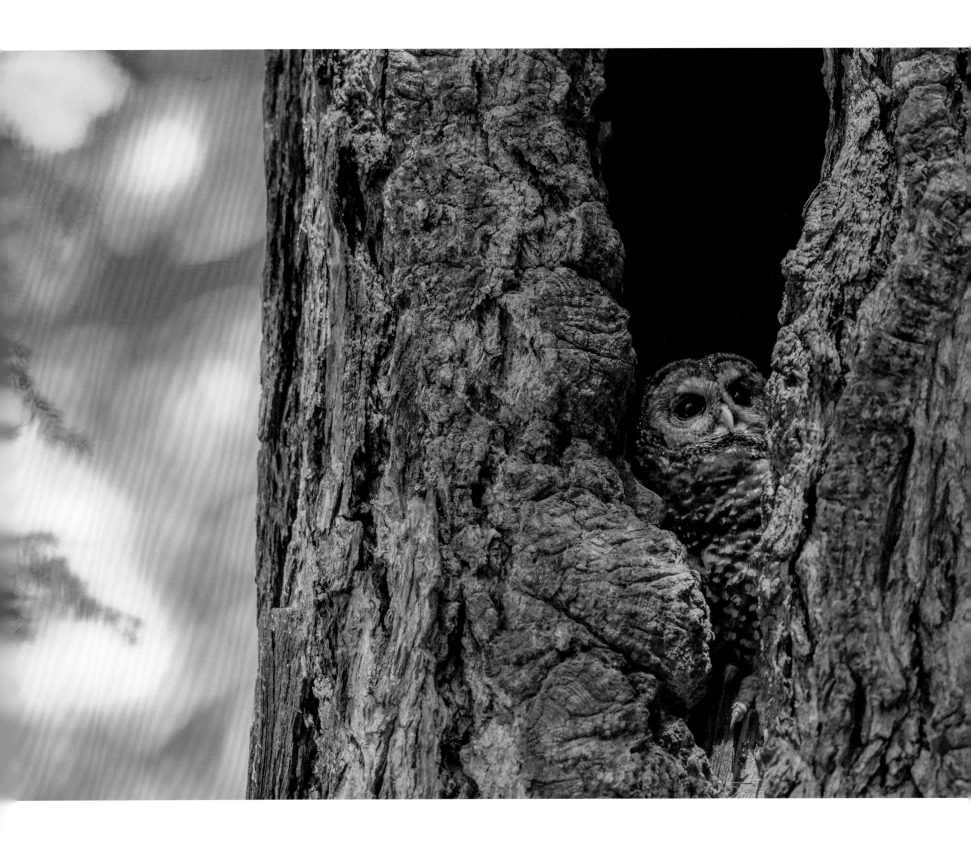

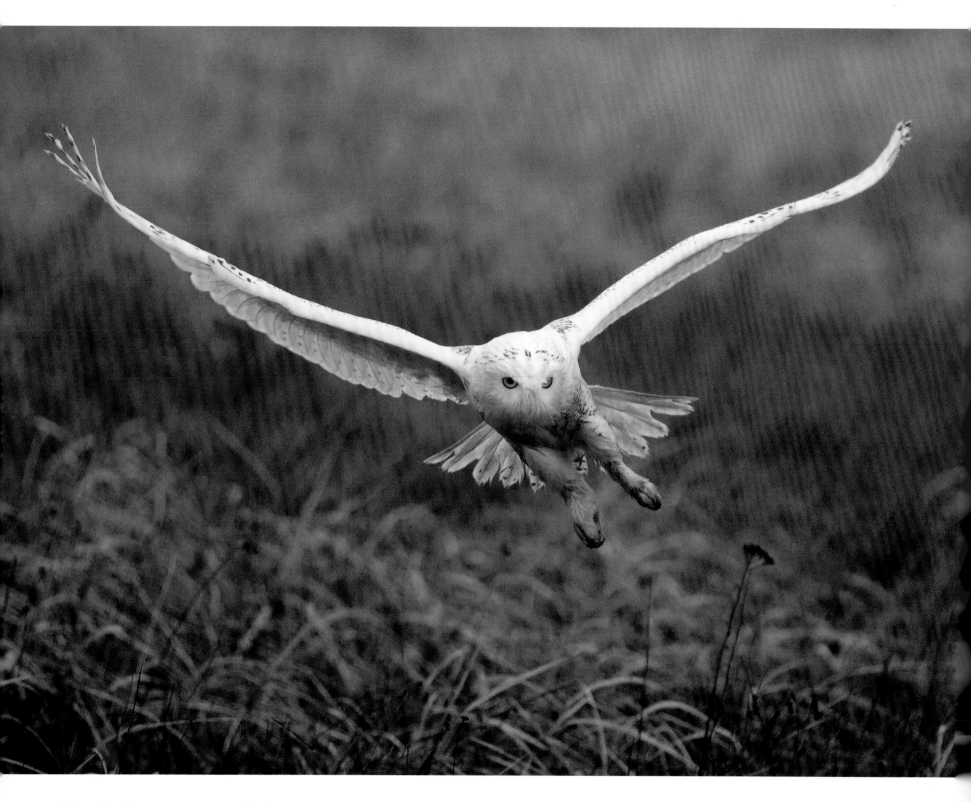

A Snowy Owl hovers over prey on a windy day..

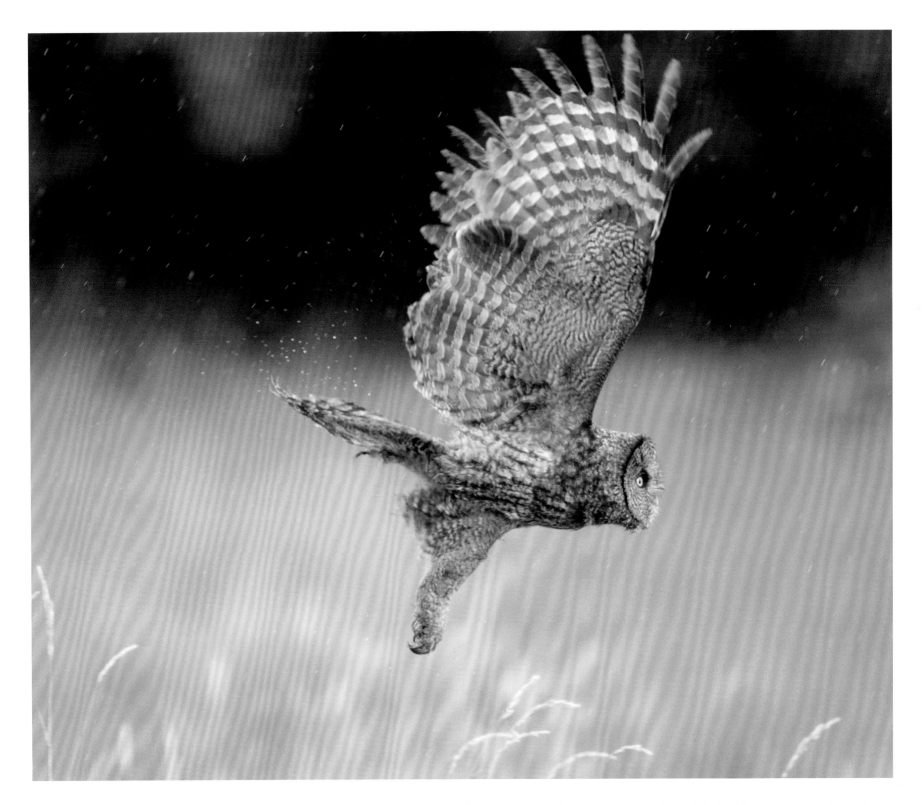

As they near independence, juvenile Great Gray Owls look much like their parents except for their leaner profile, smaller heads, and less distinct white patches below their chins.

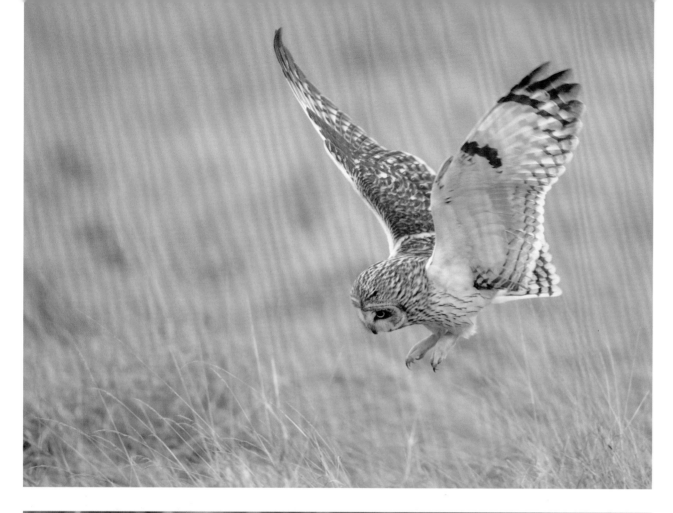

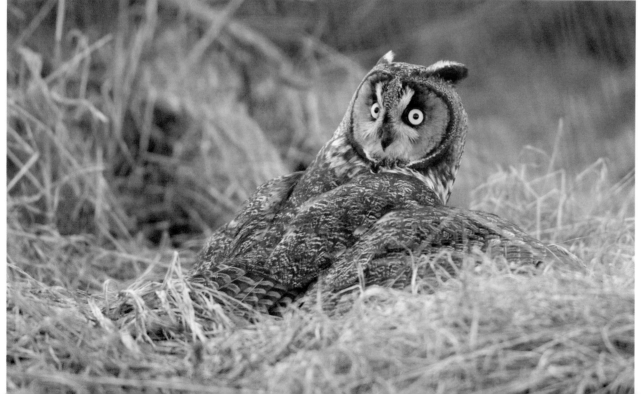

{ top } A Short-eared Owl prepares to strike after hearing a vole moving through the grass.

{ bottom } Long-eared Owls, in common with other owls, often spread their wings over their prey to hide it from potential thieves, a strategy known as "mantling."

{ opposite } A light-brown morph Western Screech-Owl extends its ear tufts in an attempt to remain hidden inside of the entrance of its roost cavity in the rotted limb of a big-leaf maple. Western and Eastern Screech-Owls and Barn Owls are surprisingly among the few cavity-nesting owls that also roost in cavities. Most cavity-nesting owls roost in dense vegetation or against the trunks of trees.

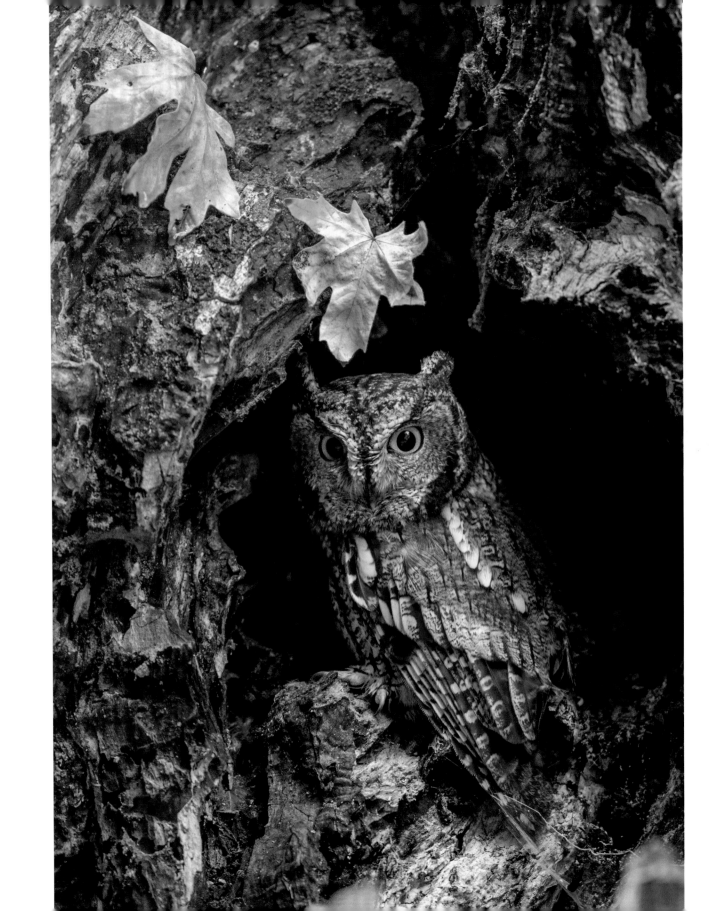

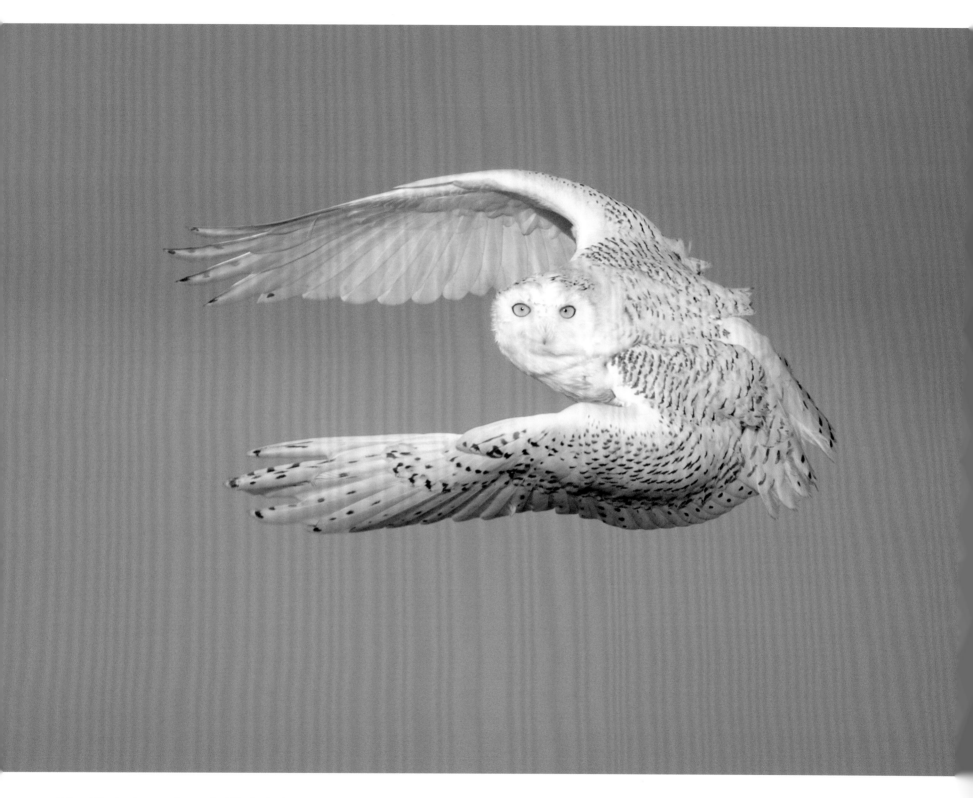

Using stiff wing beats, a Snowy Owl lifts its body nearly straight up and into the air after spotting a vole in the grass nearby.

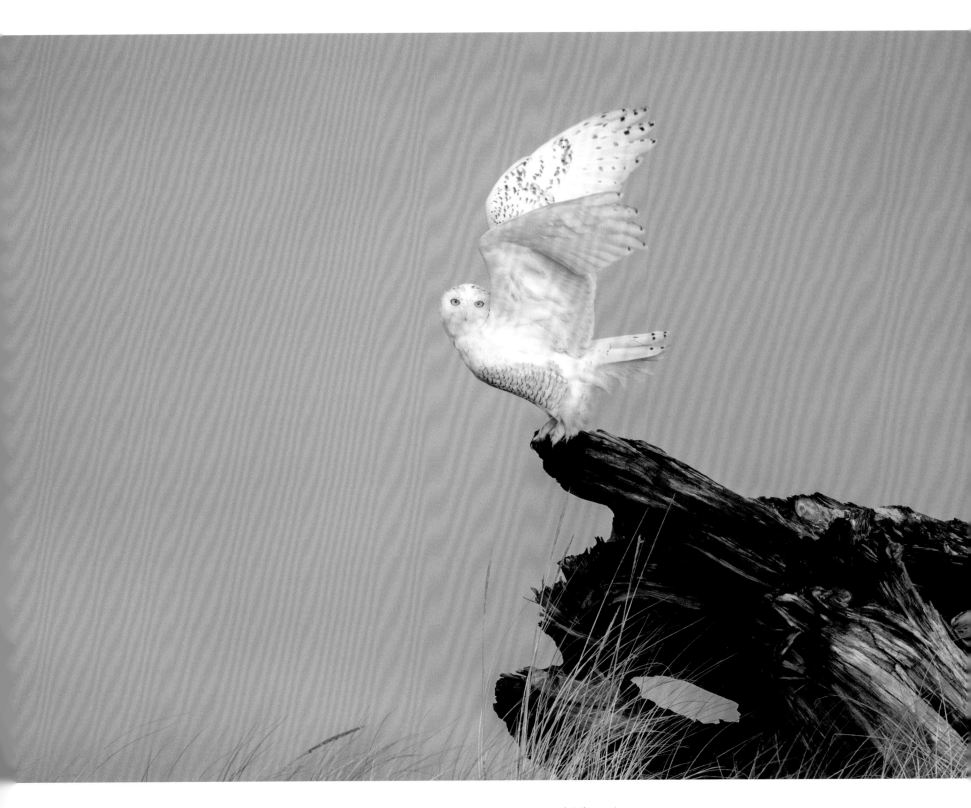

Snowy Owls commonly winter along coastlines where they pursue seabird or rodent prey from the tops of driftwood.

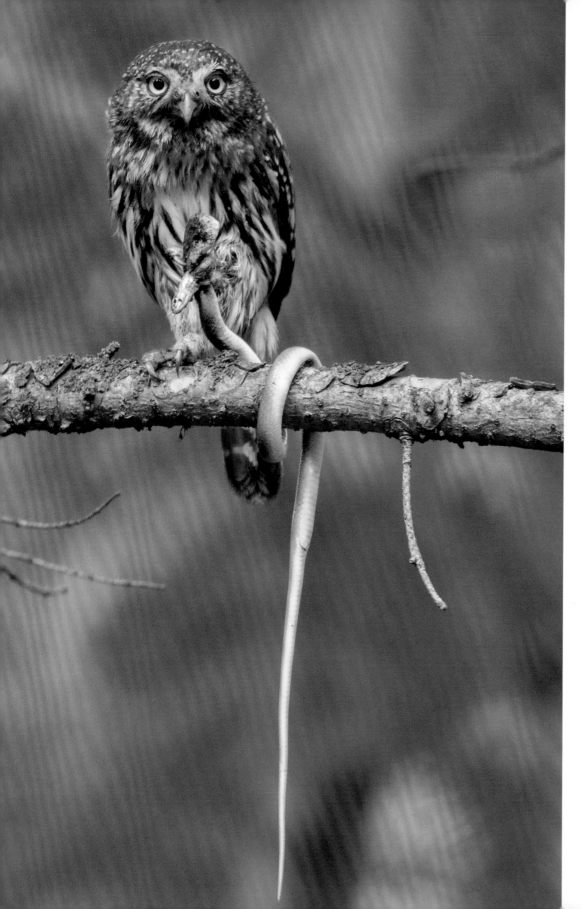

A Northern Pygmy-Owl prepares to bring a freshly killed green snake, which is more than twice as long as itself, to its waiting nestlings. Pygmy-Owls feed on a range of birds, mammals, and even reptiles. They often hunt in riparian areas where prey like voles, shrews, birds, and snakes are more abundant.

{ *opposite* } Northern Hawk Owls are among the fastest owls, particularly when they dive with their wings pulled in to maximize their speed.

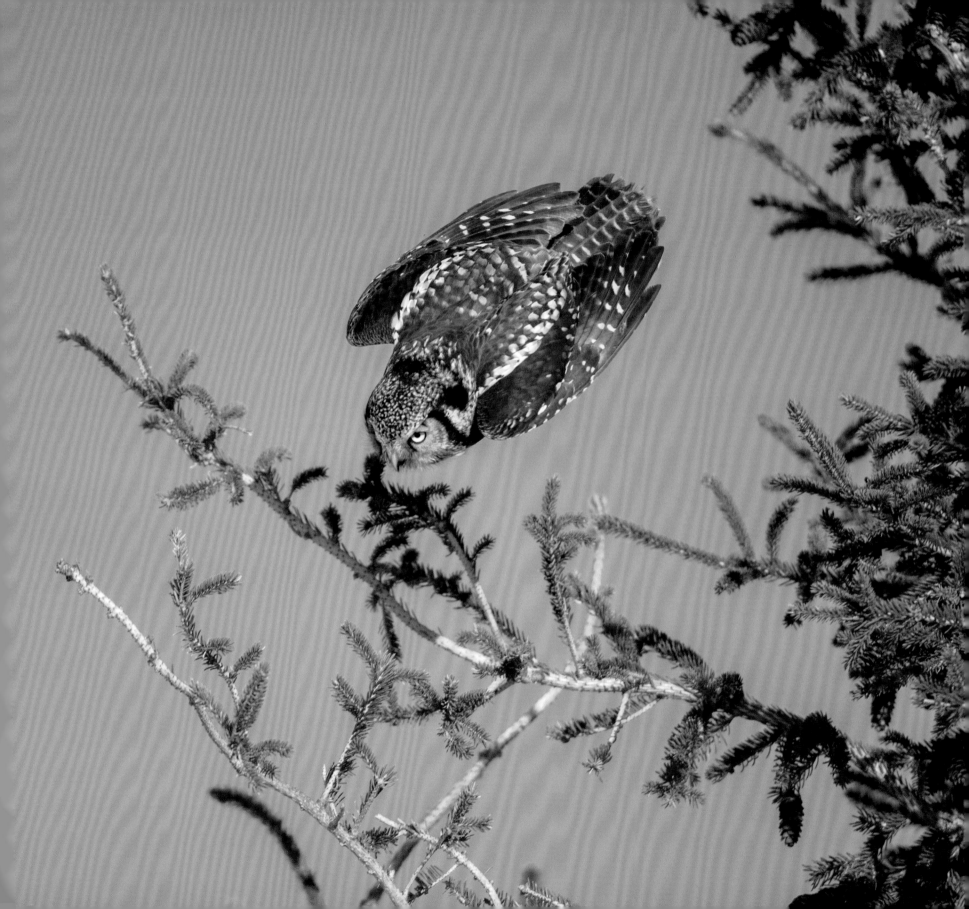

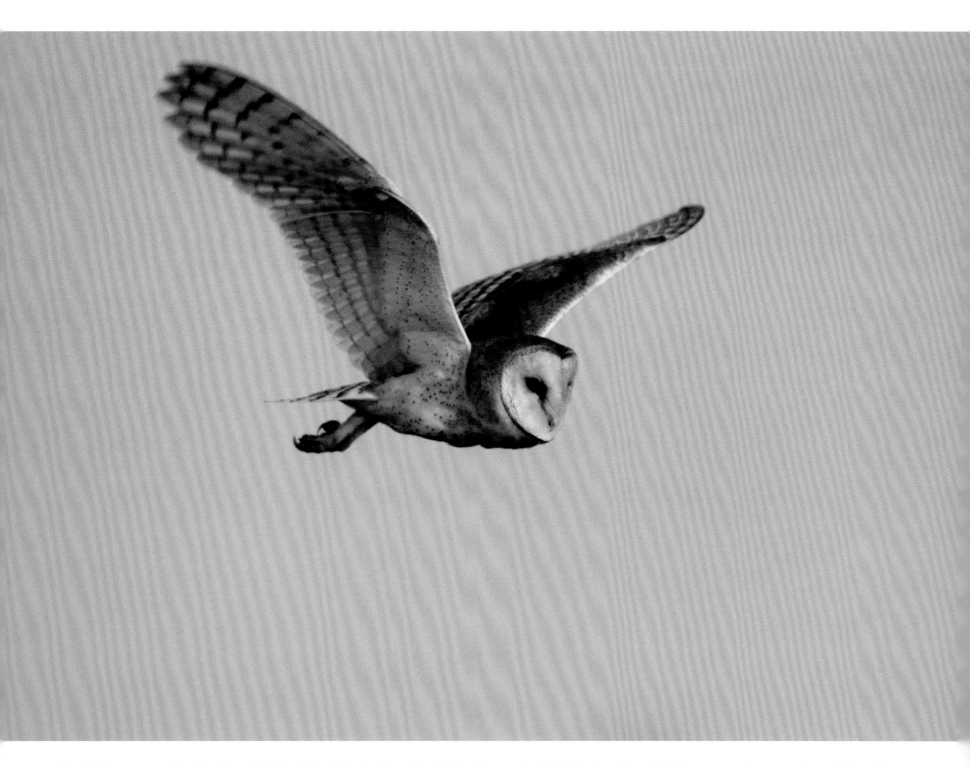

Barn Owls are commonly referred to as "strictly nocturnal," but on the coldest of days they may begin their hunts earlier, while it is warmer, and prey may be easier to catch.

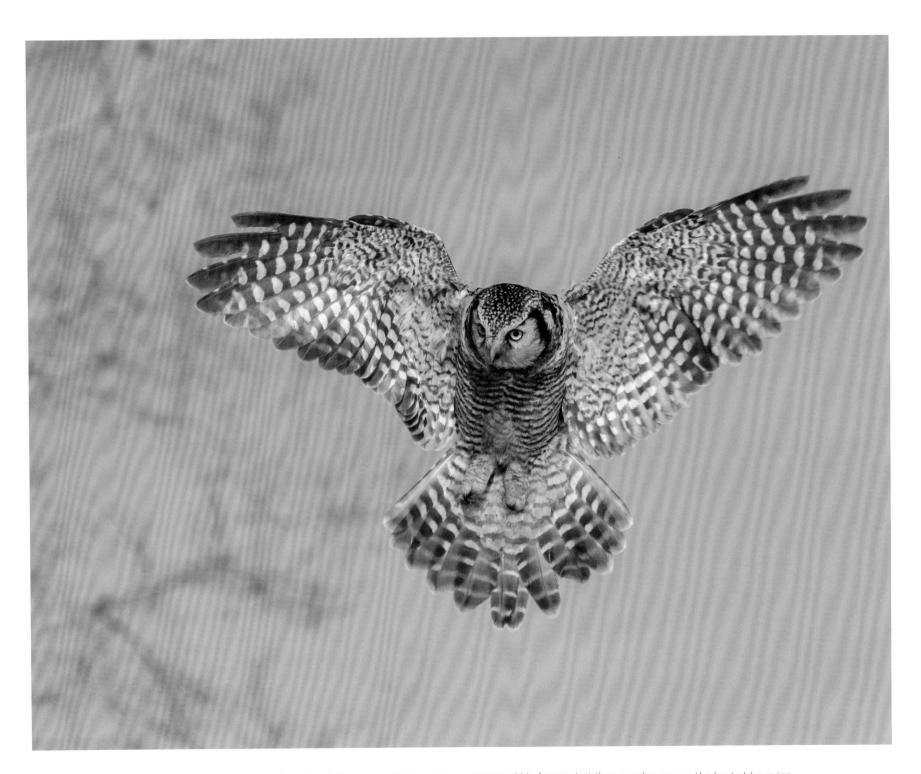

With their long tails and relatively short wings, Northern Hawk Owls are built for quick maneuvers within forests, but they are also among the best at hovering.

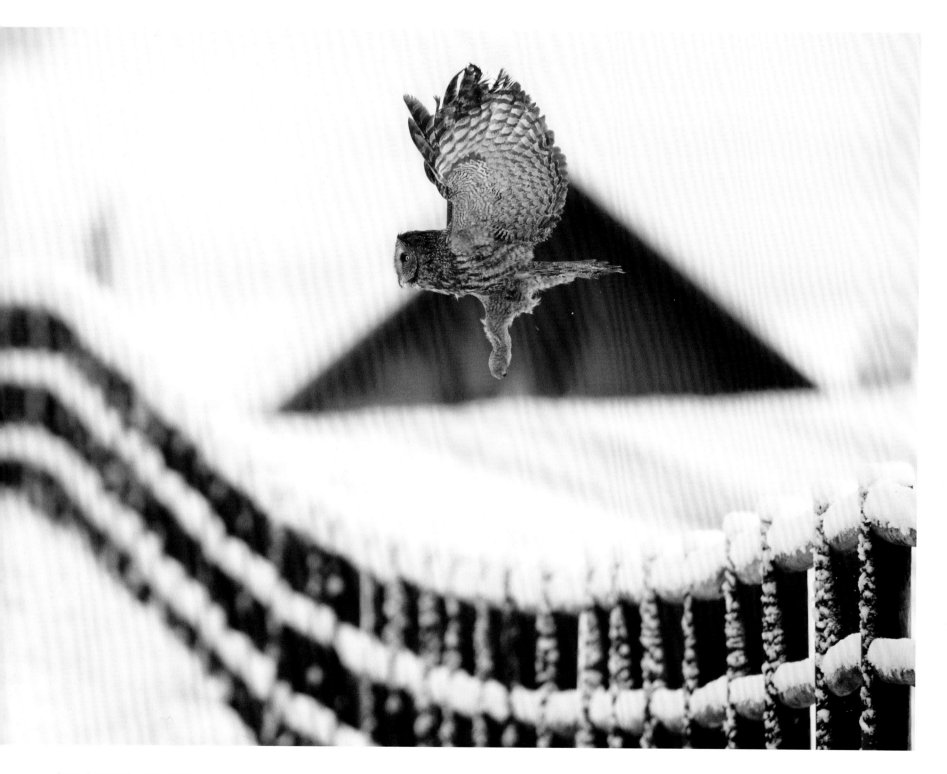

Great Gray Owls often irrupt, migrate, or move downslope during the winter when they may be unexpected visitors at parks and other public lands as well as on ranches and farms. During these times they must be able to live in close proximity to people in order to survive the winter.

A tombstone in an Arctic graveyard provides a temporary hunting and resting spot for a juvenile Snowy Owl.

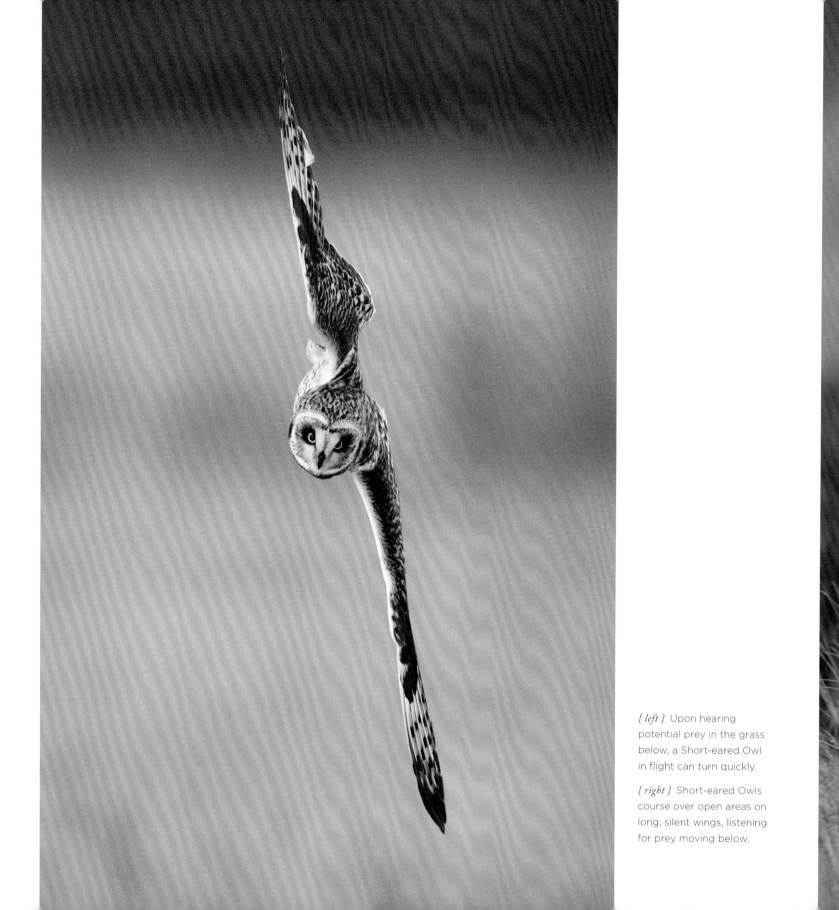

{ left } Upon hearing potential prey in the grass below, a Short-eared Owl in flight can turn quickly.

{ right } Short-eared Owls course over open areas on long, silent wings, listening for prey moving below.

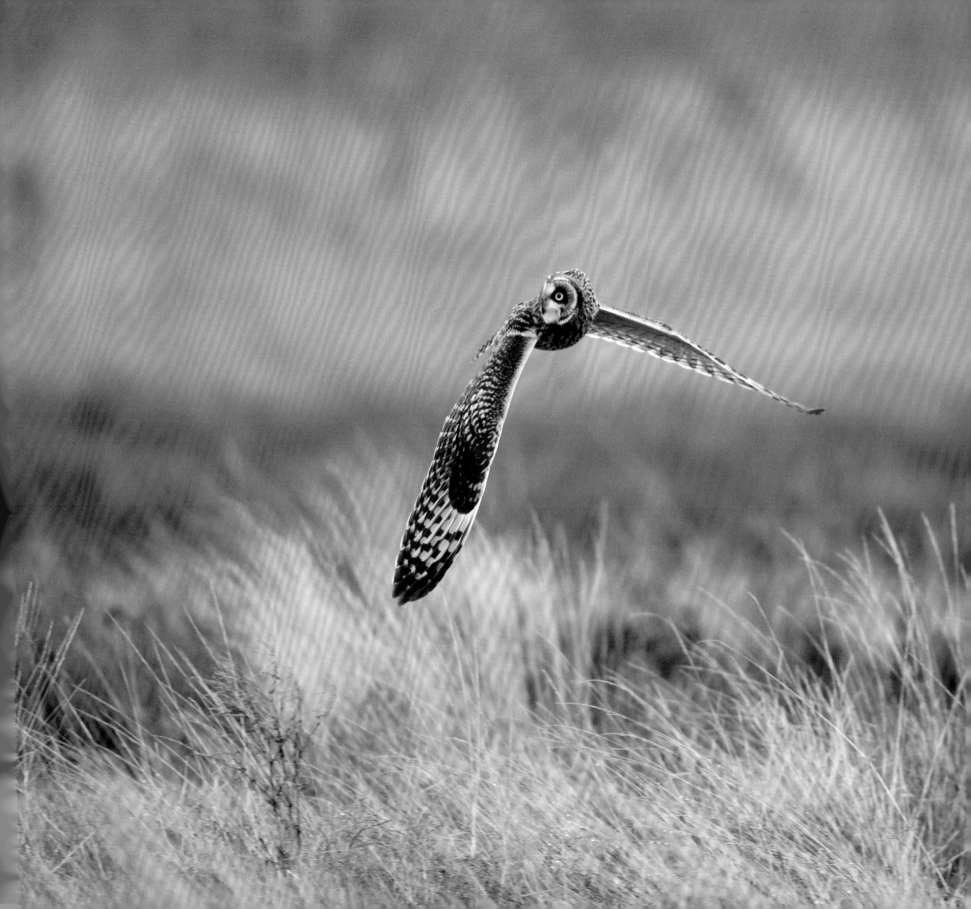

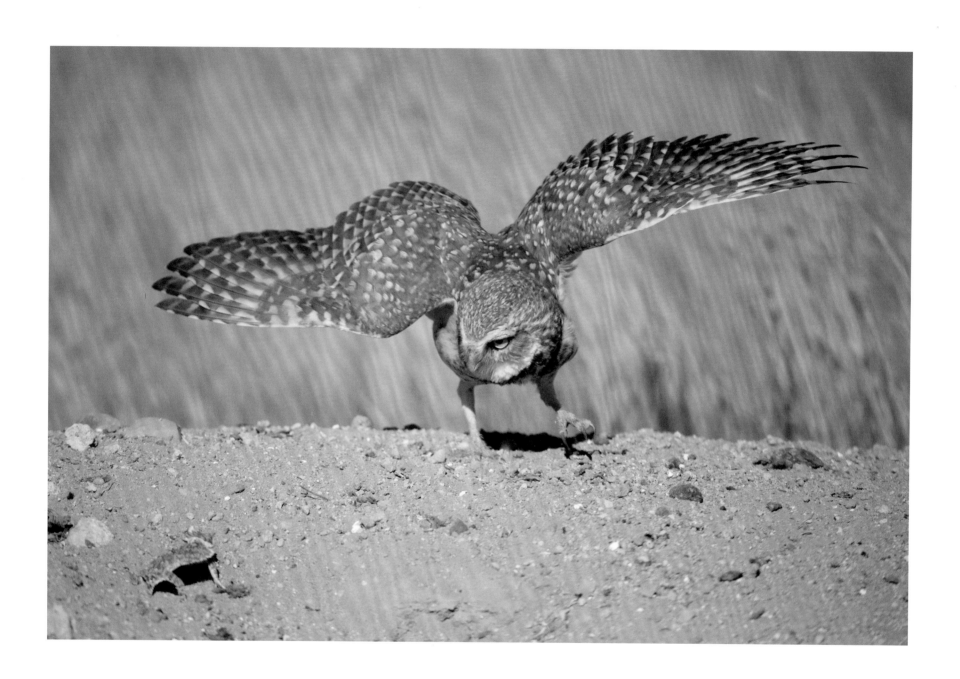

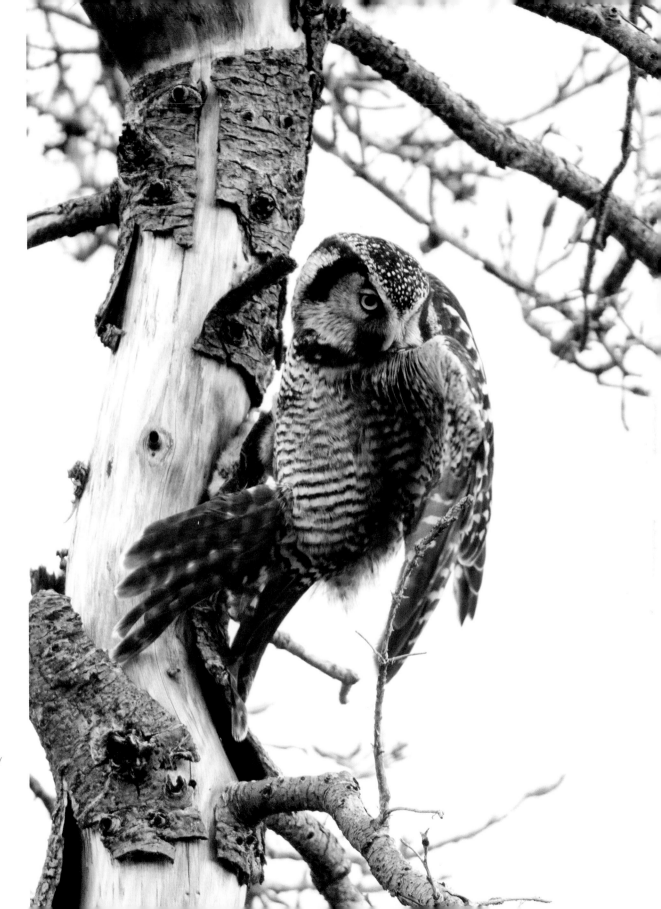

A Northern Hawk Owl stashes
a recently killed vole behind
a slab of bark in a burned
stand of trees. Many species
of owls will cache food
throughout the year when
food is plentiful and rely upon
the caches during lean times.

{ opposite } A Burrowing Owl
confronts a horned lizard. They
lock eyes, raise their bodies,
and shuffle in a circle on the
sand near a badger burrow.
The Burrowing Owl eventually
ate the horned lizard.

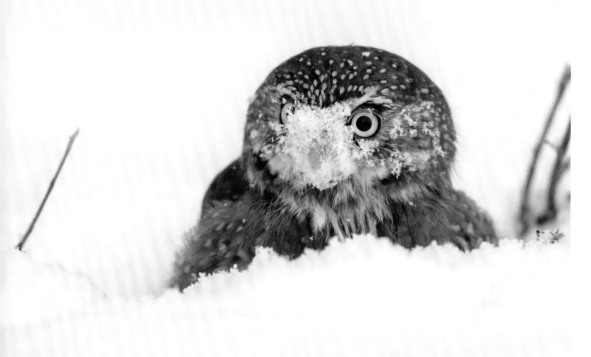

{ top } A Northern Pygmy-Owl cleans its bill by rubbing each side in the snow. Owls will usually clean their bills after eating by rubbing them on bark, branches, or snow.

{ bottom } A Northern Pygmy-Owl lifts its head from the snow to look for potential trouble after digging up its cache of quail from under the fresh snow.

{ opposite } Massive, broadly spread wings and tail allow the Great Gray Owl to hover above the snow, listening to determine the exact location of its prey.

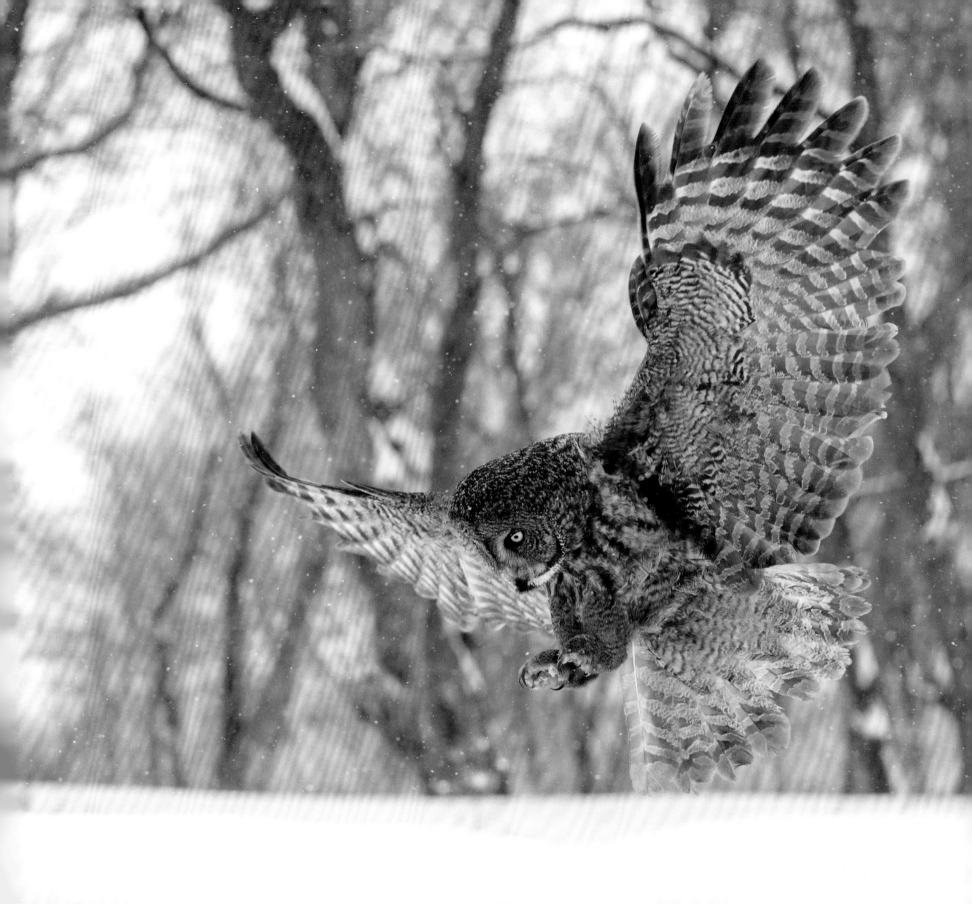

Two Short-eared Owls squabble over territorial boundaries as the sun sets against the Canadian Cascades.

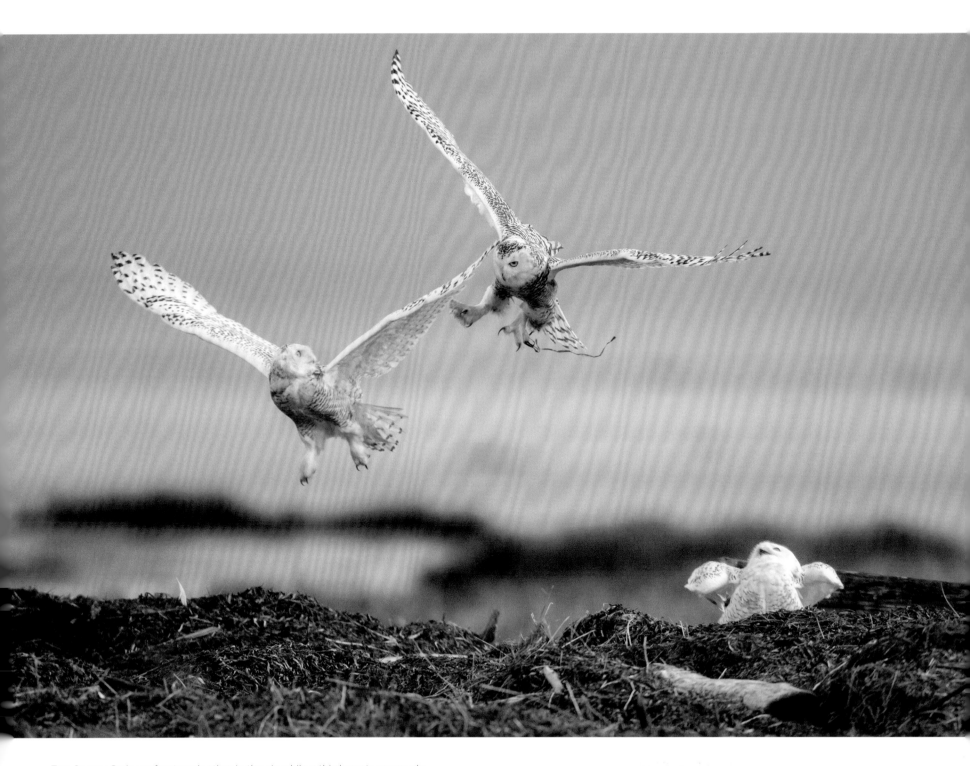

Two Snowy Owls confront each other in the air, while a third reacts nervously.

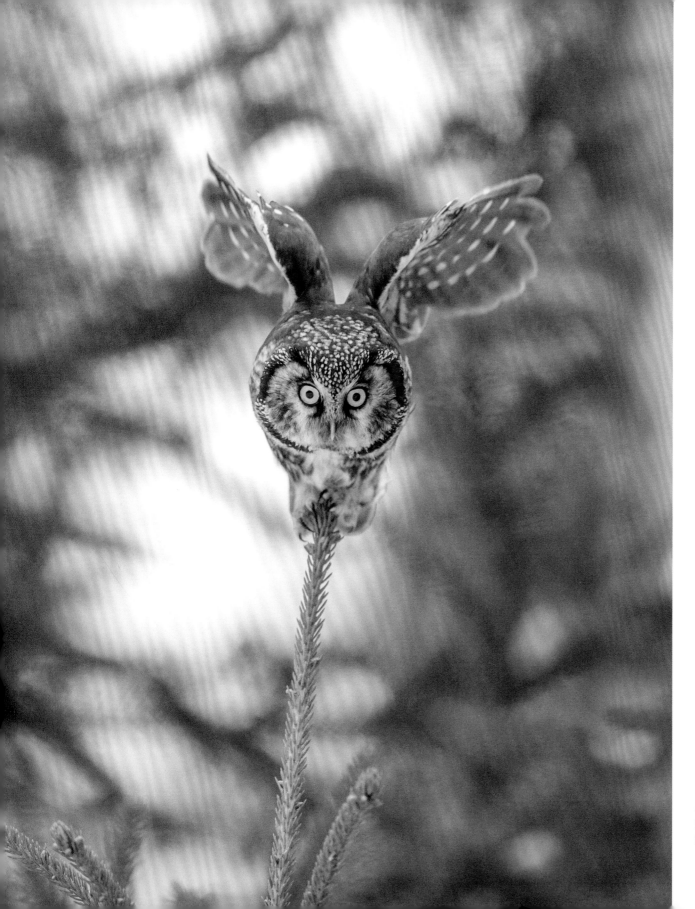

A Boreal Owl begins spreading
its wings before floating
into a dive to pursue prey.

FIELD GUIDE TO NORTH AMERICAN OWL SPECIES

This field guide owes a huge debt to Scott Weidensaul's excellent book *Peterson Reference Guide to Owls of North America and the Caribbean*, upon which I relied heavily in compiling the information it contains. The United States and Canada host nineteen owl species from two different families and ten genera, with all but the Barn Owl grouped in the same family. Most owls are active in periods of low light, but seven North American owls are at least partly diurnal (active in daylight) or crepuscular (active at twilight).

Owls, with rare exceptions, do not create their own nests. They use a wide range of nests that generally fall into one of four categories. Cavity-nesting owls nest in woodpecker-created or natural cavities in the faces of trees or cacti; platform-nesting owls nest on natural platforms, such as those formed by a depression on the broken top of a tree, the nest of another bird, or even on the ledge of a cliff; tunnel-nesting owls nest in the burrows of animals or, less frequently, the tunnels they dig themselves; and ground-nesting owls nest directly on the ground, where they often scratch a depression with their talons.

Owl species weigh between 1.2 ounces and 6.5 pounds, measure 5.25 to 33 inches from top of head to tip of tail, and have a wingspan of 12 to 62 inches. North American owls take advantage of virtually every habitat in North America except the alpine tundra: from grasslands to rain forests to dry deserts to the arctic tundra. Some are sedentary; some are migratory; some are irruptive (experience unpredictable spikes in numbers in unusual areas); while others are nomadic.

Many owls are "species of concern," which is an informal term in wildlife conservation referring to species that are declining or appear to be in need of conservation actions. This term includes but is not limited to specific designations under the US Federal Endangered Species Act ("endangered," "threatened," "candidate"), Canada's Species at Risk Act ("endangered," "threatened," "special concern"), and state and provincial agency designations. Specific country, state, or provincial designations are noted below in parentheses.

For ease of reference, the following is arranged alphabetically by common name.

A parliament of seven Snowy Owls rests together on a beach. During irruptions, owls that are usually solitary are more likely to tolerate the proximity of others of their species.

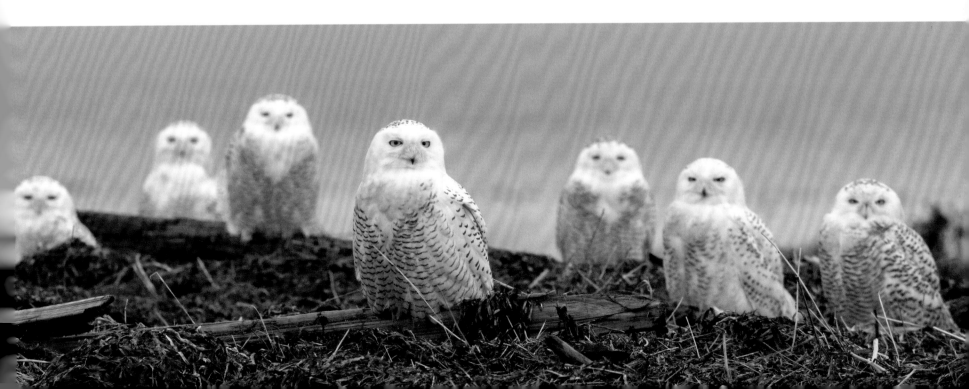

BARN OWL *(Tyto alba)*

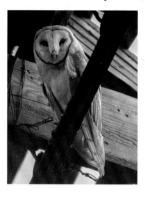
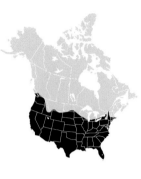

DESCRIPTION: A medium-size buff-colored owl with a distinctive heart-shaped facial disk; 12.5 to 16 inches long, with a wingspan of 33 to 42 inches.

SIMILAR SPECIES: Unlikely to be confused with any other North American owl except in flight. Because of its light coloration, one might mistake it for the larger and whiter Snowy Owl.

INTERESTING FACT: World's most widespread owl, and one of the most adapted to living alongside humans. It is also the only owl of the United States and Canada that commonly lays more than one clutch.

NORTH AMERICAN DISTRIBUTION AND HABITAT: Found in a wide variety of agricultural, rural, urban, and suburban habitats throughout most states, and in the extreme southern parts of British Columbia and Alberta, and—rarely—in southern Ontario and Saskatchewan. In all places, their range is limited by winter low temperatures.

NESTING: A cavity nester and tunnel nester; nests in cliffs and road banks, haystacks, barns, church steeples, nest boxes, and such. Sometimes known to dig tunnels in soft soil banks. Lays 2 to 18 eggs, sometimes 2 or 3 clutches a season.

VOCALIZATION: Most common call is a drawn-out hissing scream, *sssssshhh*.

CONSERVATION STATUS: "Endangered," "threatened," or other designation of conservation concern in twenty-three states, particularly in northern areas with colder winters; is listed as "endangered" where it occurs in Eastern Canada and a species of "special concern" in British Columbia.

BARRED OWL *(Strix varia)*

DESCRIPTION: A medium-size brown owl with a streaked breast; 19 to 22 inches long, with a wingspan of 42.5 to 44 inches.

SIMILAR SPECIES: Very similar in appearance to the slightly smaller and browner Spotted Owl, but distinguished by its streaked rather than spotted breast.

INTERESTING FACT: Expanding its range more than any other North American owl in some areas at the expense of the Spotted Owl, Western Screech-Owl, and perhaps even the Northern Pygmy-Owl.

NORTH AMERICAN DISTRIBUTION AND HABITAT: Year-round resident of eastern forests, parts of the boreal forest and western forests from the northern Rockies, and the Pacific Northwest south to northern California, and throughout the Sierra Nevada.

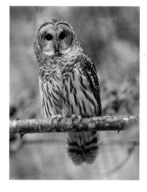
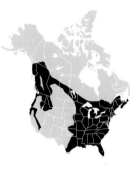

NESTING: A cavity and platform nester; utilizes natural tree cavities created by lightning or broken limbs, or nests upon the broken tops of trees, in mistletoe brooms, or in abandoned squirrel or bird nests; lays 1 to 5 eggs. Does not necessarily nest each year. Often reuses nests.

VOCALIZATION: Call phonetically sounds like *Who Cooks for You, Who Cooks for You All*.

CONSERVATION STATUS: Secure and expanding its range.

BOREAL OWL *(Aegolius funereus)*

DESCRIPTION: A small brown owl with a large head and distinctive facial disk; 8.25 to 11 inches long, with a wingspan of 21.5 to 24.5 inches.

SIMILAR SPECIES: Looks very much like the smaller Saw-whet Owl but larger and darker colored.

INTERESTING FACT: Females are larger than males to a greater degree than any other North American owl.

NORTH AMERICAN DISTRIBUTION AND HABITAT: Year-round resident of boreal forests into the northern tip of Minnesota, with isolated pockets in the western mountains of British Columbia, Washington, Idaho, Montana, Wyoming, Utah, Colorado, and New Mexico.

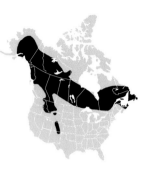

NESTING: A cavity nester that utilizes Northern Flicker or Pileated Woodpecker tree cavities, natural cavities, and nest boxes; lays 2 to 9 eggs.

VOCALIZATION: A trill comprised of whistled *toot* calls.

CONSERVATION STATUS: Common in most of its range, but has special conservation status ("imperiled," "threatened," "special concern") in four states at the southern parts of its US breeding range.

BURROWING OWL *(Athene cunicularia)*

DESCRIPTION: A small brown owl with long, unfeathered legs and a flat head; 9 to 10 inches long, with a wingspan of 22 to 24 inches.

SIMILAR SPECIES: Unlikely to be confused with any other North American species.

INTERESTING FACT: The only owl in the world that nests exclusively underground.

NORTH AMERICAN DISTRIBUTION AND HABITAT: A year-round resident of grasslands and shrub-steppe areas of North America, east and south of the western mountains, and in Florida.

NESTING: A tunnel nester that nests in the burrows of digging animals like prairie dogs, badgers, and ground

squirrels, or in burrows they dig themselves in Florida; lays 1 to 14 eggs.

VOCALIZATION: Double-note, single-pitched *cooo coooo* sung by male.

CONSERVATION STATUS: Canada lists them as "endangered," and the majority of the nineteen US states in which they live have given them specific conservation designations.

EASTERN SCREECH-OWL *(Megascops asio)*

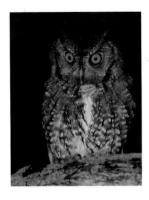

DESCRIPTION: A small, gray, brown, or red eared owl with yellow eyes; 6 to 10 inches long, with a wingspan of 18 to 22 inches.

SIMILAR SPECIES: Distinguished from Western Screech-Owl mostly by call, although bill color also differs. Distinguished from Whiskered Screech-Owl by call and larger size.

INTERESTING FACT: Several color morphs exist, including a red morph most commonly found in humid, warmer areas and a gray morph that is the more common morph in drier and cooler regions.

NORTH AMERICAN DISTRIBUTION AND HABITAT: A resident owl in most of the eastern United States and a few parts of southern Canada.

NESTING: A cavity-nesting owl that utilizes woodpecker-created or natural cavities in trees or snags, or nest boxes: lays 3 to 7 eggs. Frequently reuses nest cavity.

VOCALIZATION: A monotonic whistled trill.

CONSERVATION STATUS: Secure and widespread.

ELF OWL *(Micrathene whitneyi)*

DESCRIPTION: A small grayish-brown owl with yellow eyes; 5.25 to 5.75 inches long, with a wingspan of 12 to 14 inches.

SIMILAR SPECIES: Distinguished from the Flammulated Owl by yellow eyes and slightly smaller size.

INTERESTING FACT: World's smallest owl.

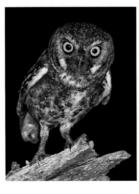

NORTH AMERICAN DISTRIBUTION AND HABITAT: An insectivorous migratory owl that breeds through southern Arizona, southwestern New Mexico, and southern Texas. Some might still breed at the southeastern edge of California. Winters in Mexico and Central America.

NESTING: A cavity-nesting owl that utilizes woodpecker cavities in trees, snags, cacti, agave stalks, and utility poles, as well as nest boxes; lays 1 to 5 eggs.

VOCALIZATION: Rapid, descending *pe, pe, pe, pe, pe, pe.*

CONSERVATION STATUS: Local population declines in Arizona and "endangered" in California.

FERRUGINOUS PYGMY-OWL
(Glaucidium brasilianum)

DESCRIPTION: A small reddish-brown owl, with a long tail; 6.75 to 7.5 inches long, with a wingspan of 12 to 15 inches.

SIMILAR SPECIES: More reddish brown compared to the darker brown of the Northern Pygmy-Owl, tail bars of reddish brown rather than white, and streaked crown in contrast to the spotted crown.

INTERESTING FACT: Prefers cavities created by the Gila Woodpecker over those created by Gilded Flickers because they are large enough to fit into but small enough to prevent entrance by Western Screech-Owls, a predator.

NORTH AMERICAN DISTRIBUTION AND HABITAT: A resident owl in southcentral Arizona and southern Texas.

NESTING: A cavity-nesting owl that utilizes woodpecker-created or natural cavities in snags, trees, and cacti, as well as nest boxes; lays 3 to 7 eggs. Frequently reuses nest cavities.

VOCALIZATION: A series of a few to a hundred evenly spaced notes prior to a pause.

CONSERVATION STATUS: "Critically Imperiled" in Arizona and "Threatened" in Texas.

FLAMMULATED OWL *(Psiloscops flammeolus)*

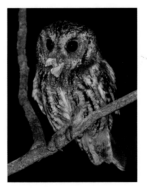

DESCRIPTION: A small reddish-gray owl with black eyes; 6 to 6.5 inches long, with a wingspan of 16 inches.

SIMILAR SPECIES: Distinguished from the Elf Owl by black eyes, slightly larger size, and ear tufts when in its hiding posture.

INTERESTING FACT: The most migratory North American owl.

NORTH AMERICAN DISTRIBUTION AND HABITAT: An insectivorous migratory owl that breeds in mountain pine forests throughout the West from southern British Columbia to California, Arizona, and New Mexico, basically overlapping the distribution of yellow pines such as ponderosa and Jeffrey pines. Winters south of the United States in Mexico and Central America.

NESTING: A cavity nester that utilizes woodpecker-created and natural cavities in trees and snags; lays 2 to 4 eggs.

VOCALIZATION: A flat tonal *hoot.*

CONSERVATION STATUS: Considered sensitive in the United States, where five states assign special conservation status; and considered vulnerable in Canada where it is designated as a species of "special concern."

GREAT GRAY OWL *(Strix nebulosa)*

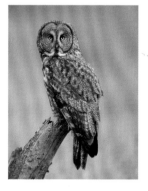
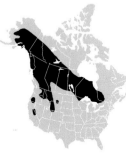

DESCRIPTION: A large gray owl with a distinctive facial disk, and small yellow eyes; 25 to 33 inches long, with a wingspan of 54 to 60 inches.

SIMILAR SPECIES: Larger and grayer than the Barred Owl or Spotted Owl, with yellow rather than black eyes.

INTERESTING FACT: The longest owl in North America.

NORTH AMERICAN DISTRIBUTION AND HABITAT: A year-round resident of boreal forests of Canada, Alaska, and conifer and mixed-conifer forests of the western mountains. Boreal Great Gray Owls periodically irrupt south, east, or less commonly north in some winters, while some western birds move downslope.

NESTING: A platform-nesting owl that nests on broken-topped trees, mistletoe brooms, and stick nests of Northern Goshawks and other hawks; lays 1 to 5 eggs.

VOCALIZATION: Series of low *hooo* calls.

CONSERVATION STATUS: Sensitive in the United States, at the edge of its range, where Minnesota, Idaho, Wyoming, and New Mexico afford it special conservation status.

GREAT HORNED OWL *(Bubo virginianus)*

DESCRIPTION: A large, usually brown owl with distinctive ear tufts; 18 to 26 inches long, with a wingspan of 49 to 62 inches.

SIMILAR SPECIES: At rest, might be confused with the much smaller and thinner Long-eared Owl; whitish Arctic forms might be confused with heavily barred juvenile Snowy Owls.

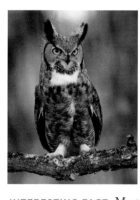
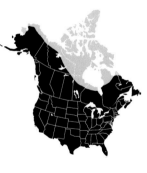

INTERESTING FACT: Most widespread owl in North America, with significant regional color variation.

NORTH AMERICAN DISTRIBUTION AND HABITAT: Year-round resident throughout most of the United States and Canada south of the tundra.

NESTING: A cavity-nesting and platform-nesting owl that nests inside various natural and manmade cavities like cliffside lava tubes, caves, animal burrows, hollow or broken-topped trees and snags, abandoned buildings, and on nest platforms and stick nests of other birds; lays 1 to 5 eggs.

VOCALIZATION: Deep, foghorn-like *who-hoo-ho-ooo*, with variations.

CONSERVATION STATUS: Mostly secure and widespread, with some evidence of declines of specific US populations.

LONG-EARED OWL *(Asio otus)*

DESCRIPTION: A medium-size, long-winged, light-brown, owl with prominent ear tufts; 14 to 16 inches long, with a wingspan of 35 to 40 inches.

SIMILAR SPECIES: At rest with ear tufts up, it might be mistaken for the much larger Great Horned Owl. In flight with lowered ear tufts, it can be confused with the longer-winged and lighter-colored Short-eared Owl.

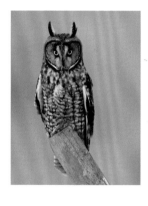
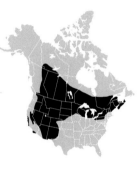

INTERESTING FACT: Roosts communally during the nonbreeding season with up to two hundred others, and sometimes with Short-eared Owls.

NORTH AMERICAN DISTRIBUTION AND HABITAT: Nests in stands of trees and hunts in adjacent farmlands, meadows, grasslands, and steppe of Canada, the interior West, the Southwest, Great Plains, parts of California, and parts of the eastern states. Winters south and east of these areas.

NESTING: A platform nester; uses the stick nests of magpies and other corvids and hawks; lays 2 to 10 eggs.

VOCALIZATION: A series of soft, low *hooo* notes, separated by a couple of seconds. Several to more than one hundred notes can be heard in a row.

CONSERVATION STATUS: Carries conservation designations such as "endangered," "threatened," "imperiled," or "special concern" in fourteen states but is not listed at the provincial or federal level in Canada.

NORTHERN HAWK OWL *(Surnia ulula)*

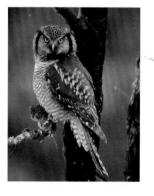
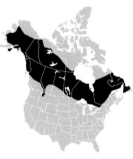

DESCRIPTION: A medium-size brown owl, with a long tail; 13.5 to 17.5 inches long, with a wingspan of 30 to 35 inches.

SIMILAR SPECIES: Not likely to be confused with any other owl.

INTERESTING FACT: Hunts in the open, in the daylight, from exposed perches where it can spot prey from almost half a mile away.

NORTH AMERICAN DISTRIBUTION AND HABITAT: A resident of the boreal forest up to the tree line, with rare breeding occurrences in northern parts of Minnesota, Washington, Idaho, and Montana, particularly in mature, uncut, burned forest. Periodically irrupts south into the northern US states.

NESTING: A cavity- and platform-nesting owl that nests in large natural or woodpecker-created cavities, or

platforms created on broken tops of trees or snags, or on mistletoe brooms; lays 3 to 13 eggs.

VOCALIZATION: Rapid, high-pitched trill.

CONSERVATION STATUS: Uncommon and uncertain status in Canada and Alaska boreal forests; "vulnerable" at the southern edge of their breeding range in Montana, Washington, Idaho, and Minnesota.

NORTHERN PYGMY-OWL *(Glaucidium gnoma)*

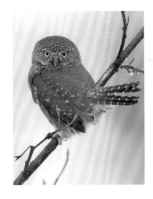
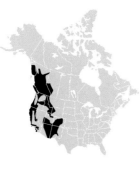

DESCRIPTION: A small grayish-brown or reddish-brown owl, with a long tail; 6.5 to 7.3 inches long, with a wingspan of 15 inches.

SIMILAR SPECIES: In general, browner than the Ferruginous Pygmy-Owl, with tail bars of white rather than reddish; crown is spotted in contrast to a streaked crown.

INTERESTING FACT: Like the Ferruginous Pygmy-Owl, the Northern Pygmy-Owl has false eyes on the back of the head thought to confuse and ward off potential predators. An aggressive hunter, often indifferent to human presence.

NORTH AMERICAN DISTRIBUTION AND HABITAT: A resident owl in mixed forests of the West, from southeast Alaska to Arizona and New Mexico.

NESTING: A cavity-nesting owl that utilizes woodpecker-created or natural cavities in trees or snags; lays 2 to 7 eggs.

VOCALIZATION: Makes a single pair of *toot* calls with a second or two between each.

CONSERVATION STATUS: Likely declining in several parts of North America where Barred Owls are advancing and where timber harvests are changing the structure of forests.

NORTHERN SAW-WHET OWL

(Aegolius acadicus)

DESCRIPTION: A small brown owl with a distinctive facial disk; 8 to 8.5 inches long, with a wingspan of 16 to 18 inches.

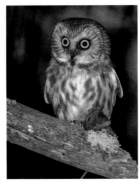
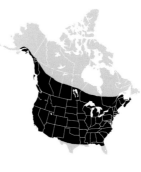

SIMILAR SPECIES: Very similar in appearance to the larger Boreal Owl, but smaller, lighter colored, and with more distinctive white eyebrows.

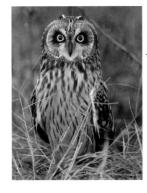

INTERESTING FACT: Can locate prey through hearing alone.

NORTH AMERICAN DISTRIBUTION AND HABITAT: A year-round resident of southern boreal, western, and northeastern forests, with wintering birds occasionally found throughout all but the most southern extremes of the United States.

NESTING: A cavity nester that utilizes woodpecker-created cavities, natural cavities, and nest boxes; lays 4 to 7 eggs.

VOCALIZATION: A series of whistles of a single tone, with two seconds between each.

CONSERVATION STATUS: Special conservation designations in ten states, primarily at the southern part of its breeding range. Canada considers the Queen Charlotte Islands (off the British Columbia coast) subspecies "threatened."

SHORT-EARED OWL *(Asio flammeus)*

DESCRIPTION: A medium-size, long-winged, light-brown owl; 14.5 to 15 inches long, with a wingspan of 36 to 39 inches.

SIMILAR SPECIES: At rest, with or without small ear tufts displayed, it is distinctive; in flight, it can be confused with the darker Long-eared Owl.

INTERESTING FACT: Short-eared Owl's "sky-dancing" is perhaps the most impressive courtship display among owls.

NORTH AMERICAN DISTRIBUTION AND HABITAT: Breeds in open landscapes throughout much of the Arctic and subarctic, boreal interior, Intermountain West, Great Plains, and the Central Valley and eastern parts of California. It is rare in parts of the US Northeast and Midwest and in Southeastern Canada. Winters in open areas from southern Canada throughout the US contiguous

states although rarely in the Southwest and Southeast. A Caribbean subspecies occasionally shows up in southern parts of Florida during the spring and summer.

NESTING: A ground-nesting owl that may occasionally scrape out a bowl shape; may also line the nest with grass or feathers; lays 1 to 11 eggs.

VOCALIZATION: Silent except during mating season, when a low but forceful *voo-poo-poopoo* is uttered over a few seconds from the ground or in flight.

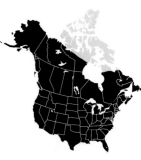

CONSERVATION STATUS: An "endangered" or "imperiled" species in a dozen states and listed as a "species of concern" in more than a dozen others. At the federal level in Canada, it is listed as a "special concern" and holds conservation designations "threatened," "vulnerable," or "special concern" in six provinces.

SNOWY OWL *(Bubo scandiacus)*

DESCRIPTION: A large, long-winged white owl; approximately 23.5 inches long, with a wingspan of 56 to 61 inches.

SIMILAR SPECIES: Heavily barred juveniles might be confused with whitish-colored Arctic forms of the Great Horned Owl.

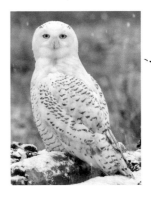
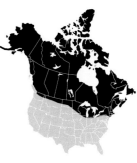

INTERESTING FACT: Some Snowy Owls are migratory, irruptive, or nomadic and may breed in different places from year to year and may skip breeding altogether some years.

NORTH AMERICAN DISTRIBUTION AND HABITAT: Some are year-round residents of the Arctic, others migrate into the Great Plains of Canada and the United States in the winter, while still others show up in other states particularly in the Great Lakes region, Northeast, and Northwest during irruption years. Exceptionally in large irruptions, birds have appeared in locations like Hawaii and the Carolinas.

NESTING: A ground-nesting owl that scrapes a bowl on elevated ground on the Arctic tundra; lays 2 to 15 eggs.

VOCALIZATION: A loud foghorn-like *hoo-hoo* call, usually in two parts but sometimes in several parts.

CONSERVATION STATUS: Uncertain status in North America, but declines in Europe are of concern for the United States.

SPOTTED OWL *(Strix occidentalis)*

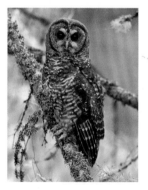

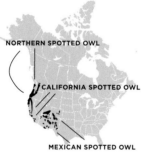

DESCRIPTION: A medium-size brown owl with a spotted breast; 17 to 19 inches long, with a wingspan of 42 to 44.5 inches. Three subspecies, the Northern Spotted Owl, the California Spotted Owl, and the Mexican Spotted Owl can be found in North America.

SIMILAR SPECIES: Very similar in appearance to the slightly larger Barred Owl, but distinguished by browner color and a spotted rather than streaked breast.

INTERESTING FACT: Hunts and roosts within the forest canopy. Northern subspecies population rapidly declining. An individual Northern Spotted Owl needs 400 to almost 6,000 acres in the Pacific Northwest to meet its hunting and nesting needs.

NORTH AMERICAN DISTRIBUTION AND HABITAT: A year-round resident of mature western forests, including those of the Pacific Coast from extreme southern British Columbia through California and in isolated patches in the Southwest.

NESTING: A cavity, platform, and tunnel nester that utilizes natural tree cavities created by lightning, broken limbs, or nests on the broken tops of trees, in mistletoe brooms, abandoned squirrel or birds nests or in cliffside caves; lays 1 to 4 eggs. Does not necessarily nest each year.

VOCALIZATION: Like many owls, uses several vocalizations. Primary vocalization is a low-pitched series of hoot calls referred to as the "four-note location call," consisting of a single *hoot* with a short pause, two tightly placed *hoot* calls, and a final fading *hoot*.

CONSERVATION STATUS: Northern Spotted Owl and Mexican Spotted Owl are listed as "threatened" under US Endangered Species Act, while the California Spotted Owl is listed as a "species of special concern" in California. The Northern Spotted Owl is also listed as "endangered" in Canada.

WESTERN SCREECH-OWL
(Megascops kennicottii)

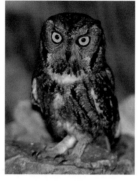

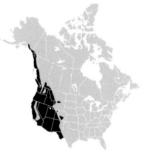

DESCRIPTION: A small gray, brown, or reddish, eared owl with yellow eyes; 7.5 to 9.5 inches long, with a wingspan of 18 to 22 inches.

SIMILAR SPECIES: Distinguished from the Eastern Screech-Owl mostly by call, and different bill color. Distinguished from Whiskered Screech-Owl by call and larger size.

INTERESTING FACT: Color varies regionally, with lightest gray-colored birds in the driest habitats and brownest and darkest in Pacific Northwest coastal areas.

NORTH AMERICAN DISTRIBUTION AND HABITAT: A resident owl in lower elevation areas with trees or large cacti from southeast Alaska to Arizona, west of the Great Plains, and south to California, Arizona, New Mexico, and west Texas, with some pockets in eastern areas of Montana, Wyoming, Colorado, Oklahoma, New Mexico, and Texas.

NESTING: A cavity-nesting owl that utilizes woodpecker-created or natural cavities in trees or snags, or nest boxes; lays 2 to 7 eggs. Often reuses nest cavities.

VOCALIZATION: "Bouncing ball" call best described as a series of five to nine or nine to fifteen short, whistled *hoot* calls becoming more tightly spaced toward their conclusion.

CONSERVATION STATUS: Common across much of range, but western Washington populations are experiencing local extirpations from Barred Owls and habitat loss, Wyoming populations are of "potential concern," and both subspecies in British Columbia have special conservation designations.

WHISKERED SCREECH-OWL
(Megascops trichopsis)

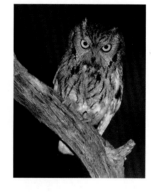

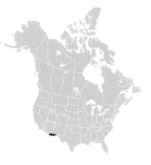

DESCRIPTION: A small grayish owl with ear tufts and gold-orange eyes; approximately 7.25 inches long, with a wingspan of 17.5 inches.

SIMILAR SPECIES: Distinguished from Eastern and Western Screech-Owls by smaller size and call.

INTERESTING FACT: The only small forest owl that seems to prefer natural cavities over those created by woodpeckers.

NORTH AMERICAN DISTRIBUTION AND HABITAT: A Mexican Screech-Owl whose range enters the United States only in the mountains of southeast Arizona and southwest New Mexico.

NESTING: A cavity-nesting owl that prefers natural cavities in trees or snags but will also use woodpecker-created cavities; lays 3 to 4 eggs. Occasionally reuses nest cavities.

VOCALIZATION: An evenly spaced group of several whistles.

CONSERVATION STATUS: "threatened" in New Mexico and a "species of special concern" in Arizona.

Acknowledgments

I dedicate this book to the many who helped me in my quest to watch, study, photograph, and write about owls over the past decade.

Generous donors contributed to Braided River in order to make publication of this book a reality. Thank you, Tom and Sonya Campion. Thank you, Tina Bullitt. I feel a special gratitude to the following friends who helped make this book possible, especially Jeff and Cheryl Copeland, Jeremy Doschka and Anna Neuzil, Steve, Ann, and Sydney Godwin, Dave and Katy Hedrick, Walter Henzee and Sarah Kaiser, Keith and Pam Kingdon, Dave and Jill Russell, Jerry and Natalie Smith, Jack and Lisa Whitman, and Linda and Dennis Wilcox.

Many others, including friends, birders, and researchers, were helpful in making this book come to fruition including, Steve Ackers, Aaron Anderson, Bud Anderson, Larry Arnold, Christian Artuso, Audrey Boag, Travis Booms, Jay Carlisle, Linda and David Cornfield, Ray Cromie, Rita Claremont, Della Dash, Mike and MerryLynn Denny, Rosa Duarte, James Duncan, Desiree Early, Eric Forsman, Finn Garaas, Gina Gerkin, Green Diamond Resource Company, Kara Greer, Wenyan Guo, Andrew Haeger, Chris and Lori Hedrick, Mike Hendrickson, Lisa Hern, Tristan Higgins, Denver Holt, Michael Kessig, Matt Larson, Brian Linkhart, Teresa Lorenz, Jason Mandich, Diarmuid McGuire, Joe Medley, Robert Miller, Robin Mongoyak, Kirsti Muul, The Owl Research Institute, Dennis Paulson, Scott Rashid, Janice Reid, Scott Richardson, Zach Riley, Beth Rogers, Megan Sandri, Jo Ann Schafer, Stan Sovern, Meredith Spencer, Herman Veenendaal, Graham Ward, and David Willey. I'd also like to acknowledge Scott Weidensaul who reviewed this book for scientific accuracy and whose book *Peterson Reference Guide to Owls of North America and the Caribbean* I found to be most informative.

Several talented friends assisted in reviewing my manuscript and photographs to help me deliver a better product, including Jamie Acker, Jean Budroe, Peter Jackson, and Phil and Katy Vogelzang.

Last but not least, I would like to thank Helen Cherullo for her wise advice and faith in my work, Kate Rogers for her skillful direction and guidance, Mary Metz and Jen Grable for shepherding the book to its completion, and Linda Gunnerson and Ellen Wheat for their editorial assistance.

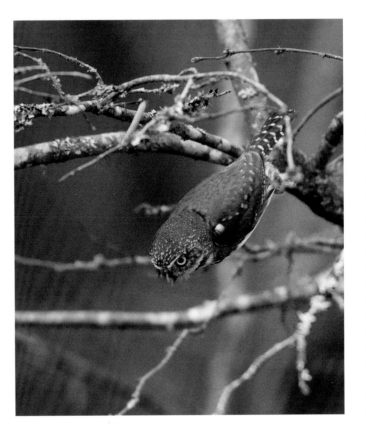

The wings of Northern Pygmy-Owls are not as silent as those of other owls, so they must rely more upon surprise and speed; they often hold their wings tight at their sides as they dart toward their unsuspecting prey.

{ page 212 } A young Mexican Spotted Owl explores its canyon habitat under the watchful eye of its mother. Although this young owl looks helpless, it is already about to fly and follow its parents through the canyons and forests. The Mexican subspecies is slightly lighter in color than the Northern subspecies, but otherwise appears almost identical.

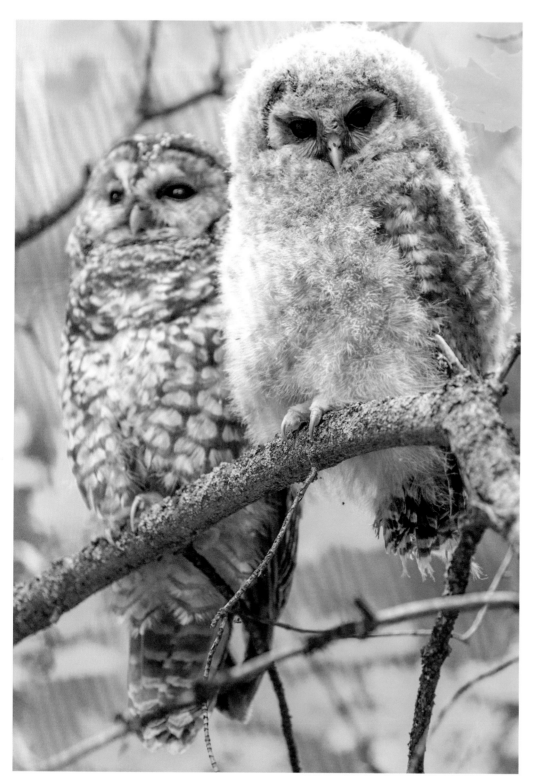

Bibliography

Bannick, Paul. *The Owl and the Woodpecker*. Seattle: Mountaineers Books, 2008.

Bull, Evelyn L. and James R. Duncan. "Great Gray Owl *(Strix nebulosa)*." In *The Birds of North America*, A. Poole, and F. Gill, eds. (see below)

Bull, Evelyn L. and Mark G. Henjum. "Ecology of the Great Gray Owl." United States Department of Agriculture, Forest Service, Pacific Northwest Research Station, General Technical Report. PNW-GTR-265, September 1990.

Bunnell, Fred L., Isabelle Houde, Barb Johnston, and Elke Wind. "How Dead Trees Sustain Live Organisms in Western Forests." USDA, Forest Service Gen. Tech. Rep. PSW-GTR-181, 2002.

Dugger, Katie M., Eric D. Forsman, et al. "The effects of habitat, climate, and Barred Owls on long-term demography of Northern Spotted Owls." *The Condor* (Cooper Ornithological Society), 118(1):57–116, December 2015.

Duncan, J.R. "Movement strategies, mortality and behaviour of radio marked great gray owls in southeastern Manitoba and northern Minnesota." In *Biology and Conservation of Northern Forest Owls: Symposium proceedings* by R.W. Nero, R.J. Clark, R.J. Knapton & R.H. Hamre (eds.), 101–07. February 3–7, 1987. Winnipeg, Manitoba. USDA, Forest Service, Gen. Tech. Report RM 142.

Duncan, James R. and Patricia A. Duncan. "Northern Hawk Owl *(Surnia ulula)*." In *The Birds of North America*, A. Poole, and F. Gill, eds. (see below)

Duncan, James R. and Patricia H. Hayward. "Review of Technical Knowledge: Great Gray Owls." In *Flammulated, Boreal, And Great Gray Owls In The United States: A Technical Conservation Assessment.* Gen. Tech. Rep. RM-253. Fort Collins, CO: U.S. Department of Agriculture, Forest Service, Rocky Mountain Forest and Range Experiment Station, 159–175, January 12, 2015.

Frye, Graham G. and Harry R. Jageman. "Post-Fledging Ecology Of Northern Pygmy-Owls In The Rocky Mountains.*" The Wilson Journal of Ornithology* (Wilson Ornithological Society): 199–428, June 2012.

Gehlbach, Frederick R. "Eastern Screech-Owl *(Megascops asio)*." In *The Birds of North America*, A. Poole, and F. Gill, eds. (see below)

Gutiérrez, R. J., A. B. Franklin and W. S. Lahaye. "Spotted Owl *(Strix occidentalis)*." In *The Birds of North America*, A. Poole, and F. Gill, eds. (see below)

Holt, Denver, Matt D. Larson, Norman Smith, Dave Evans and David F. Parmelee. 2015. "Snowy Owl *(Bubo scandiacus)*." In *The Birds of North America*, A. Poole, and F. Gill, eds. (see below)

Holt, Denver W. and Julie L. Petersen. "Northern Pygmy-Owl *(Glaucidium gnoma)*." In *The Birds of North America*, A. Poole, and F. Gill, eds. (see below)

Linkhart, Brian D. "Home range and habitat of breeding Flammulated Owls in Colorado." *Wilson Bulletin* (Wilson Ornithological Society). September 1, 1998.

Linkhart, Brian D. and D. Archibald Mccallum. "Flammulated Owl *(Otus flammeolus)*." In *The Birds of North America*, A. Poole, and F. Gill, eds. (see below)

Linkhart, Brian D. and Richard Reynolds. "Return Rate, Fidelity, And Dispersal In A Breeding Population Of Flammulated Owls (*Otus Flammeolus*)." *The Auk* 124(1):264–275, 2007.

Marks, J. S., D. L. Evans and D. W. Holt. "Long-eared Owl *(Asio otus)*." In *The Birds of North America*, A. Poole, and F. Gill, eds. (see below)

Marti, Carl D., Alan F. Poole and L. R. Bevier. "Barn Owl *(Tyto alba)*." In *The Birds of North America*, A. Poole, and F. Gill, eds. (see below)

Millsap, B.A. 2002. "Survival of Florida Burrowing Owls along an urban development gradient." *Journal of Raptor Research* 36:3–10.

Moulton, Colleen E., Ryan S. Brady and James R. Belthoff. "Association between Wildlife and Agriculture: Underlying Mechanisms and Implications in Burrowing Owls." *The Journal of Wildlife Management*, Volume 70, Issue 3: 708–716, June 2006.

Nelson, Mark D., David H. Johnson, Brian D. Linkhart, and Patrick D. Miles "Flammulated Owl (*Otus Flammeolus*) Breeding Habitat Abundance In Ponderosa Pine Forests Of The United States." Proceedings of the Fourth International Partners in Flight Conference: Tundra to Tropics 71–81

Nero, R. W. *The Great Gray Owl: Phantom of the Northern Forest.* Washington, DC: Smithsonian Institution Press, 1980.

Poole, A., and F. Gill, eds. *The Birds of North America*. Philadelphia: Academy of Natural Sciences, and Washington, DC: American Ornithologists' Union, 2002. Online edition: bna.birds.cornell.edu/bna/

Poulin, Ray, L. Danielle Todd, E. A. Haug, B. A. Millsap and M. S. Martell. 2011. "Burrowing Owl *(Athene cunicularia)*." In *The Birds of North America*, A. Poole, and F. Gill, eds. (see above)

Proudfoot, Glenn A. and R. Roy Johnson. "Ferruginous Pygmy-Owl *(Glaucidium brasilianum)*." In *The Birds of North America*, A. Poole, and F. Gill, eds. (see above)

Therrien, Jean-François, Gilles Gauthier and Joël Bêty. "An avian terrestrial predator of the Arctic relies on the marine ecosystem during winter." *Journal of Avian Biology* Volume 42, Issue 4: 363–369, June 2011.

Thomsen, Lise. "Behavior and Ecology of Burrowing Owls on the Oakland Municipal Airport." *The Condor*, Vol 73, No. 2, 177–192, 1971.

Weidensaul, Scott. *Peterson Reference Guide to Owls of North America and the Caribbean*, Boston and New York: Hougthon Mifflin Harcourt, 2015.

Wiggins, D. A., D. W. Holt and S. M. Leasure. "Short-eared Owl *(Asio flammeus)*." In *The Birds of North America*, A. Poole, and F. Gill, eds. (see above)

Wu, Joanna X., Rodney B. Siegal et al. "Diversity of Great Gray Owl Nest Sites and Nesting Habitats in California." *The Journal of Wildlife Management* 79(6):937–947; 2015; DOI: 10.1002/jwmg.910, June 15, 2015.

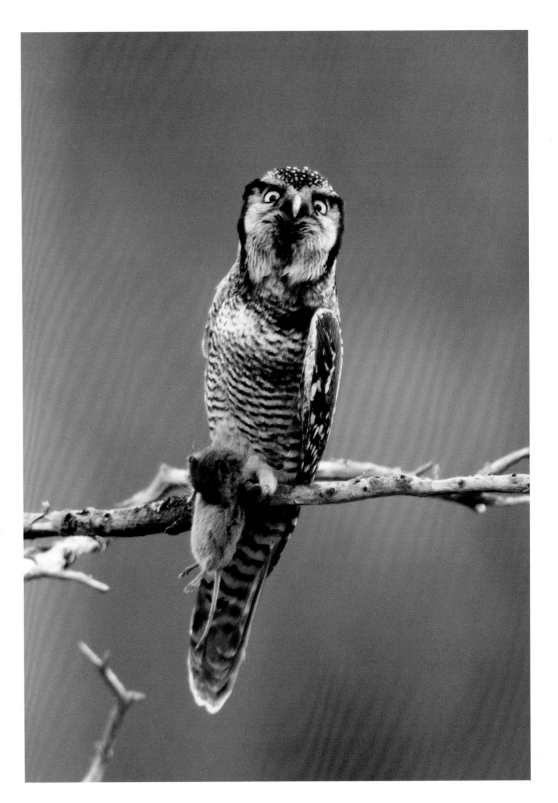

Most owls adopt concealment postures in response to predators (in this case a raven). Northern Hawk Owls often adopt Thin-Upright Concealment Posture: flattening its plumage, standing erect, and making its eyes less visible. These postures are meant to break up the typical round, big-eyed shape that predators and prey recognize as an owl.

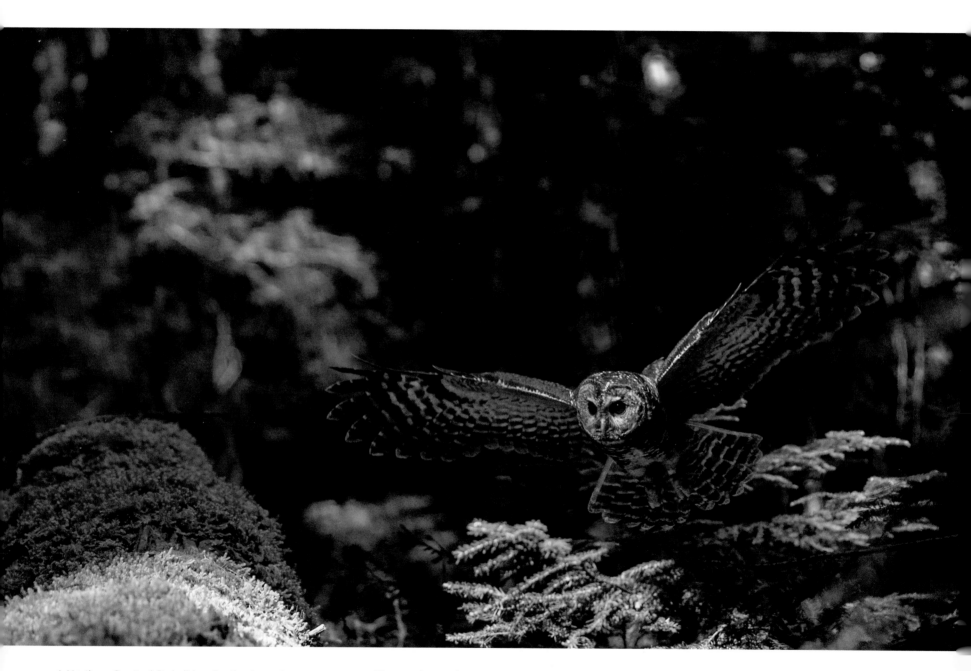

A Northern Spotted Owl glides silently above damp, moss-covered logs and toward its prey. Northern Spotted Owls are denizens of ancient forests with cathedral-like canopies where rays of sun filter though several layers of limbs before reaching the ground.

Index

Page numbers in bold type refer to photographs.

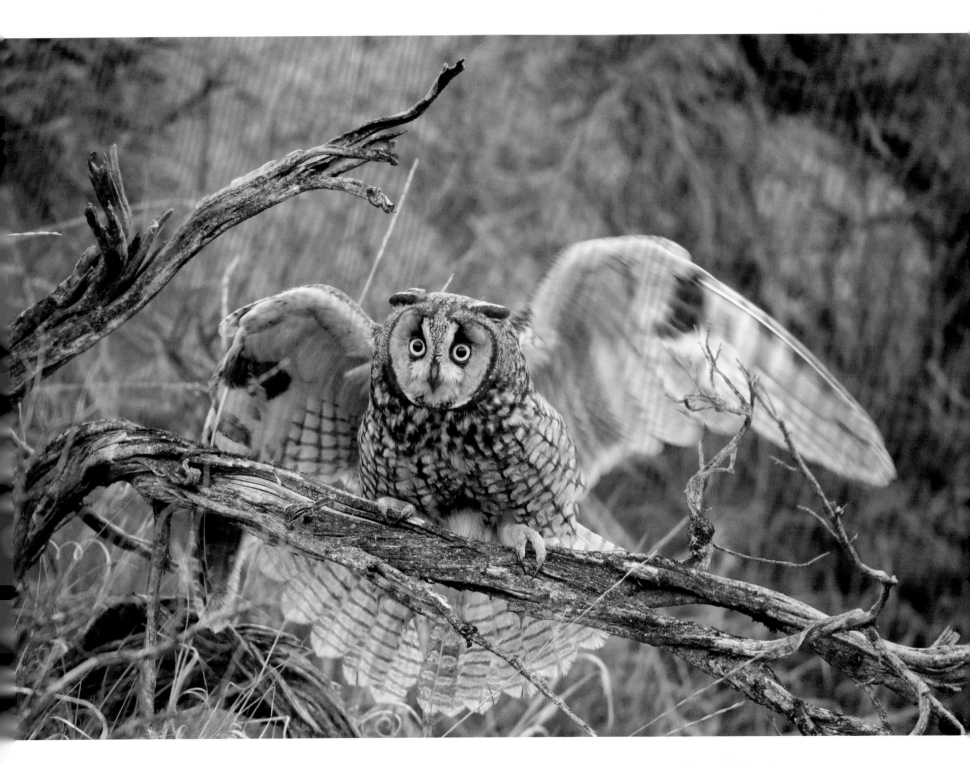

Like other adult owls, this Long-eared Owl makes loud, plaintive noises and waves its wings to distract potential predators and lead them away from its nest or young.

About the Author

Paul Bannick is an award-winning wildlife photographer specializing in birds and their habitat. His first book, *The Owl and the Woodpecker*, is the subject of a national traveling exhibit of the same title. Paul is the photographer for *Journey with the Owls* and *Woodpeckers of North America: A Naturalist's Handbook*. His photographs can also be found prominently in dozens of books including guides from The Smithsonian, Audubon, and Peterson. Paul's work has appeared in hundreds of publications including *The New York Times*, *Audubon*, *Nature's Best Photography*, and *Sunset* and in calendars by National Geographic and many others.

Paul currently serves as the major gifts director for Conservation Northwest, an organization dedicated to protecting and connecting wild areas from the Pacific Coast to the Canadian Rockies. Paul is a regular keynote speaker and presenter at bird festivals, conservation events, and conventions across North America. Visit www.paulbannick.com to learn more about his work.

The author holds a Northern Hawk Owl fledgling in the field while assisting the Owl Research Institute in a long-term research study on Northern Hawk Owls. (Photo by Matt Larson)

A Note about the Photography

I strive to capture images of actual behavior with minimum impact upon the subject and to record faithful documentations of the natural moments including imperfections in the subject, background, and foreground. To this end, I limit post-processing to the digital equivalent of traditional methods. None of the images are composites. The photographs were taken with Canon digital cameras and lenses without camera traps or remote triggers.

All of the bird images feature wild subjects. With the exception of some fledgling owls that were moved by researchers during the banding process, none were captive or restrained in any way. Northern Spotted Owls were fed as part of research protocol, but none of the other owls were baited.

With Special Appreciation

To Tom and Sonya Campion for their ongoing friendship and support.

BRAIDED RIVER®

BRAIDED RIVER, the conservation imprint of Mountaineers Books, combines photography and writing to bring a fresh perspective to key environmental issues facing western North America's wildest places. Our books reach beyond the printed page as we take these distinctive voices and vision to a wider audience through lectures, exhibits, and multimedia events. Our goal is to build public support for wilderness preservation campaigns, and inspire public action. This work is made possible through the book sales and contributions made to Braided River, a 501(c)(3) nonprofit organization. Please visit BraidedRiver.org for more information on events, exhibits, speakers, and how to contribute to this work.

Braided River books may be purchased for corporate, educational, or other promotional sales. For special discounts and information, contact our sales department at 800.553.4453 or mbooks@mountaineersbooks.org.

THE MOUNTAINEERS, founded in 1906, is a nonprofit outdoor activity and conservation organization, whose mission is "to explore, study, preserve, and enjoy the natural beauty of the outdoors . . . " Mountaineers Books supports this mission by publishing travel and natural history guides, instructional texts, and works on conservation and history.

Send or call for our catalog of more than 600 outdoor titles:
Mountaineers Books

1001 SW Klickitat Way, Suite 201
Seattle, WA 98134
800.553.4453
www.mountaineersbooks.org

Manufactured in China on FSC-certified paper, using soy-based ink.

For more information, or to order prints from this book, visit www.paulbannickcom.

COVER PHOTO: *A Great Gray Owl, hovering above the snow, opens its talons and waits for the right moment to strike at potential prey.* PAGE 1: *A Great Gray Owl perches on a downed tree several days after fledging.* PAGE 2: *An incubating female Pygmy-Owl calls to her mate from the nest cavity entrance.* PAGE 3: *Pulling his wings forward to slow his speed, a male Snowy Owl descends to the nest to deliver a lemming.* PAGES 4-5: *Nine Burrowing Owls engage one another outside of their burrow.* PAGE 6: *Northern Hawk Owls, more than most other owls, will hover when hunting, particularly when prey is hidden by snow.* PAGE 8: *With his ears up, head jutting forward, and throat full of air, a calling Great Horned Owl appears to pump the hoos out of his body with the up-and-down motion of his tail.*

PUBLISHER: Helen Cherullo
ACQUISITIONS EDITOR: Kate Rogers
PROJECT MANAGER: Mary Metz
DEVELOPMENTAL EDITOR: Linda Gunnerson
COPY EDITOR: Ellen Wheat
COVER AND BOOK DESIGNER AND CARTOGRAPHER: Kate Basart/Union Pageworks
BRAIDED RIVER DEVELOPMENT AND COMMUNICATIONS: Lace Thornberg
SCIENTIFIC ADVISOR: Scott Weidensaul

Library of Congress Cataloging-in-Publication Data:
Names: Bannick, Paul, 1963– author.
Title: A year in the lives of North American owls / by Paul Bannick.
Description: Seattle : Braided River, 2016. | Includes bibliographical references and index.
Identifiers: LCCN 2016005104 | ISBN 9781594858000 (cloth)
Subjects: LCSH: Owls—North America.
Classification: LCC QL696.S8 B37 2016 | DDC 598.9/7—dc23
LC record available at http://lccn.loc.gov/2016005104

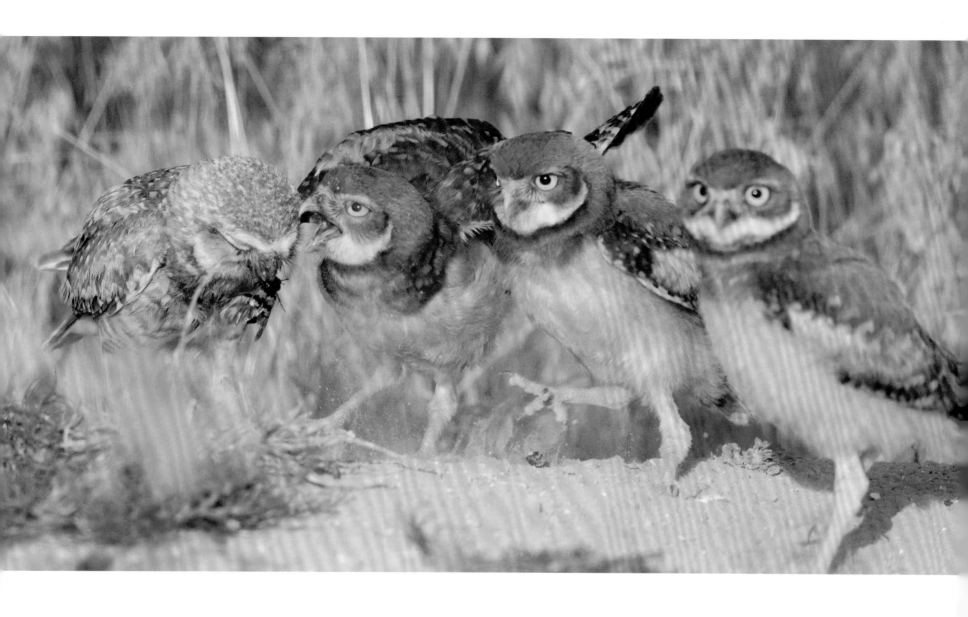

A Burrowing Owl delivers a burying beetle (a species of beetle that buries its prey) to her young waiting at the nest.

{ *opposite* } When Snowy Owls spot prey, they launch quickly into the air where they pursue their prey using powerful wing beats, effective even in strong winds.

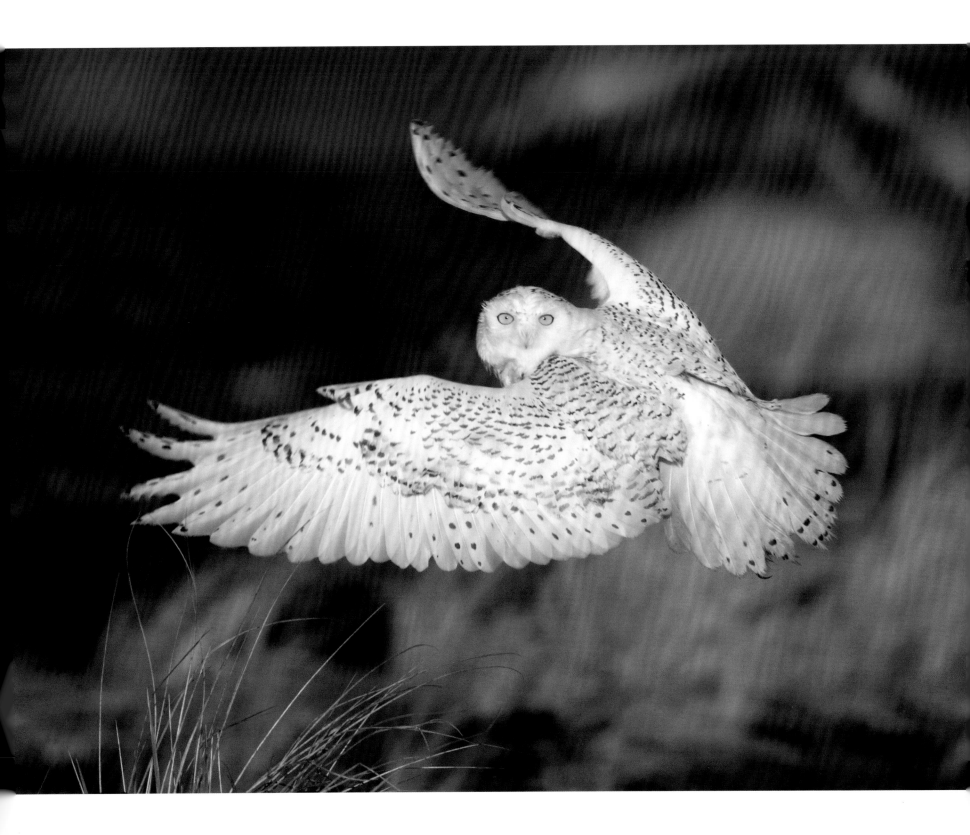

The reddest Northern
Pygmy-Owls are found in the
wettest parts of their range
in the coastal areas of British
Columbia and Washington.

{final page } A juvenile Great
Gray Owl pops his head
around from behind a tree.

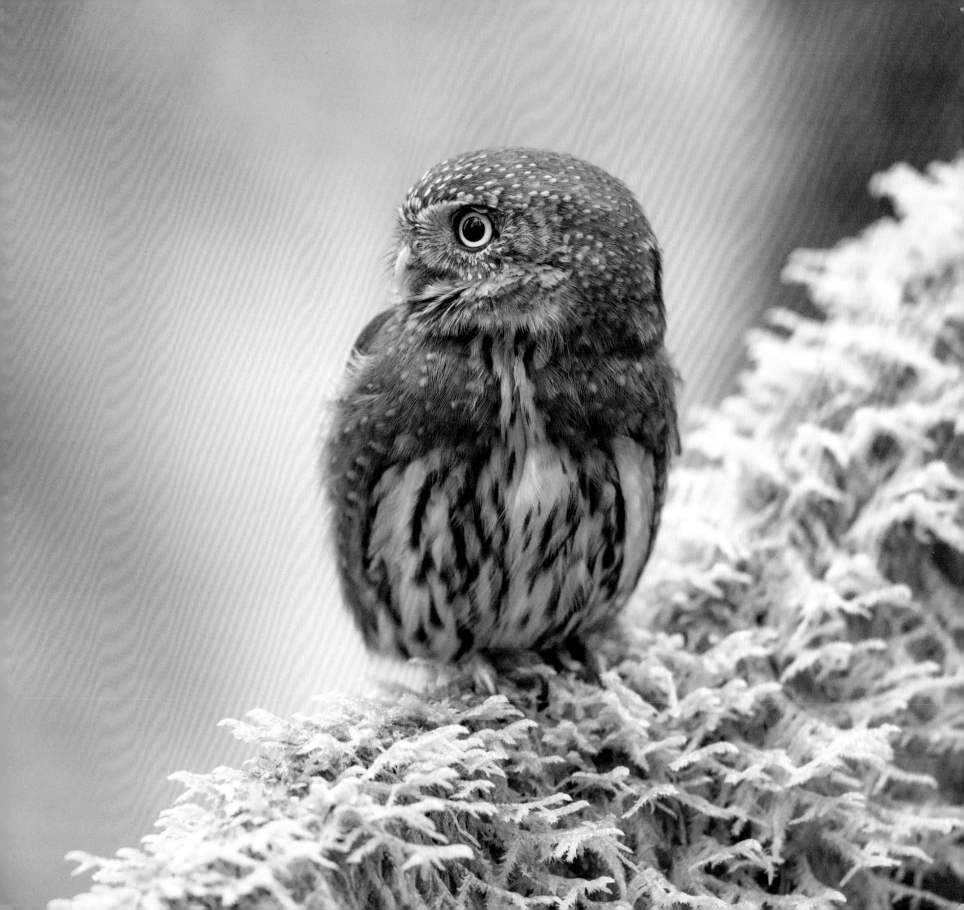

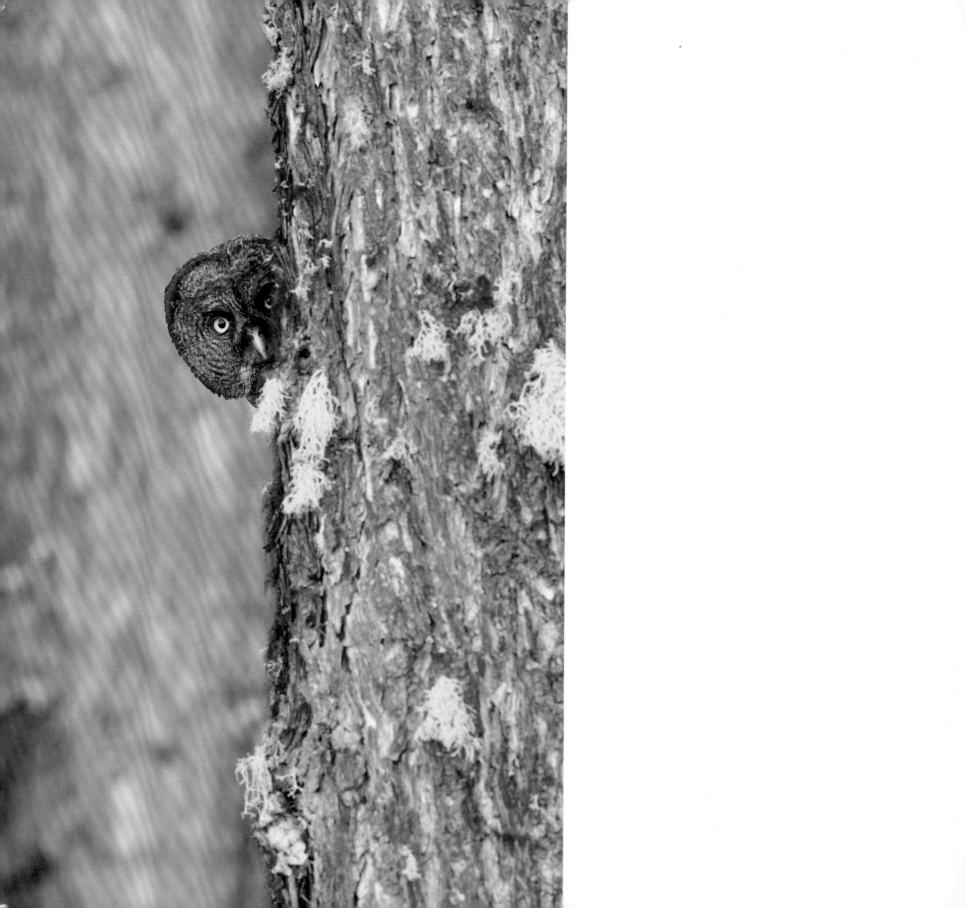